A Motor City Year

A Motor City Year

JOHN SOBCZAK

with a foreword by

JEFF DANIELS

A Painted Turtle book
Detroit, Michigan

13 12 11 10 09 5 4 3 2 1

Library of Congress Cataloging-in-Publication Data

Sobczak, John.
A Motor City year / John Sobczak.
 p. cm.
ISBN 978-0-8143-3410-2 (cloth : alk. paper)
1. Detroit (Mich.)—Pictorial works. 2. City and town life—Michigan—Detroit—Pictorial works.
3. Detroit (Mich.)—Social life and customs—Pictorial works. 4. Detroit (Mich.)—Biography—Pictorial works. I. Title.
F574.D443S68 2009
977.4'340440222—dc22
2009010845

Designed and typeset by Brad Norr Design
Composed in New Baskerville and Frutiger

CONTENTS

FOREWORD

Is it me or does everyone in the world have a camera in their phone? Or is it a phone in their camera? No matter. Despite the deluge of quick-take-a-picture photography nowadays, to create art it still takes a photographer with a camera who knows where to look. John Sobczak has been doing just that in and around the city of Detroit for decades. His work in *A Motor City Year* is no exception. Great photographs, such as those in this book, happen when you wait. As the subject of many a lens in my time, there comes a moment when the photographer—no, the artist—is doing absolutely nothing. In fact, what he's doing is waiting for that something he can't create, can't manufacture, can't make happen. He stands there, taking in his subject, the surroundings, patiently waiting to capture the essence of whatever it is that is now, and only now, right there in front of him. When he sees it, his camera comes alive. Art is everywhere, you just have to know where to look and how to wait. John Sobczak knows how to do both. Luckily for us, he usually has a camera in his hands.

Jeff Daniels

PREFACE

Have you ever wondered what it's like to work on the roof of the Fisher Building? Have you watched the Passion play as it unfolds on the streets of Mexican Town? Are you familiar with Rock 'n' Bowl at the Majestic? Did you know that Detroit has its own Roller Derby team featuring women with names like Cookie Rumble and Lady MacDeath?

You have to believe that a city with car-hopping competitions, that celebrates Cinco de Mayo as well as the Chinese New Year, and that has some of the largest jazz and electronic music festivals in the country just might have something for everyone.

The idea for this book was simple: a different image every day for one year to capture the flavor of Metro Detroit. Whether it's fishing in the mist on Lake St. Clair or sledding down the hills in Franklin, working on the line at the Rouge Plant or watching the Tigers play at Comerica Park, the photos in this book show Metro Detroit's unique communities and personalities.

From Wyandotte to Ann Arbor to Rochester, with many detours in between, the city provides an unlimited supply of visual opportunities. The challenge was in choosing only one image to tell each story.

Whether you grew up here or have yet to create memories in Metro Detroit, my hope is that the images in this book bring a smile to your face and leave you with an appreciation for all that our area has to offer.

SPRING

March

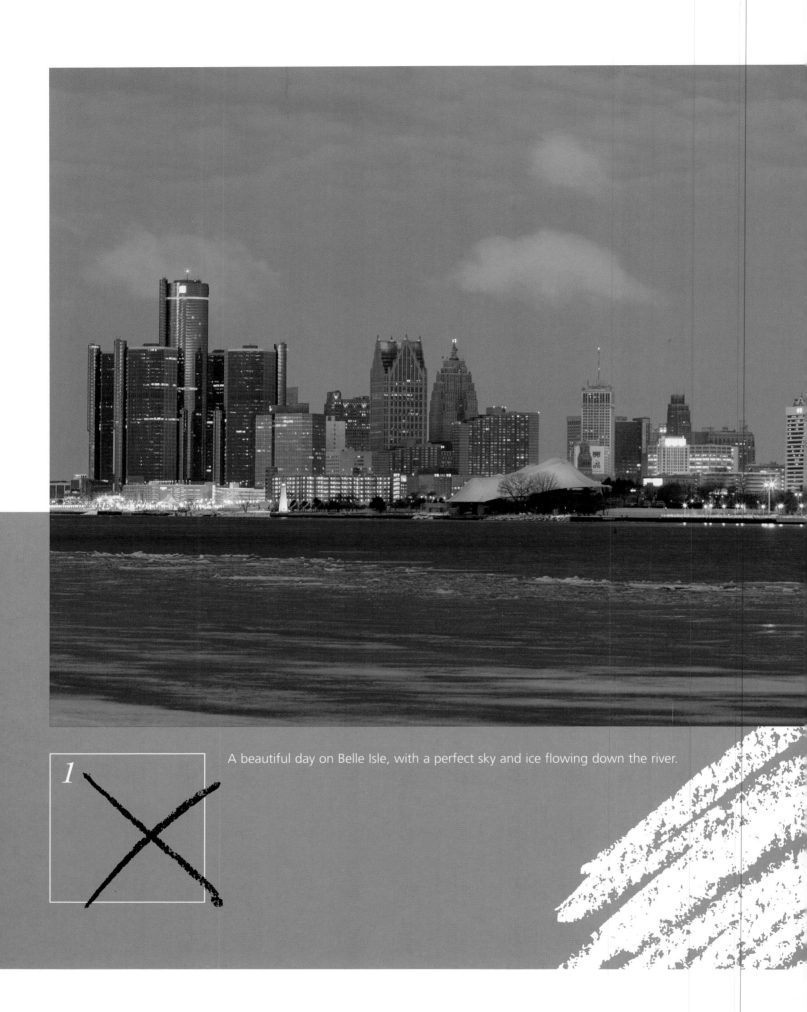

1

A beautiful day on Belle Isle, with a perfect sky and ice flowing down the river.

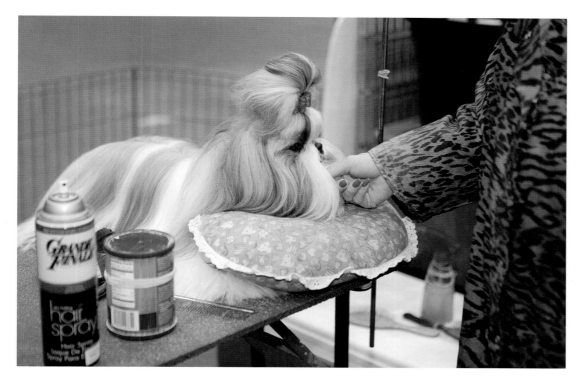

2 Ch. Souyen Dreaming of Perfection, or Vinnie for short, gets star treatment at the 101st Detroit Kennel Dog Club Show.

Alfred Ackerman of the painting conservation department of the Detroit Institute of Arts removes overpaint from an early-nineteenth-century painting.

3

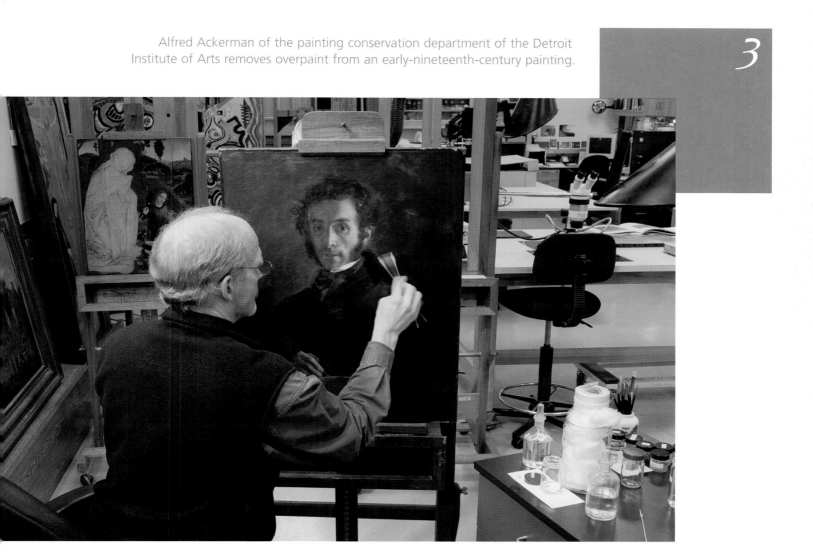

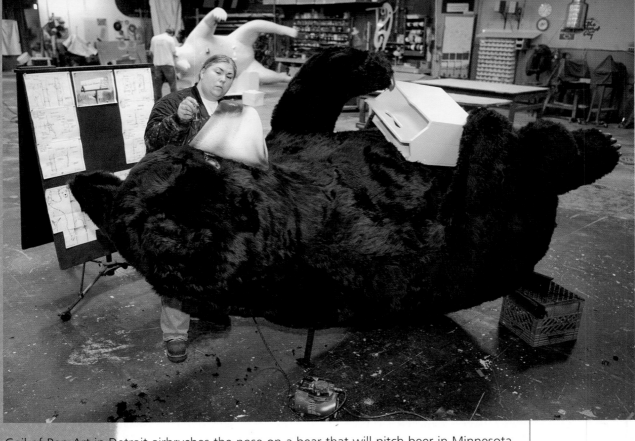

Gail of Pop Art in Detroit airbrushes the nose on a bear that will pitch beer in Minnesota.

4

Construction shuts down all lanes of I-75 for the Ambassador Bridge Gateway Project.

6

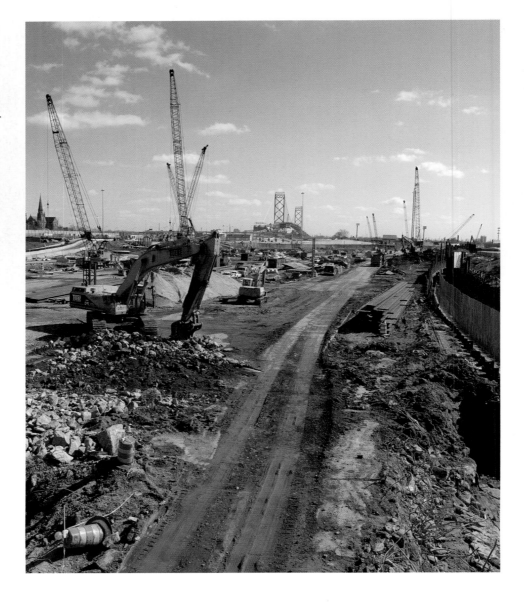

5

Snowshoeing at Kensington Metropark on a fresh blanket of snow.

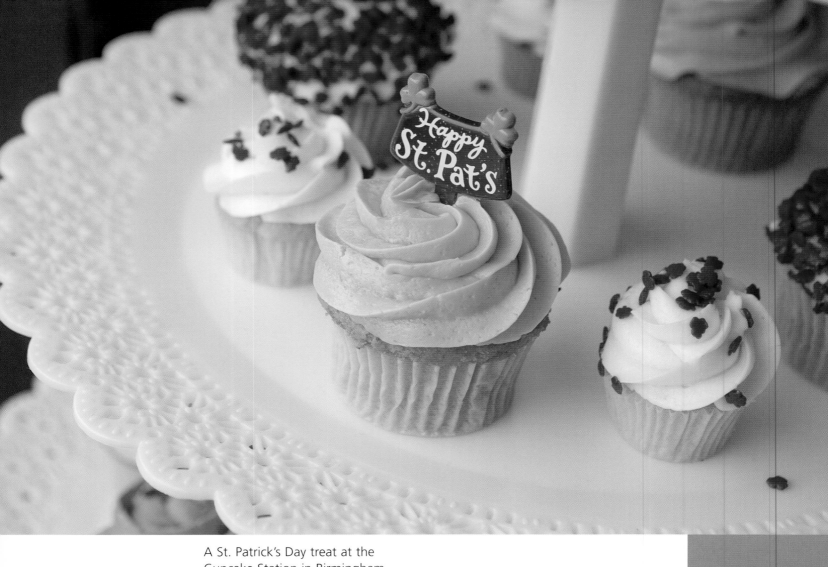

A St. Patrick's Day treat at the
Cupcake Station in Birmingham.

7

8

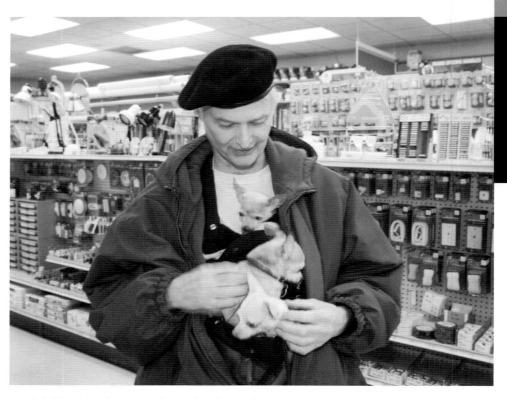

At Neighborhood Pro Hardware in Birmingham, rescued
Chihuahuas Chiquita, Bonita, and Mick shop for nails
with their owner, Richard.

John and Paul of Frankenmuth admire a Vernor's delivery truck in perfect condition on display at Autorama in Detroit.

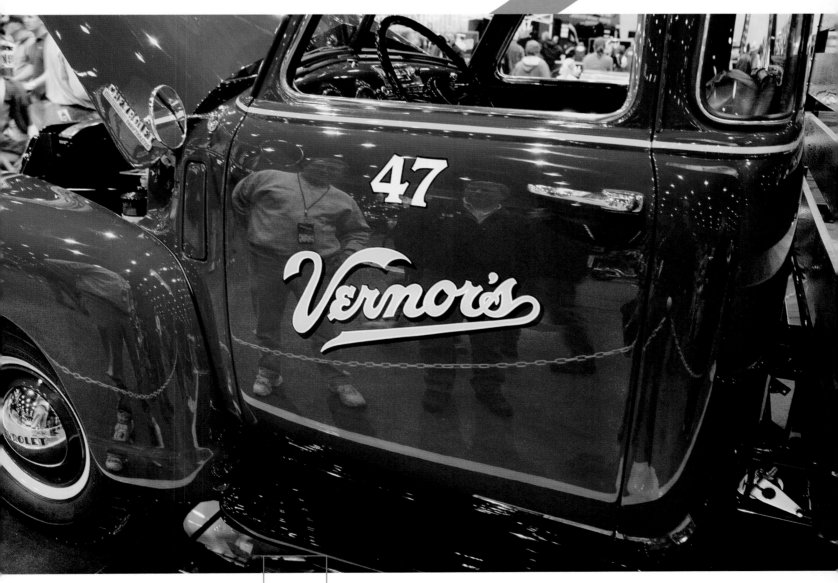

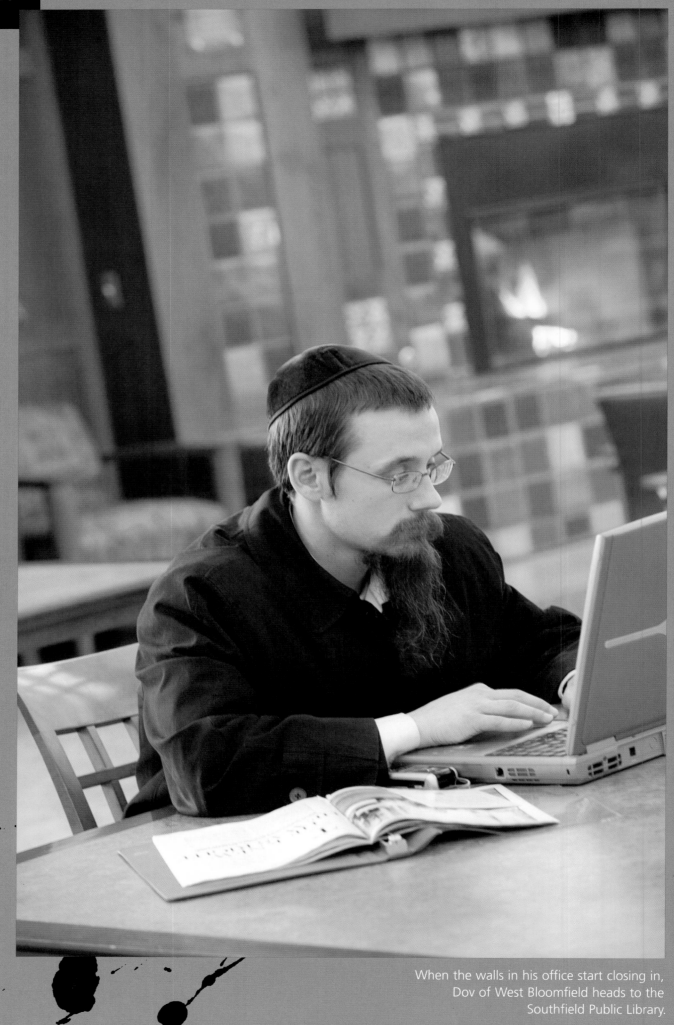

When the walls in his office start closing in,
Dov of West Bloomfield heads to the
Southfield Public Library.

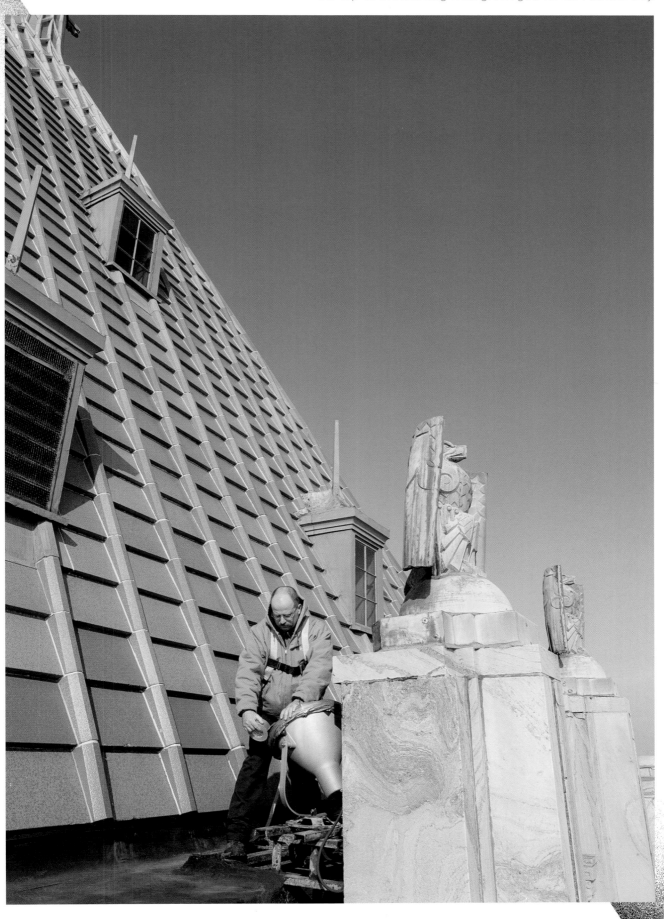

Chuck, part of the staff at the Fisher Building, illuminates the top of the building with green gels for St. Patrick's Day.

11

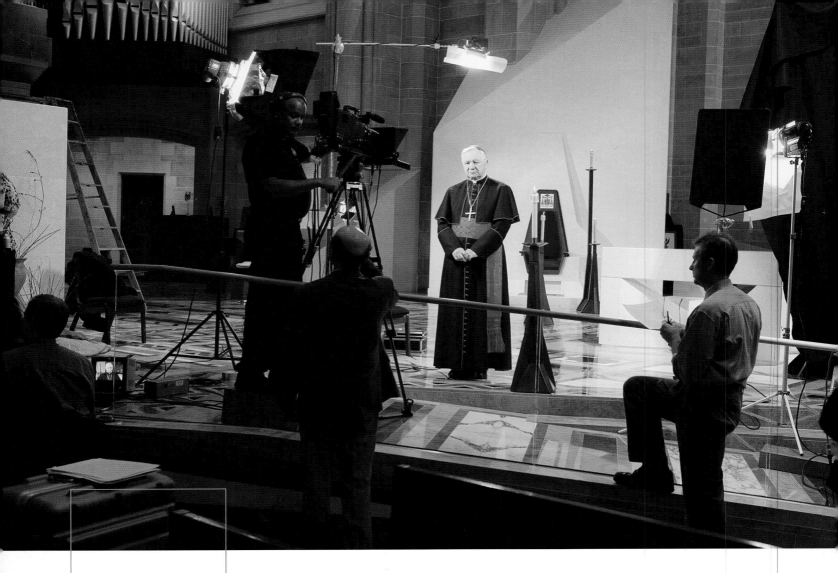

Behind the scenes as Cardinal Maida tapes a message for Pope Benedict XVI.

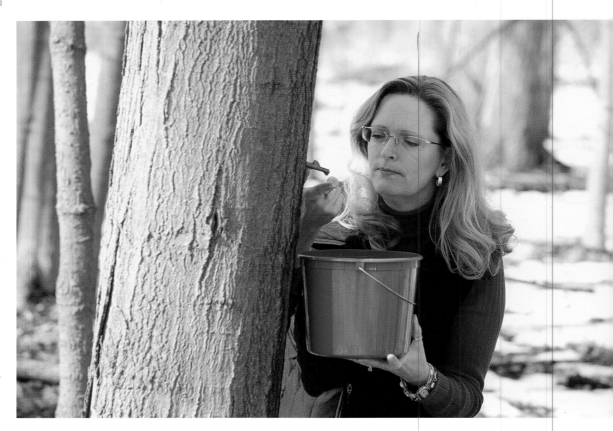

Michigan Teacher of the Year June Teisan of Grosse Pointe Woods collects sap from maple trees at University of Michigan–Dearborn.

14

Dave and his son Matt of
Waterford try their luck at
ice fishing on Oxbow Lake.

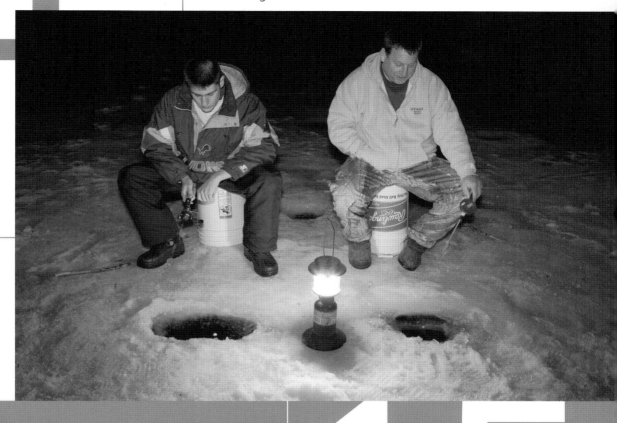

15

Ryan and his team from Michigan take
on the defending champs, Washington,
when the Detroit Curling Club hosted
the mixed nationals, its first since 1989.

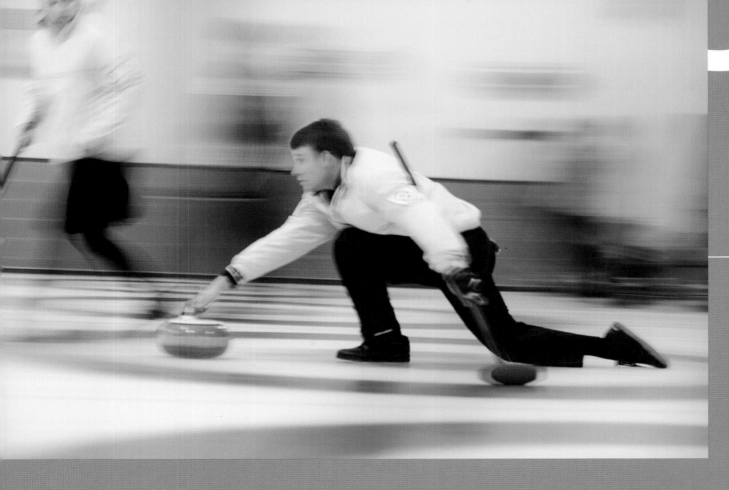

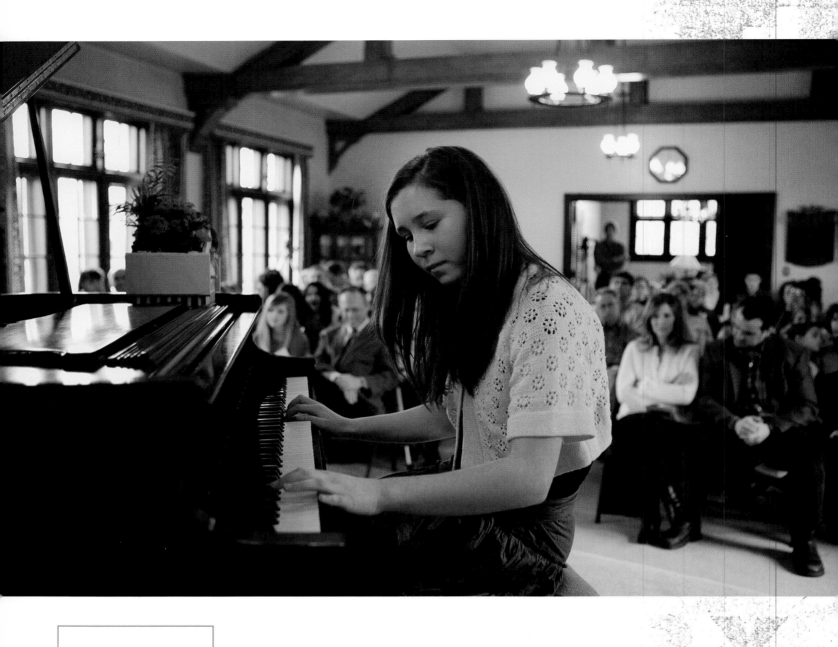

16

Tatyanna performs in a student recital held by piano teacher Mary Coburn at the Royal Oak Woman's Club.

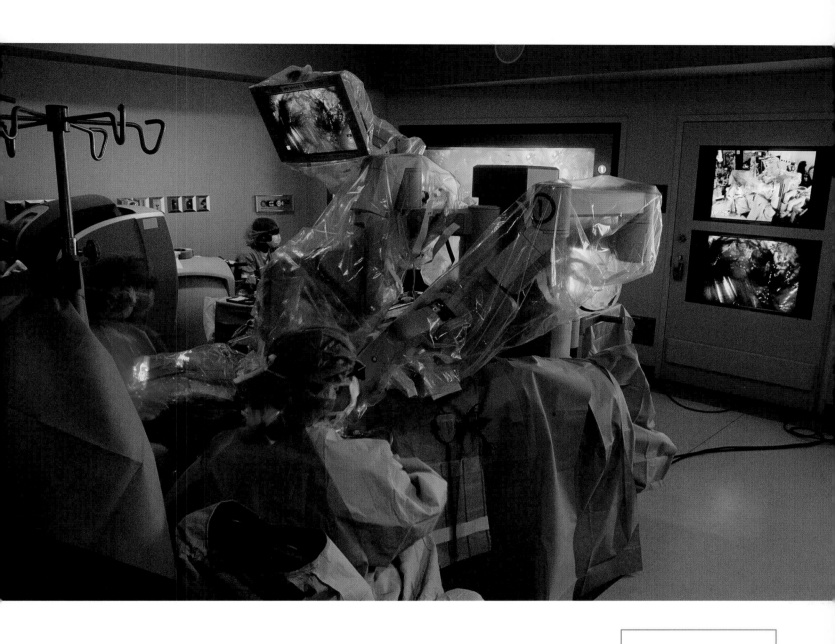

Dr. Menon of the Vattikuti Urology Institute at Henry Ford Hospital performs robotic prostatectomy, a procedure to treat prostate cancer.

17

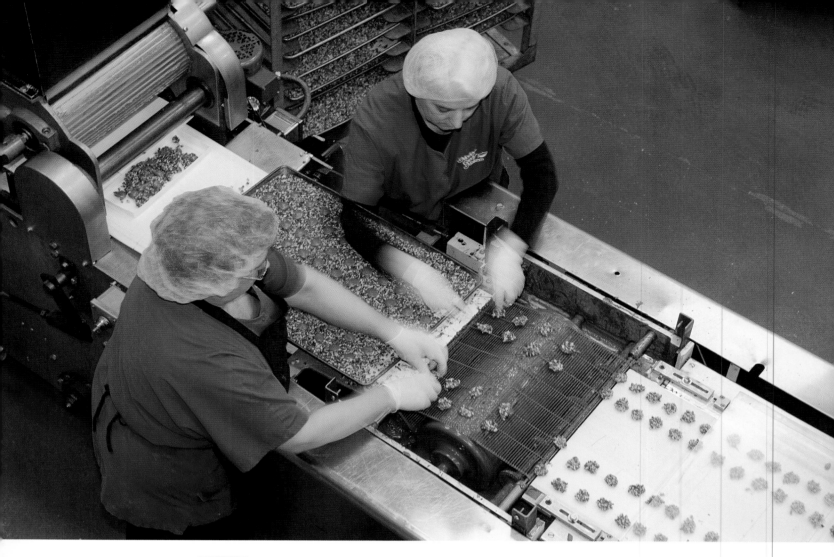

Joan and Todorka dip caramel almond clusters in chocolate at Morley Candy Makers in Clinton Township, founded in Detroit in 1919.

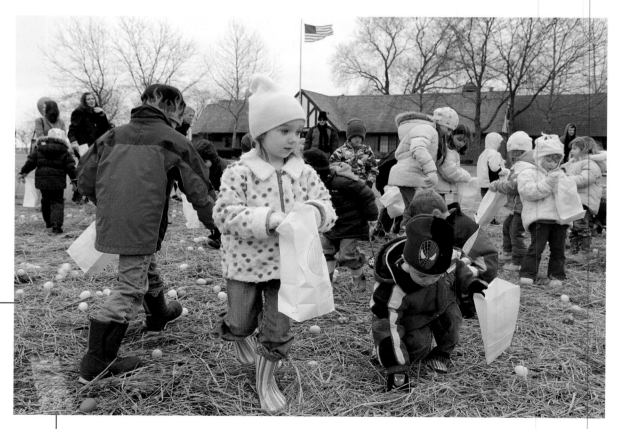

19

Marin and her brother Asher hunt eggs in Windmill Pointe Park before meeting the Easter bunny.

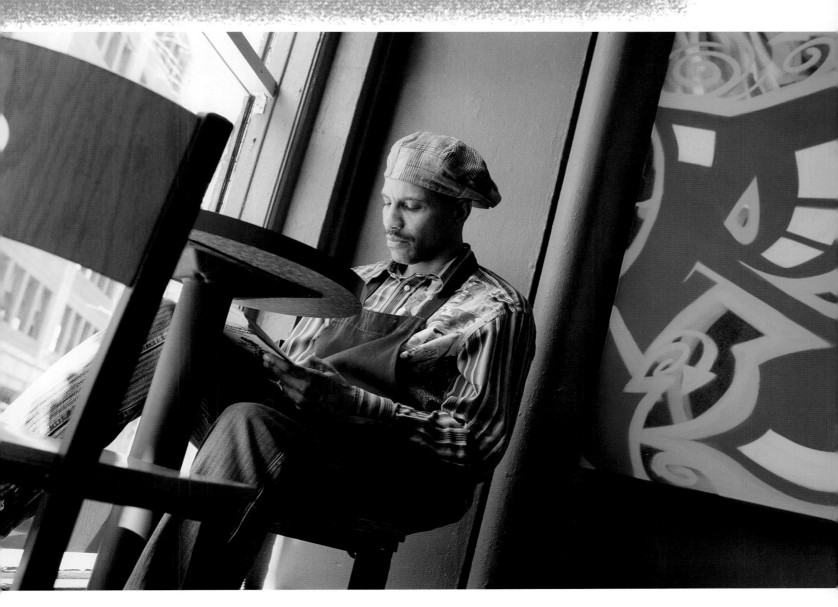

Michael catches up on his reading between customers at the Espresso Jazzy Café in downtown Detroit.

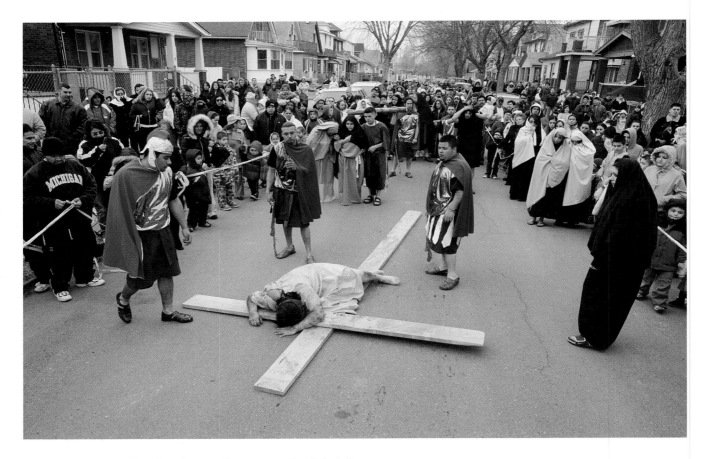

Every year on Good Friday the youth group at St. Gabriel's Church enacts the Stations of the Cross as part of the Passion Play on the streets of Mexican Town.

Patty Larkin plays at the Ark in Ann Arbor.

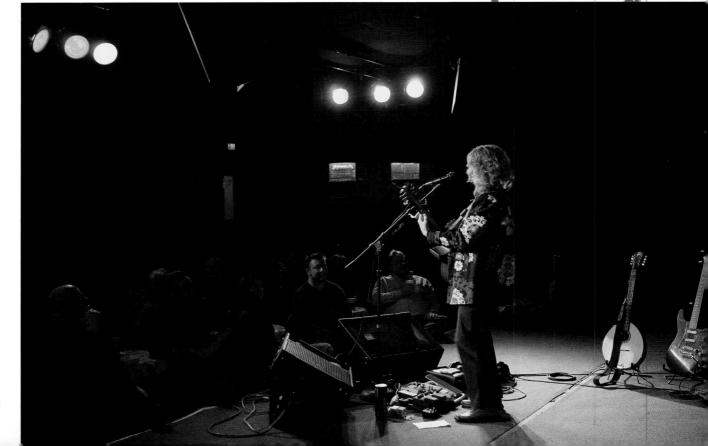

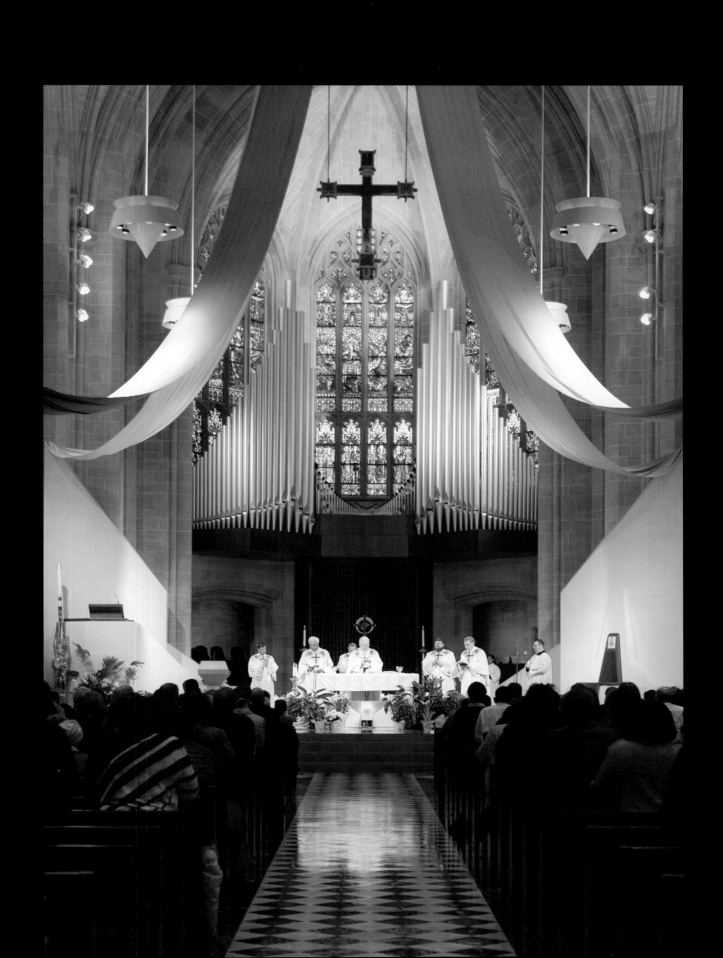

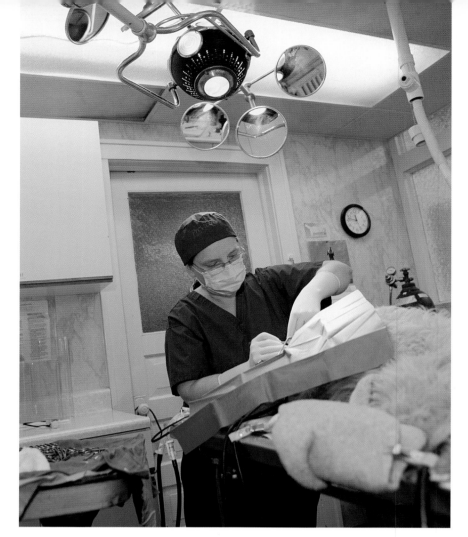

24

Dr. Graham, the owner of Patterson Dog and Cat Hospital in Detroit, the oldest continuously operating veterinary clinic in the United States, performs eye surgery on Samantha, a poodle.

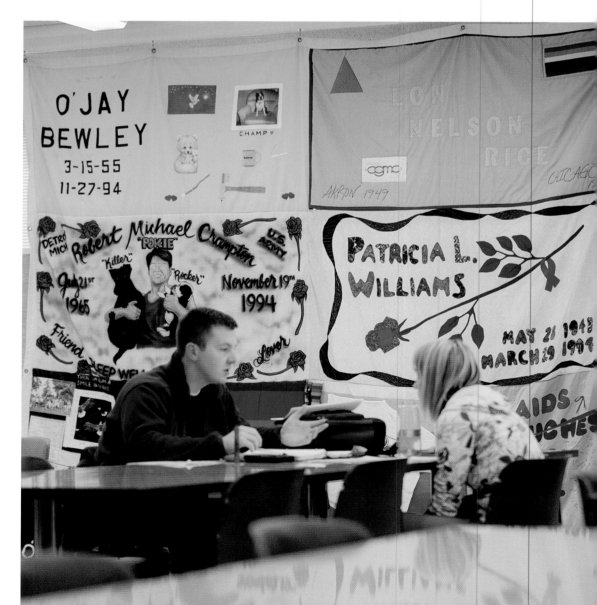

26

Wayne State University students Jessica and Michael study in front of the AIDS Memorial Quilt on display at Scott Hall.

Some of the many novelties at Marvin's Marvelous Mechanical Museum in Farmington Hills.

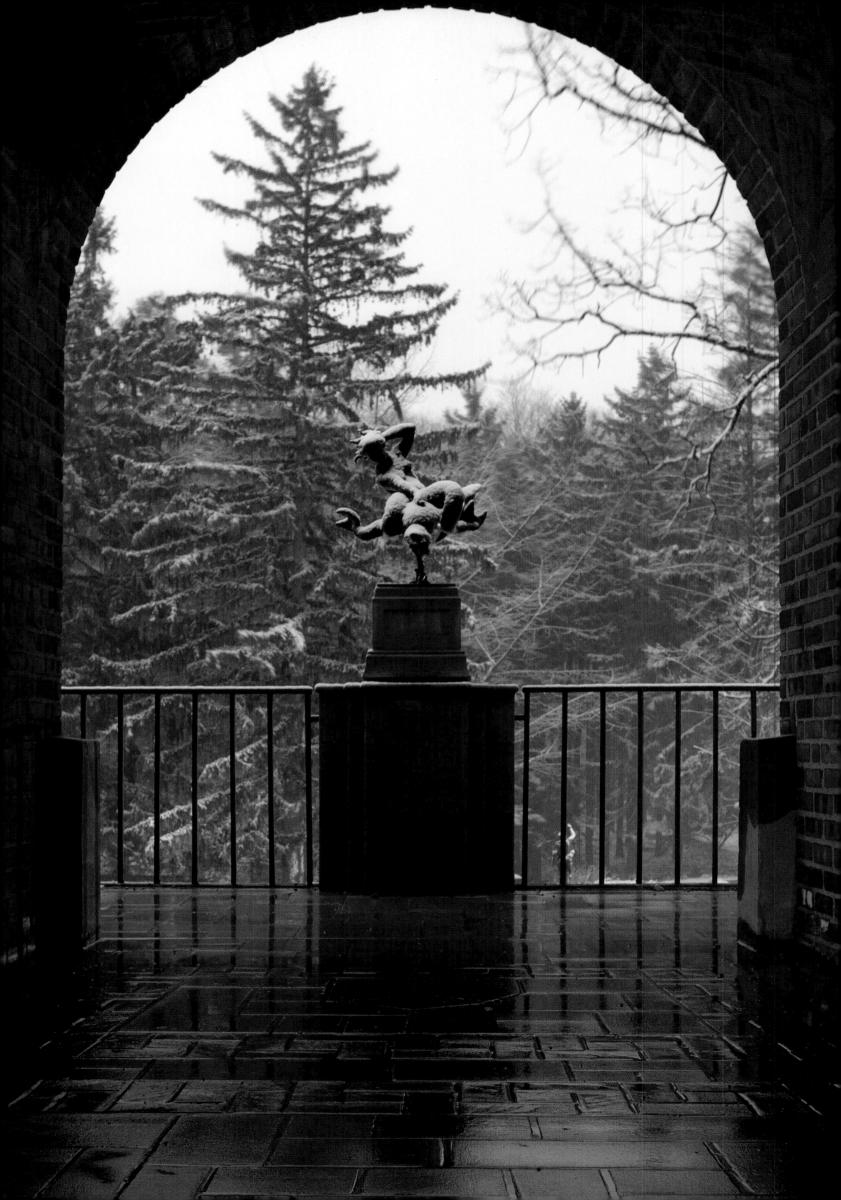

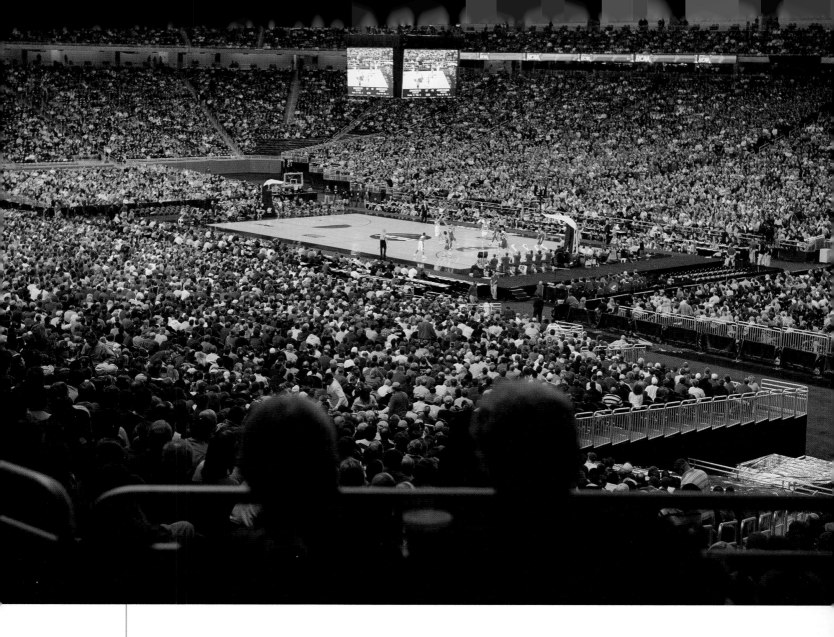

27 | The grounds at Cranbrook include many sculptures and fountains.

One of the largest crowds in NCAA Tournament history watch Davidson play Wisconsin in the Sweet 16 round at Ford Field.

28

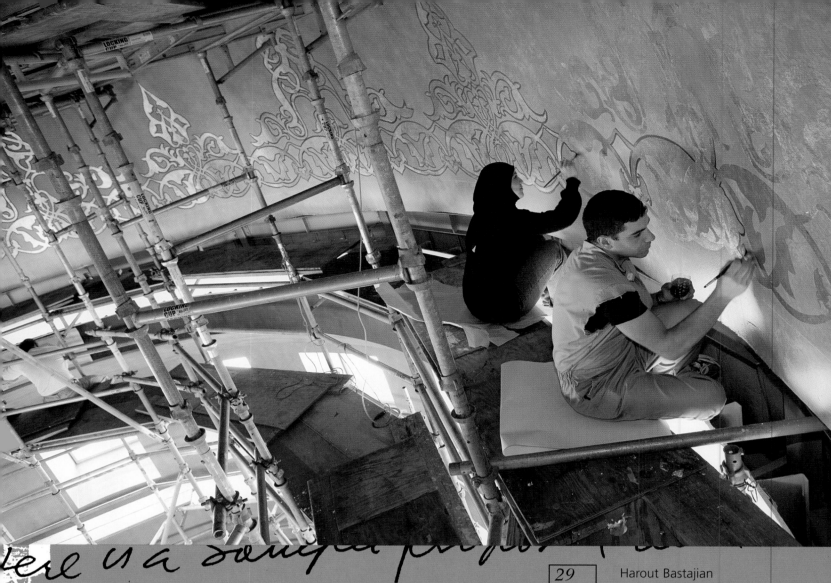

29 Harout Bastajian came all the way from Lebanon to paint the dome at the Islamic Center of America in Dearborn. He uses bronze leaf and then outlines the design, with help from Latifeh, to make it more visible from below.

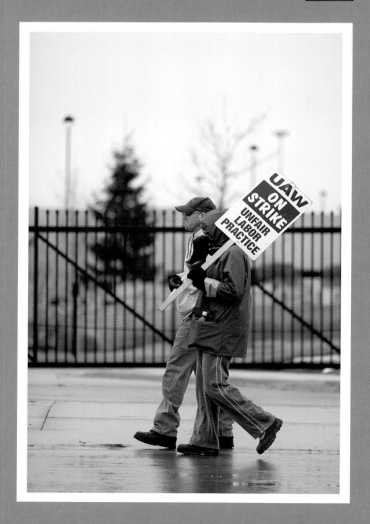

Marc and Christy walk a picket line in front of American Axle and Manufacturing headquarters.

30

24 / March

Justin Verlander throws
out the first pitch of
the season on
opening day
for the
Tigers at
Comerica
Park.

31

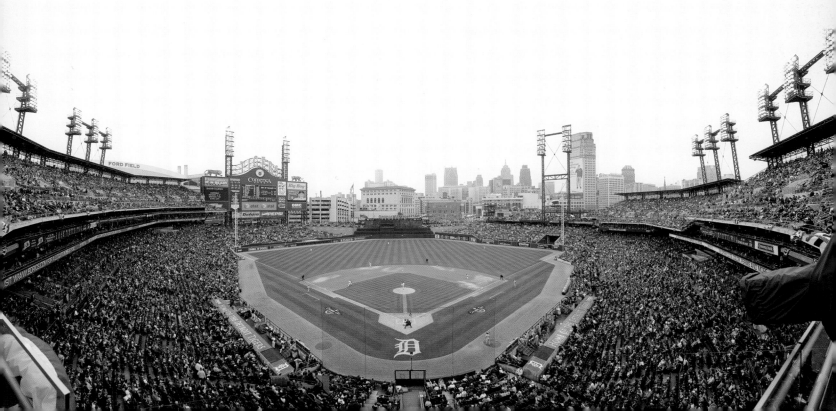

APRIL

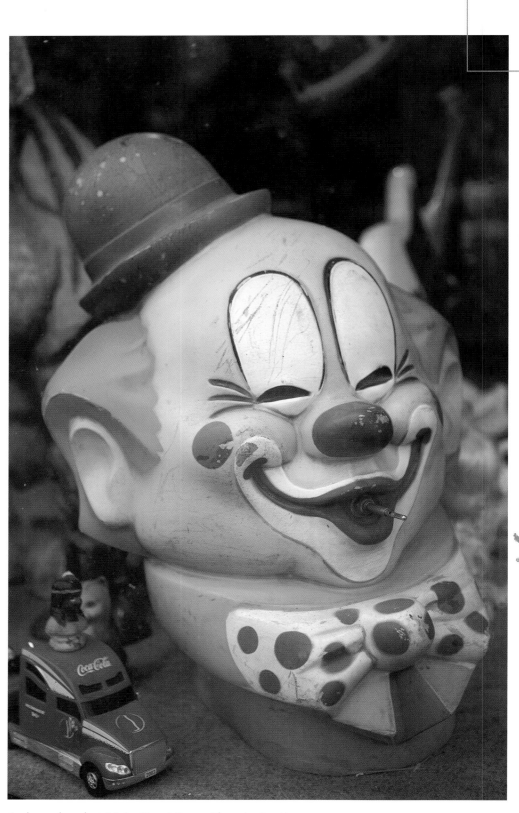

A clown head at Main Street Pawn Shop in Pontiac.

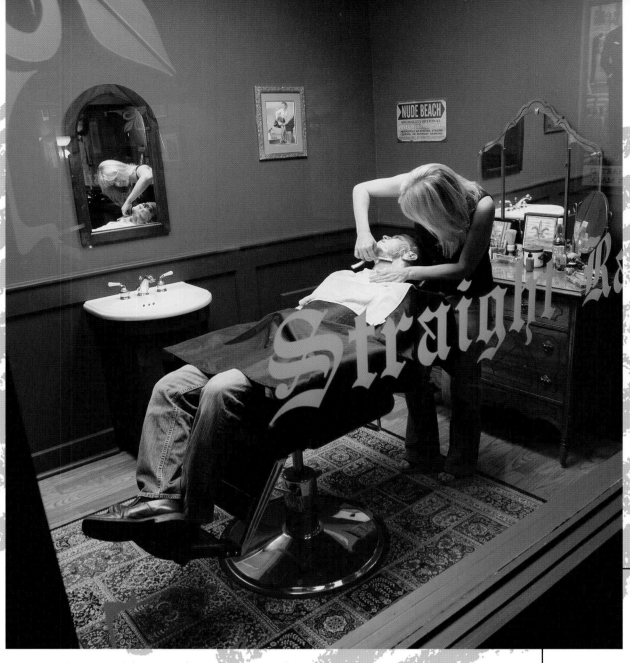

Jason receives a straight razor shave from Marcella at Trim Barber House in Clawson.

2

1

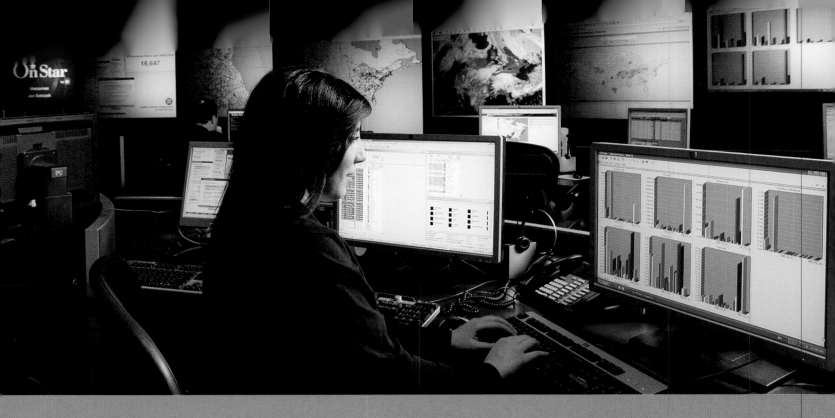

At Onstar Headquarters, located in the Renaissance Center, Laura and her colleagues assist drivers all over North America.

3/4

Leonard Slatkin conducts his first performance at Orchestra Hall as music director designate of the Detroit Symphony Orchestra.

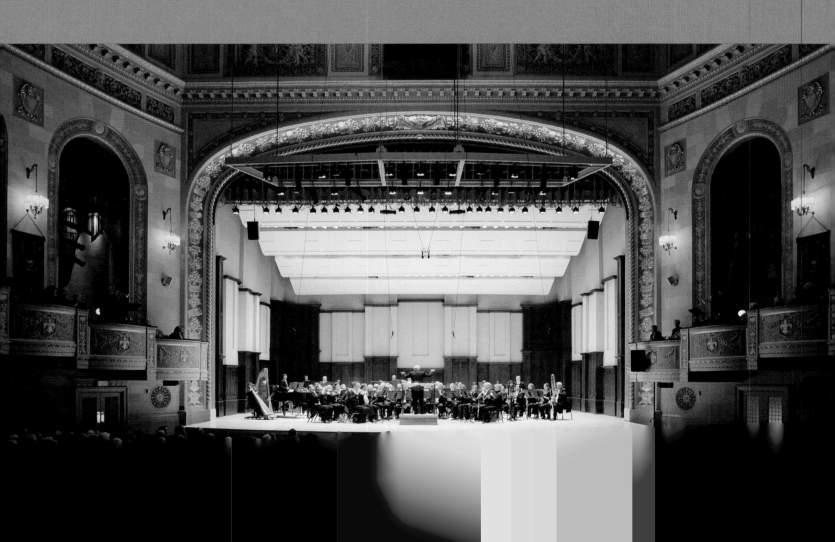

Cancer support group Gilda's Club in Royal Oak and charity organization Queen for a Day host the first-ever cancer survivors' fashion show. Seventeen-year-old Brooke models fashions from Macy's as twenty-one-year-old Catie walks behind her.

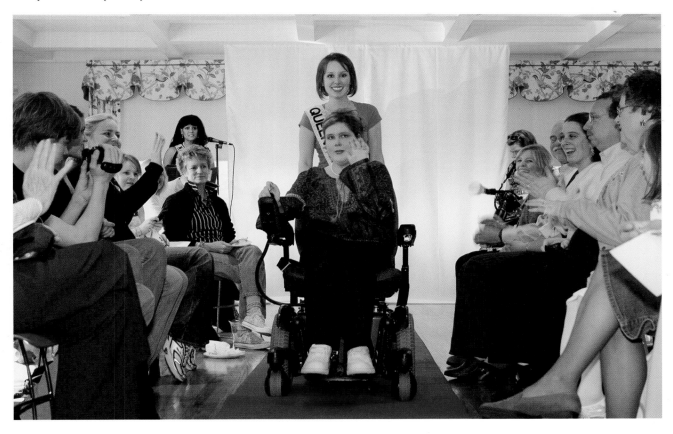

5

6

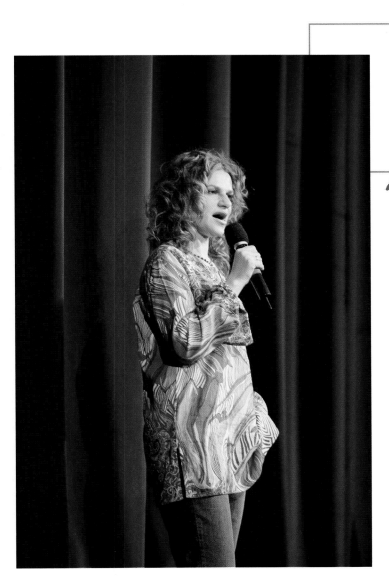

Sandra Bernhard hosts the Detroit Fringe Festival at Music Hall Center for the Performing Arts.

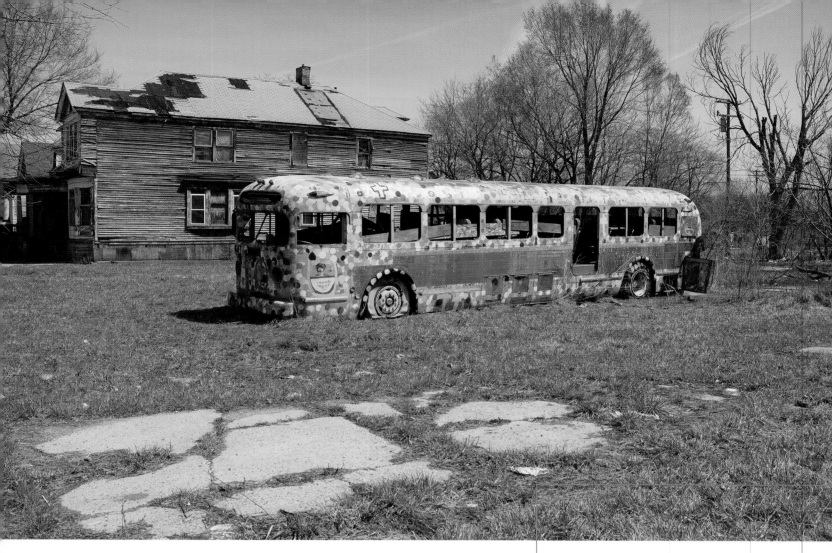

An abandoned bus
transformed into
art as part of
Tyree Guyton's
Heidelberg Project.

7

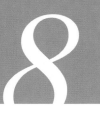

8

Darrin from Detroit rides a modified bike in front of the Hub of Detroit bicycle shop.

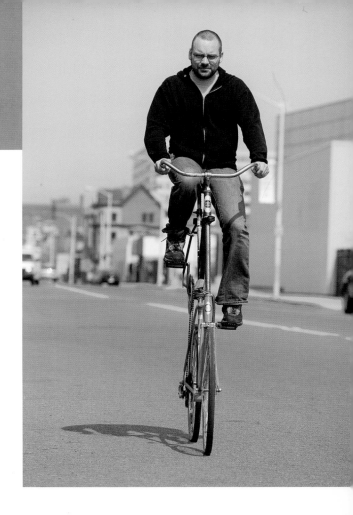

9

Neinas Elementary School students learn about matryoshka dolls from Linda at the Detroit Children's Museum.

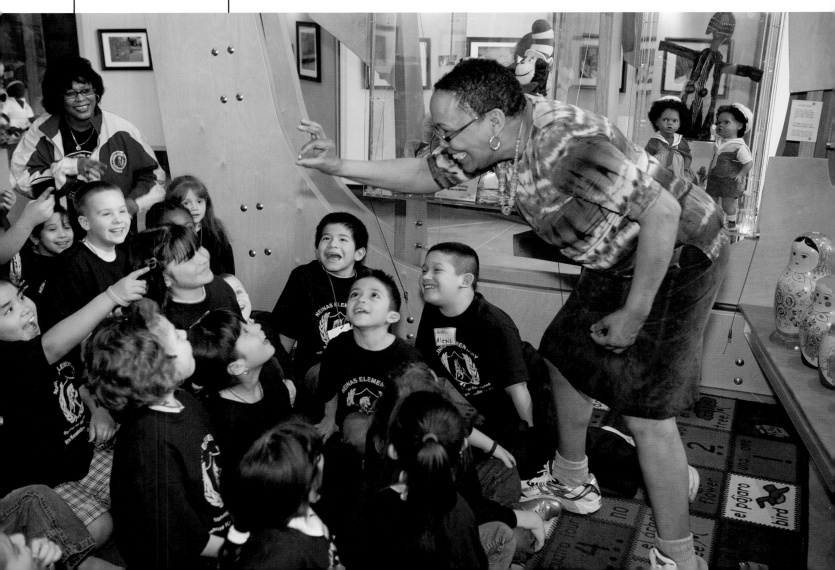

Pamela from Wyandotte browses the shelves at John K. King in Detroit, one of the largest used-book stores in the country.

10

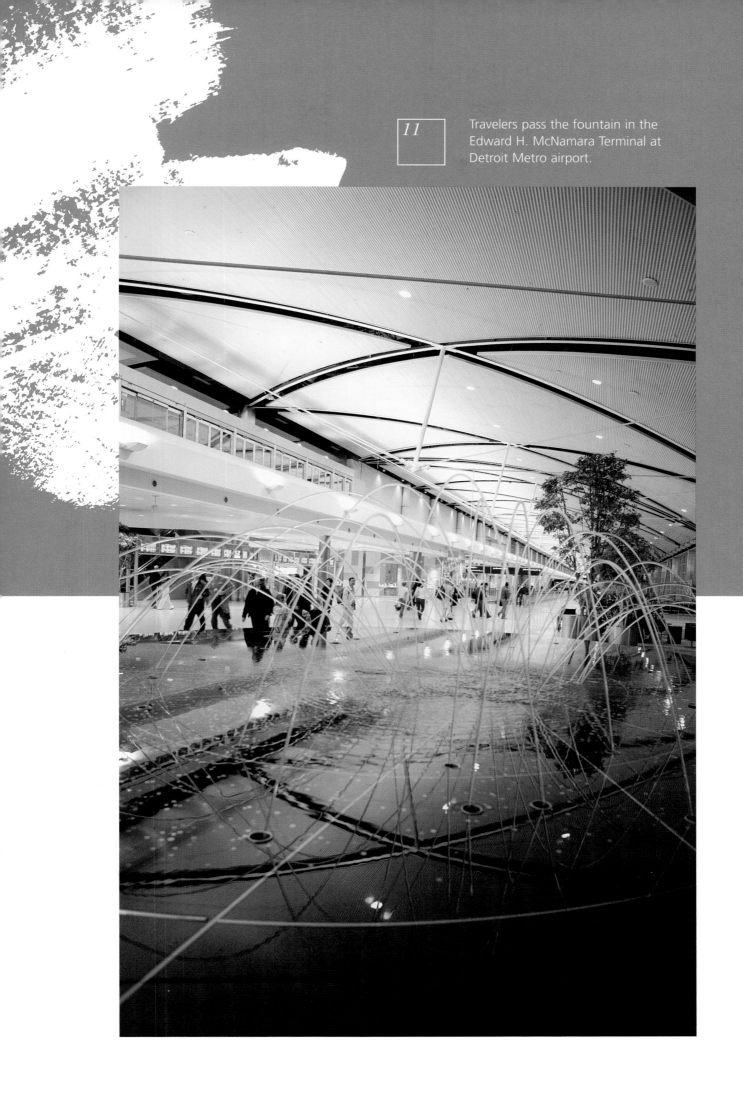

Travelers pass the fountain in the
Edward H. McNamara Terminal at
Detroit Metro airport.

12

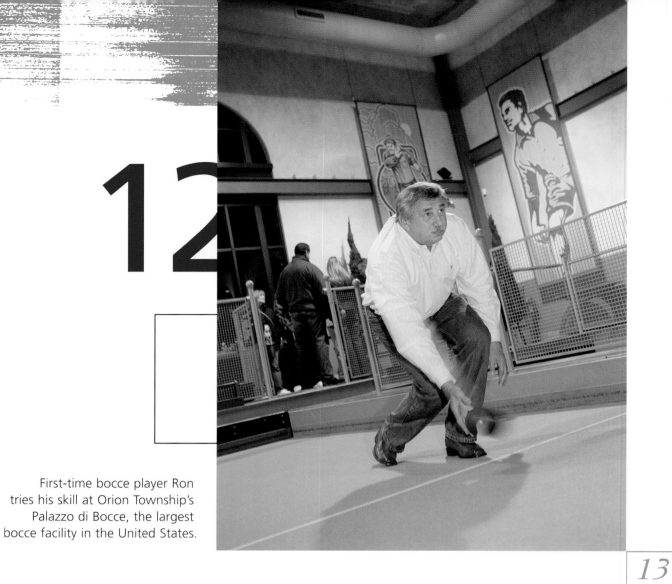

First-time bocce player Ron tries his skill at Orion Township's Palazzo di Bocce, the largest bocce facility in the United States.

13

McKenna from Plymouth tries glow-in-the-dark golf at Putting Edge in Novi.

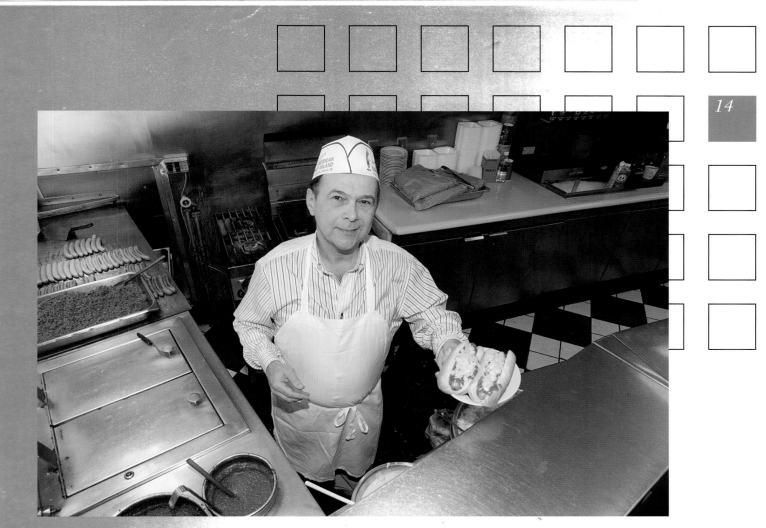

Daniel at Lafayette Coney Island in Detroit cooks up some coneys with everything.

Ron welds copper on a cornice as part of the Westin Book Cadillac Hotel renovation effort.

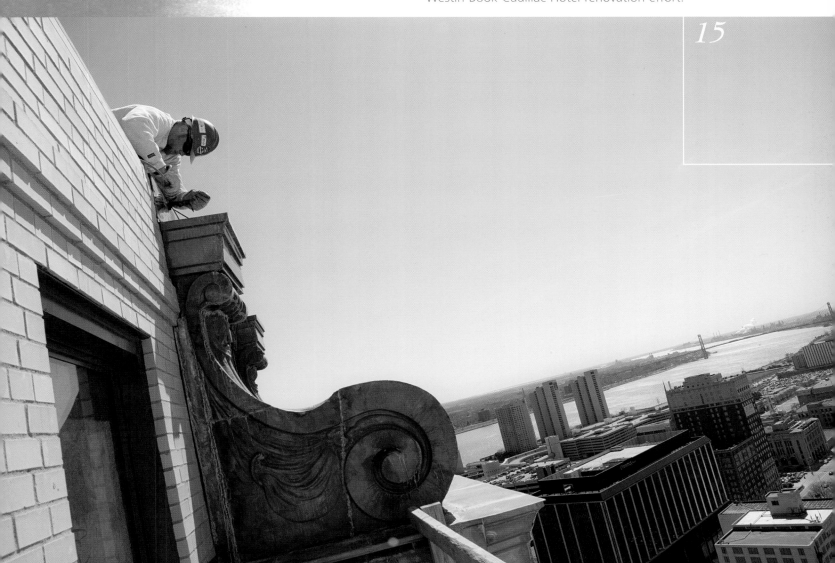

16

Owner Mike Warholak greets customers in the waiting
room of Warholak Tire Service, which has been doing
business in Detroit since 1931.

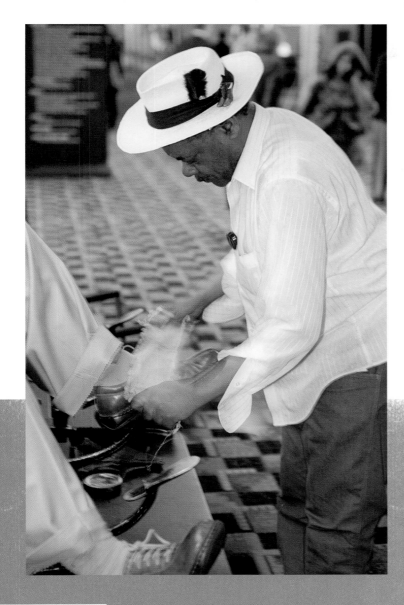

Ray shines a customer's shoe during the Society of Automotive Engineers conference at the Cobo Center.

17
18

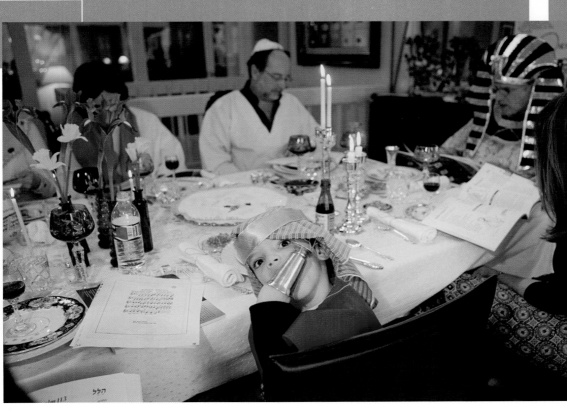

The Herz family reenacts the Passover story at its seder in Orchard Lake.

A sign overlooking the Car Wash Café in Detroit.

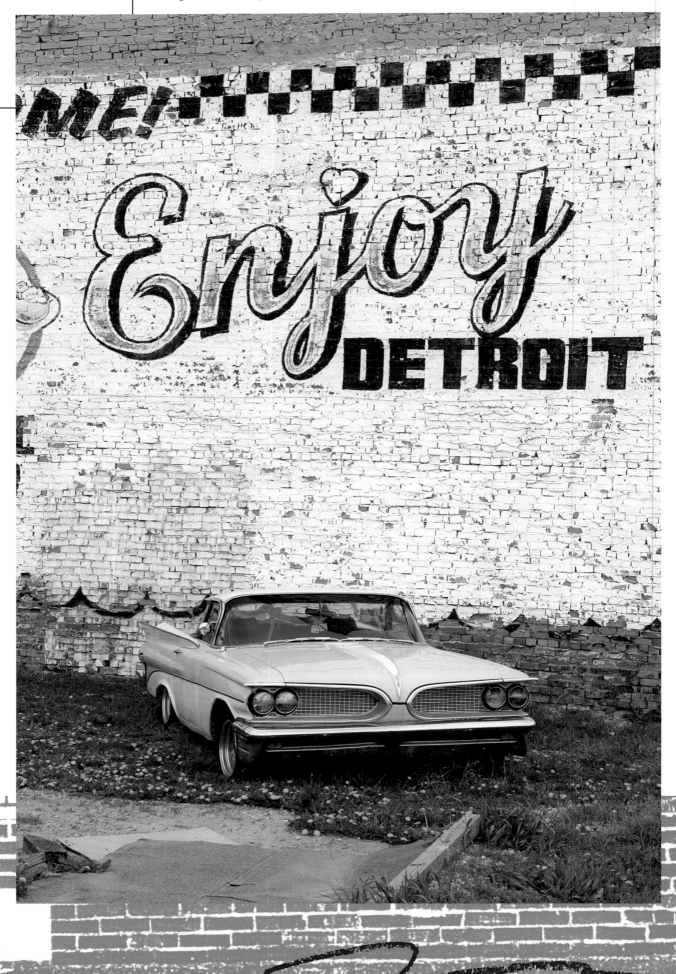

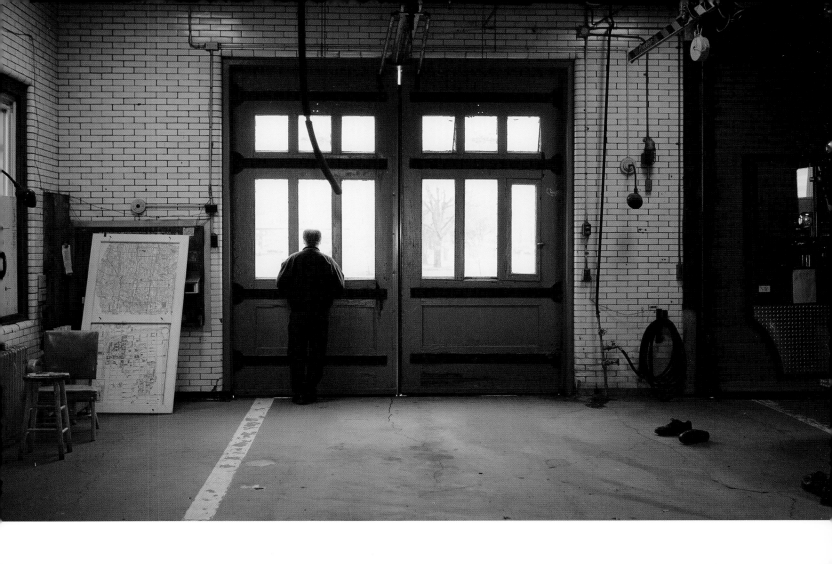

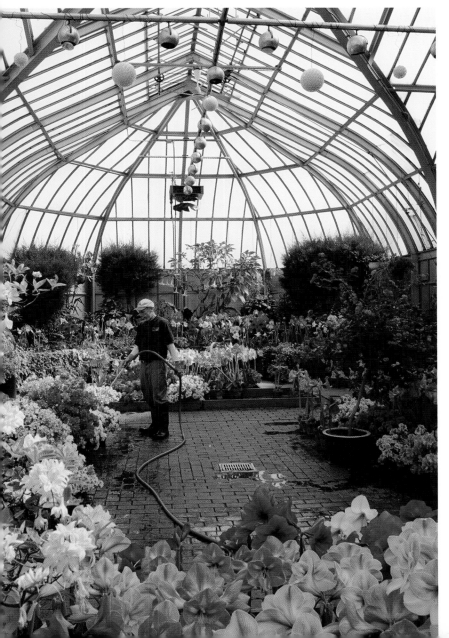

20

Terry, part of Truck 17, waits
for the return of Engine Co. 17,
out fighting a fire.

21

Steve, part of the staff
at the Anna Scripps
Whitcomb Conservatory
Formal Gardens on Belle Isle.

A freighter enters the Detroit River.

22

23

Ronnie displays the
nine-and-a-half-
pound walleye he
hooked in the
Detroit River.

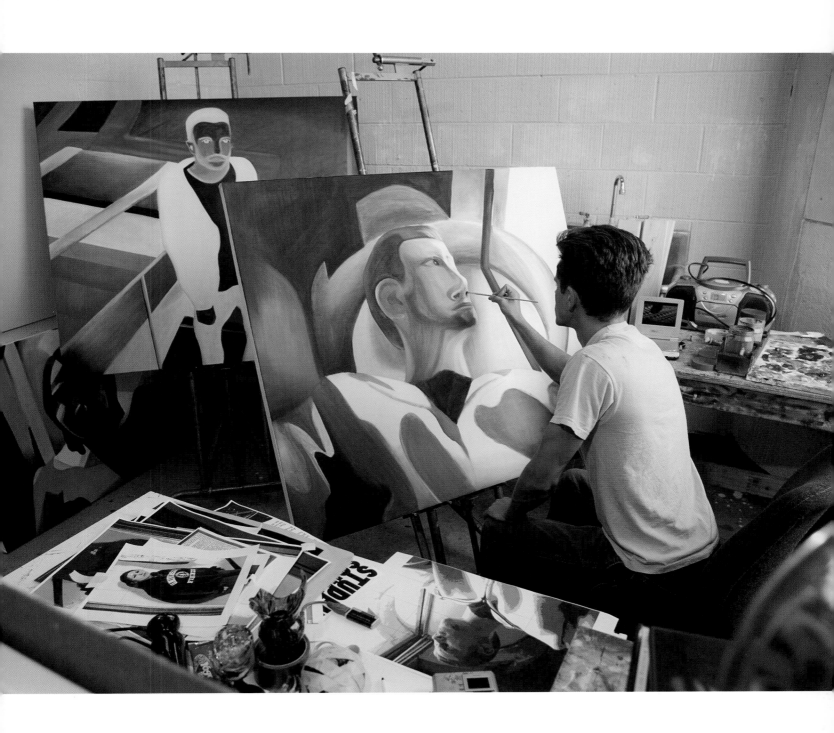

At the College for Creative
Studies in Detroit, Brandon
works on a painting for his
senior exhibit.

27

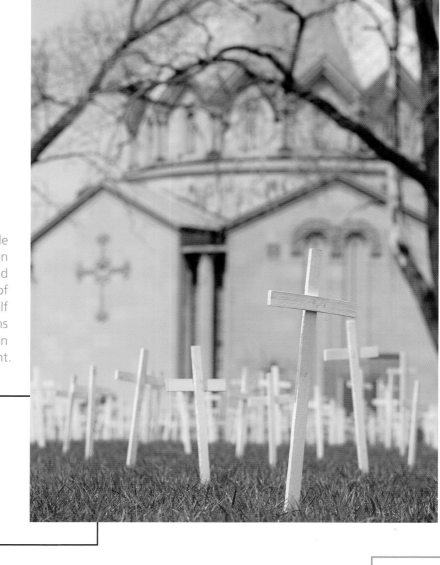

Crosses outside St. John's Armenian Church in Southfield in remembrance of the one-and-a-half million Armenians killed by the Ottoman Turkish government.

25

26

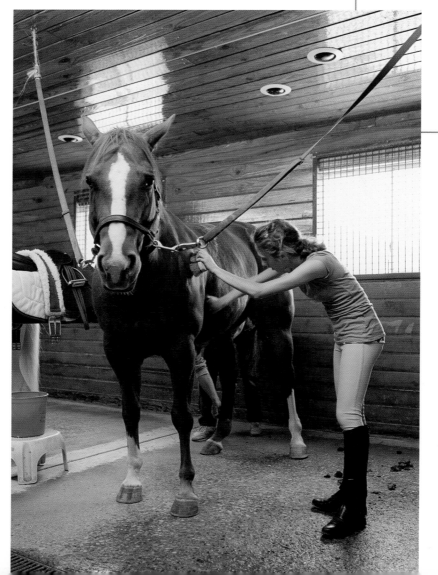

Lia from Dearborn rubs down Willow after her ride at Bloomfield Open Hunt Club in Bloomfield Hills.

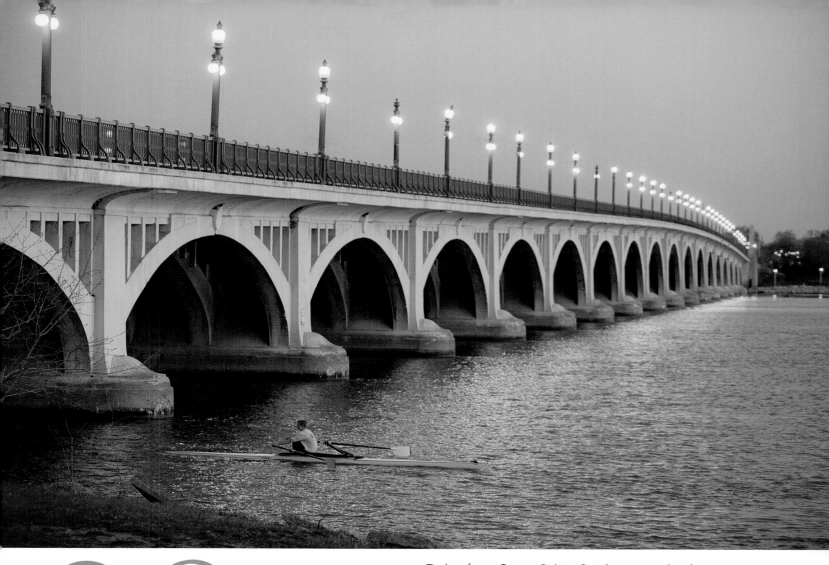

28

Tucker from Grosse Pointe South rows under the Belle Isle Bridge while training with the Detroit Boat Club crew.

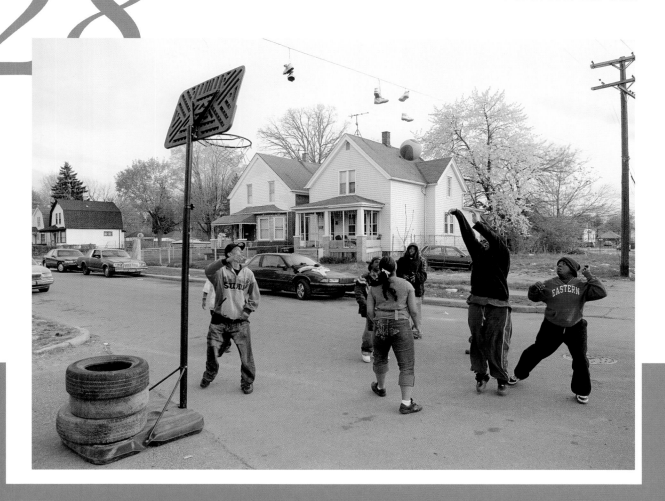

Playing street hoops in Detroit.

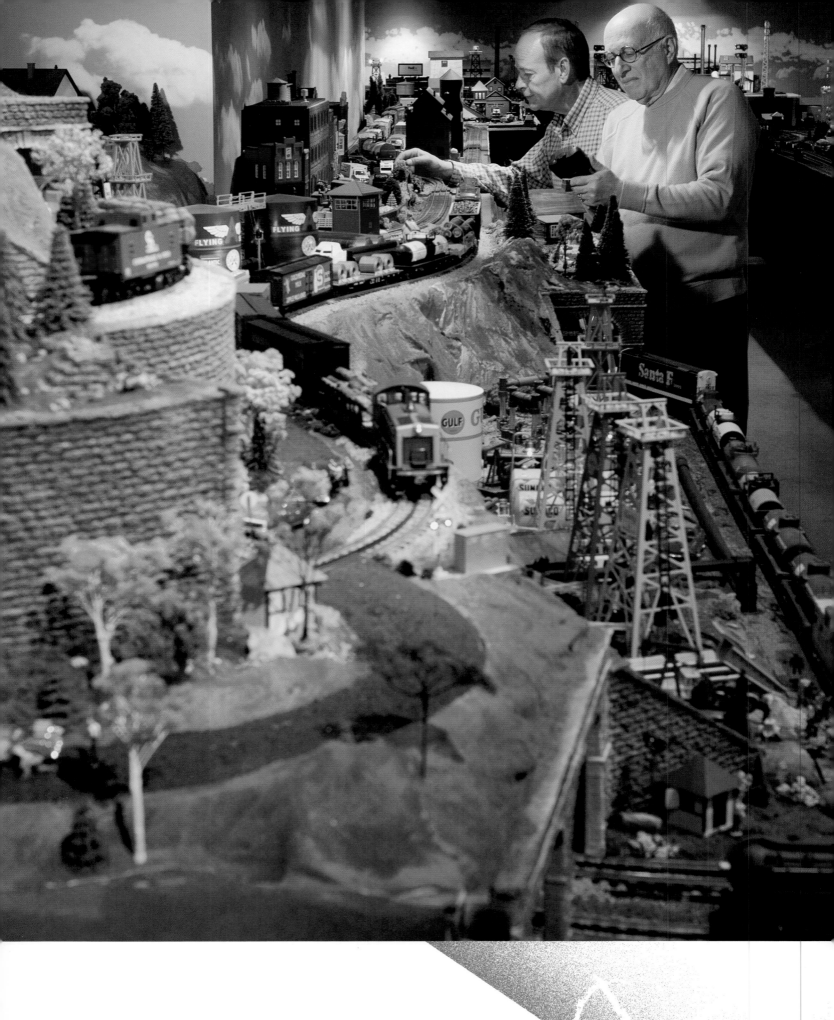

29

Doug and friend Tom work together to build an elaborate train set in Birmingham.

30

Dexter residents Luke and Johnny with their mother, Amy, touch a ram's horns at Domino's Petting Farm.

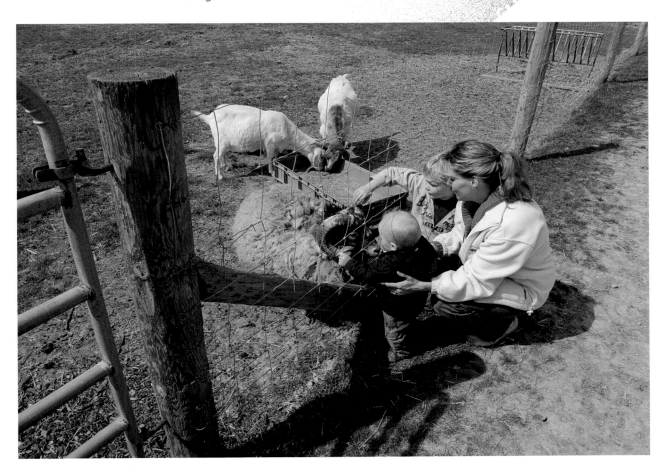

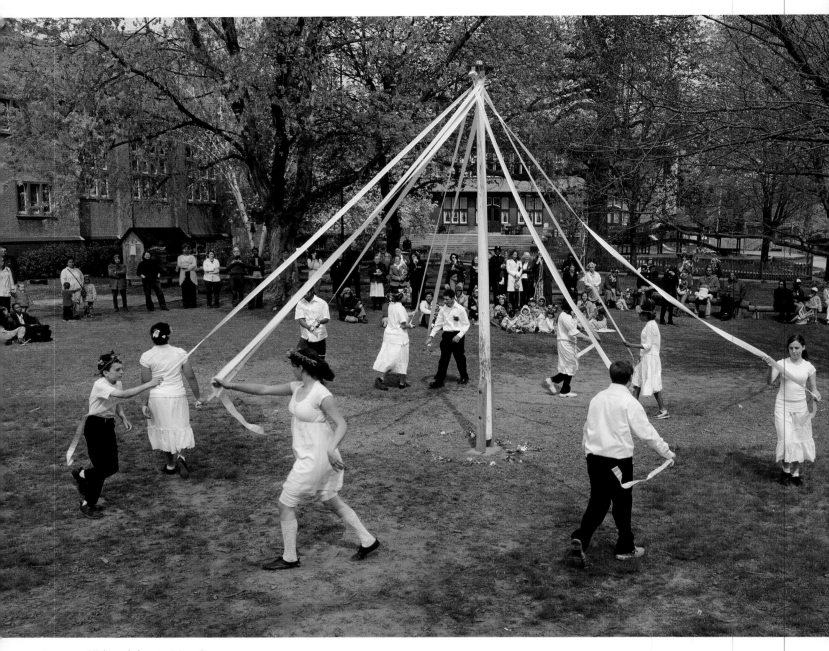

Kids celebrate May Day as
they dance around the
maypole at the Detroit
Waldorf School.

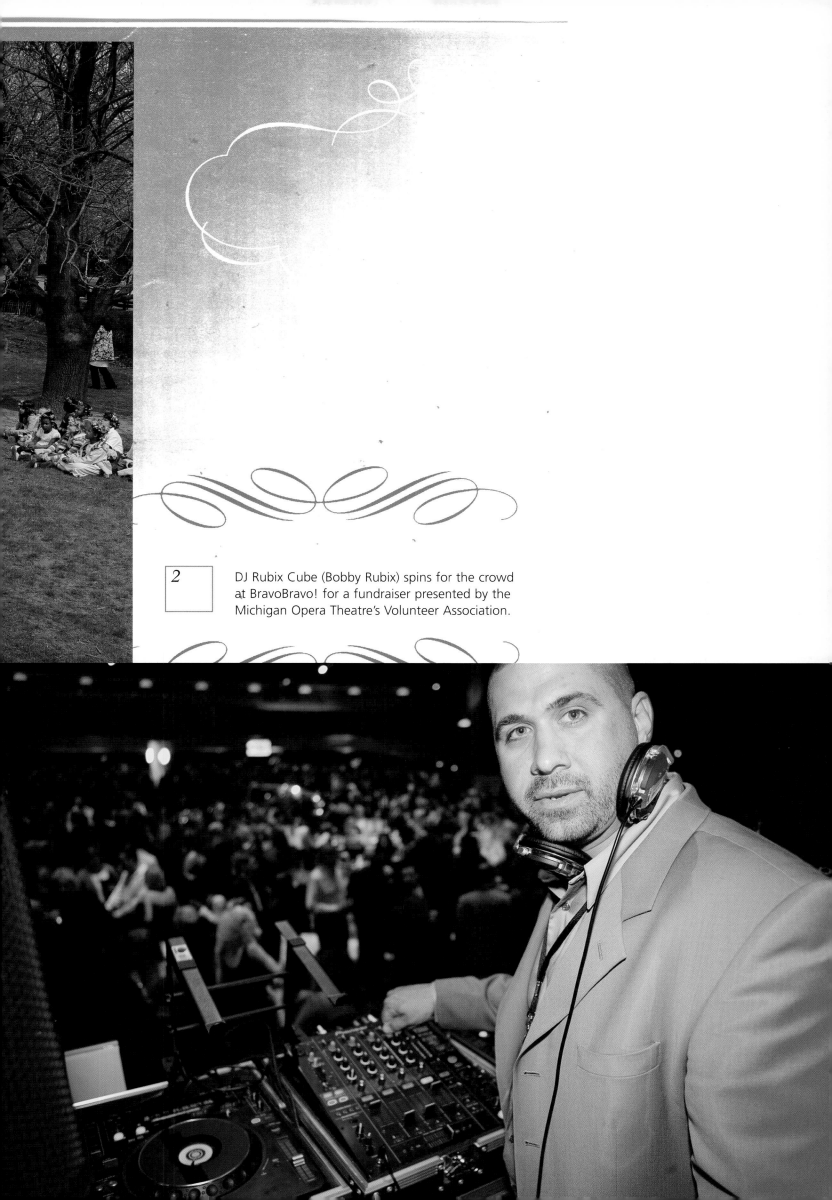

2 DJ Rubix Cube (Bobby Rubix) spins for the crowd at BravoBravo! for a fundraiser presented by the Michigan Opera Theatre's Volunteer Association.

University of Detroit
Jesuit Cub #6, Mike
Degenhardt, fends off
Brent Prior of
Birmingham Seaholm
High School in the
championship game
of the Lacrosse
Coaches Association
Tournament.

Holocaust survivor Larry Wayne and his daughter Brenda attend
the 27th Yom Hashoah (Holocaust Remembrance Day) at the
Holocaust Memorial Center.

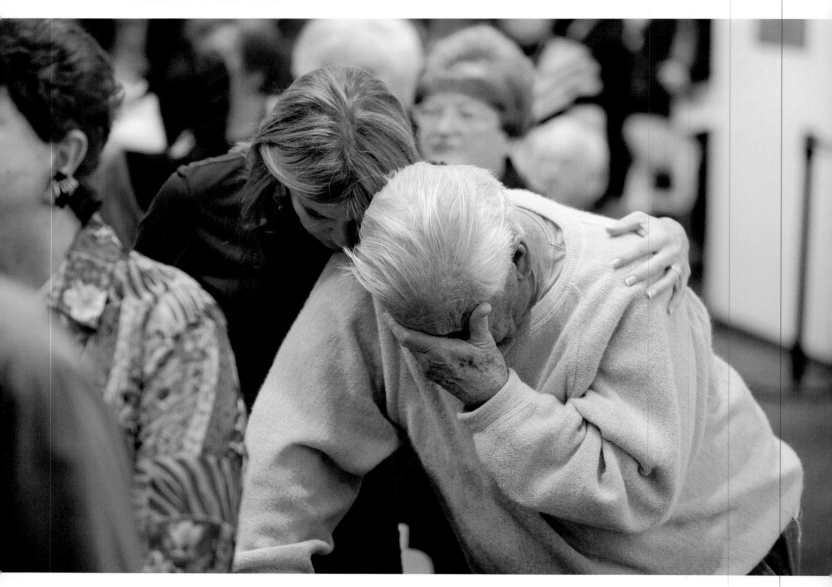

4

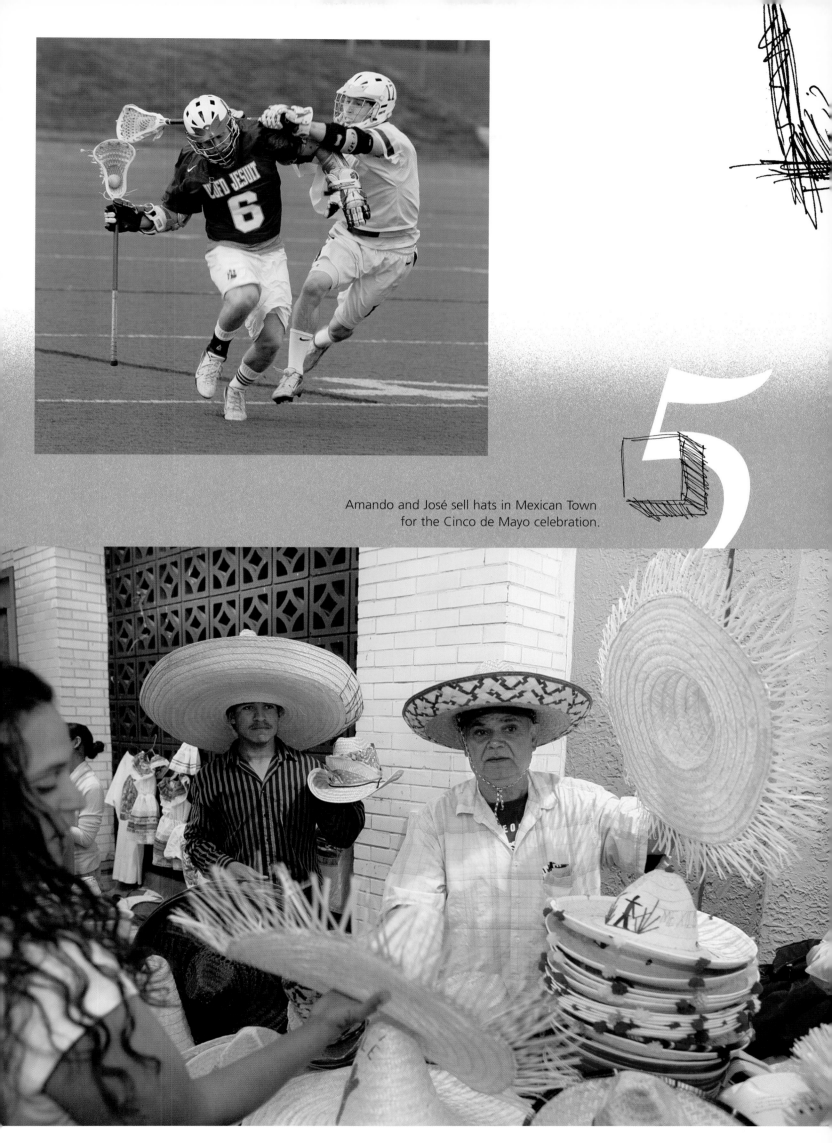

Amando and José sell hats in Mexican Town
for the Cinco de Mayo celebration.

5

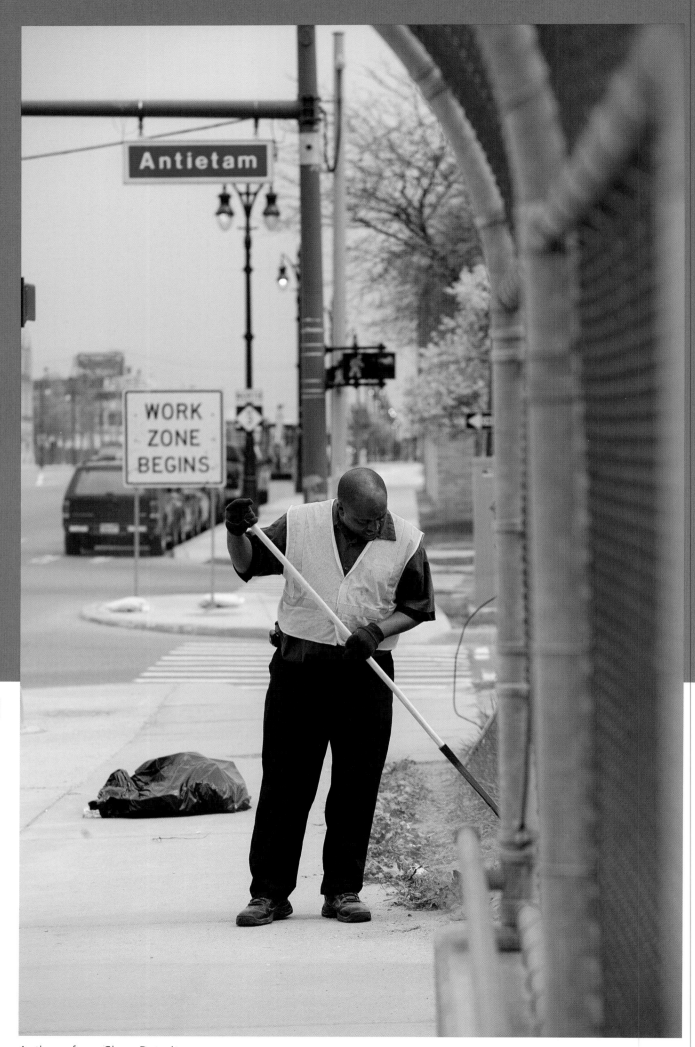

Anthony from Clean Detroit.

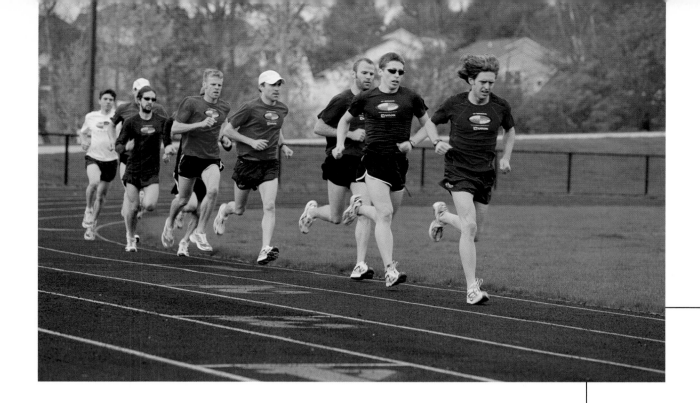

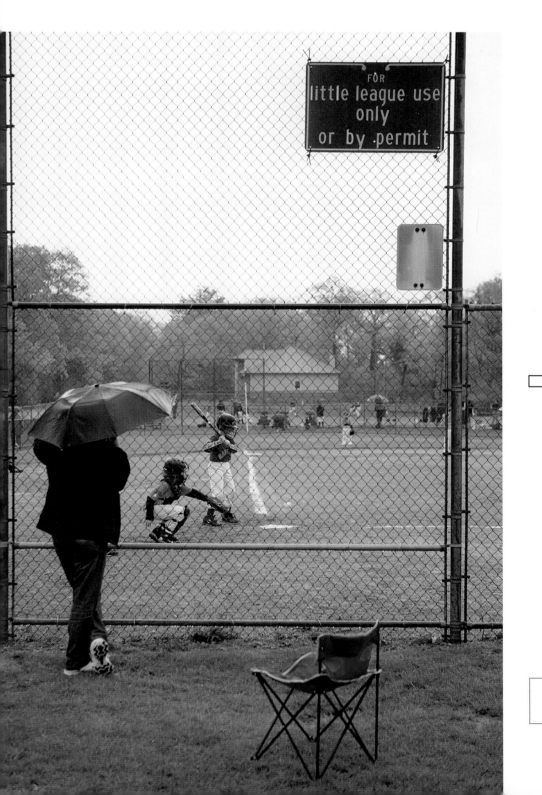

7
Hanson-Brooks distance running team training at Stoney Creek High School.

8
The Orioles and Rangers Little League teams playing baseball in Farmington Hills.

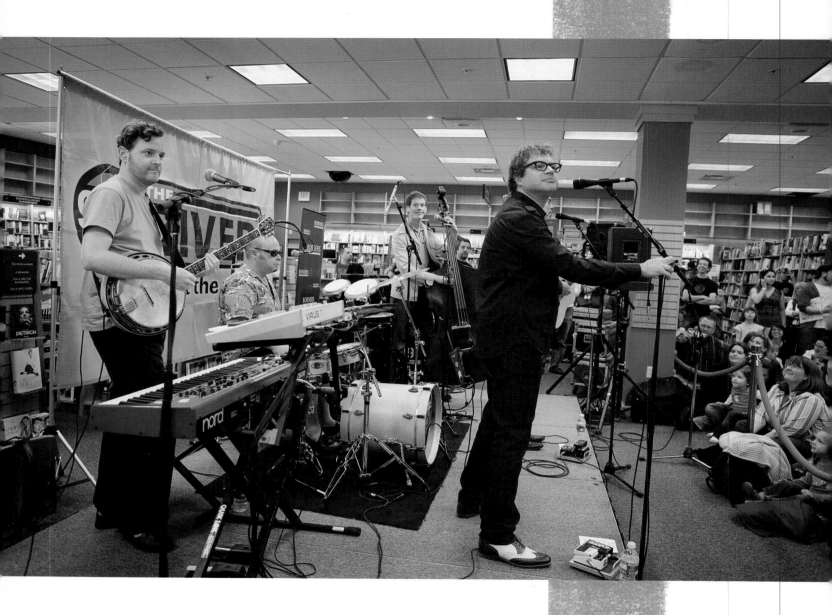

To introduce
Snacktime, their
first collection of
original children's
songs, Barenaked
Ladies play to a full
house at Borders in
Birmingham.

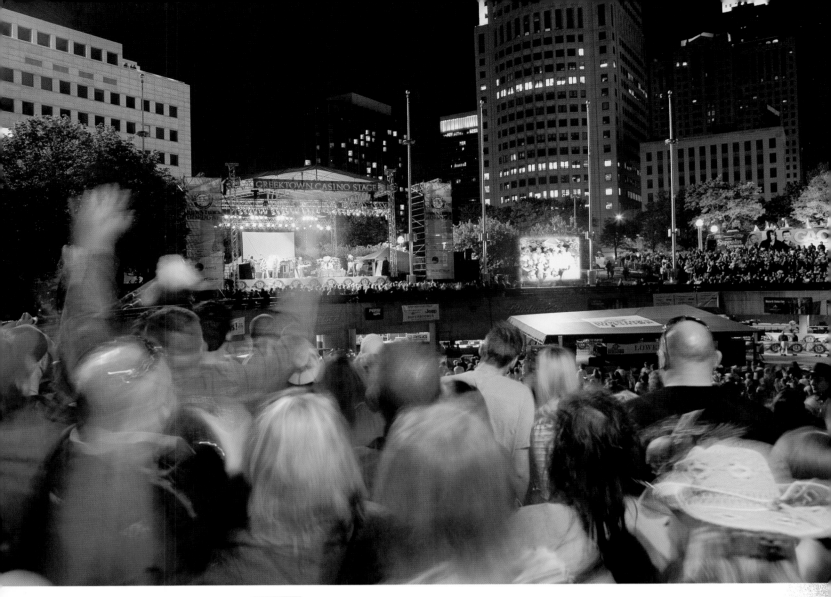

10 Little Big Town performs on the
main stage at the 26th annual
WYCD Detroit Downtown Hoedown.

11

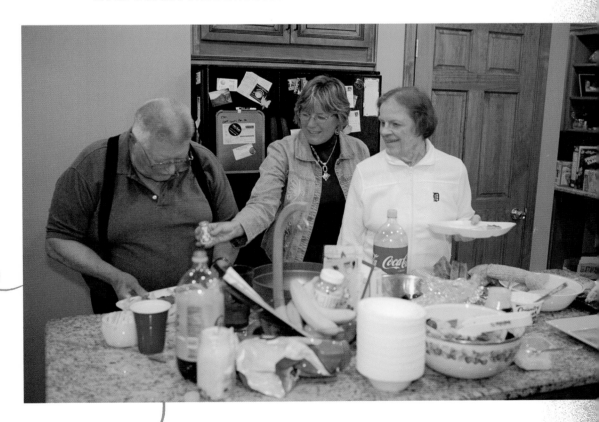

For Mother's Day,
Kim cooks dinner for her
mom and dad in
Bloomfield Township.

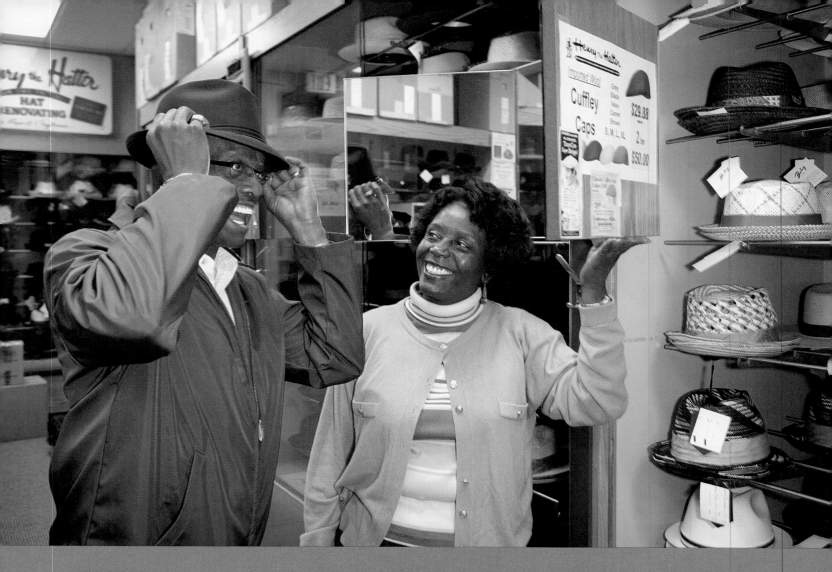

12 Pam helps Cornell from Detroit select a hat at Henry the Hatter.

Working out at the Boll Family YMCA in downtown Detroit.

13

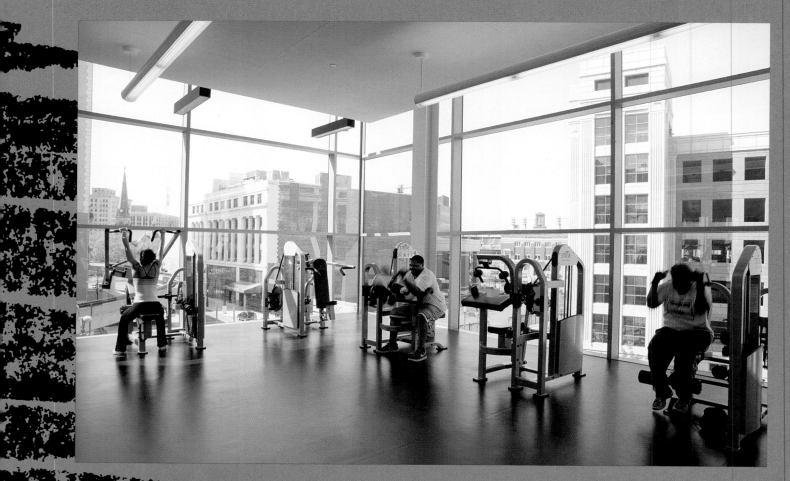

14 Novi Junior Jaguars practicing soccer despite the rain.

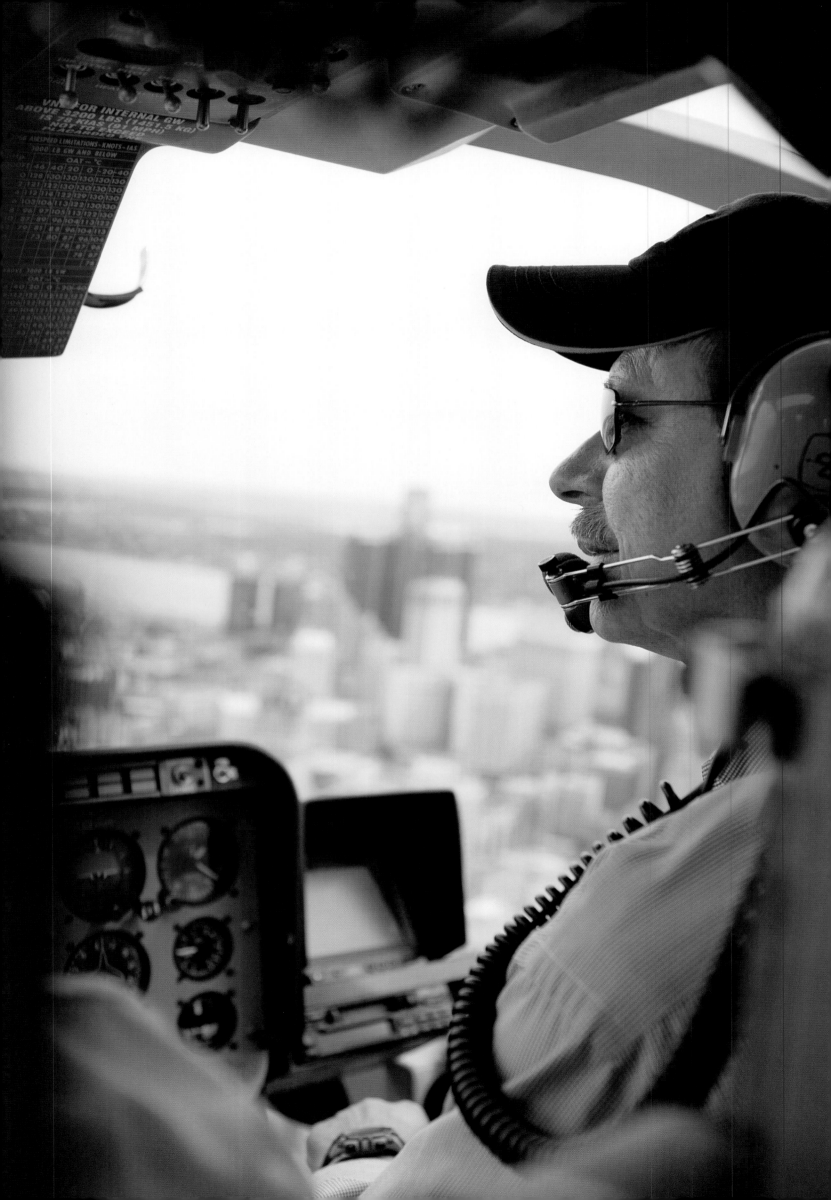

Pilot and reporter
Joel Alexander
flying WJR's
Jetcopter 760
near the
Renaissance
Center.

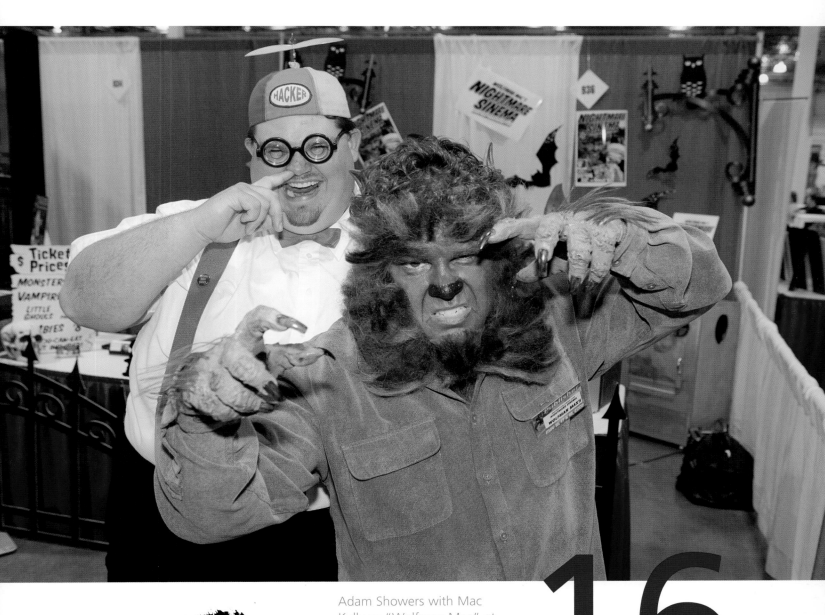

Adam Showers with Mac
Kelly as "Wolfman Mac" at
the Motor City Comic Con
in Novi.

16

May Art

17

Jill Jack performs at
Memphis Smoke
in Royal Oak.

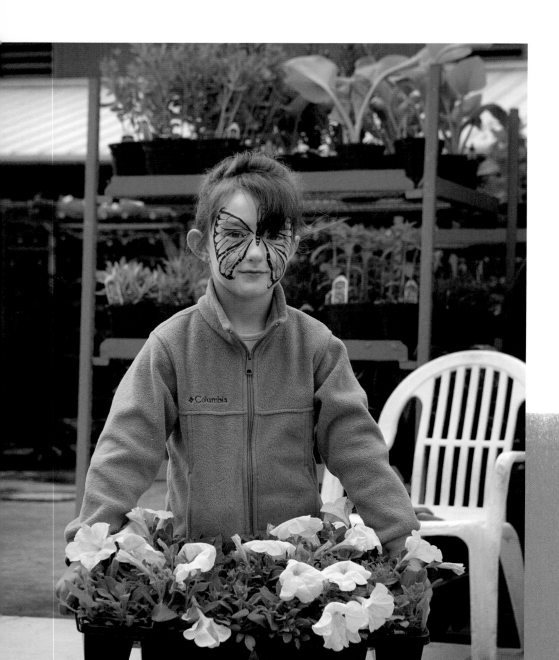

18

Six-year-old
Shannon from
New Baltimore
helps her mother
pick up flowers at
Eastern Market
on Flower Day.

RocketMath! students at
Harper Woods Middle School
integrate science, technology,
engineering, and math as they
set off rockets at school.

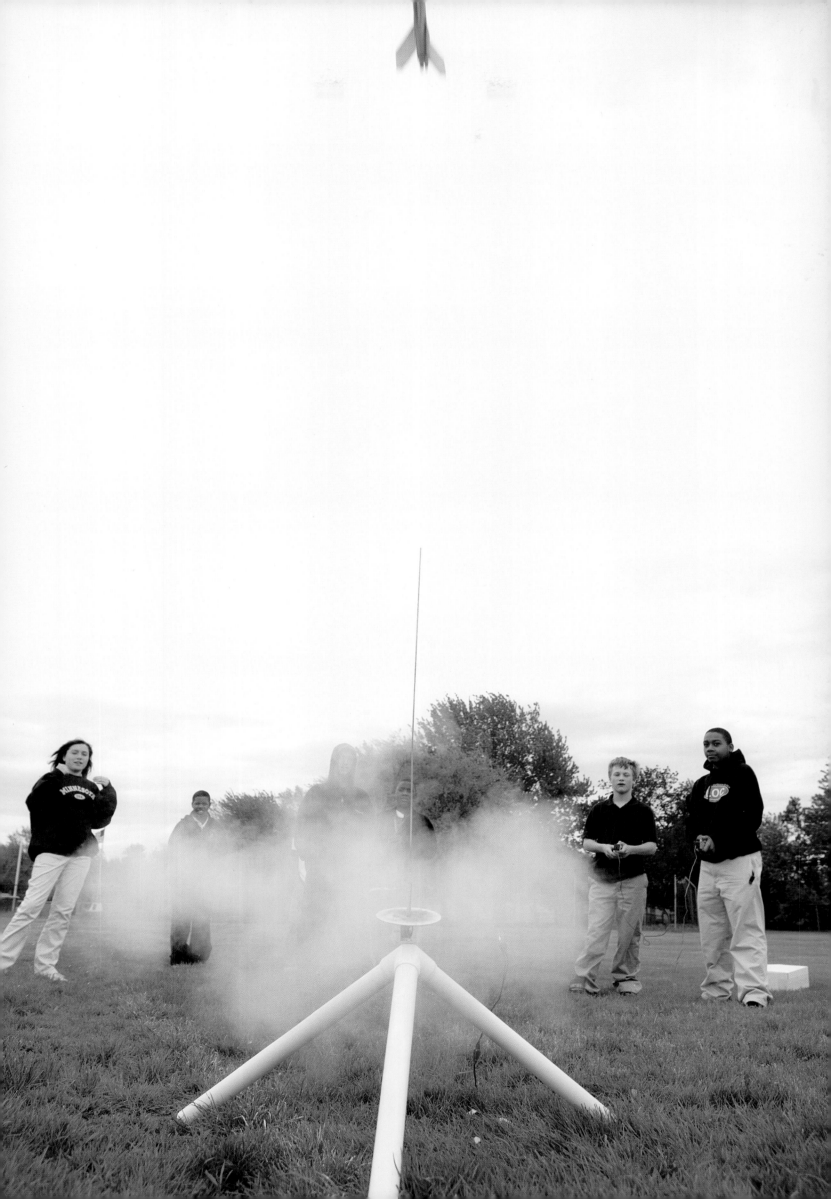

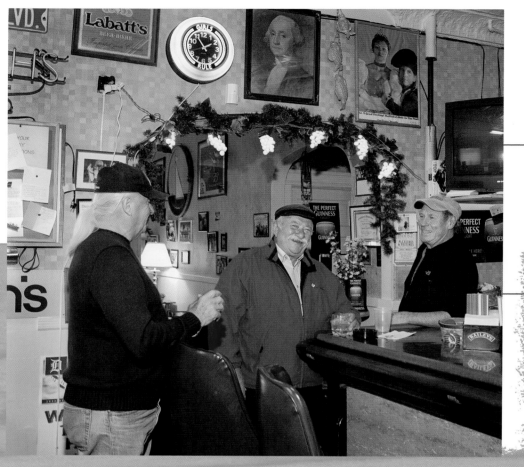

Some of the regulars at the Polish
Yacht Club: Mike, Charlie, and Mark.

20

21

Richard Karn
filming a
commercial for
Mr. Handyman.

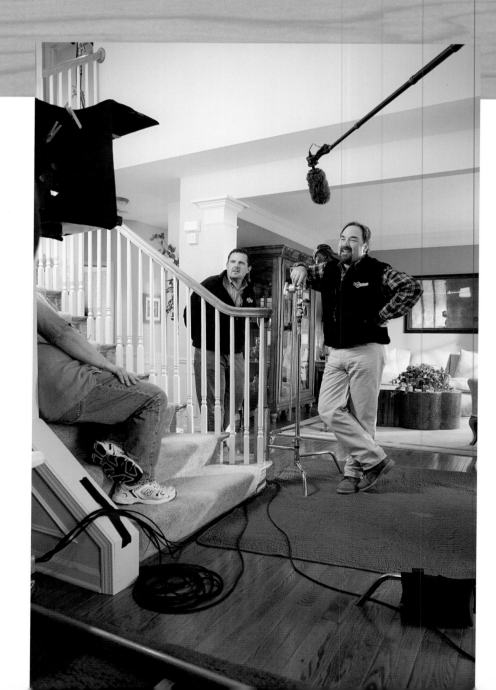

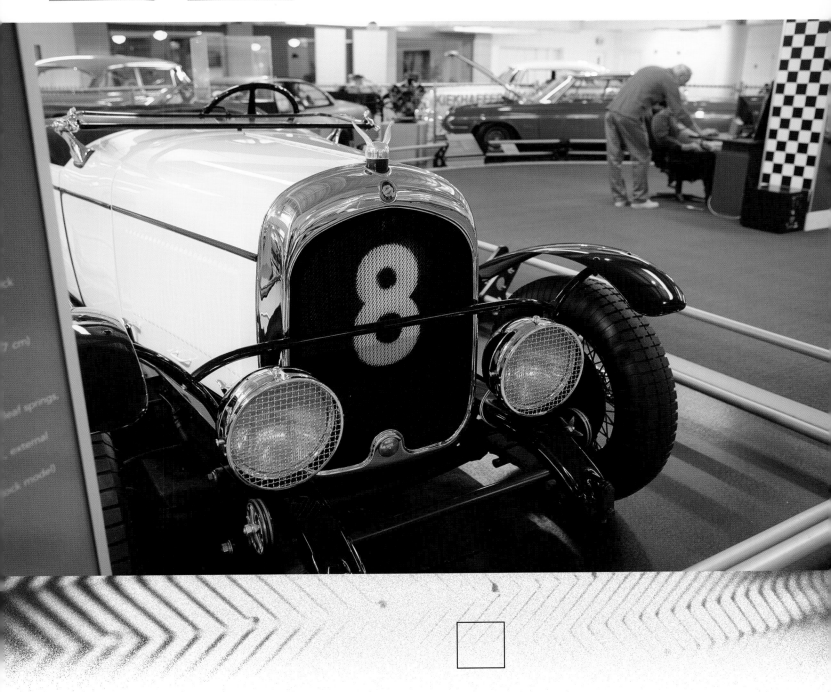

A 1928 Chrysler
Model 72 Roadster
at the Walter P.
Chrysler Museum.

23

Playing cricket at the semiannual Sant Nirankari Mission (Universal Brotherhood) tournament in Novi.

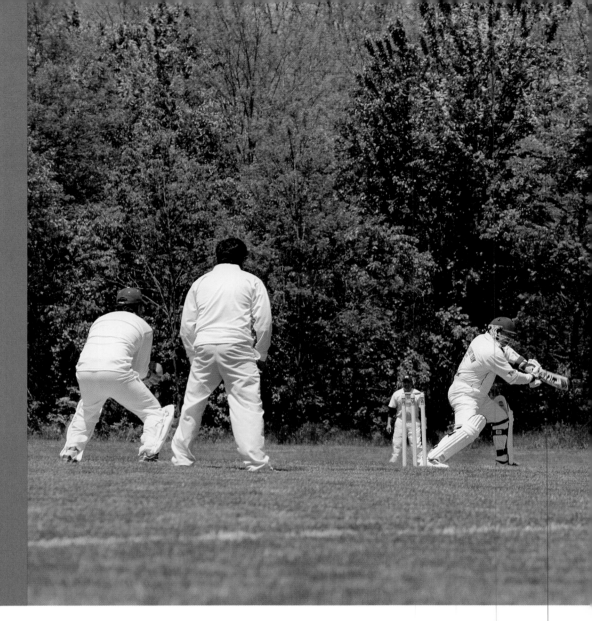

24

Thomas Franzmann, known as ZIP, plays on the main stage at the Detroit Electronic Music Festival.

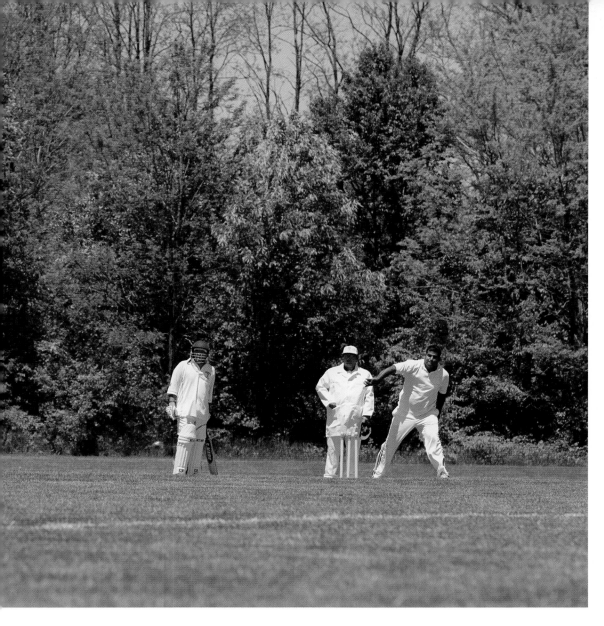

Carnival games at
St. Mary's Polish
Country Fair.

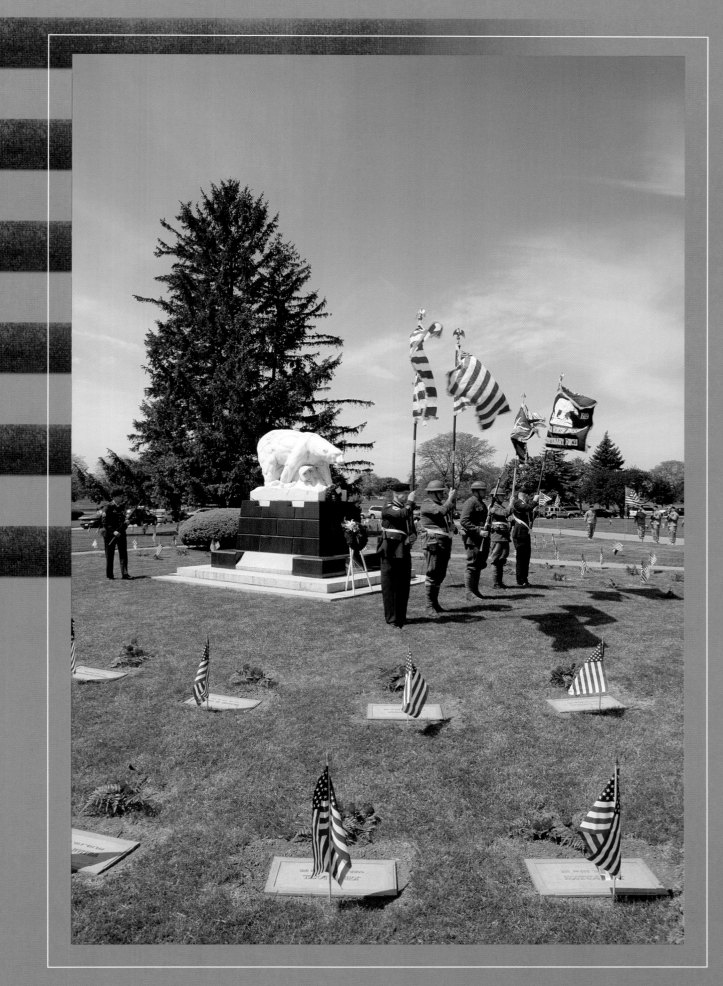

26 A memorial at White Chapel Memorial Park Cemetery in Troy to honor the U.S. Army's "Polar Bears," the expeditionary force that fought the Bolshevik Red Army in northern Russia in 1918 and 1919.

Racquetball at the courts
on Belle Isle.

27

28

A mail boat leaves a
freighter after making a
delivery on the Detroit River.

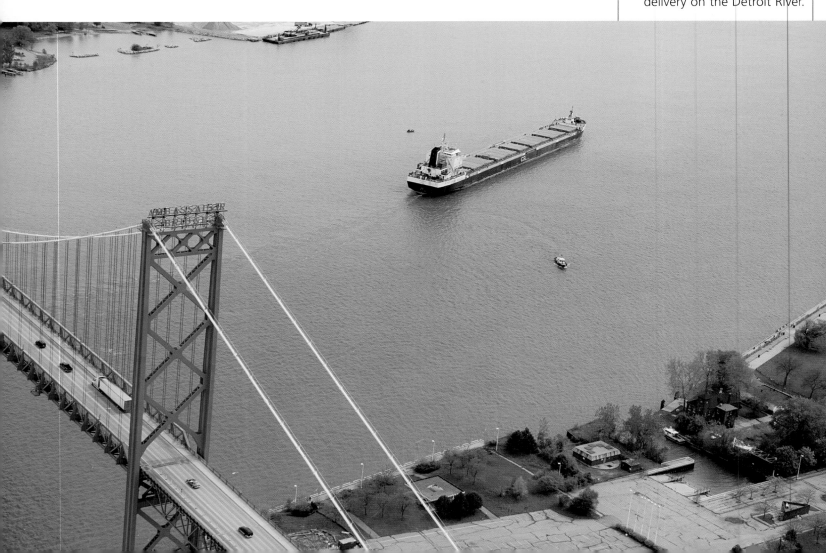

Students from Southwestern
High School enjoying their prom
at the Detroit Yacht Club.

30 Rides and games at the Birmingham Carnival.

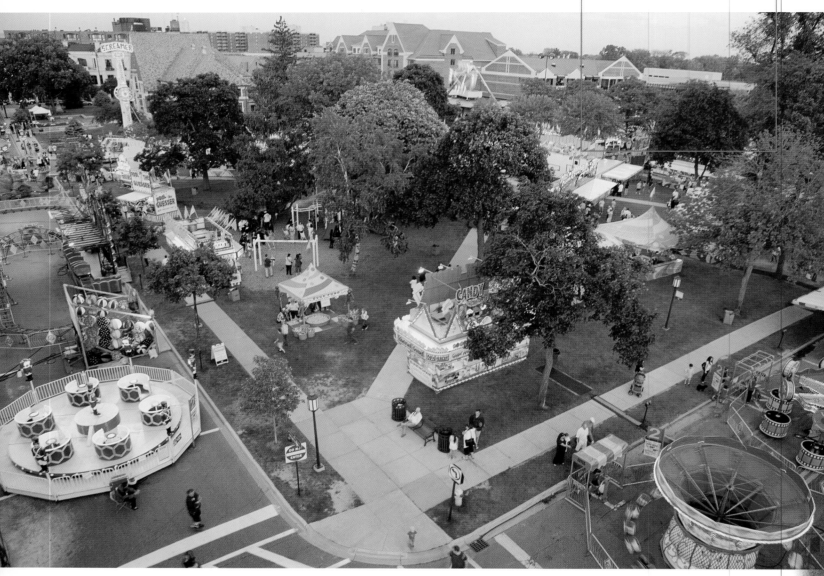

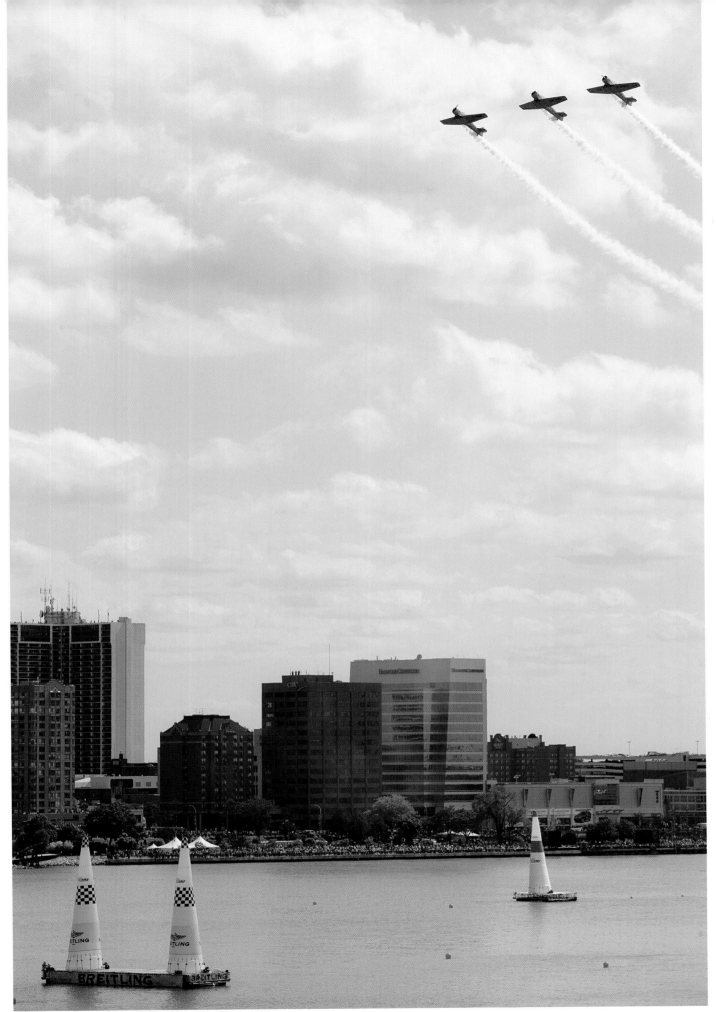

31

Pilots entertain the crowd at the
Red Bull Air Race World Series
in Detroit.

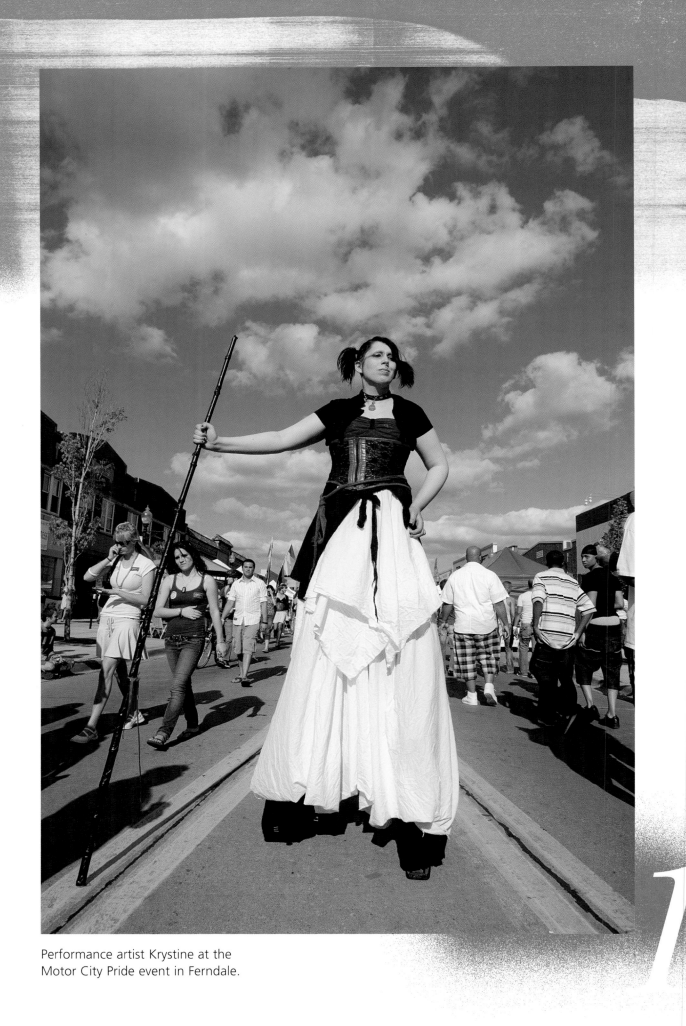

Performance artist Krystine at the
Motor City Pride event in Ferndale.

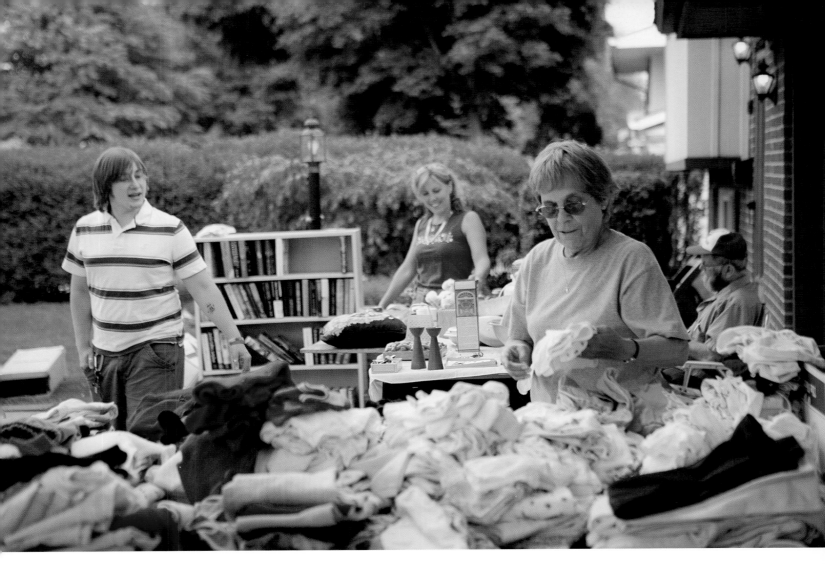

2

Ella, husband Bill, and daughter Shari help a customer at their garage sale in Clawson.

Dr. Sommerfield and dental assistant Frances work on a patient in Plymouth.

3

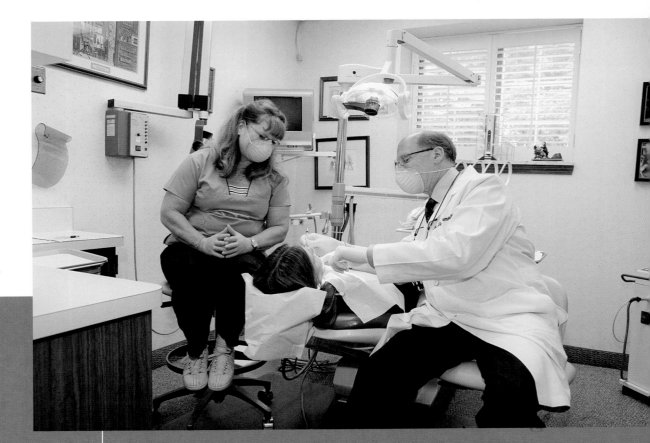

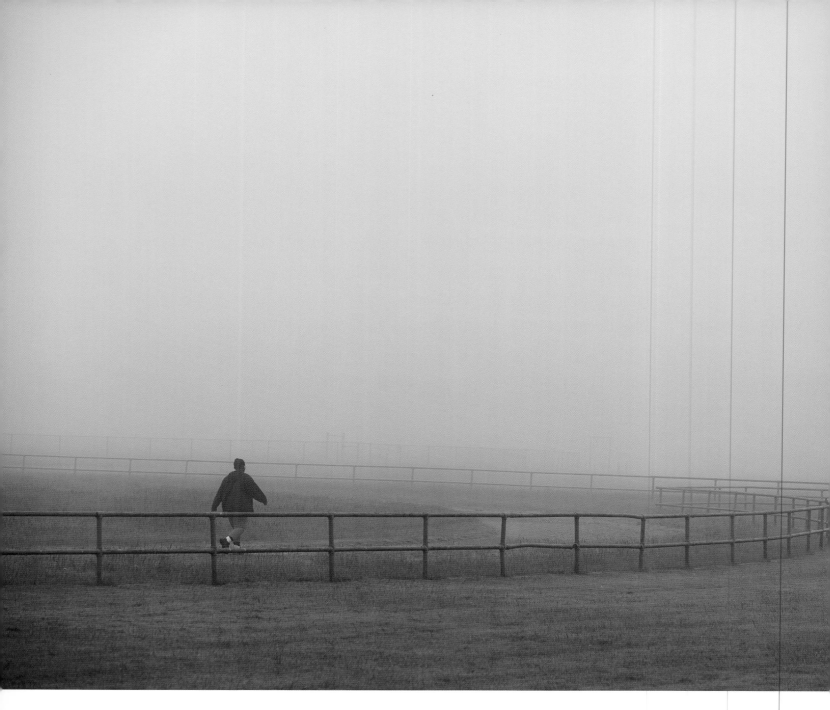

4 Sheila from Detroit walks the
Belle Isle track in the fog.

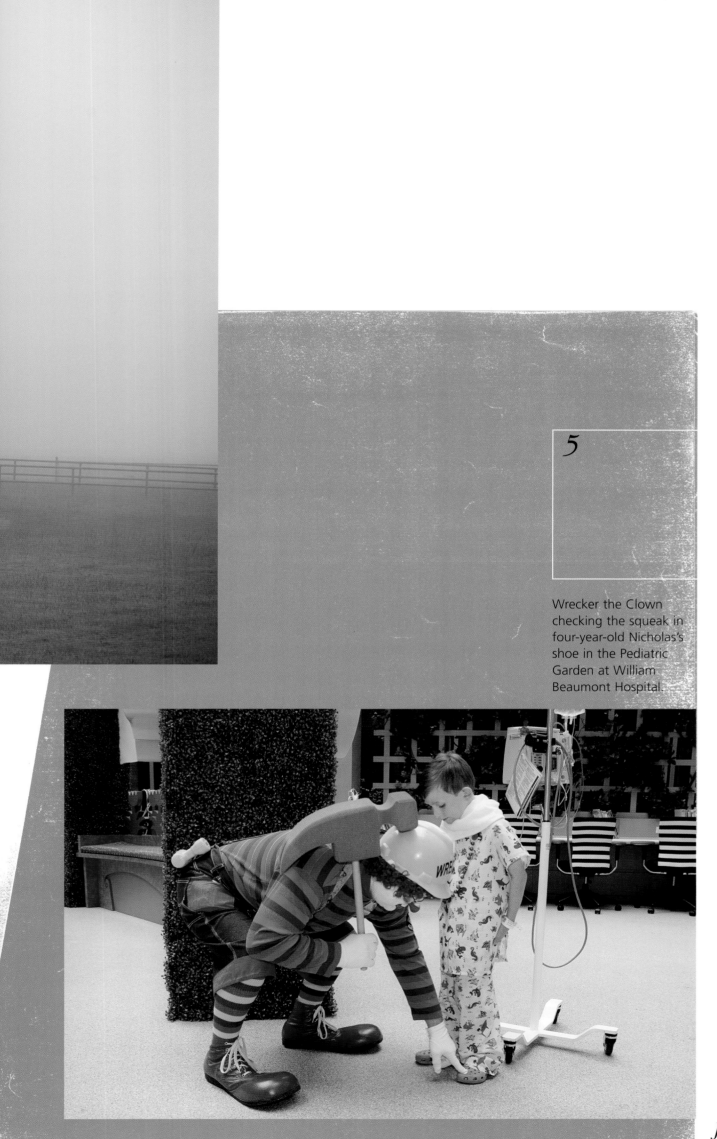

5

Wrecker the Clown
checking the squeak in
four-year-old Nicholas's
shoe in the Pediatric
Garden at William
Beaumont Hospital.

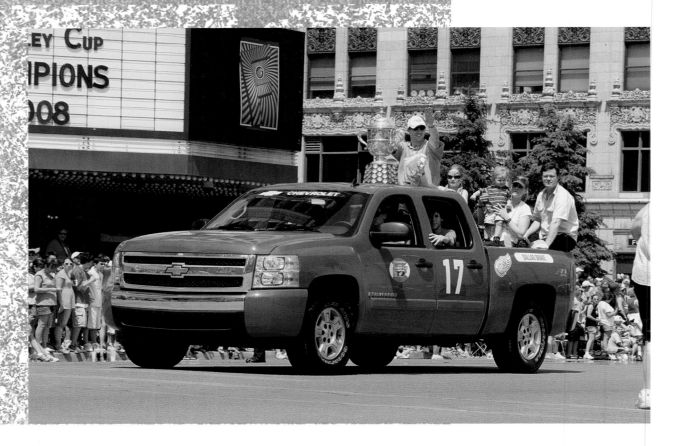

6 Detroit Red Wing Dallas Drake proudly displays the Campbell Trophy during the parade celebrating the Red Wings' championship win.

7 Local kids seen through the glass map of the St. Lawrence Seaway at Rivard Plaza on Detroit's East Riverfront.

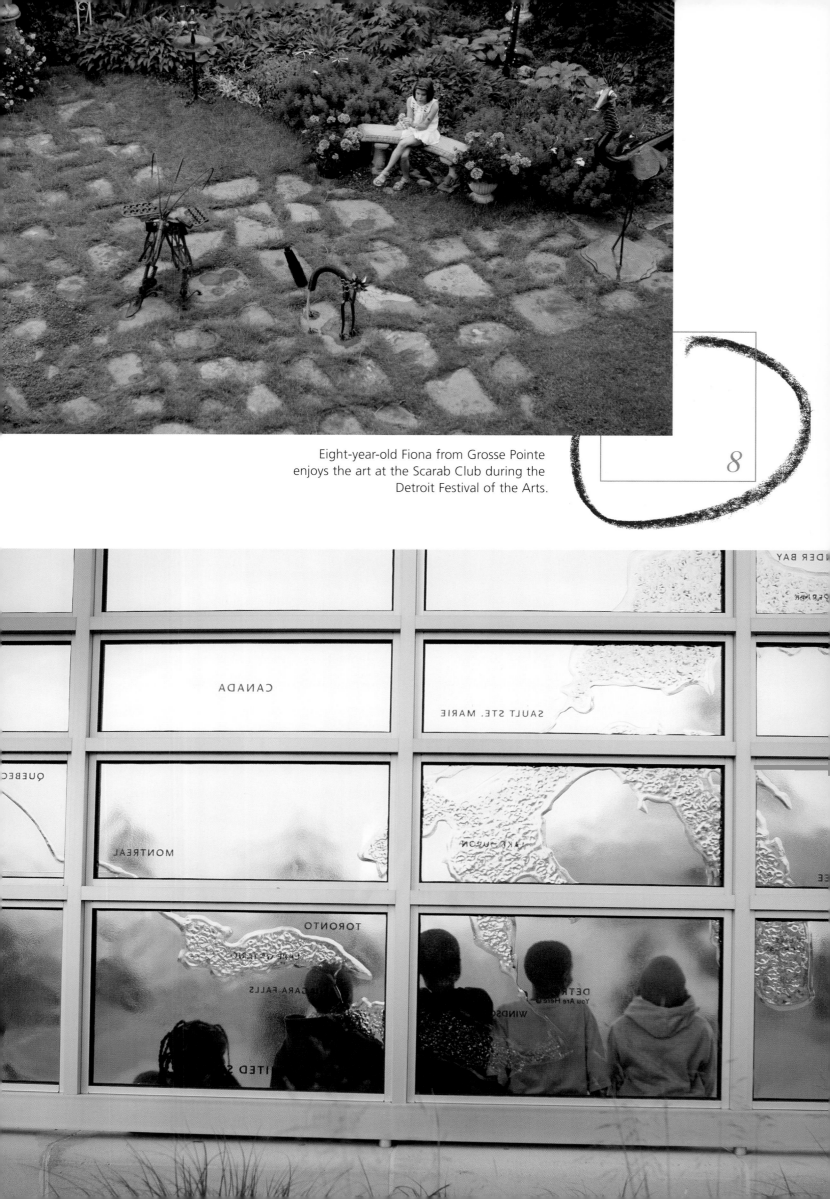

Eight-year-old Fiona from Grosse Pointe
enjoys the art at the Scarab Club during the
Detroit Festival of the Arts.

8

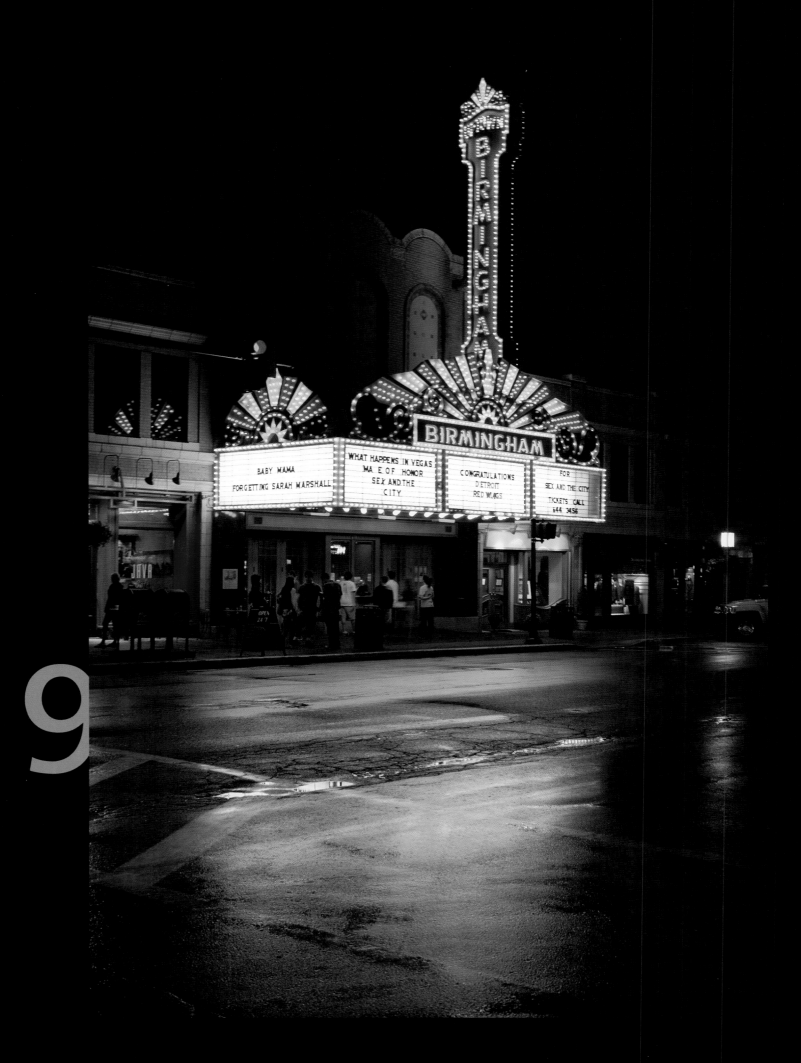

BIRMINGHAM

BABY MAMA
FORGETTING SARAH MARSHALL

WHAT HAPPENS IN VEGAS
MA E OF HONOR
SEX AND THE
CITY

CONGRATULATIONS
DETROIT
RED WINGS

FOR
SEX AND THE CITY
TICKETS CALL
644 3456

The Birmingham 8 in downtown Birmingham.

Simi, a student at Davis Aerospace Technical High School, learns to fly from instructor Clifford Miller.

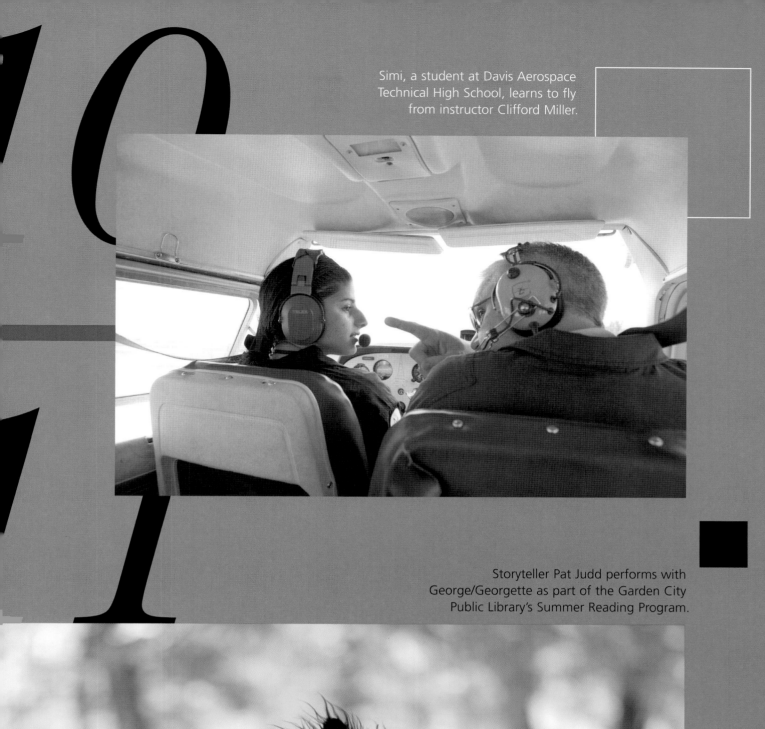

Storyteller Pat Judd performs with George/Georgette as part of the Garden City Public Library's Summer Reading Program.

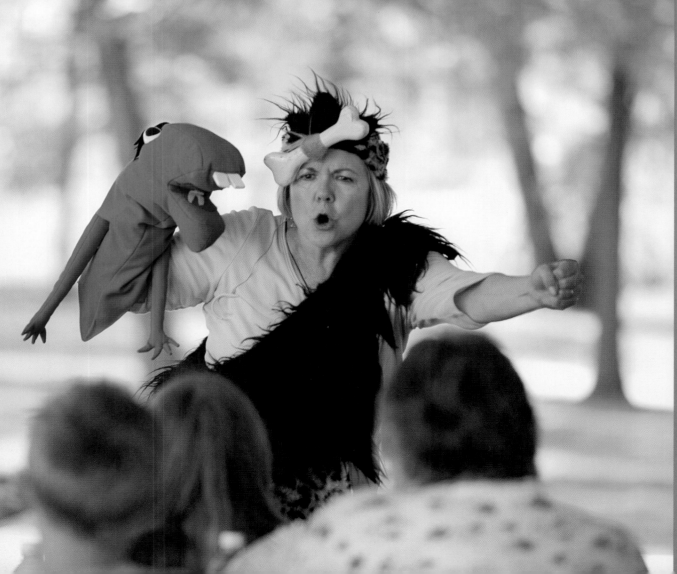

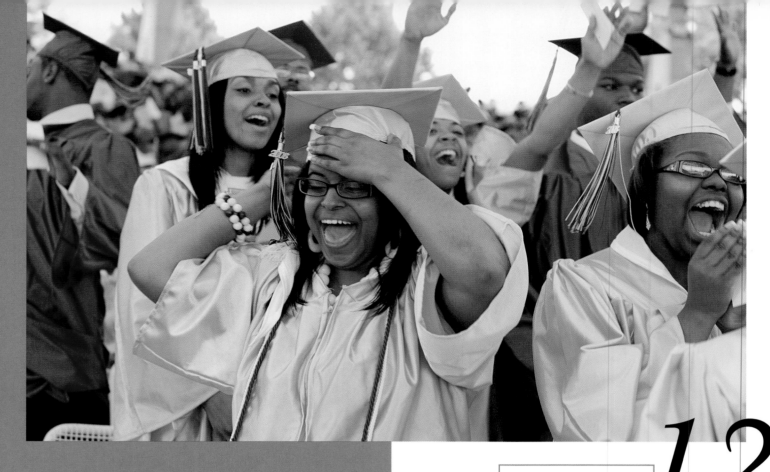

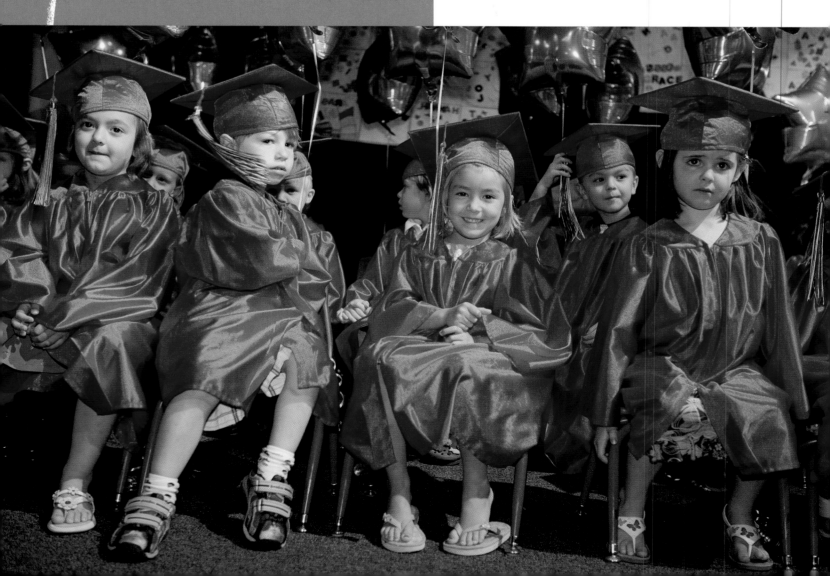

12

Mumford High School graduation at Chene Park.

13 Bridget, Jacob, Kiersten, Jameson, and Caroline graduate from preschool at Cook's Academy in Bloomfield Hills.

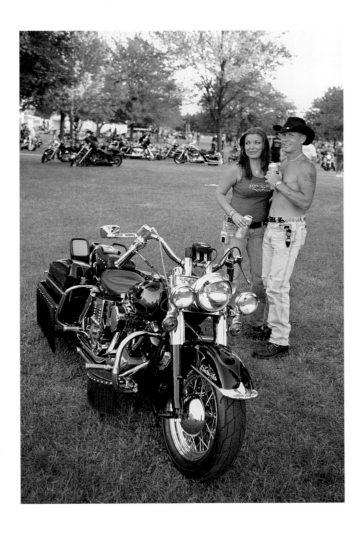

 14

Jason from Waterford and Christine from Rochester stand beside their '77 Electra Glide during Harley Fest at Freedom Hill.

Deloris Davis of the Together Team from Arkansas is one of the many bowlers competing in the USBC Women's Championship held in Canton.

15

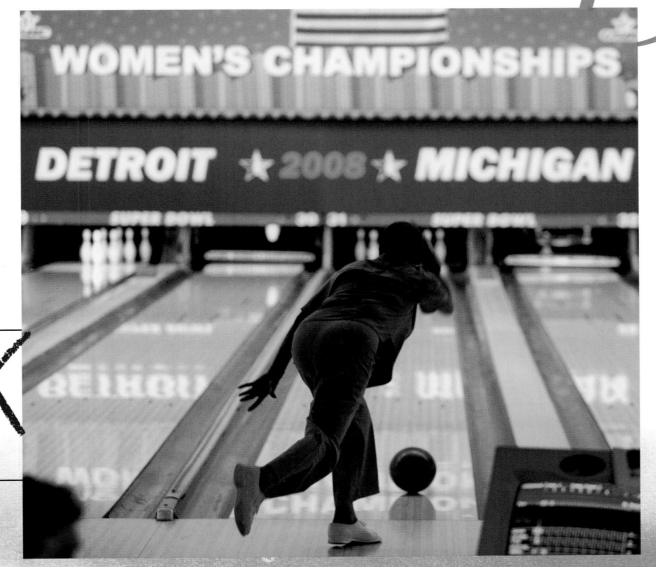

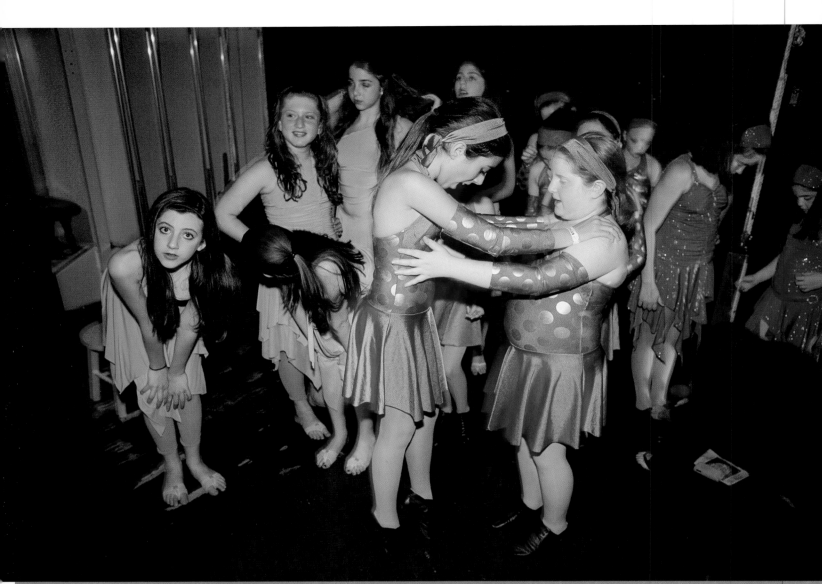

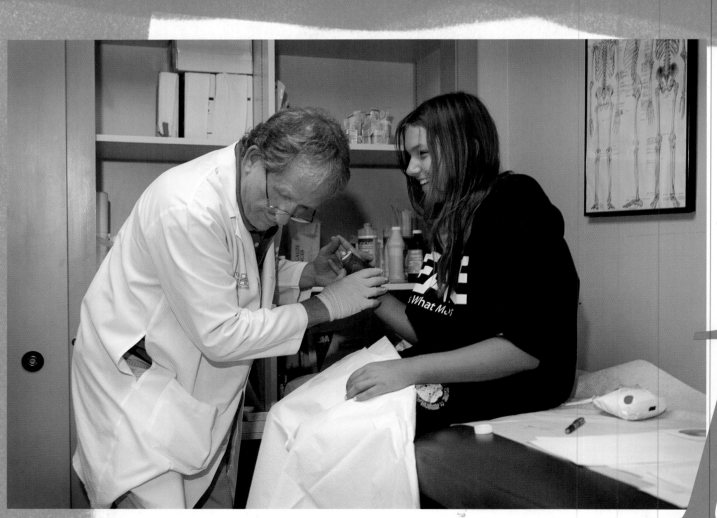

1

Dancers from Annette & Company School of Dance in Farmington Hills gather backstage before a recital.

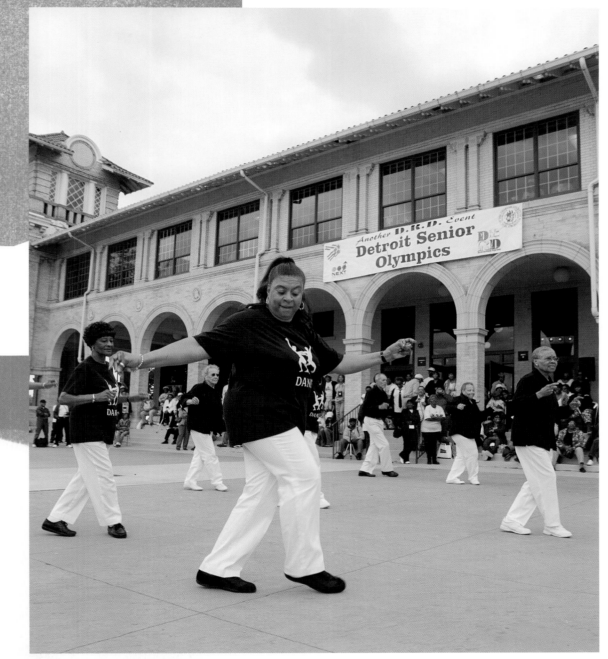

17

Dr. Limbert manages to keep Bloomfield resident Alex laughing, even while putting her thumb in a cast.

18

Myrlin Moore and her Hustle team from the Williams Center compete at the Senior Olympics on Belle Isle.

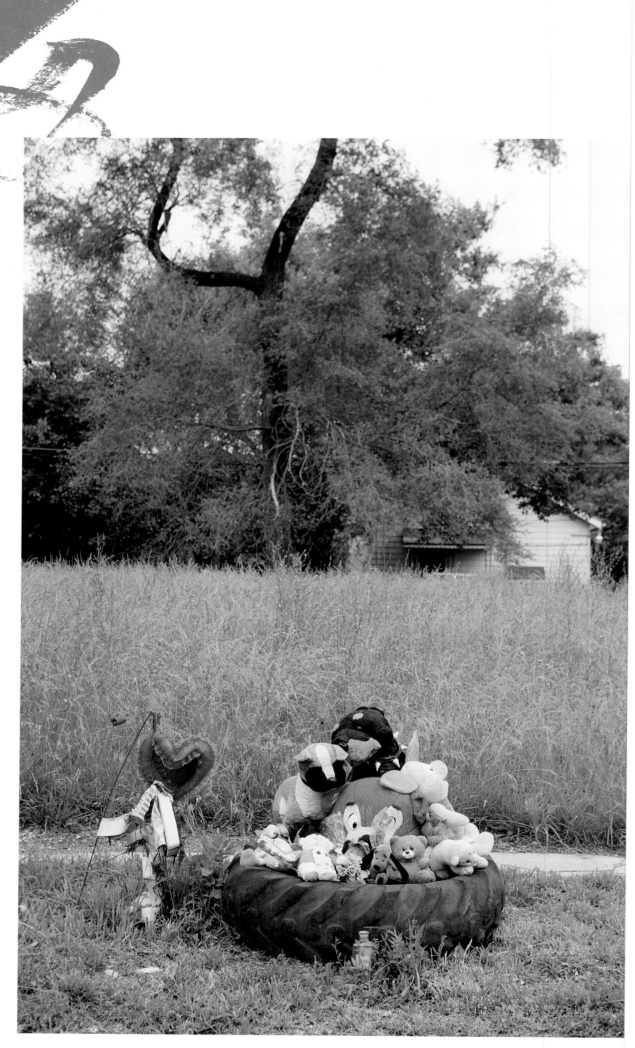

A memorial in East Detroit.

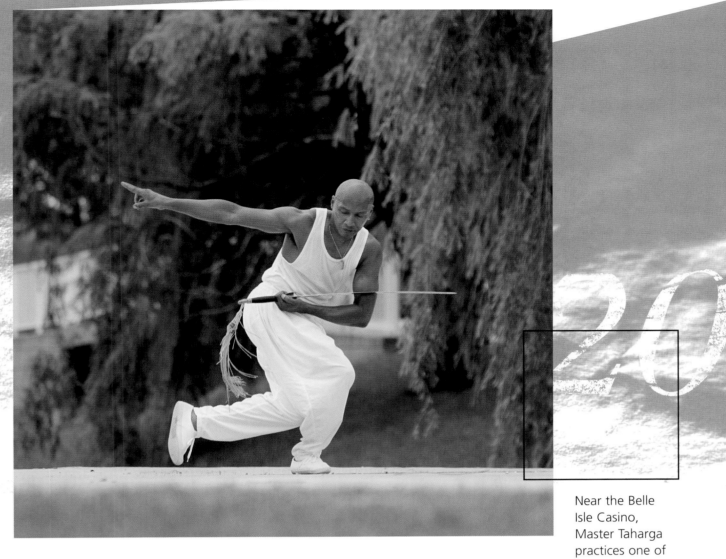

20

Near the Belle Isle Casino, Master Taharga practices one of the many forms of martial arts that he teaches.

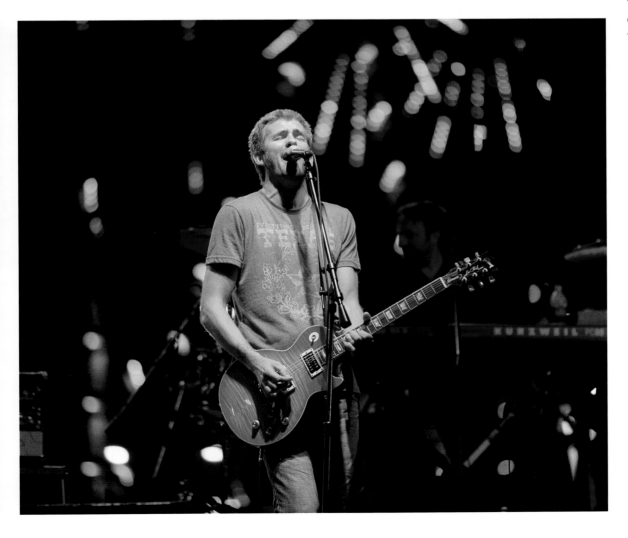

21

The Verve Pipe performing at GM River Days.

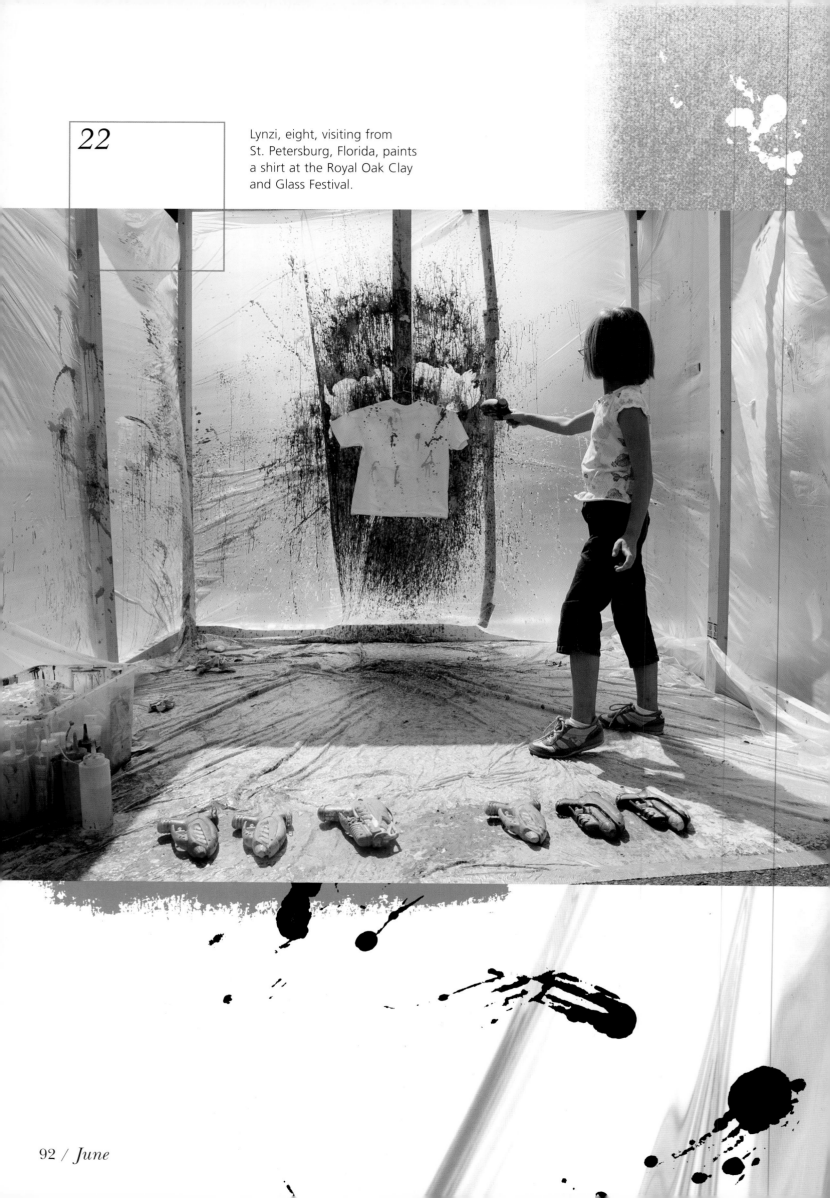

22

Lynzi, eight, visiting from
St. Petersburg, Florida, paints
a shirt at the Royal Oak Clay
and Glass Festival.

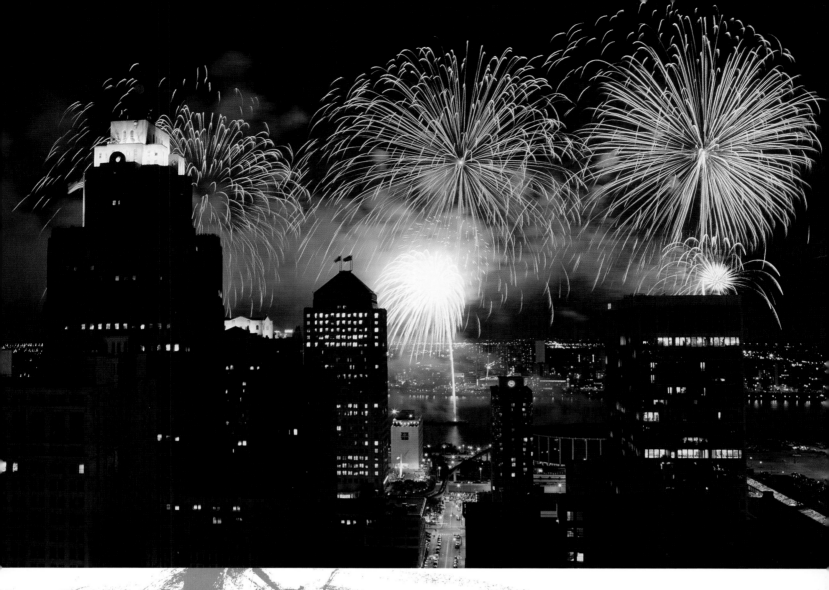

23 The Target Fireworks in Detroit.

Craig from
Auburn Hills
races around
the velodrome in
Rochester Hills.

24

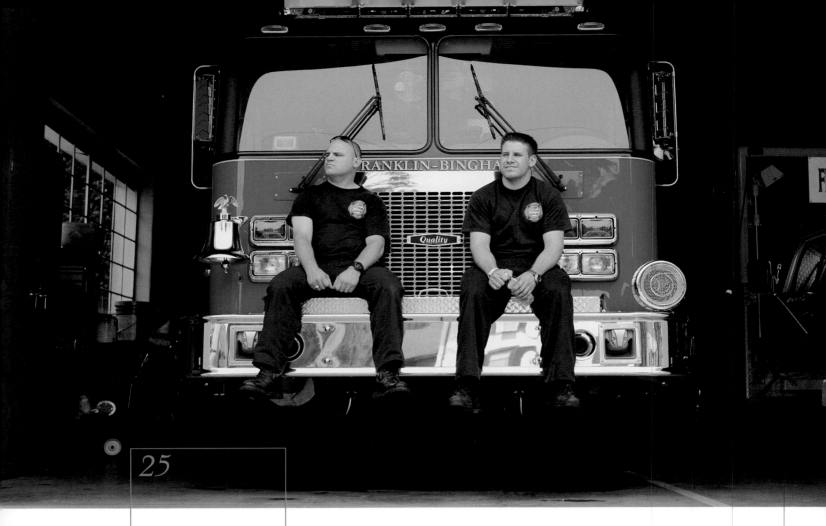

25

Tim and Drew relax between runs at the
Franklin-Bingham Fire Department.

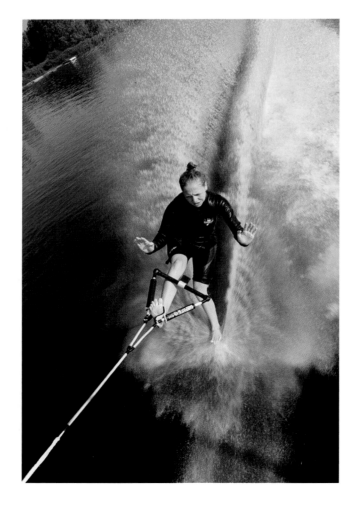

Graffiti artist
Rikku paints
around the
corner from
Eastern Market.

27

26

Laura Szwed, ranked
fifth in the world in
barefooting, trains in
White Lake.

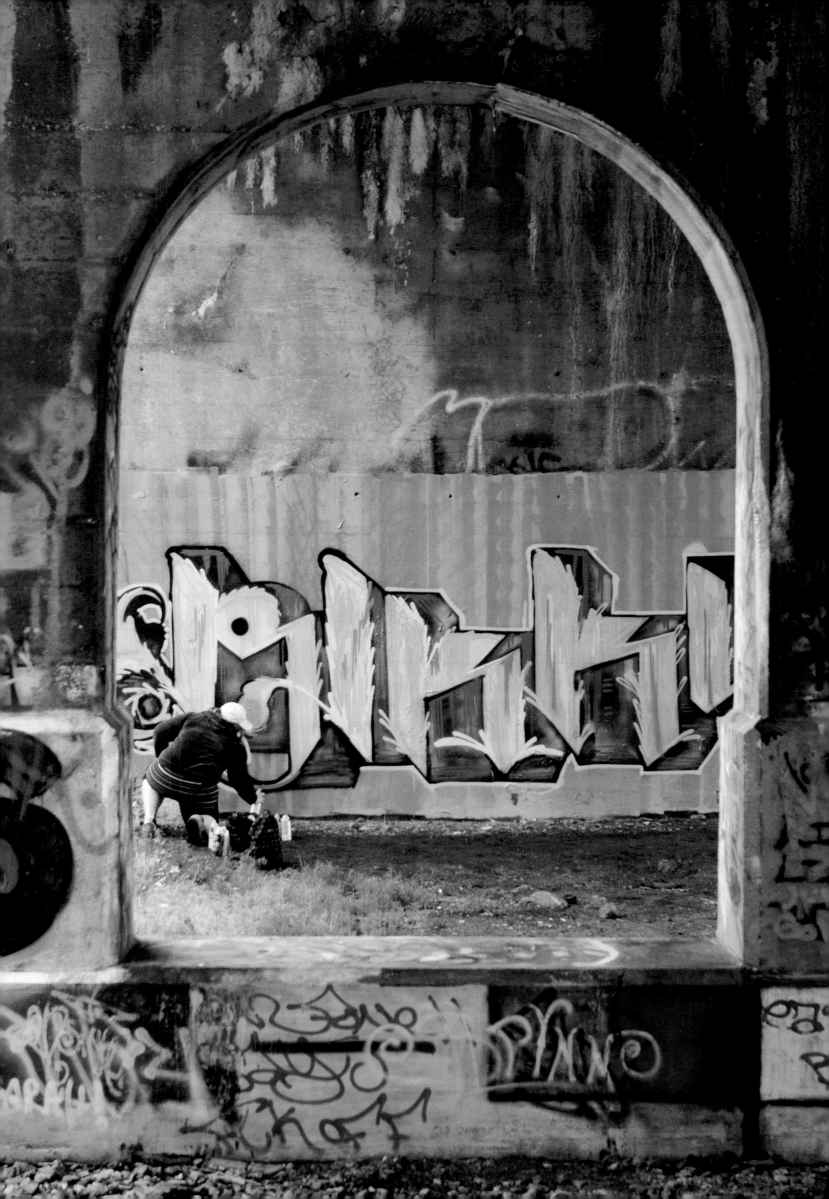

Art? In Midtown.

29

Spectators at the Stars and Stripes Festival in Mt. Clemens can have their photo taken with "America's Favorite Monkey Jockeys" after the primates have competed in the Banana Derby, where they race on the backs of dogs.

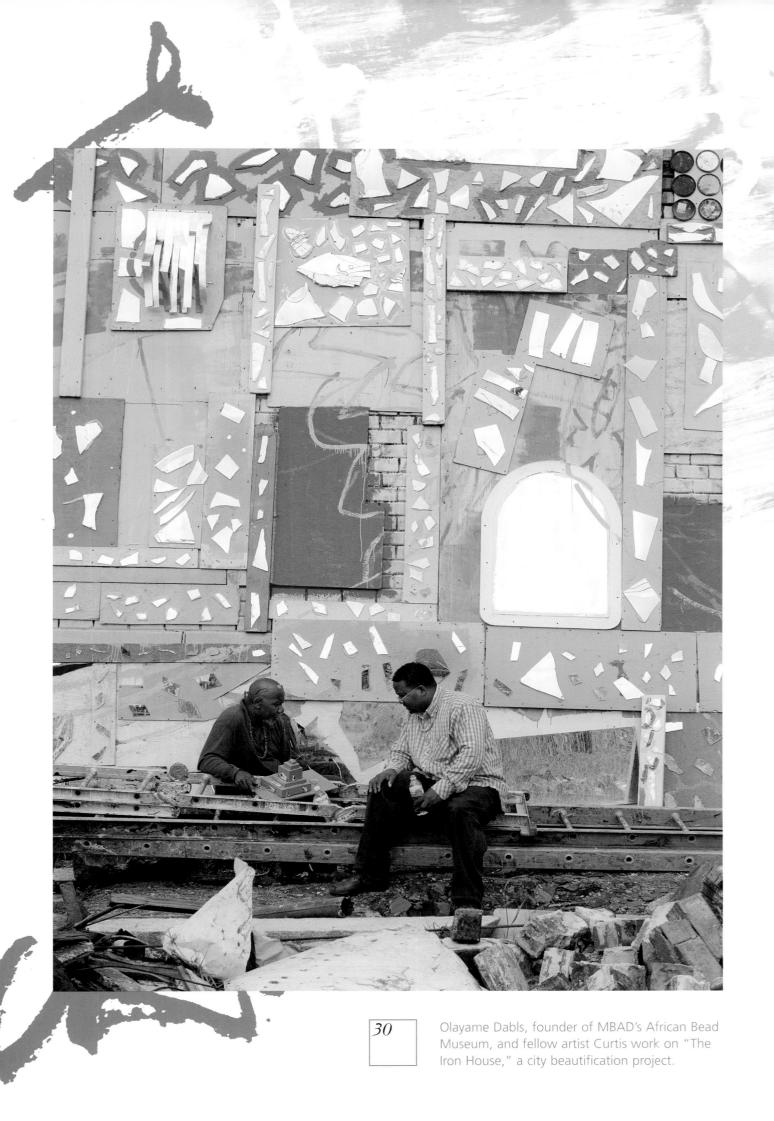

30 Olayame Dabls, founder of MBAD's African Bead Museum, and fellow artist Curtis work on "The Iron House," a city beautification project.

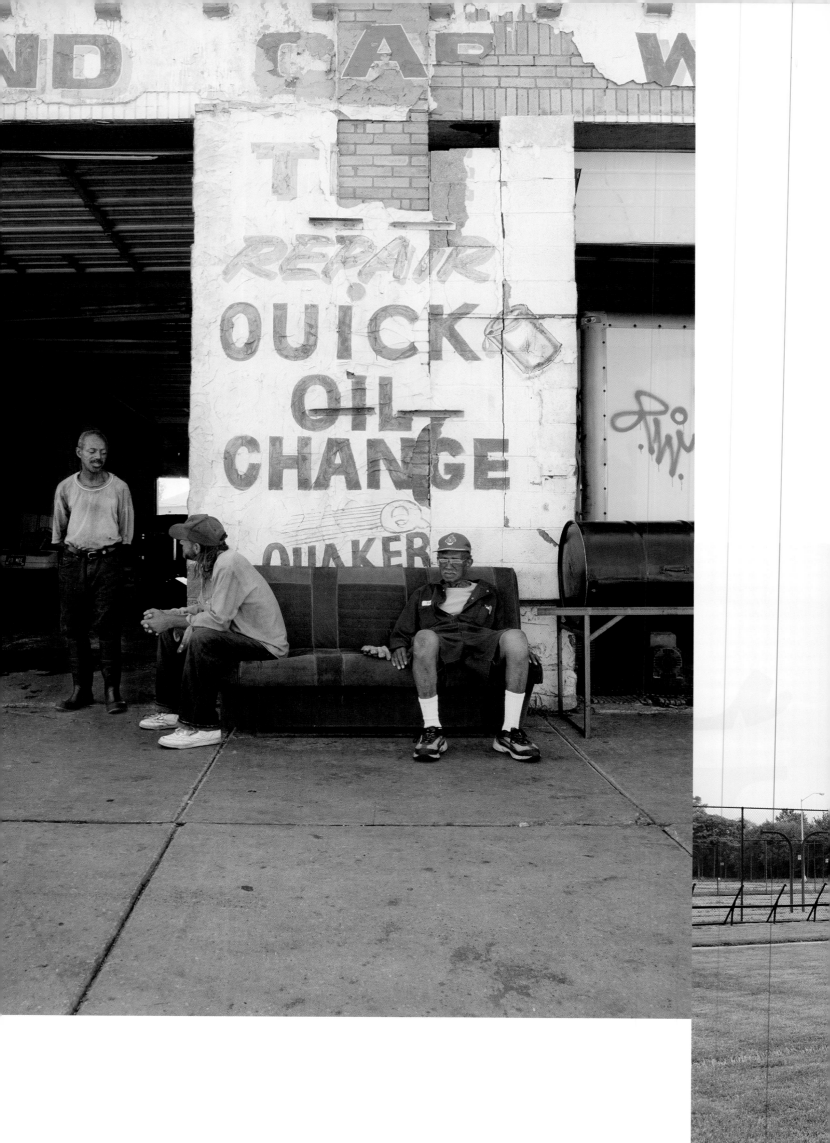

Gabriel, Bob, and Tom take a break
at Jalloppy's Car Wash in Detroit.

Members of the Douglas Fraser
High School Drum Corps practice
during the summer break.

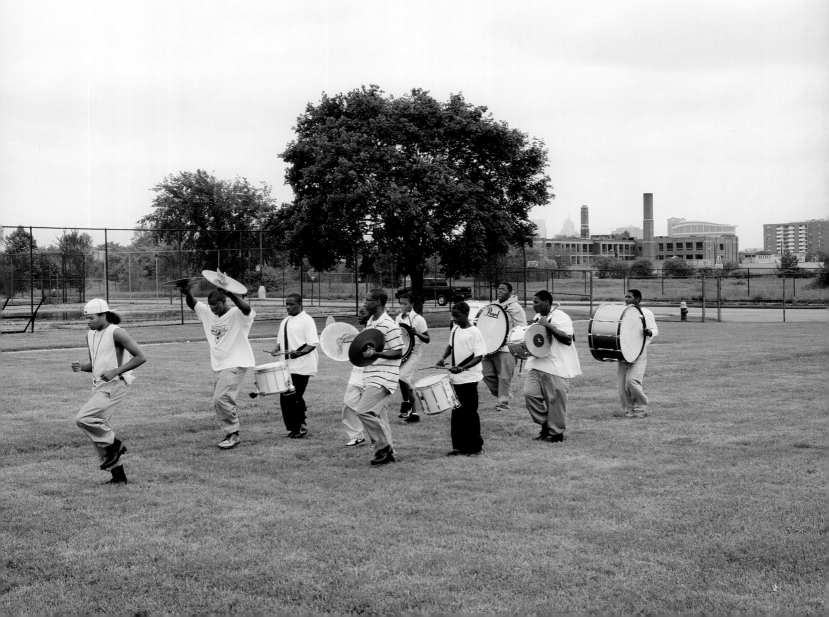

Linda getting her hair
trimmed by Fonté at
Golden Goddess salon
on Jefferson.

3

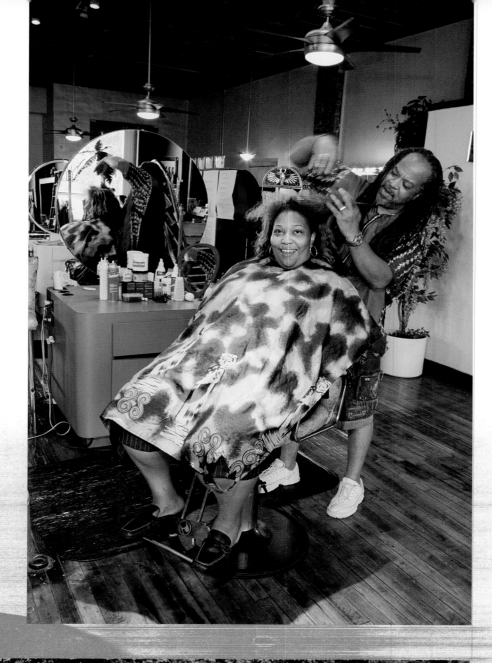

4

Cheerleaders from
Young Champions
Cheer America
march in the
Wyandotte
Independence Day
Parade.

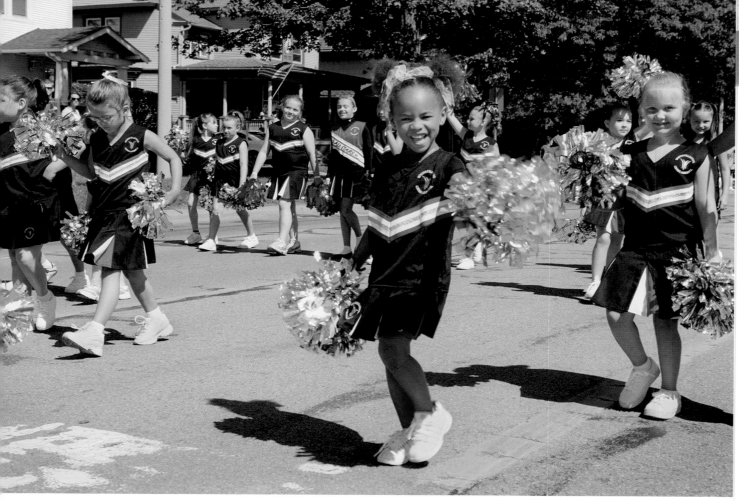

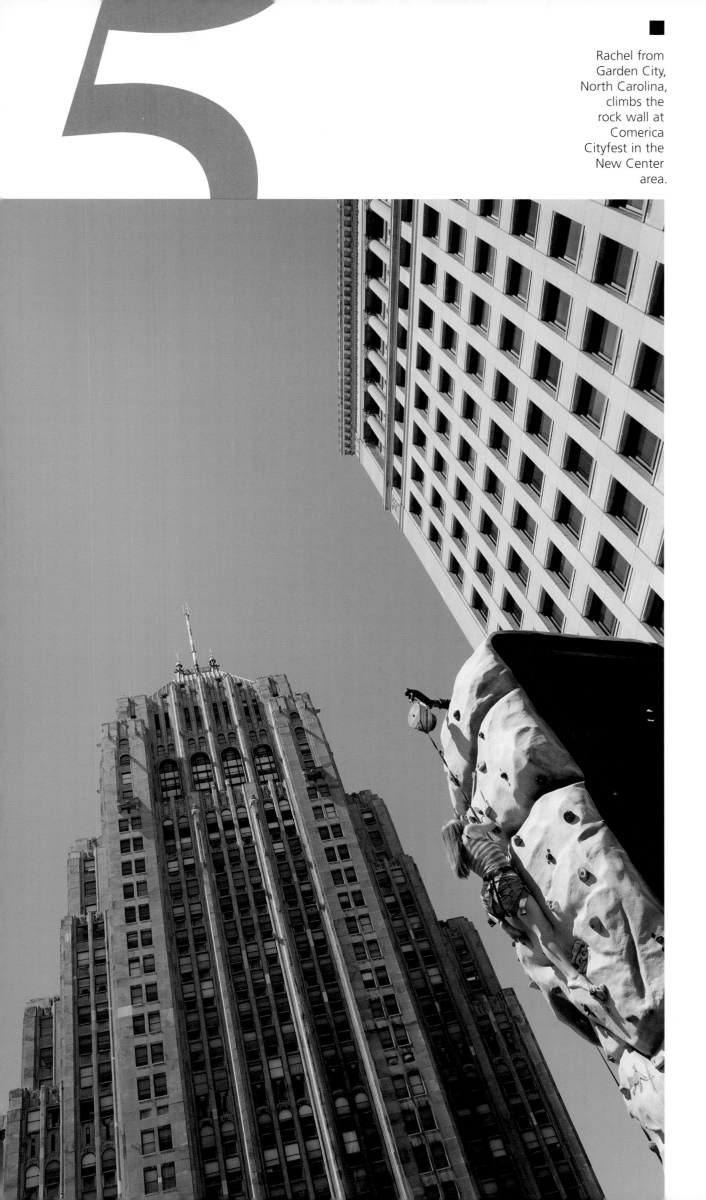

5

Rachel from Garden City, North Carolina, climbs the rock wall at Comerica Cityfest in the New Center area.

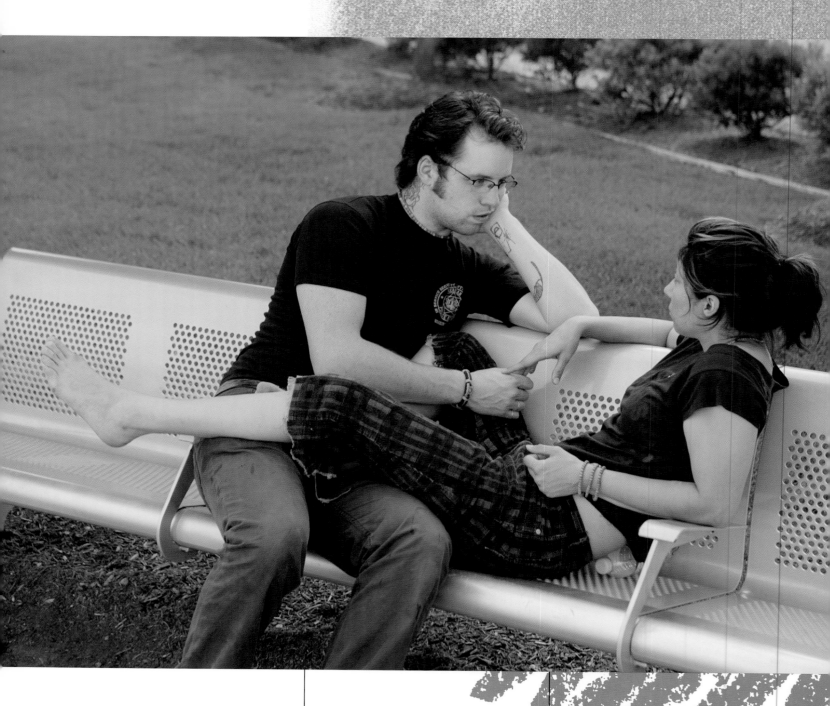

Nancy and Desoto
enjoy a moment on
one of the benches
at RiverWalk.

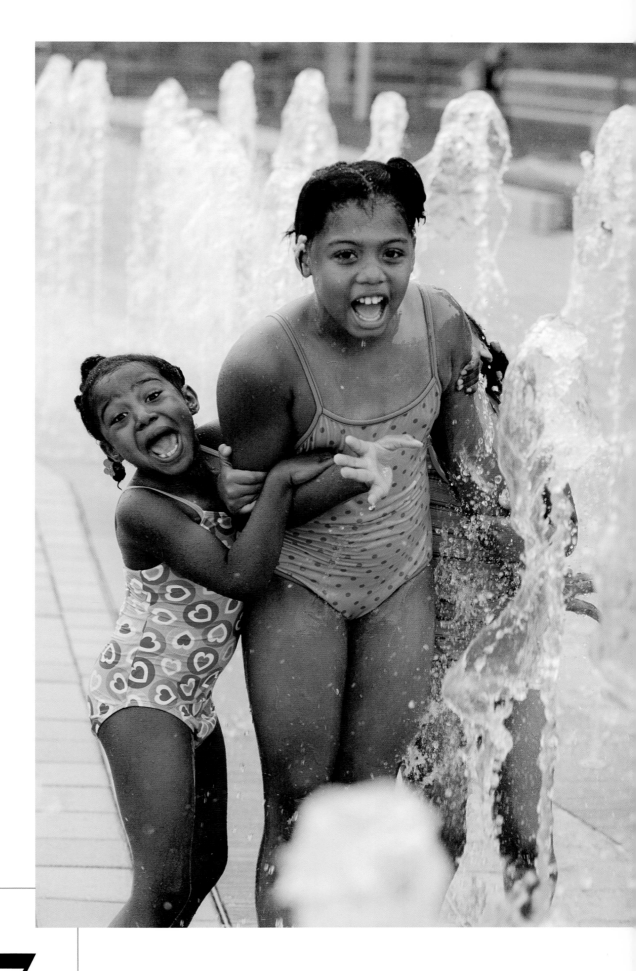

7

At RiverWalk,
Madison, Jazmine,
and Essence play in
the fountain.

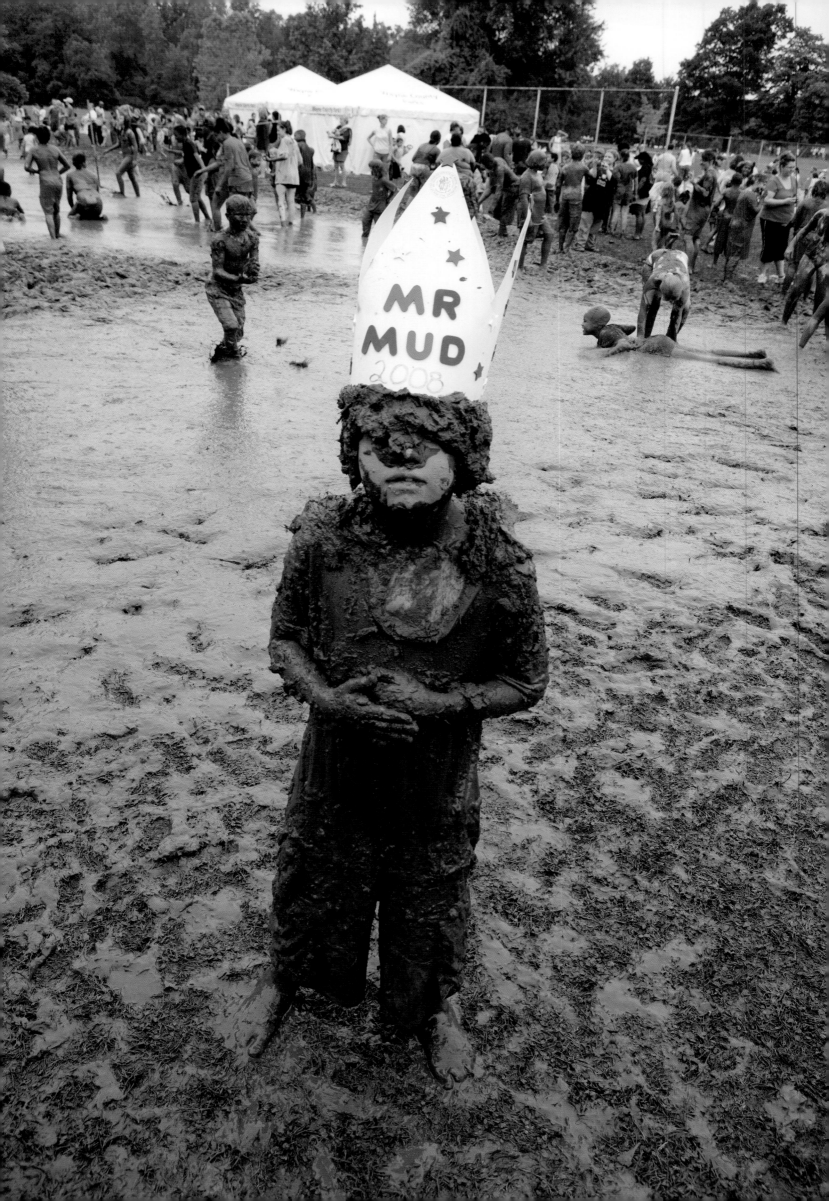

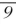

9

Detroit Shock's Kara
Braxton during a game
with the Connecticut Sun.

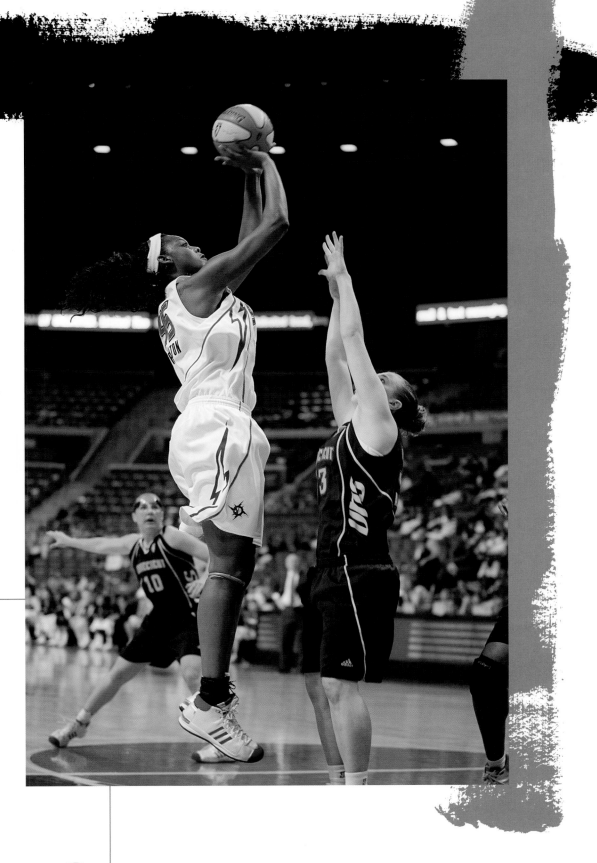

8

Nine-year-old Noah of
Livonia was named king
at Mud Day at Hines Park.

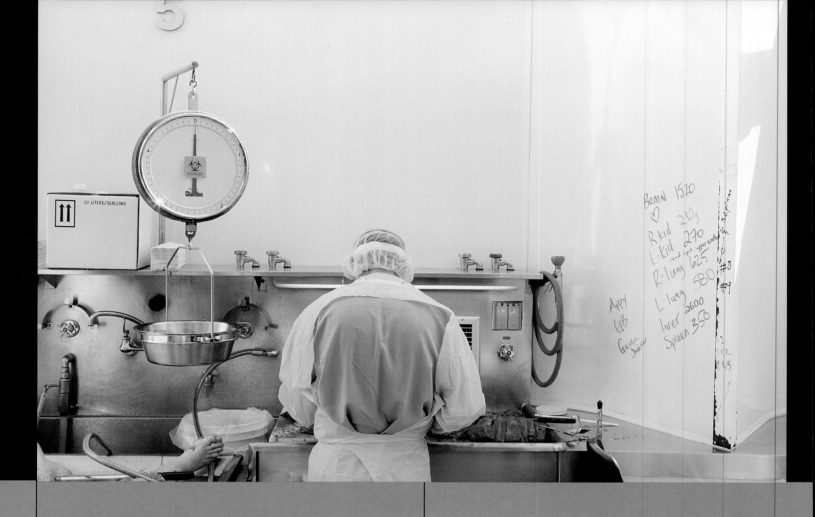

10

An autopsy at the office of the Wayne County Medical Examiner.

11

Terry at the Michigan Elvisfest.

At the Saline Celtic Festival,
Angela from Indiana competes
in the hammer throw.

12

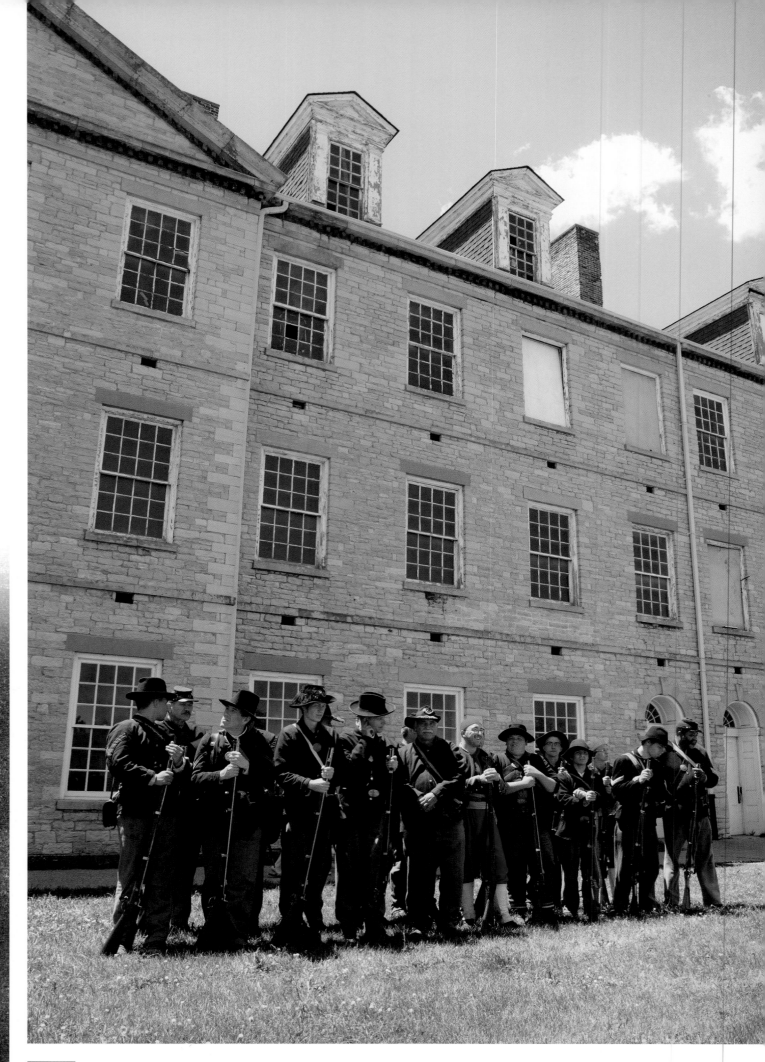

Members of the Cumberland
Guard during Civil War Days
at Historic Fort Wayne.

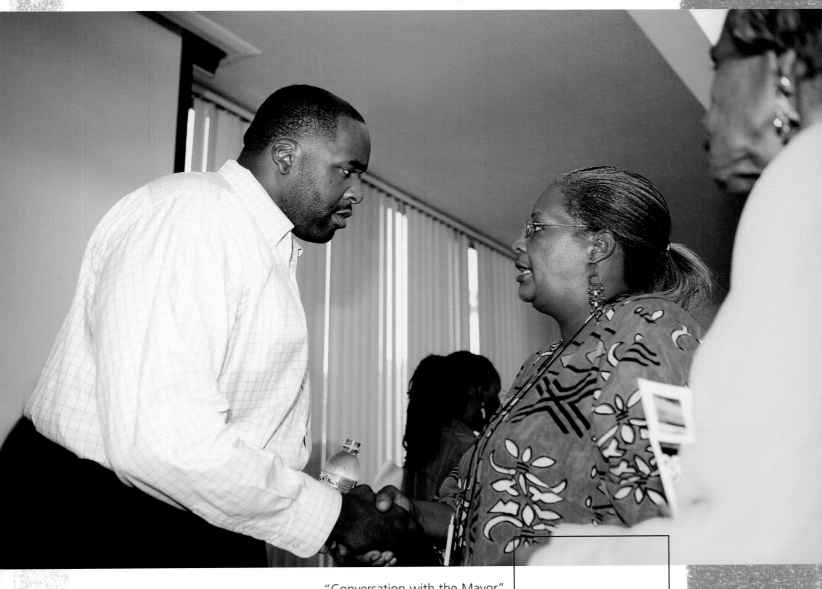

"Conversation with the Mayor"
hosted by Tene-Sandra Ramsey at
the Detroit Entrepreneurship Institute.

14

15

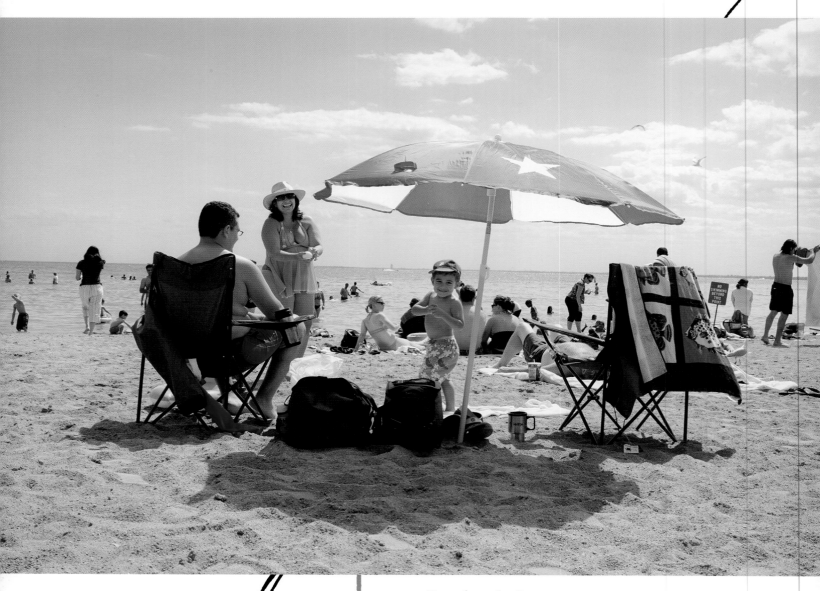

Diego from Sterling
Heights plays catch with
his mom at Metro Beach.

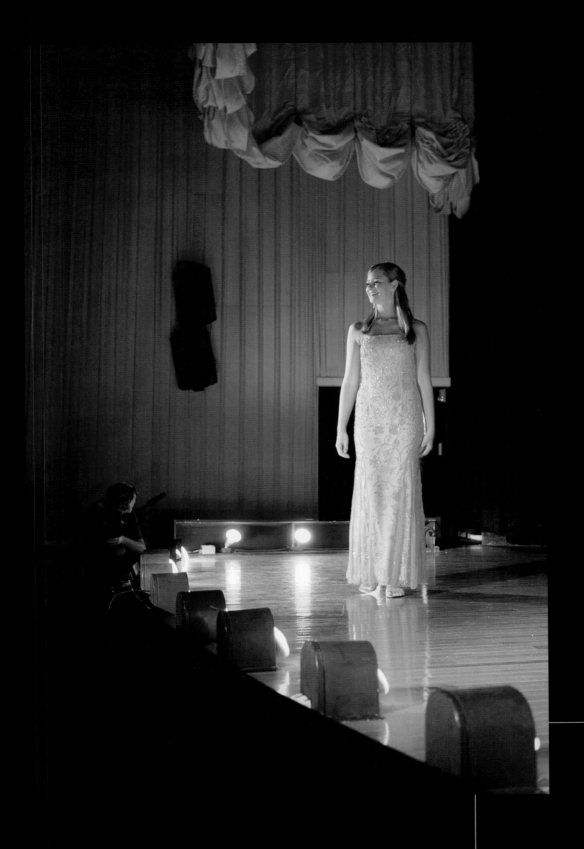

Alexandria competing in the Miss Farmington Founders Festival.

16

Art lovers examine the work of Susan E. Hunt at the Ann Arbor Art Fair.

17

18 Carly dancing at the Toy Chest in Dearborn.

At Quake on the Lake, Hunter builds a sand castle as his dad watches the races.

19

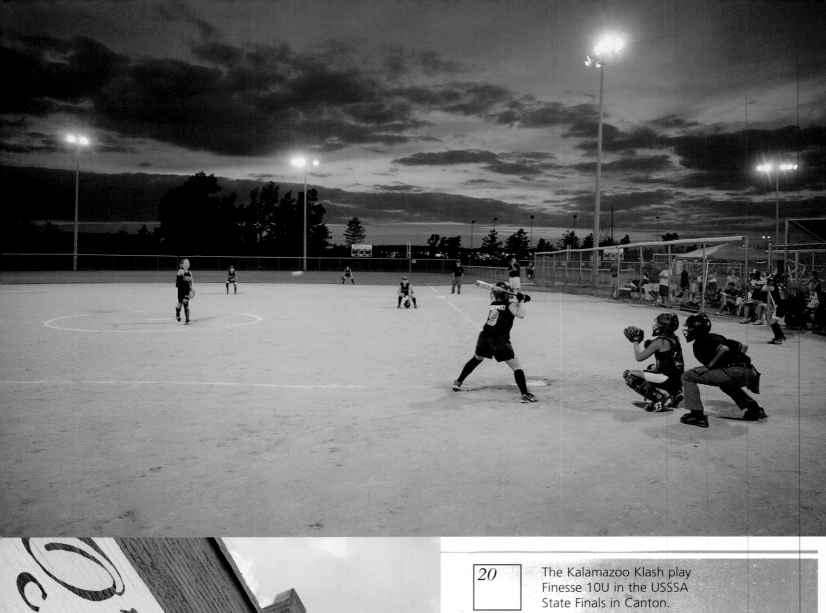

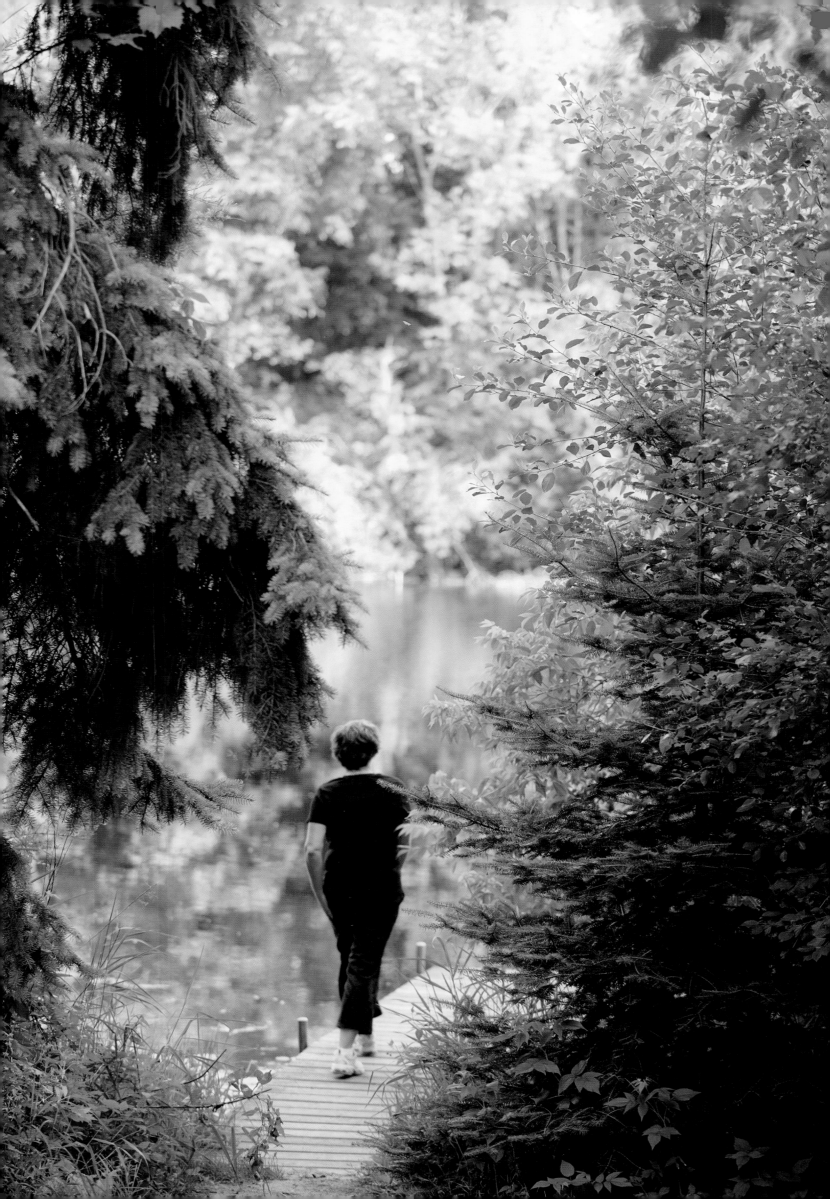

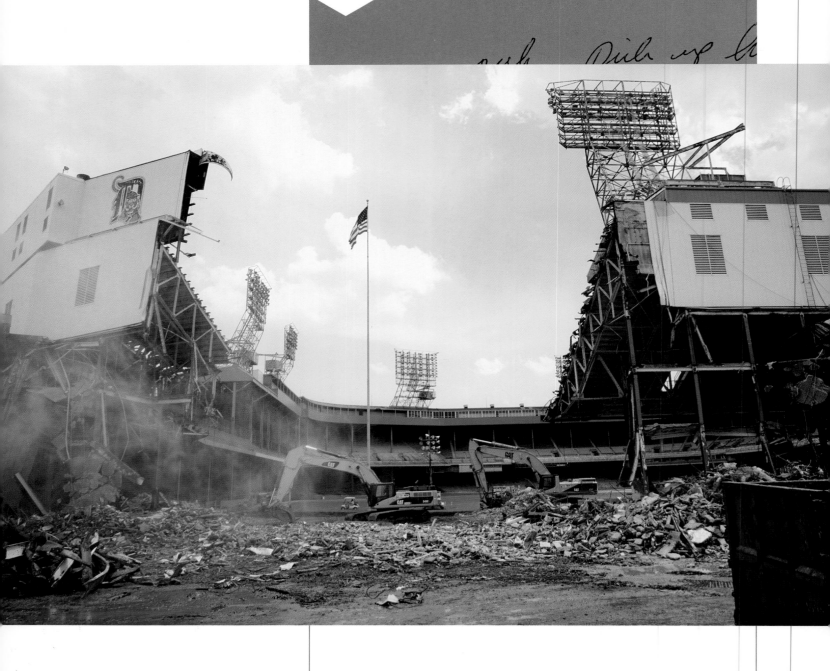

23

The old Tiger Stadium being demolished.

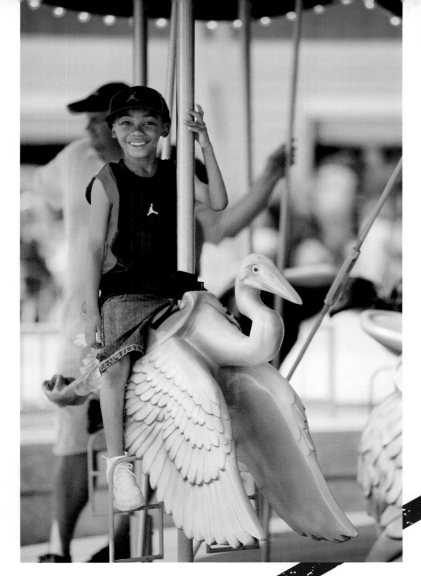

Jayden, six, from Detroit
rides the carousel at
RiverWalk.

24

25

Evan Strong from
Maui skates in the
Extremity Games,
a competition for
athletes with
missing limbs.

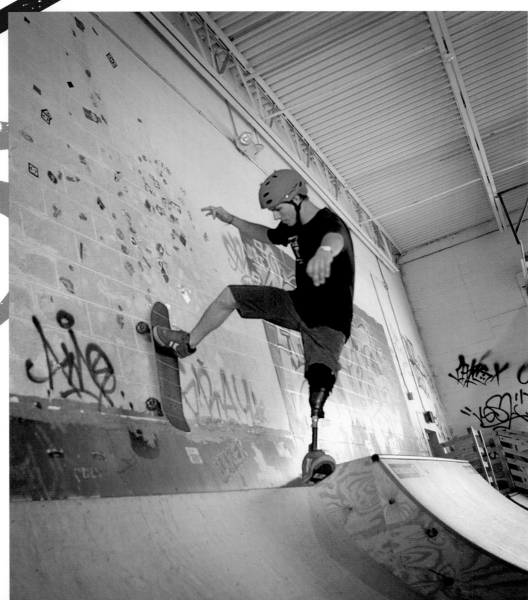

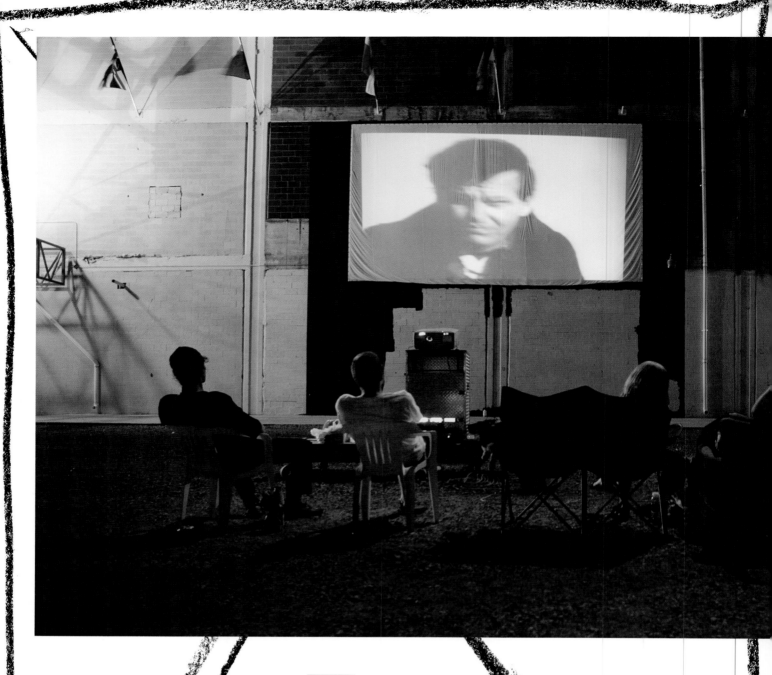

26

The Terror with Jack Nicholson plays at the Motor City Movie House at the Russell Industrial Center.

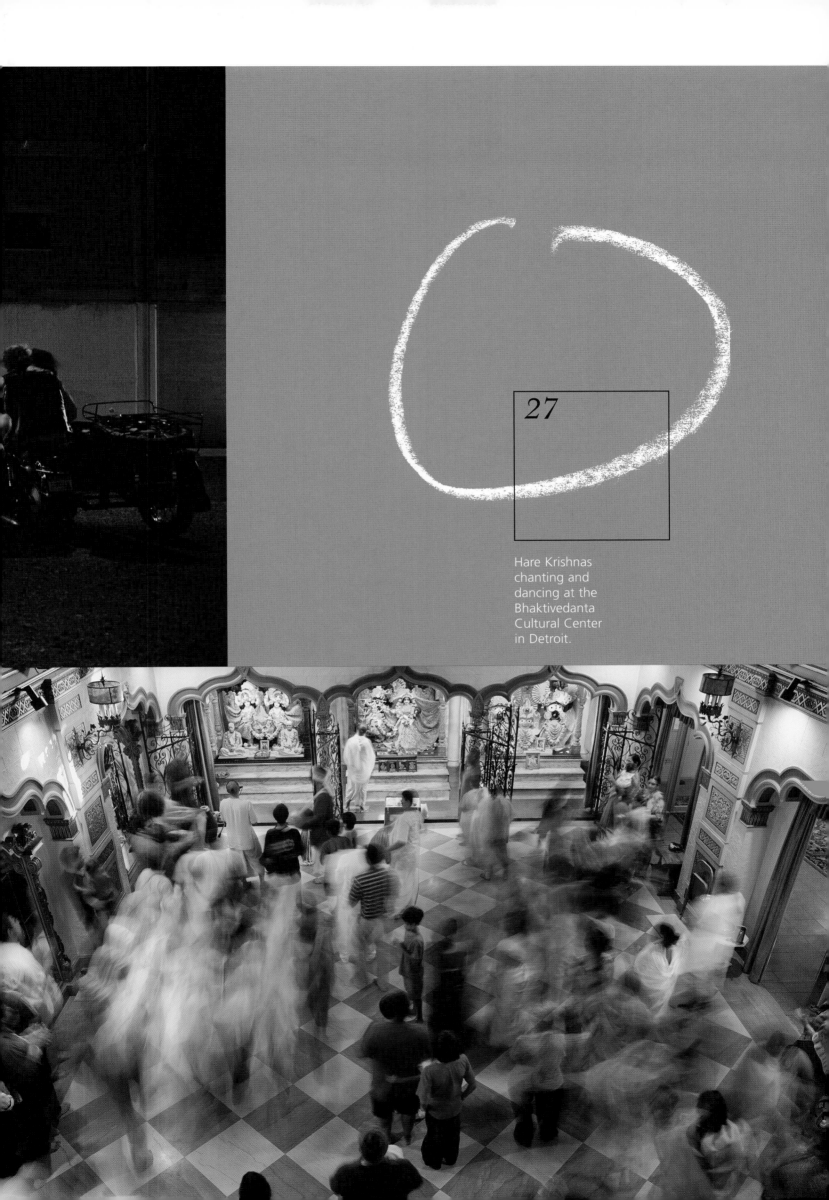

27

Hare Krishnas
chanting and
dancing at the
Bhaktivedanta
Cultural Center
in Detroit.

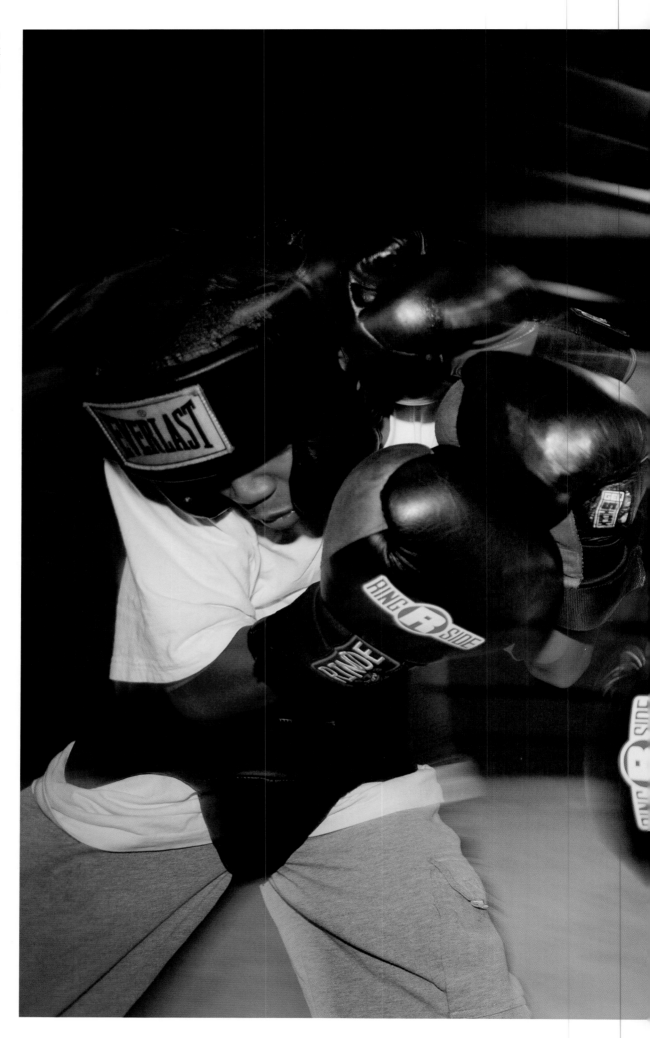

28

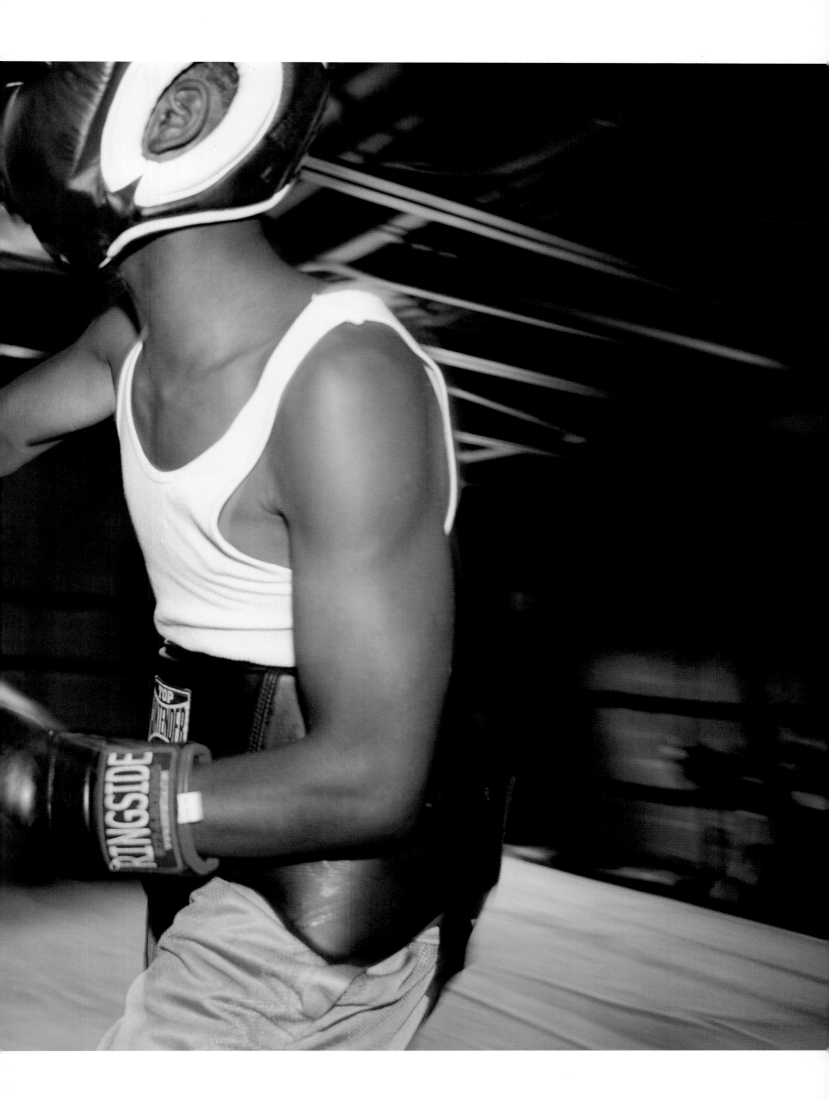

29

Doda from Livonia harvests vegetables at the community gardens at Greenmead Historical Park.

31

Six-year-old Jennah from Ferndale enjoys an airplane ride courtesy of her uncle.

30

At the Royal Oak Golf Center, Kevin from Oak Park practices his swing.

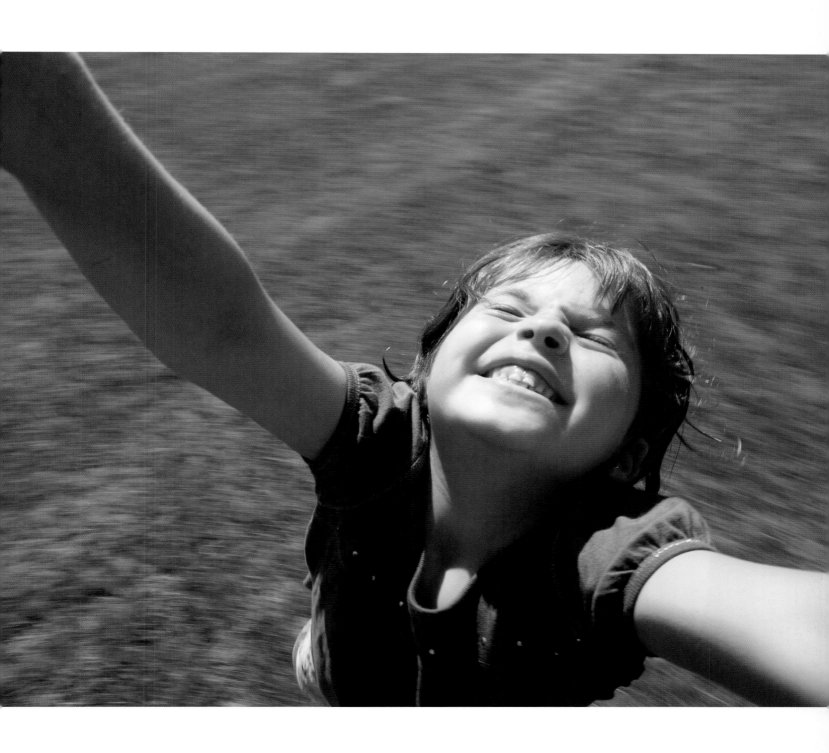

Carl Jackson from
Jackson Five Star
Catering cooks his
winning ribs at the
Ribs 'n Soul Festival
at Hart Plaza.

1

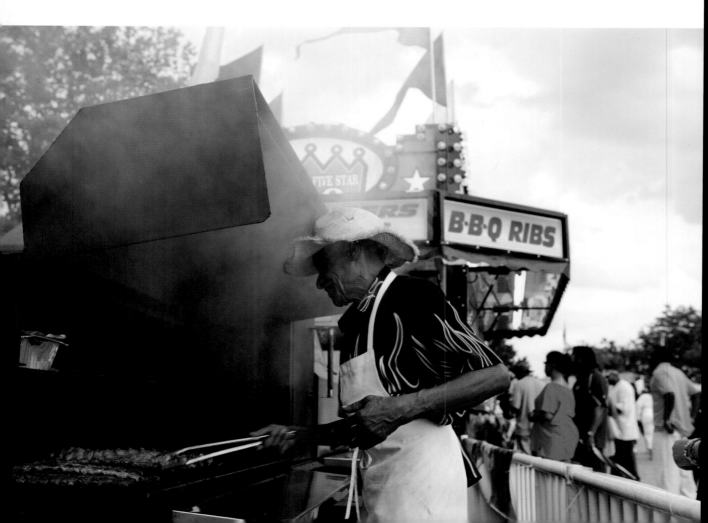

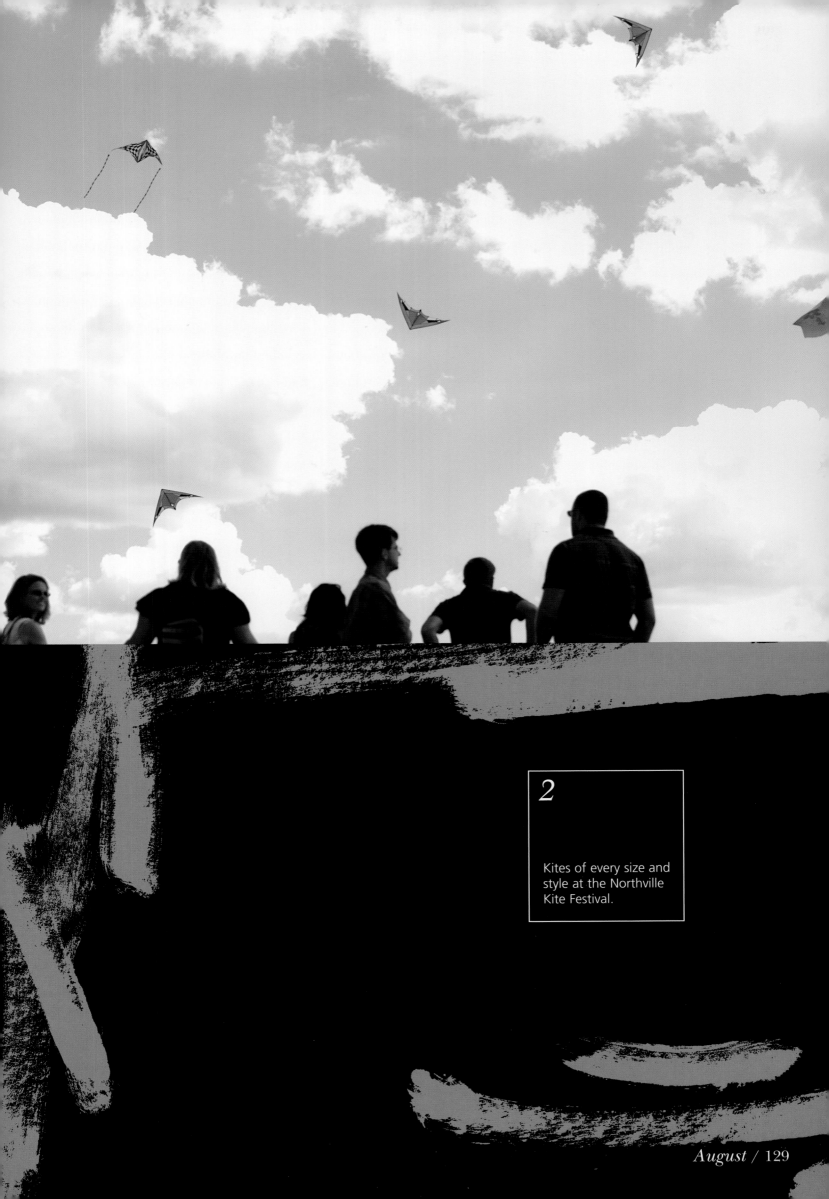

2

Kites of every size and style at the Northville Kite Festival.

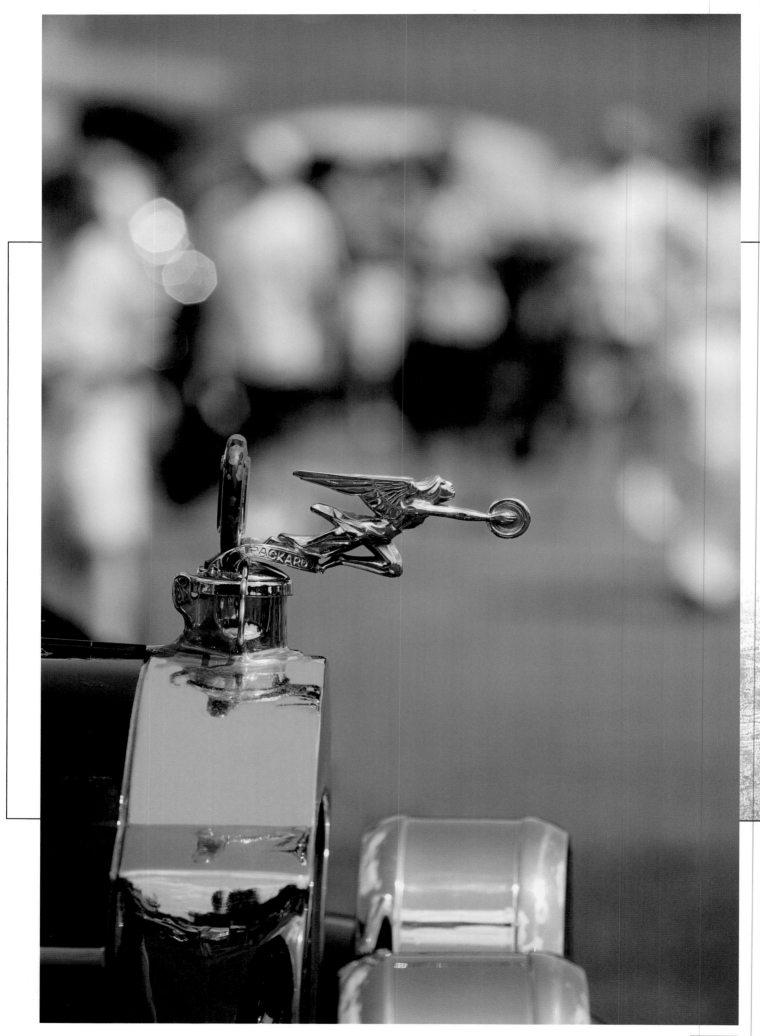

The hood ornament on a 1928 Packard
526 Phaeton at the Concours
d'Elegance at Meadow Brook.

3

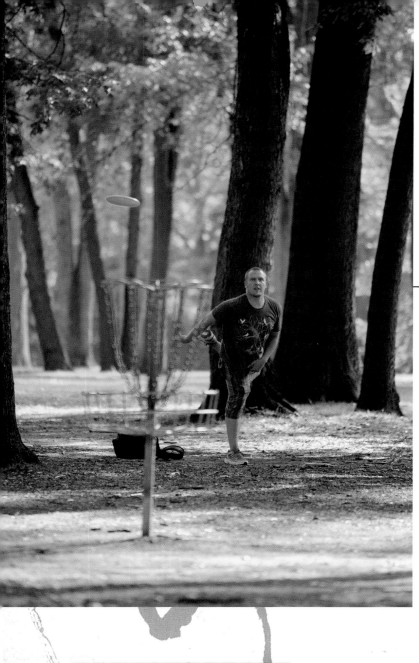

■

Billy trying for par on the Frisbee golf course in Royal Oak.

4

Charl Schwartzel signs autographs at the end of a practice round for the PGA Championship.

5

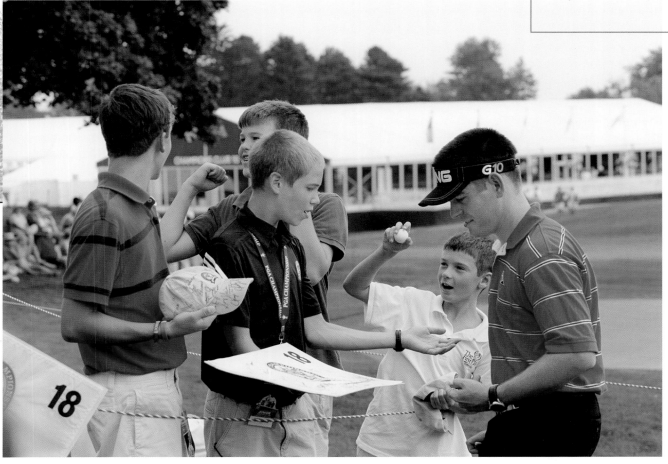

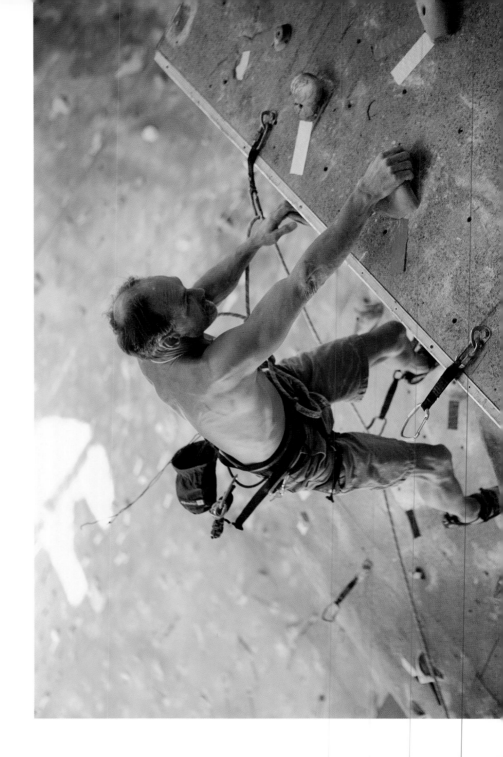

At Planet Rock
in Pontiac, Rick
ascends the
climbing wall.

Zach and Phil
practice at
Target Sports in
Royal Oak.

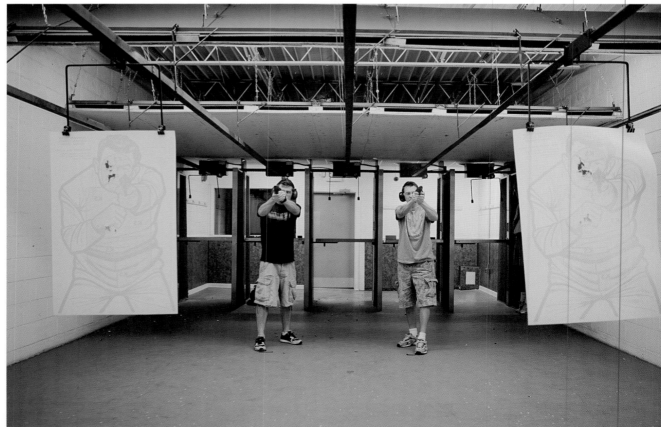

8

World War II vehicles cruise through Belleville
during Thunder Run.

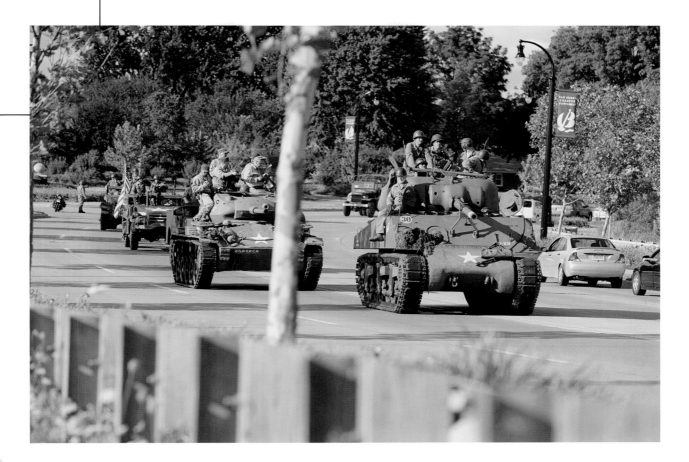

9

Dancing in the
Caribbean Parade.

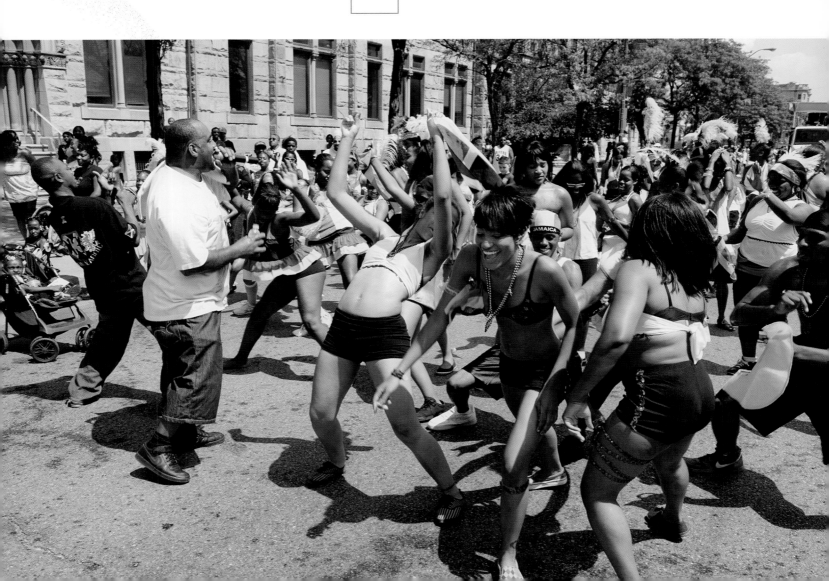

10

Sleeping Beauty performed by puppeteers Nick Pobutsky and Ashlee Armstrong at PuppetArt Theater in Detroit.

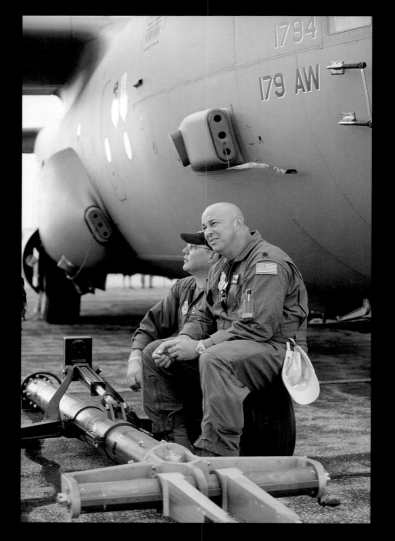

11

Mike Myers and Bob Dulap of the 179th Airlift Wing, 164th Airlift Sq. Mansfield, Ohio, answer questions about their C130 during the Thunder over Michigan Air Show at Willow Run Airport.

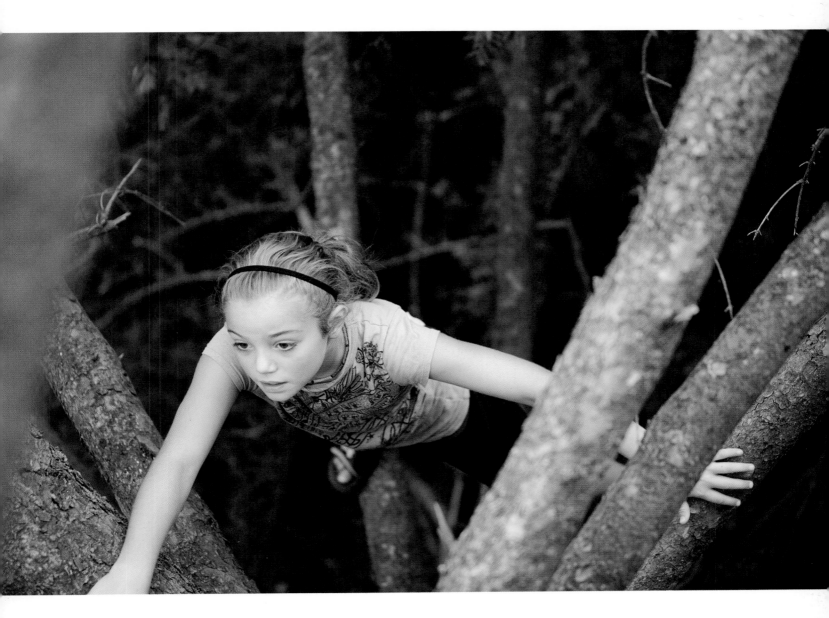

12 | Kelly from Commerce Township climbs an old pine tree.

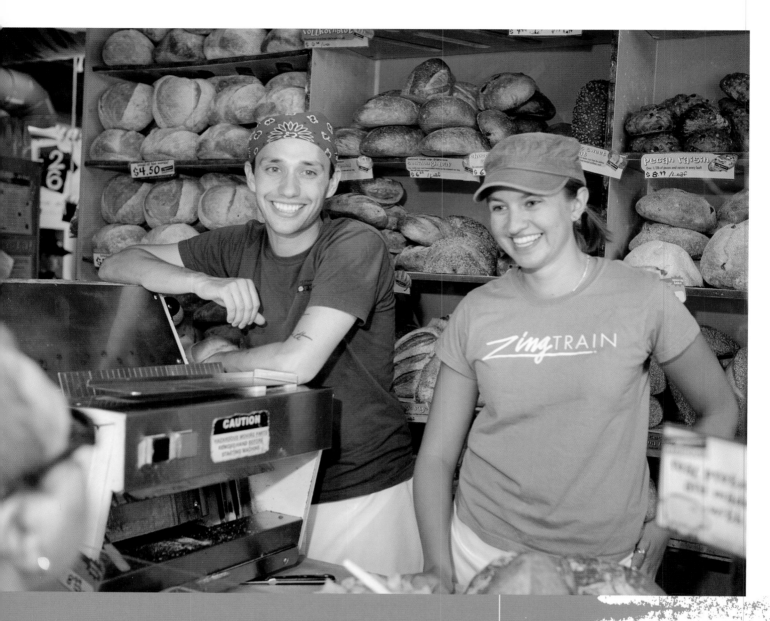

13

At Zingerman's in Ann Arbor, Thomas and Gillian help customers.

14

Station Belle Isle Coast Guard crew members train for helicopter rescues with the crew of a Coast Guard HH-65 helicopter out of Air Station Detroit on Selfridge Air Force Base.

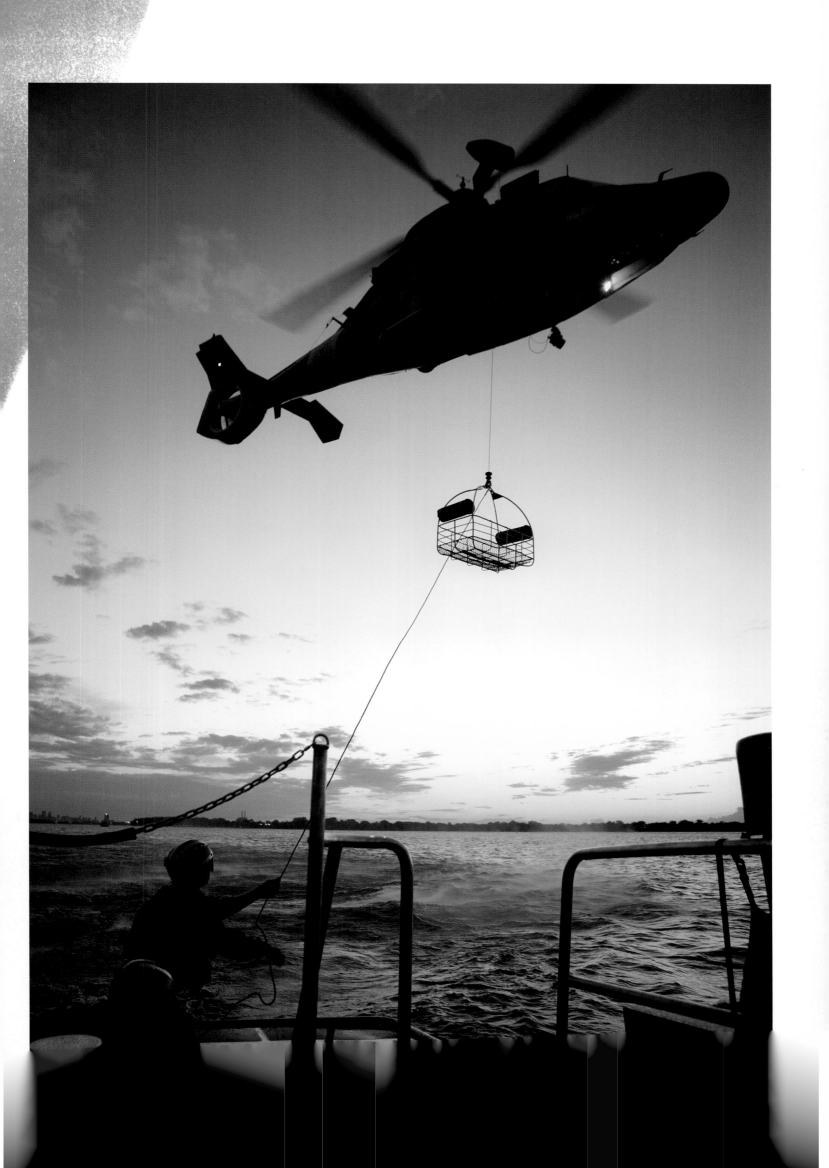

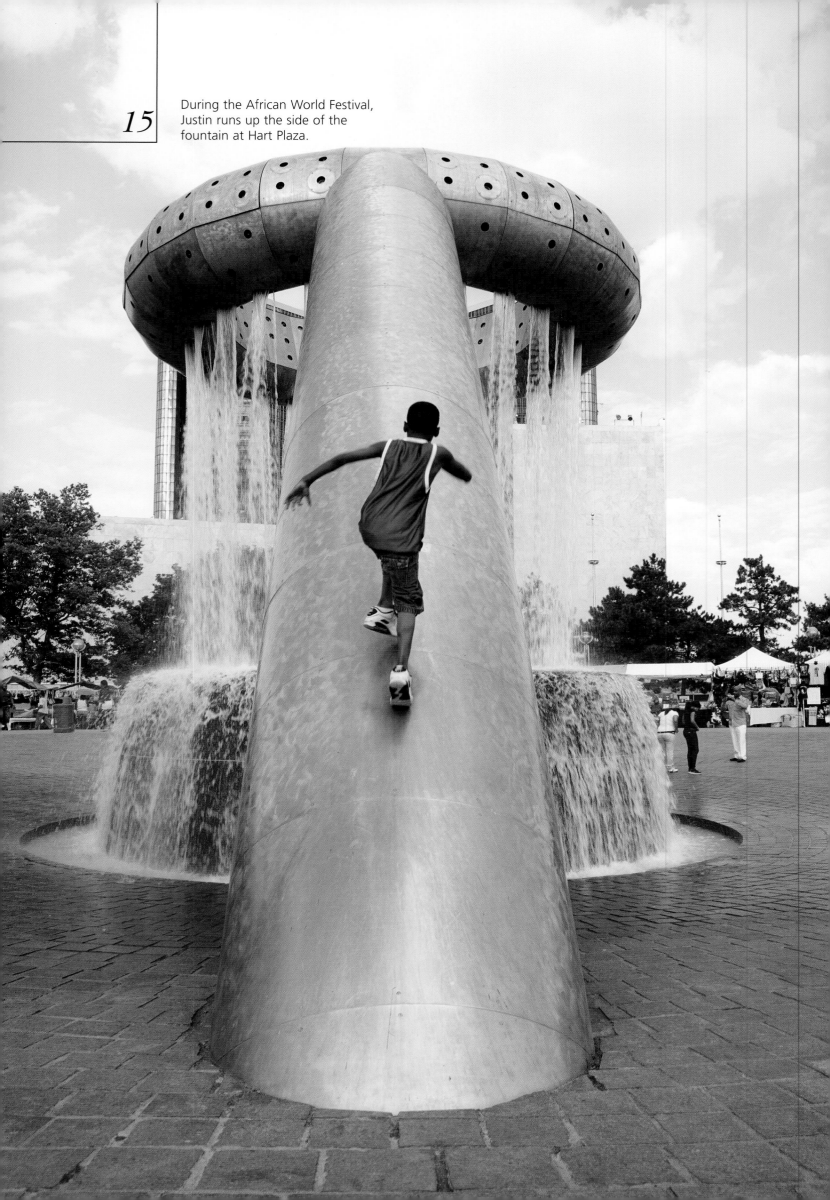

15 During the African World Festival, Justin runs up the side of the fountain at Hart Plaza.

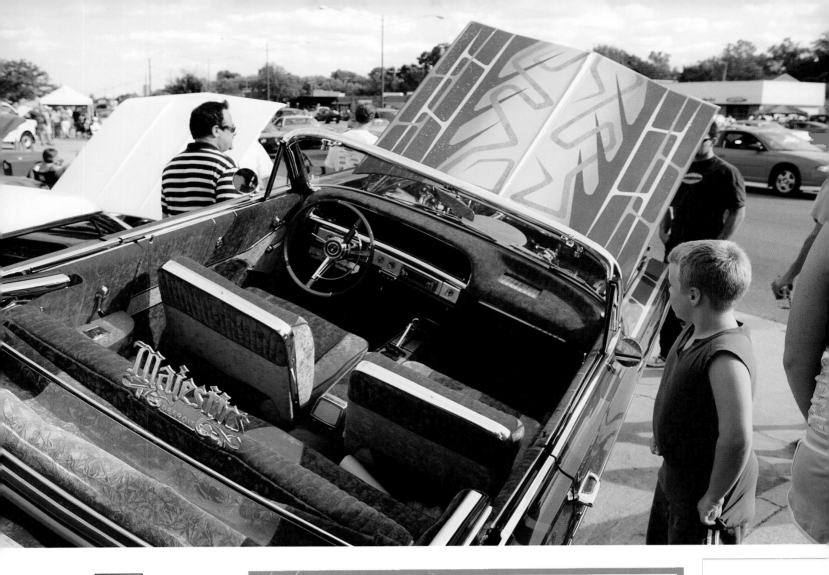

16

A '64 Impala by Show
and Go Customs draws
a crowd at the Woodward
Dream Cruise.

17

Dean shows off his ice-cream moustache.

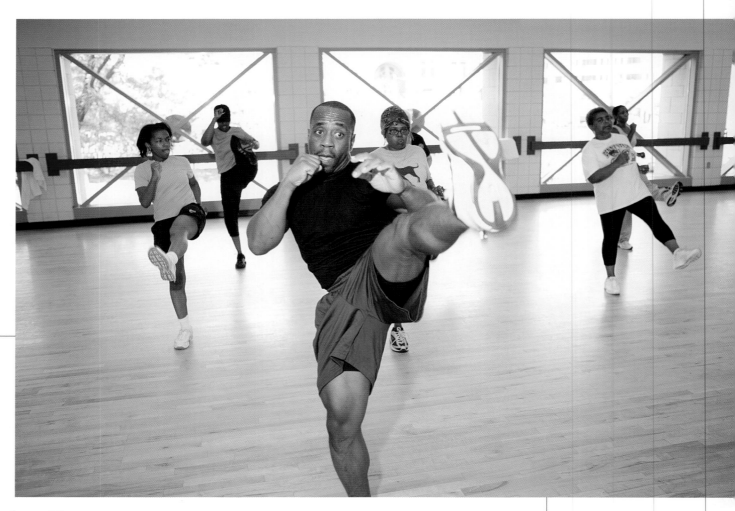

18

At FitnessWorks, Sidney leads a cardio kickboxing class.

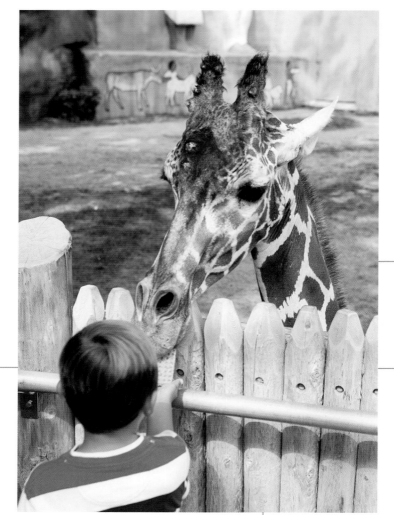

19

Ryan, five, feeds a giraffe at the Detroit Zoo in Royal Oak.

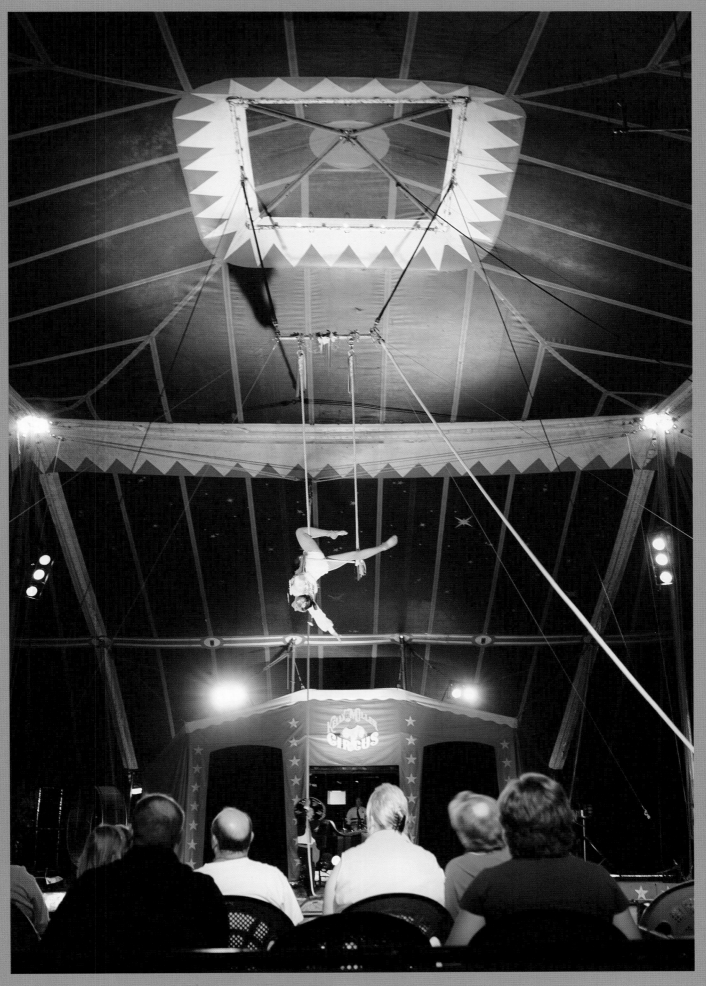

The Kelly Miller Circus
performs in Plymouth
for the Lions Club.

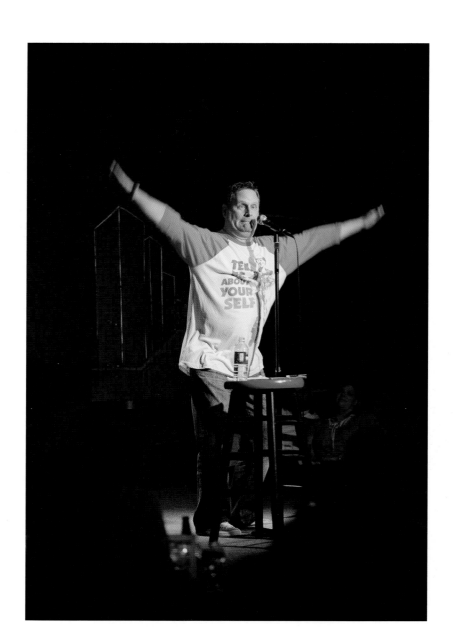

21

At Mark Ridley's Comedy Castle in Royal Oak, comedian Dave Coulier entertains the audience.

Volunteers from Aramark and CityYear help to refurbish the People's Community Center in Hamtramck.

22

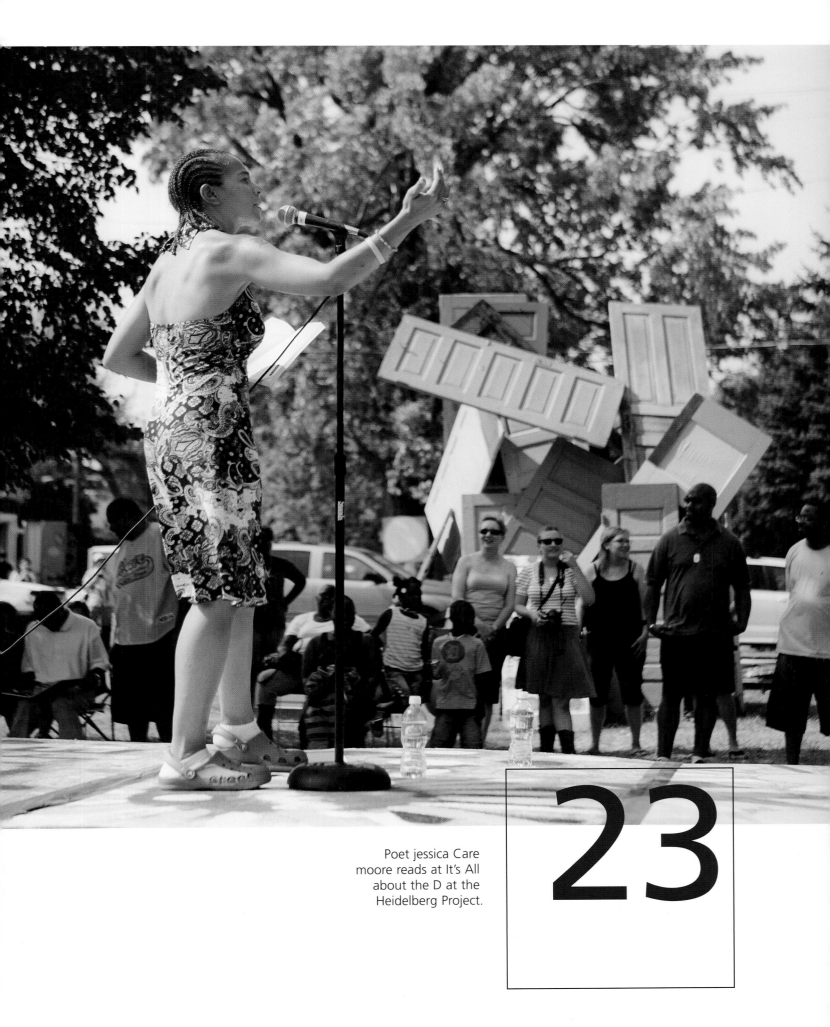

Poet jessica Care moore reads at It's All about the D at the Heidelberg Project.

23

24

Pig racing at the Michigan State Fair in Detroit.

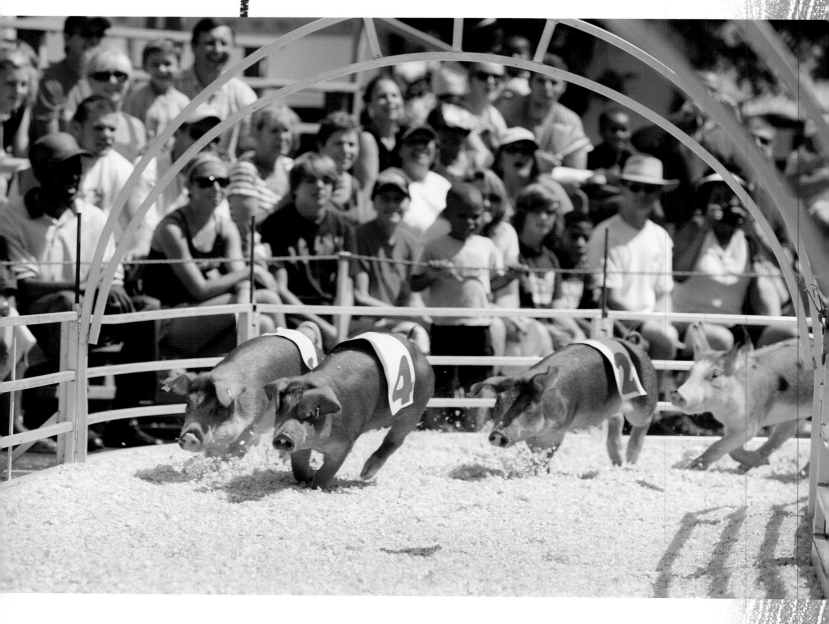

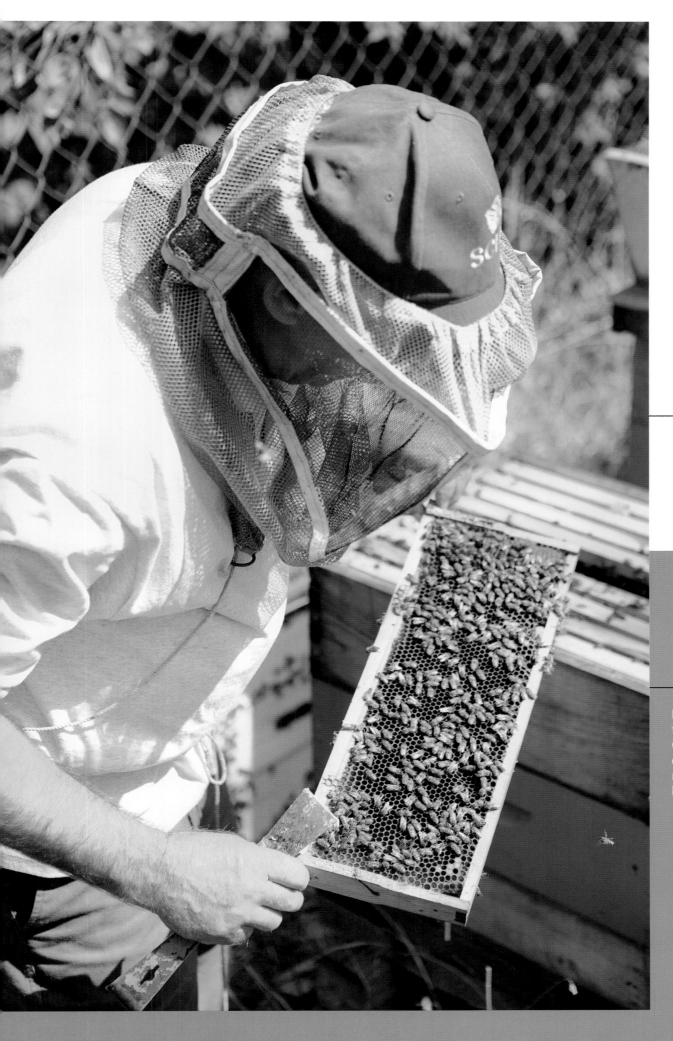

2
5

Rich Wieske
from Green Toe
Gardens checks
on one of his
many urban
bee hives.

26

Curtis Wooten bakes at
Avalon International
Breads in Detroit.

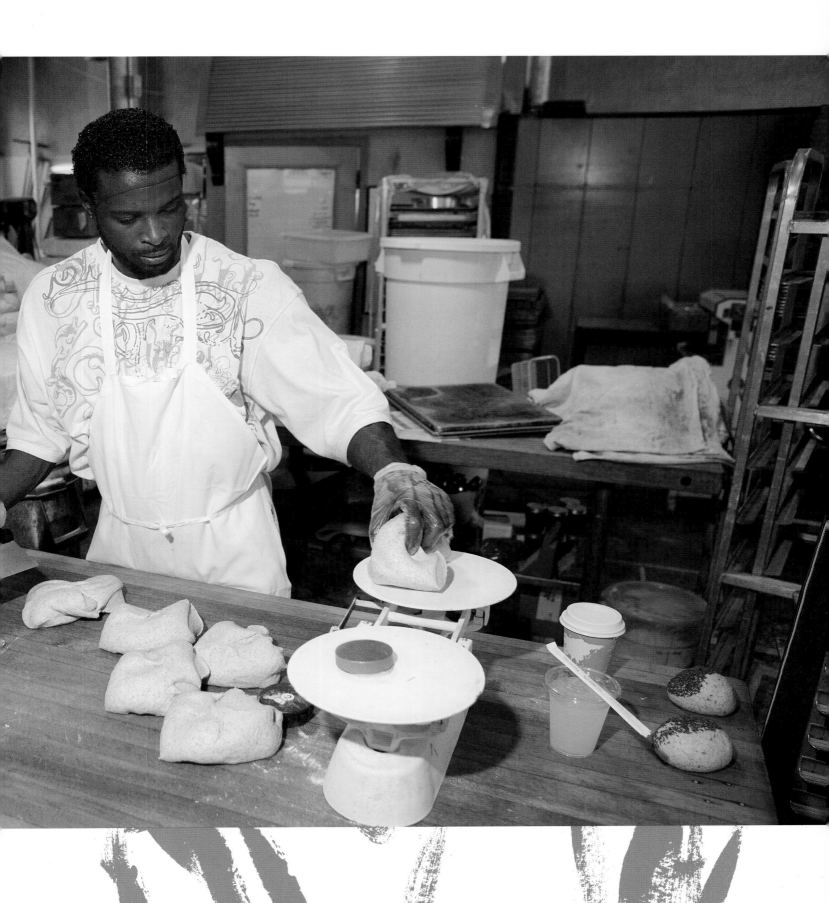

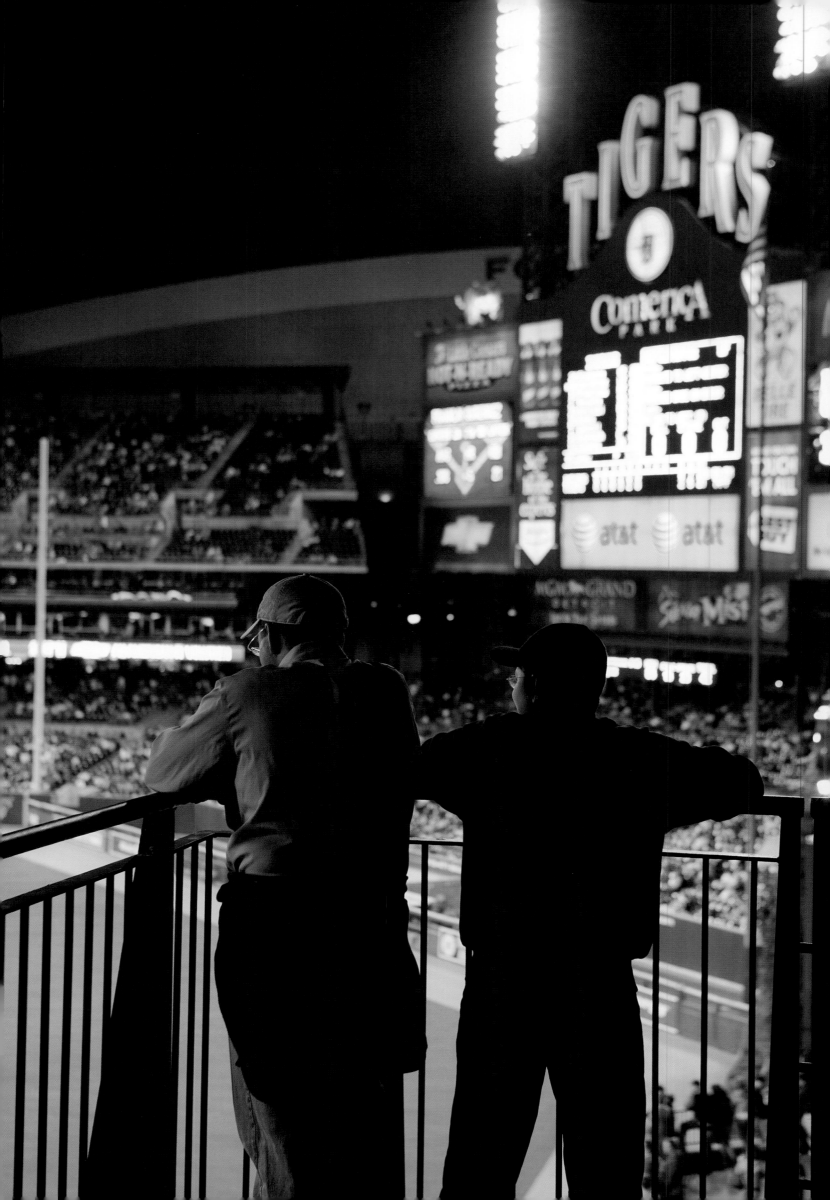

27

Steve and son Seth watch a game at Comerica Park from right field.

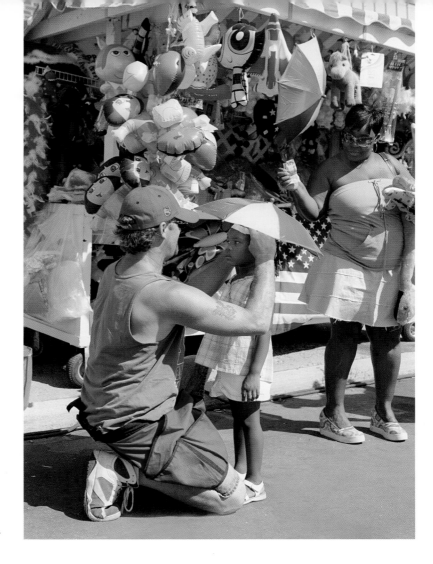

28

Nick fits Morgan, four, with an umbrella hat at the Hamtramck Labor Day Festival.

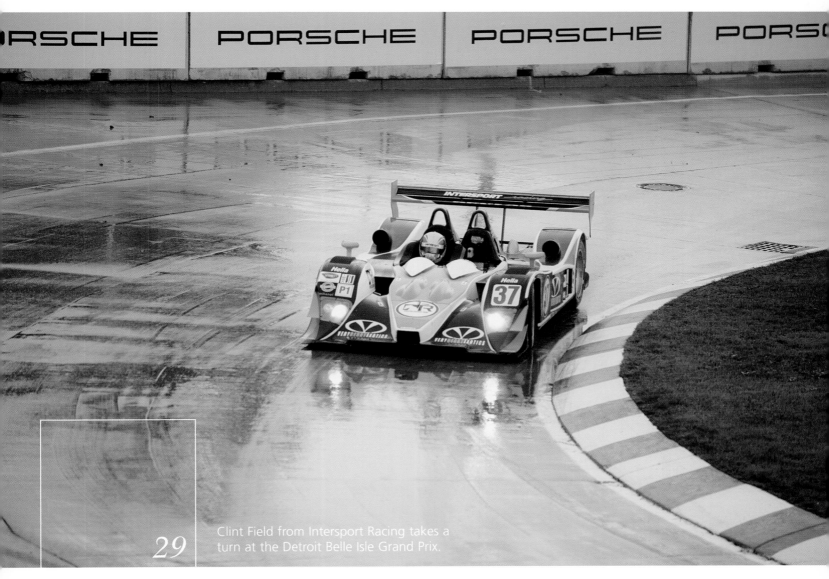

29

Clint Field from Intersport Racing takes a turn at the Detroit Belle Isle Grand Prix.

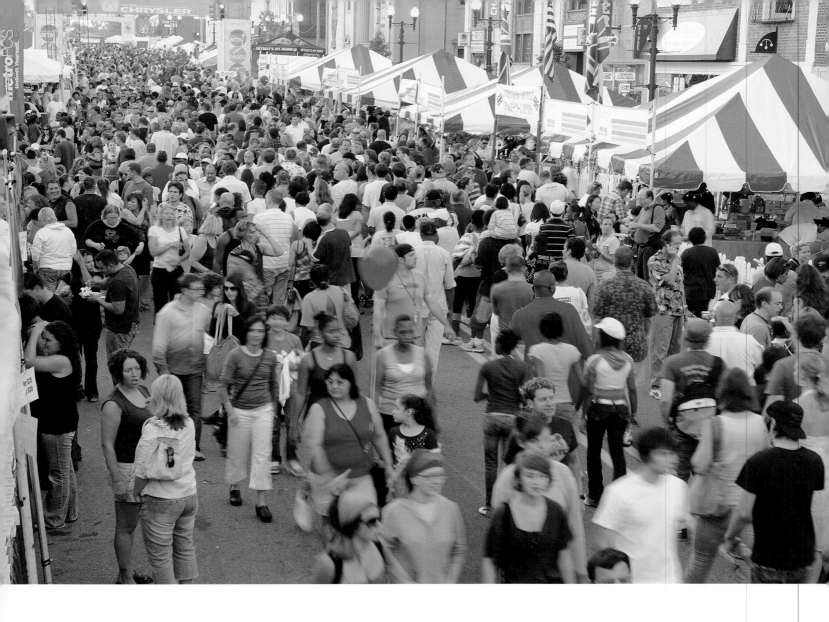

The crowd at Chrysler Arts, Beats & Eats in Pontiac.

30

31

The Derek Trucks Band performs at the Detroit International Jazz Festival.

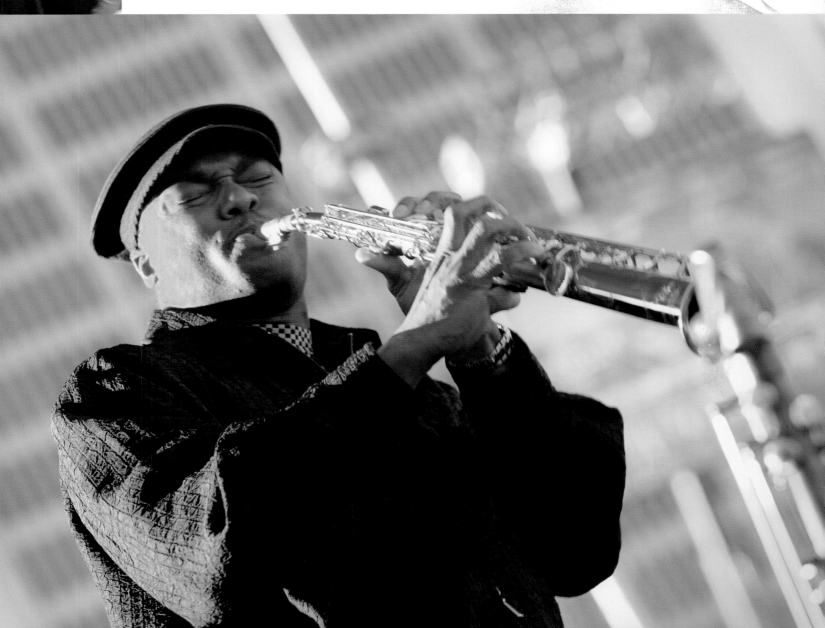

AUTUMN

SEPTEMBER

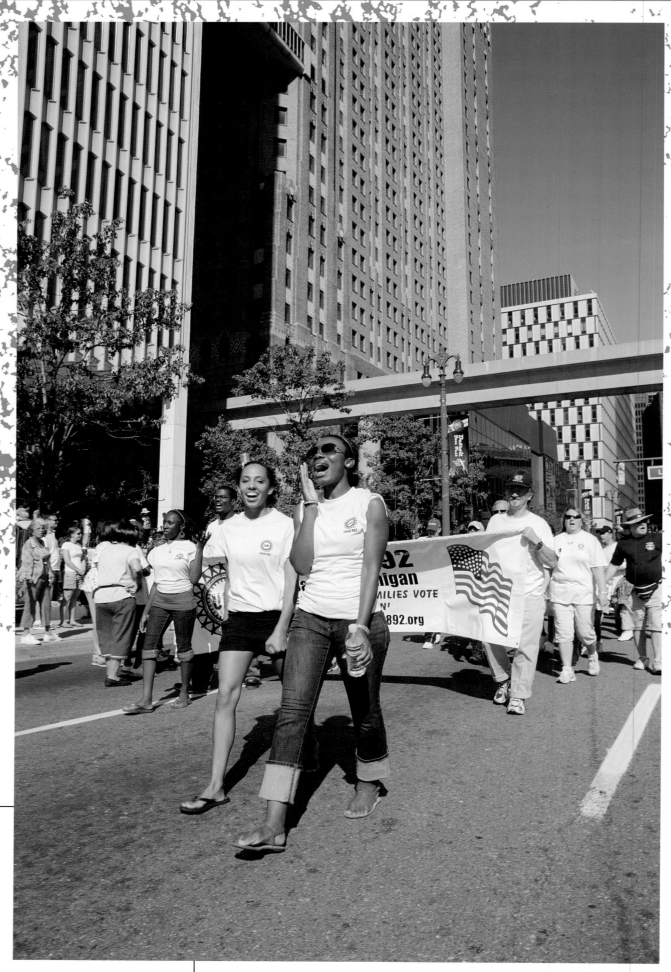

Members of UAW Local 289
march in the Detroit Labor
Day Parade.

1

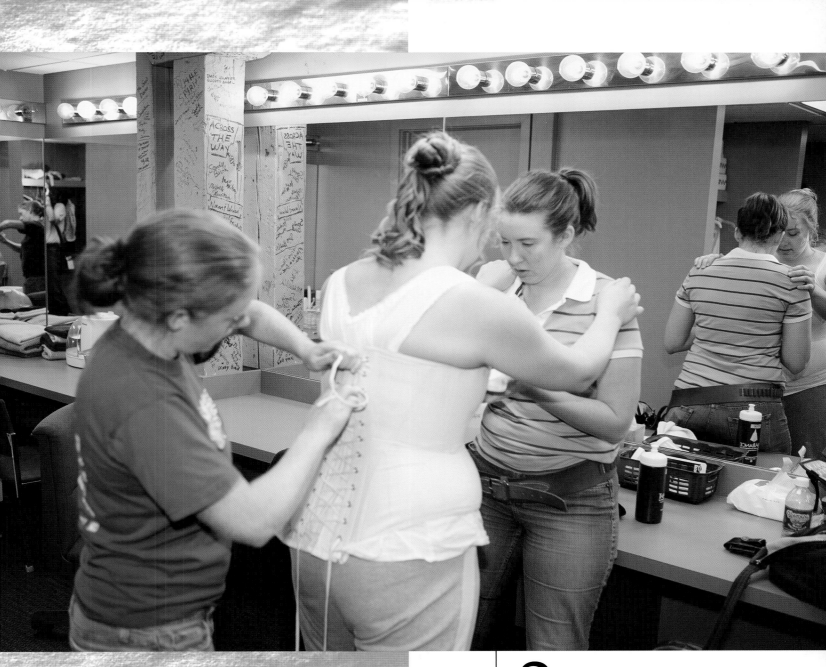

2

Michelle and Christianne help actress Jessica Garrett dress for her role in *Panhandle Slim & The Oklahoma Kid* at the Purple Rose Theatre.

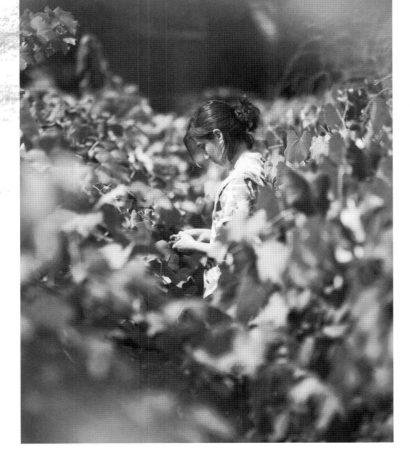

At the Earthworks Urban Farm, volunteer Kathryn picks grapes to make preserves.

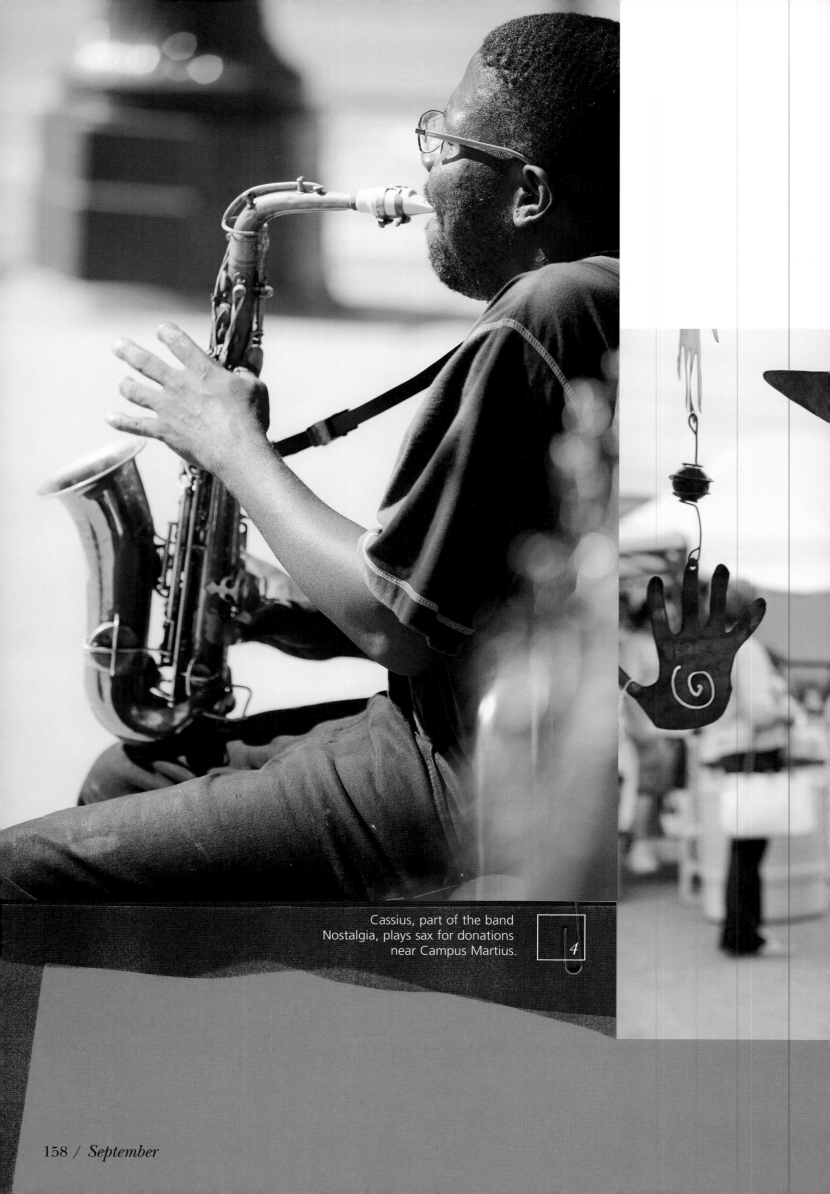

Cassius, part of the band
Nostalgia, plays sax for donations
near Campus Martius.

4

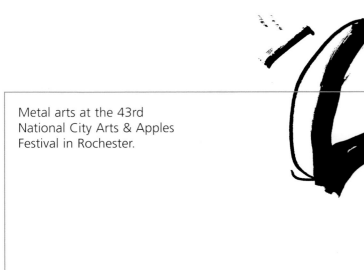

Metal arts at the 43rd
National City Arts & Apples
Festival in Rochester.

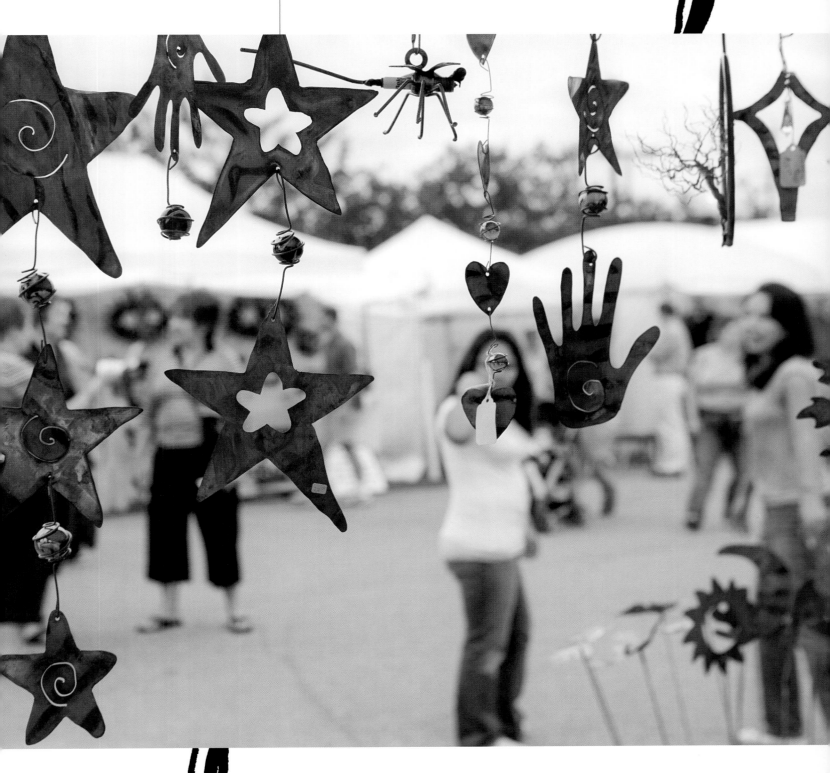

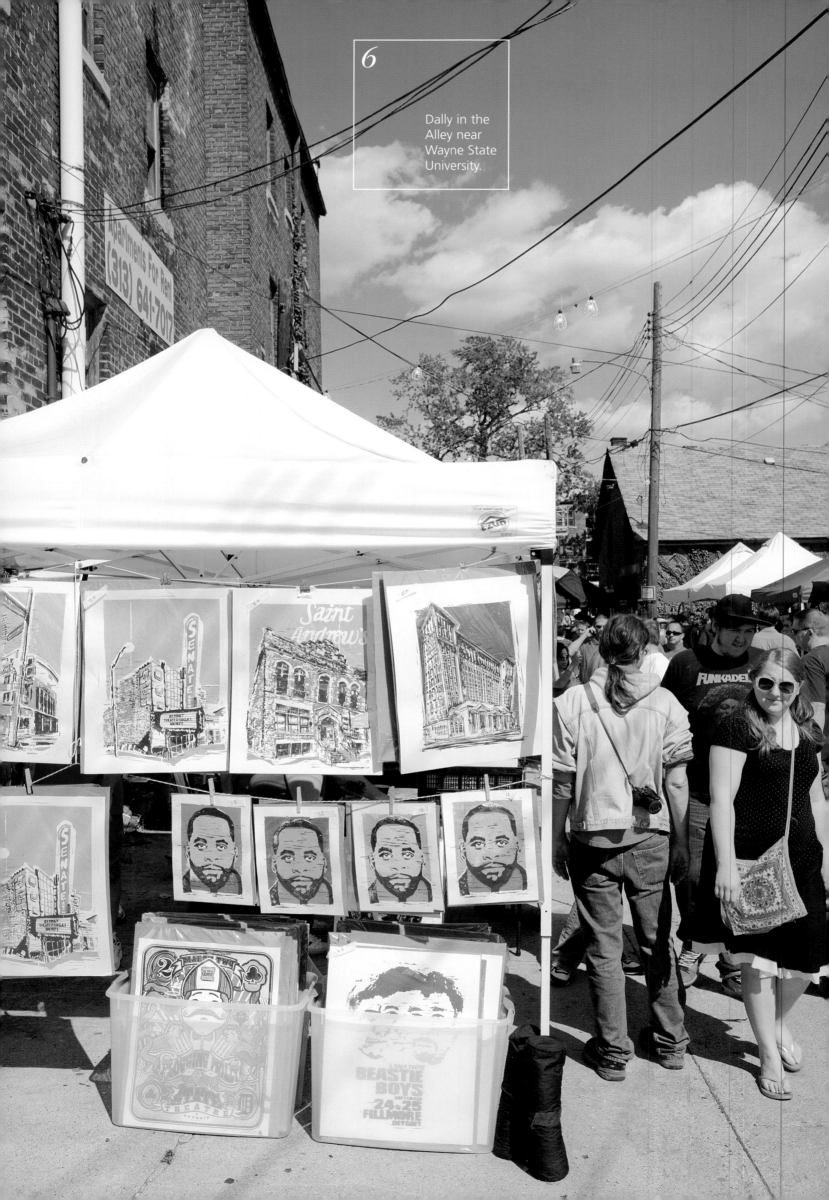

Dally in the
Alley near
Wayne State
University.

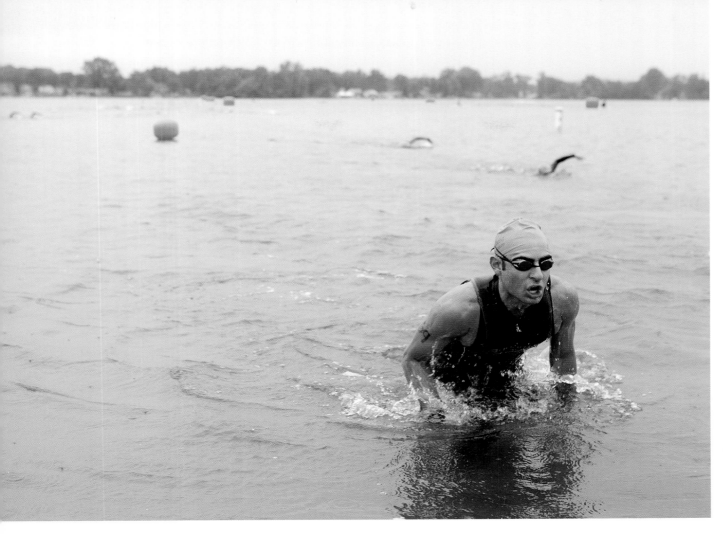

7 Chad Mahakian completes the swim portion of the Michigan Triathlon and Duathlon Championship at Pontiac Lake.

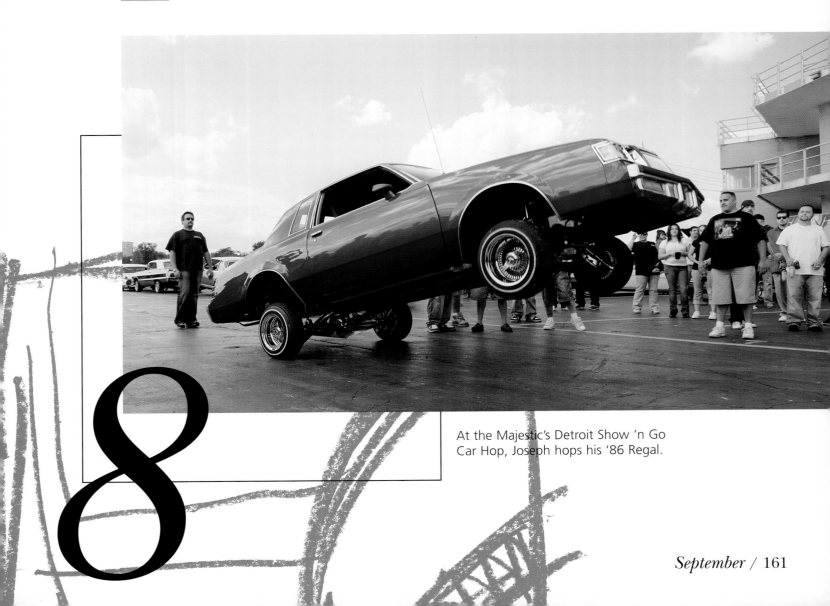

8

At the Majestic's Detroit Show 'n Go Car Hop, Joseph hops his '86 Regal.

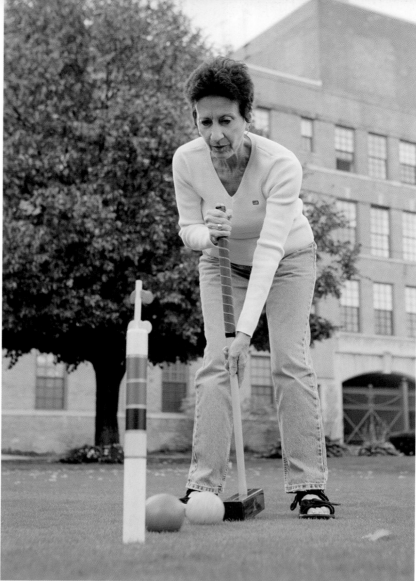

Pat from Grosse Pointe finishes a game of croquet with the Detroit Croquet Club at the Omni Detroit Hotel.

George from B&B Signs tunes the guitar in front of the Hard Rock Café in Detroit.

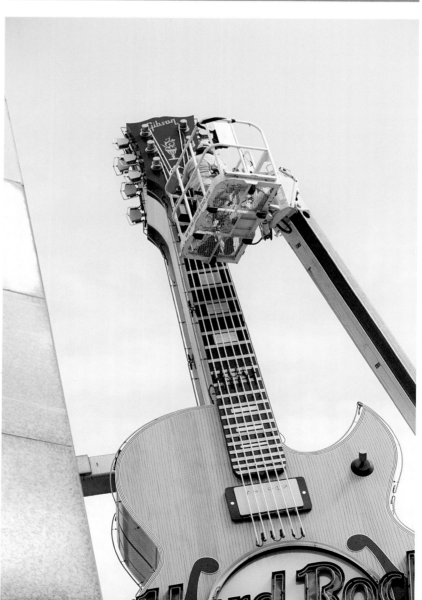

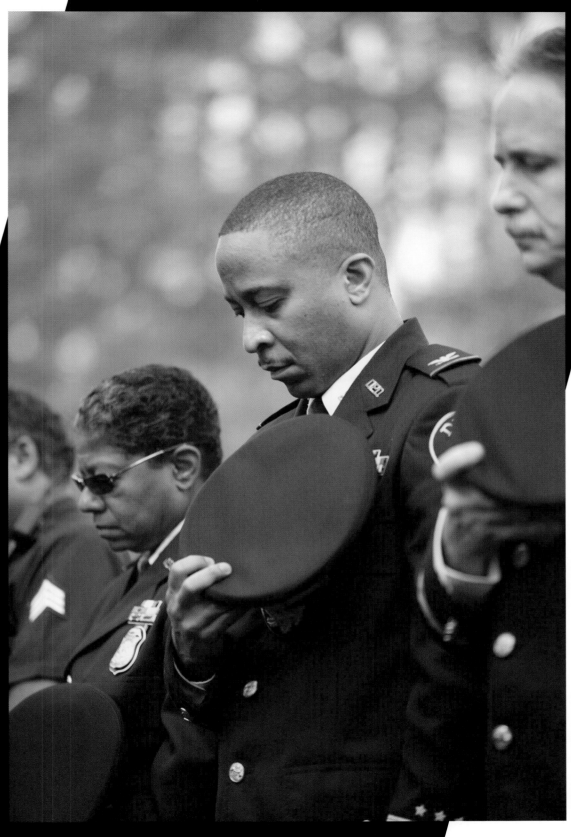

At Campus Martius Park, officers from the Detroit Police and Fire departments honor those lost on 9/11.

12

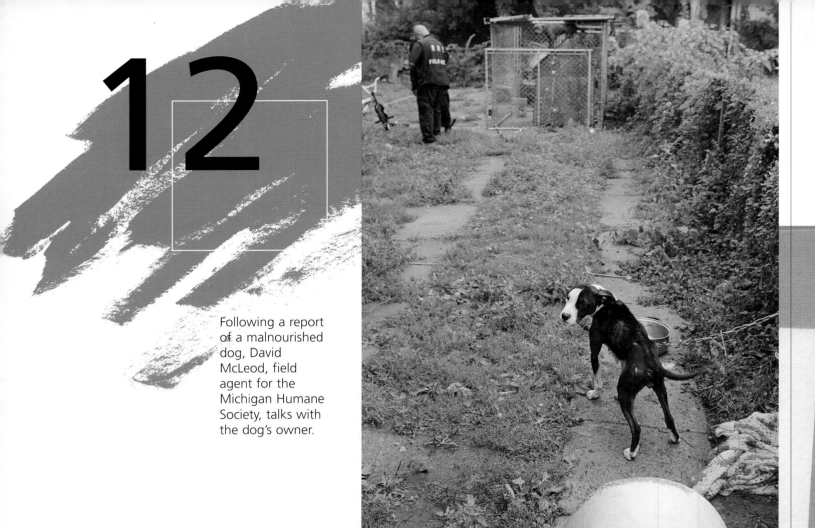

Following a report of a malnourished dog, David McLeod, field agent for the Michigan Humane Society, talks with the dog's owner.

13

Marie and Brenda enjoy an afternoon at Campus Martius.

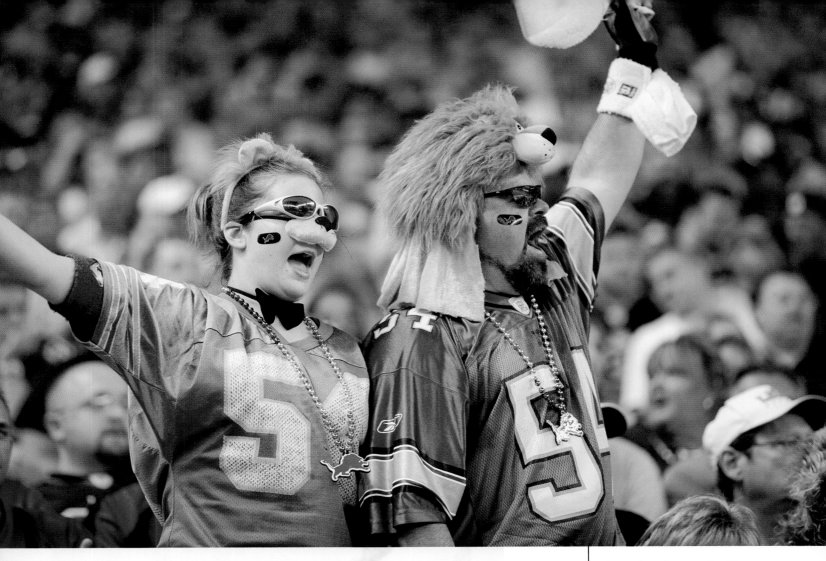

Fans cheering on the Lions during their game against the Green Bay Packers.

1415

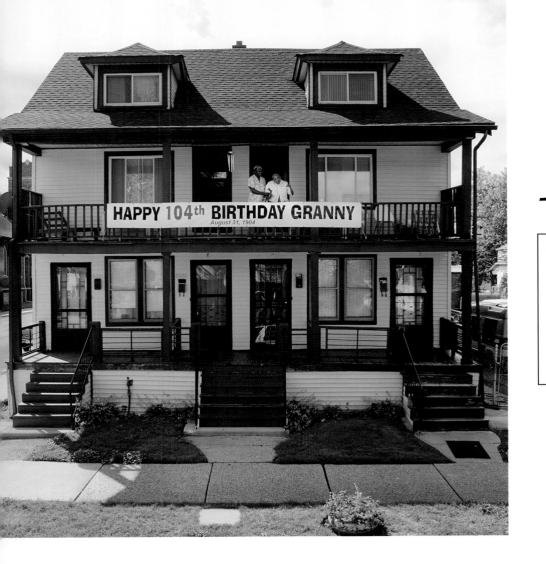

HAPPY 104th BIRTHDAY GRANNY
August 31, 1904

One of the oldest people in Detroit, 104-year-old Virginia Spencer with her caregiver, Betty.

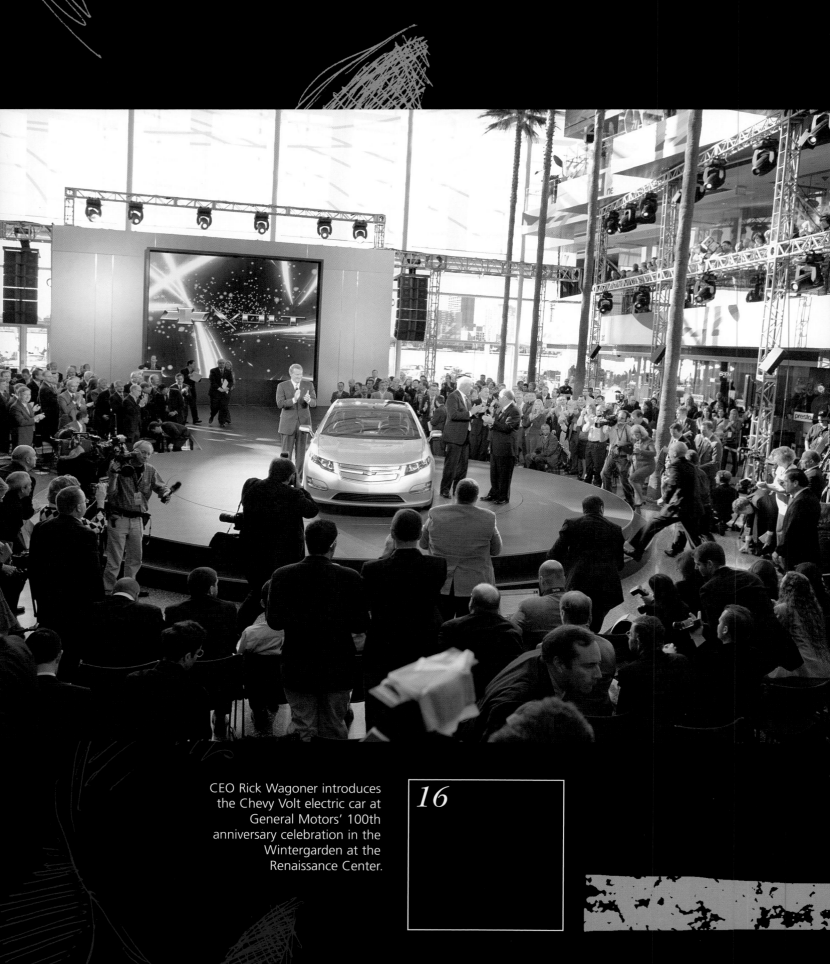

CEO Rick Wagoner introduces the Chevy Volt electric car at General Motors' 100th anniversary celebration in the Wintergarden at the Renaissance Center.

16

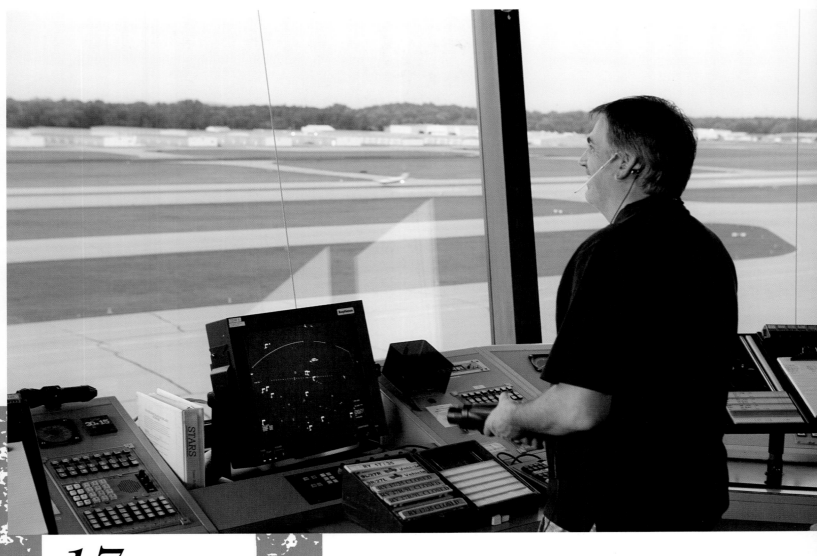

17

Air-traffic control specialist Bob Hissom directs aircraft at the Oakland County International Airport in Pontiac.

18

Joe and Nancy and their Model T at the Centennial Drive-In at Ford World Headquarters.

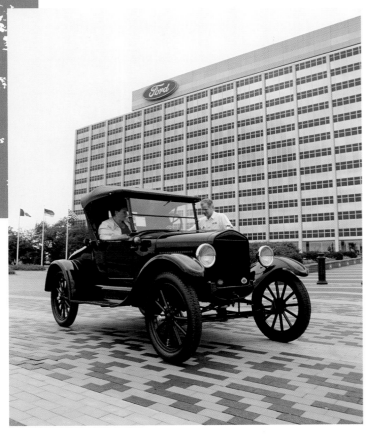

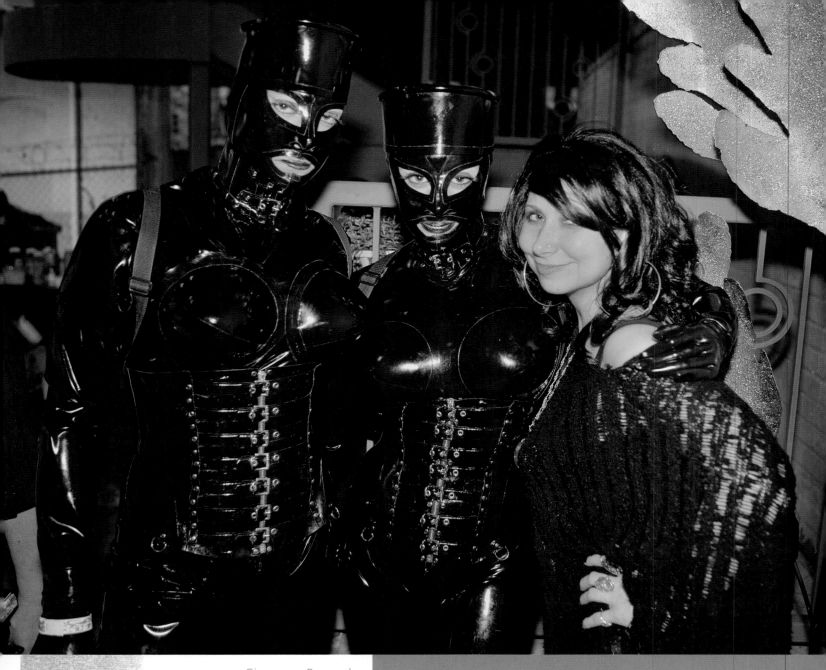

Giovanna, Raquael,
and Miss Shela
celebrate at Noir
Leather's Silver
Anniversary Bash at
the Crofoot Ballroom
in Pontiac.

19

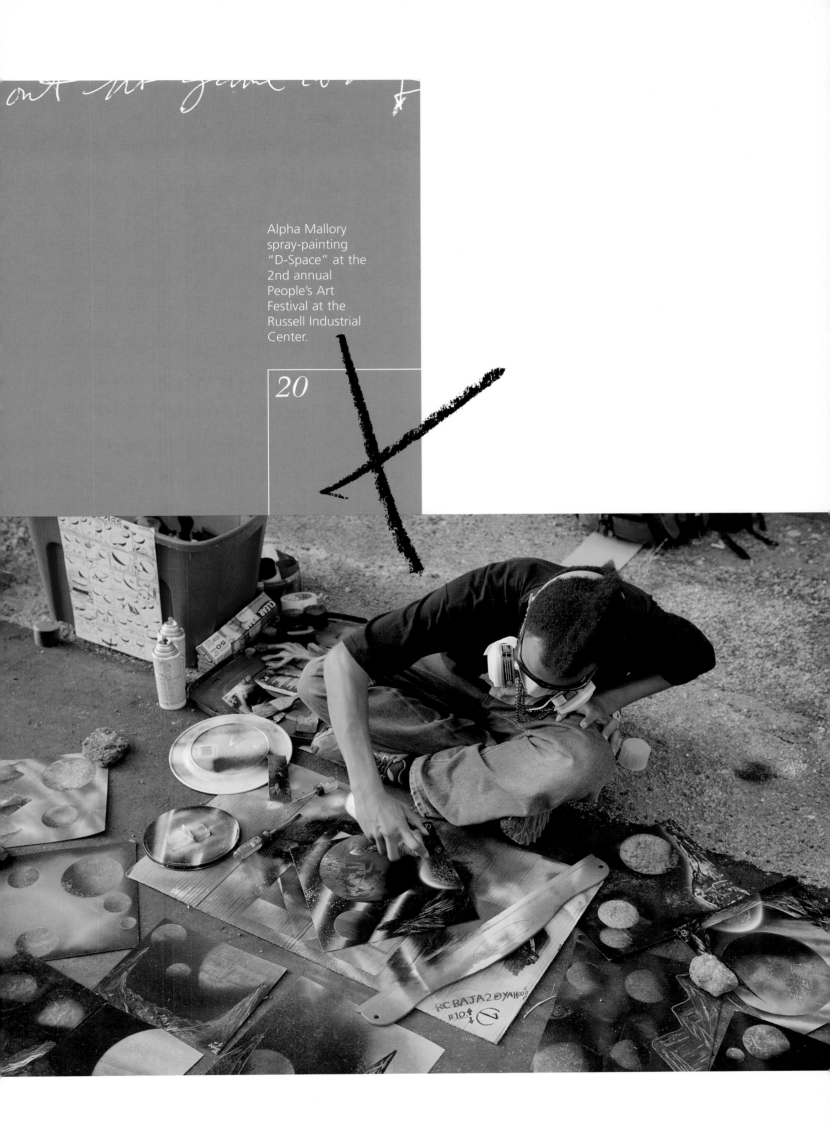

Alpha Mallory spray-painting "D-Space" at the 2nd annual People's Art Festival at the Russell Industrial Center.

20

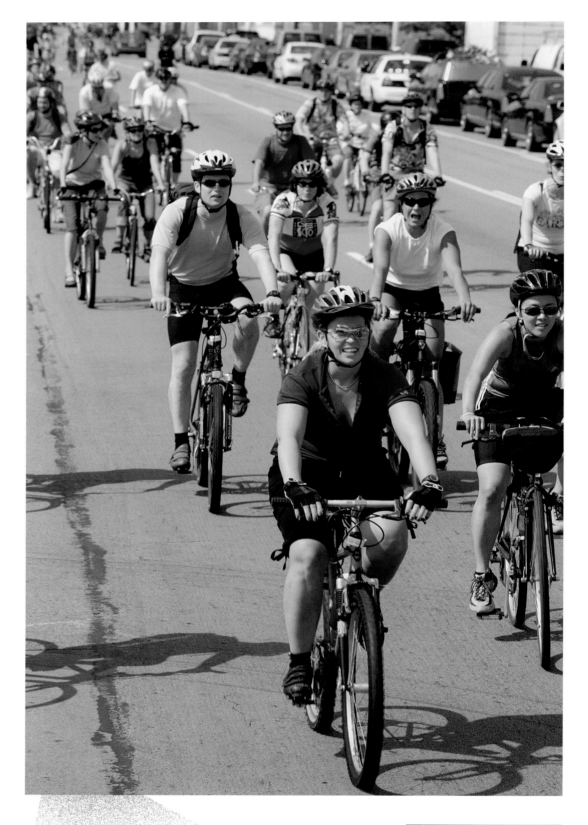

Cyclists in the
7th annual
Tour de Troit.

21

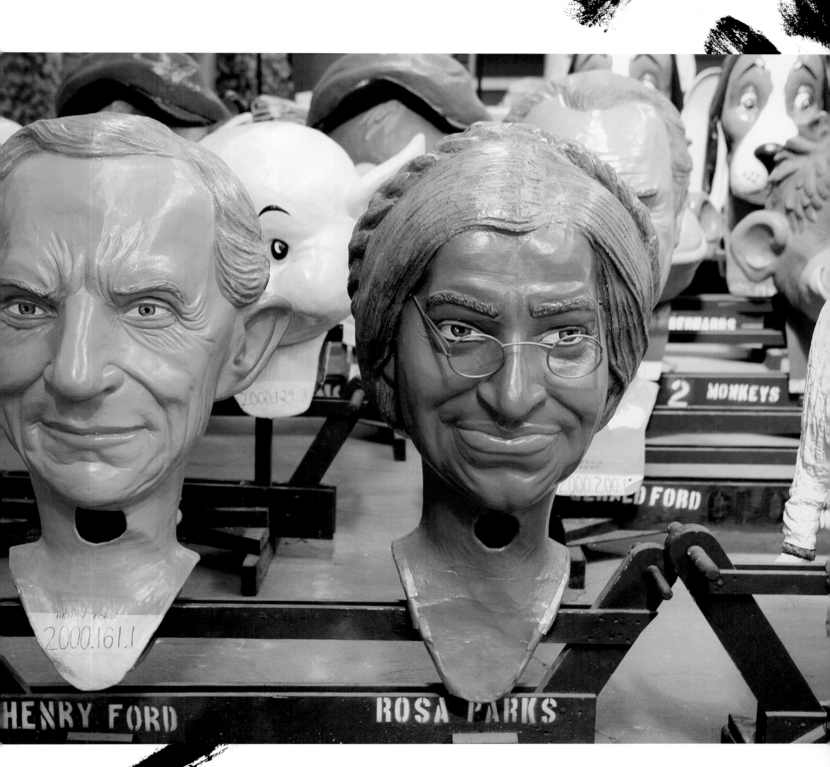

Henry Ford and Rosa Parks, part
of the Big Head Corps, wait for
the Thanksgiving Day Parade at
the Parade Company.

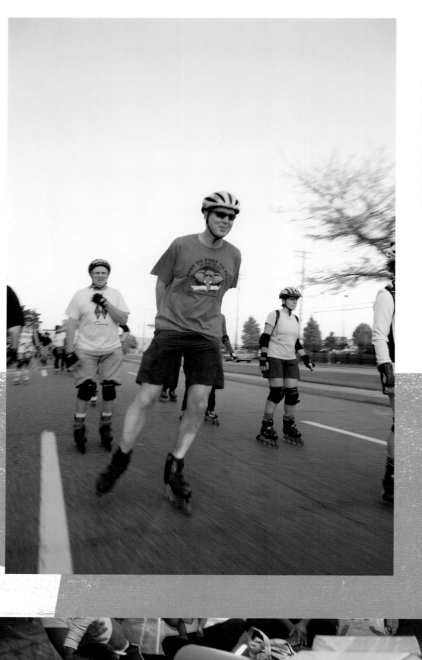

23

For the Big Old-Fashioned Skate, Mark and friends skate through the streets of Detroit.

24

Students at the Catherine Ferguson Academy, a Detroit public high school for girls who have children or are pregnant.

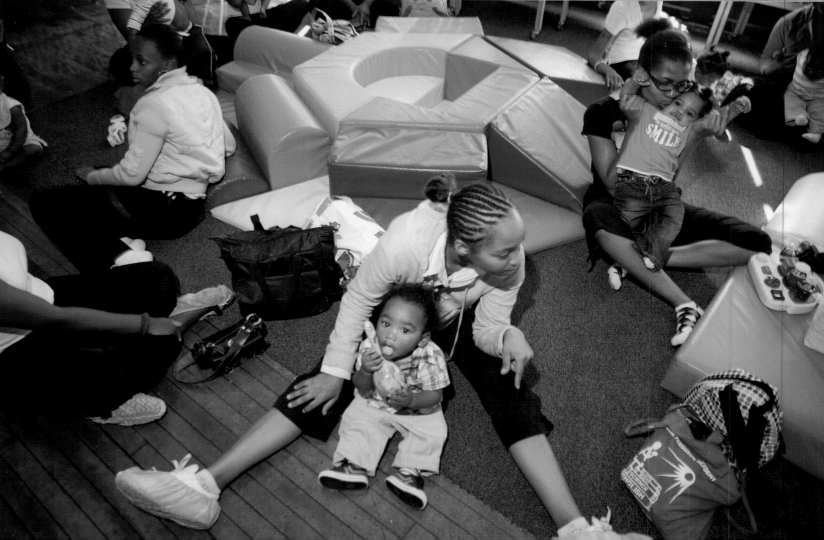

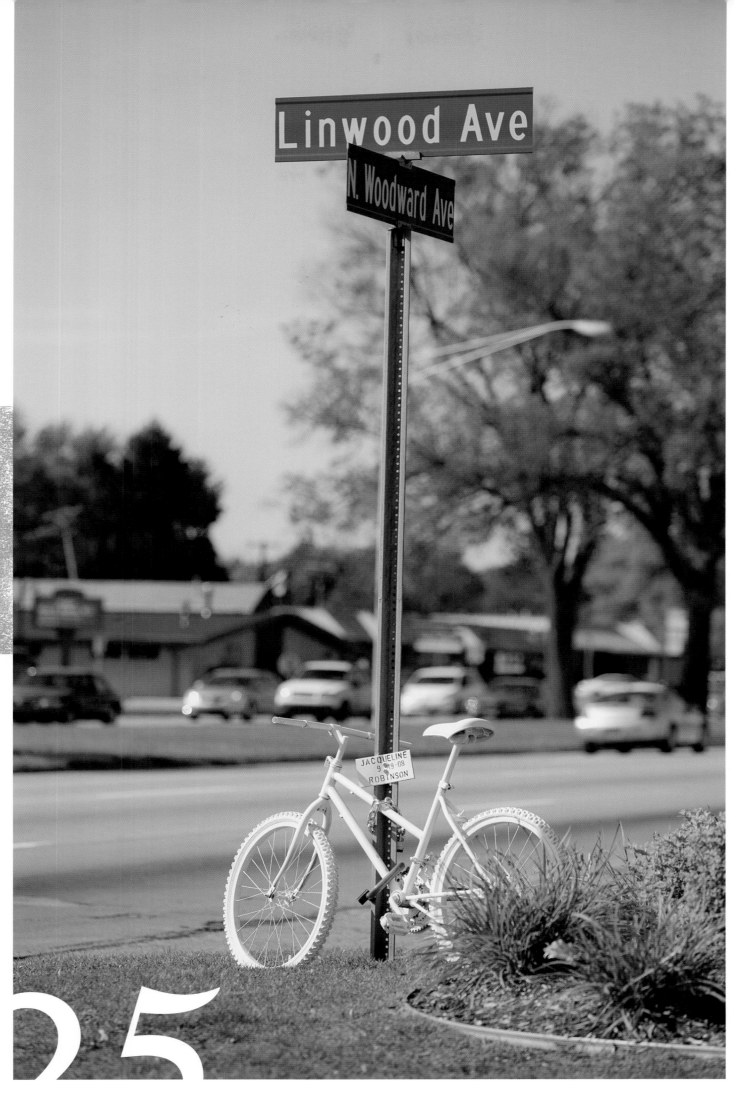

A "ghost bike" in memory of Jacqueline Robinson, who was hit and killed by a driver in Royal Oak.

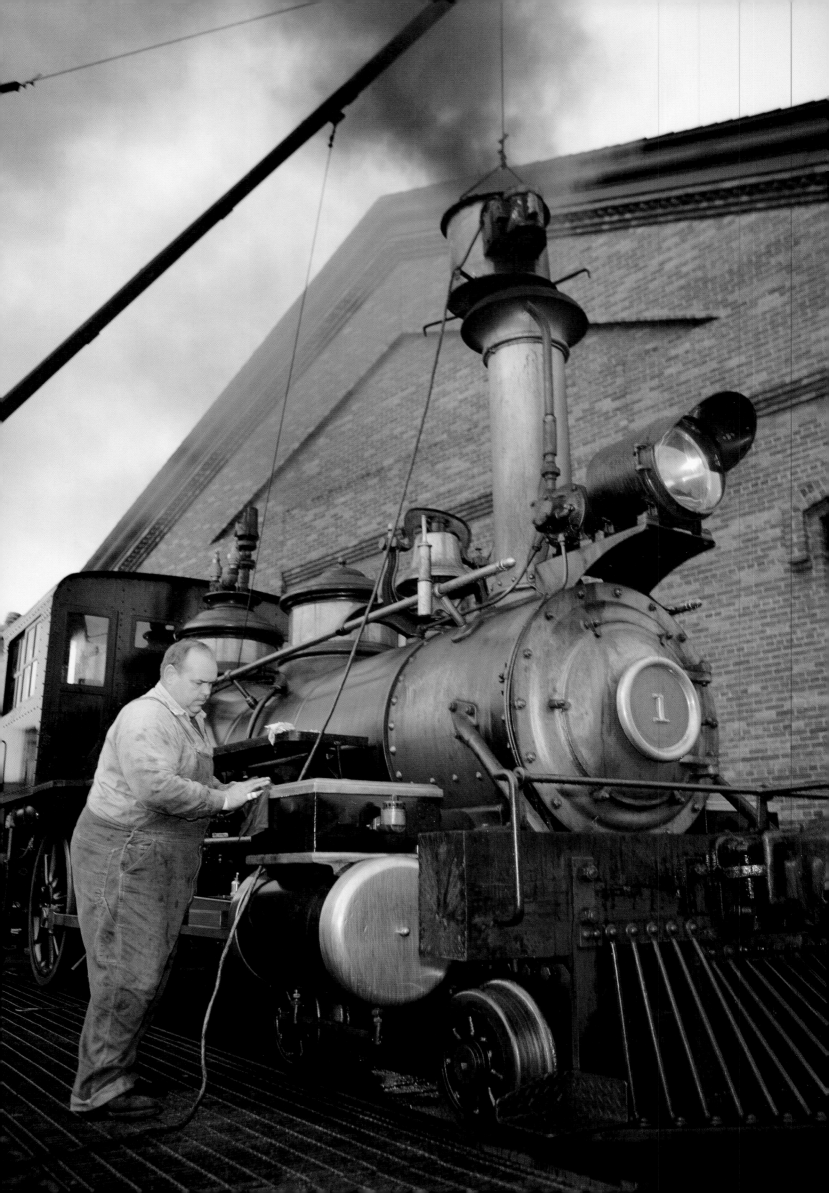

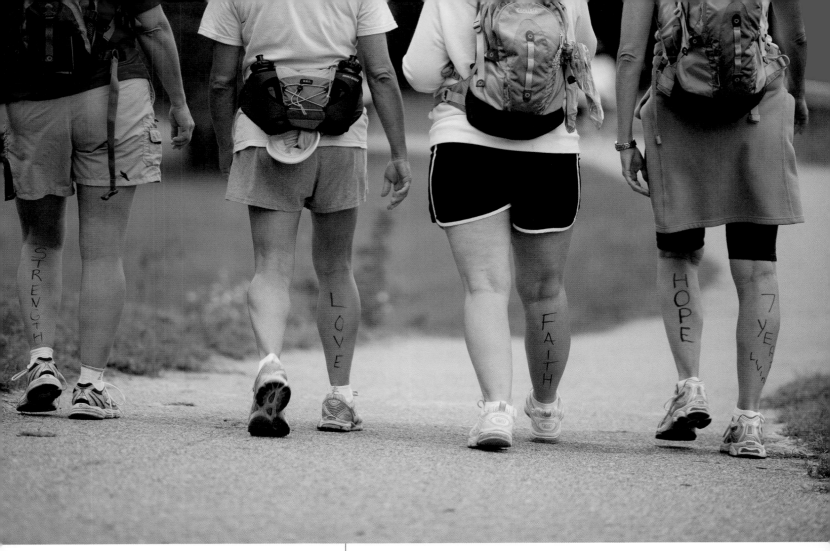

Rae Ann, a
seven-year cancer
survivor, walks
with friends
Michele, Jeannie,
and Jodie at the
Michigan Breast
Cancer 3-Day.

27

26

Engineer Gerry
Krukow prepares one
of the oldest steam
engines still in use at
The Henry Ford.

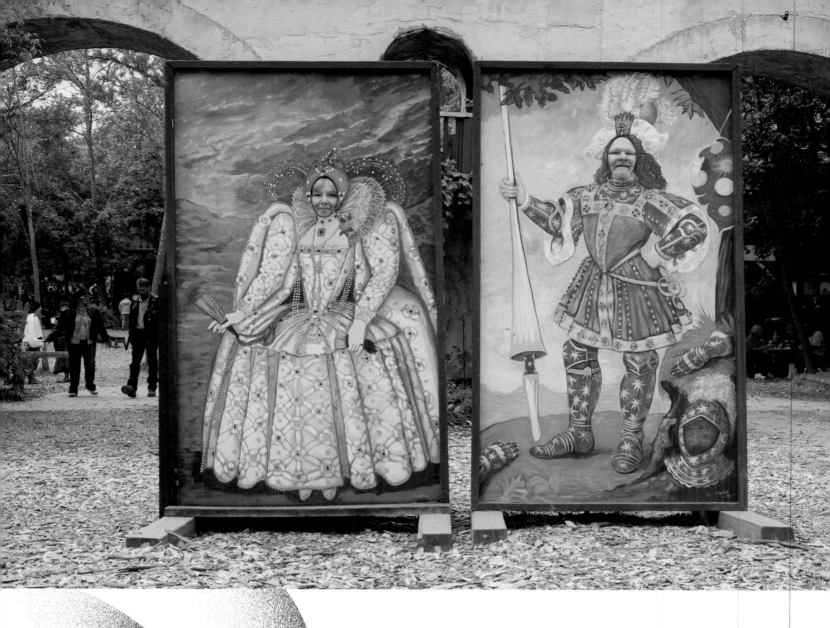

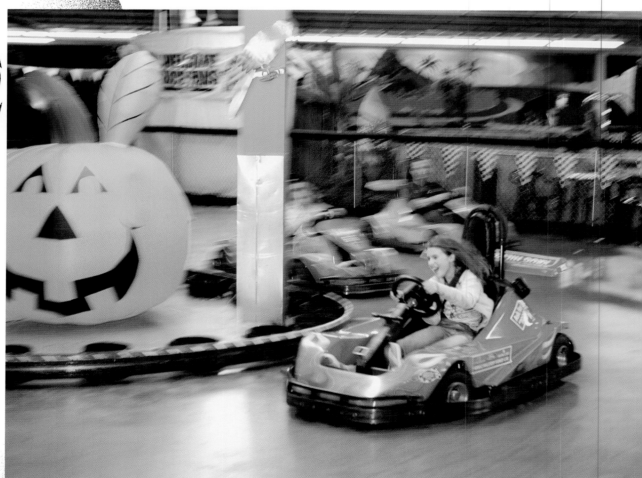

29

Enjoying a spin around the track in a go-cart at the Great Escape in Howell.

28

Karen and Tommy from Shelby Township as king and queen at the Michigan Renaissance Festival.

Preparing for their dance performance at the Hmong Cultural Festival at Jennie Mae Fleming Academy in Detroit are Allysen, Betty, Malia, and Rassami.

30

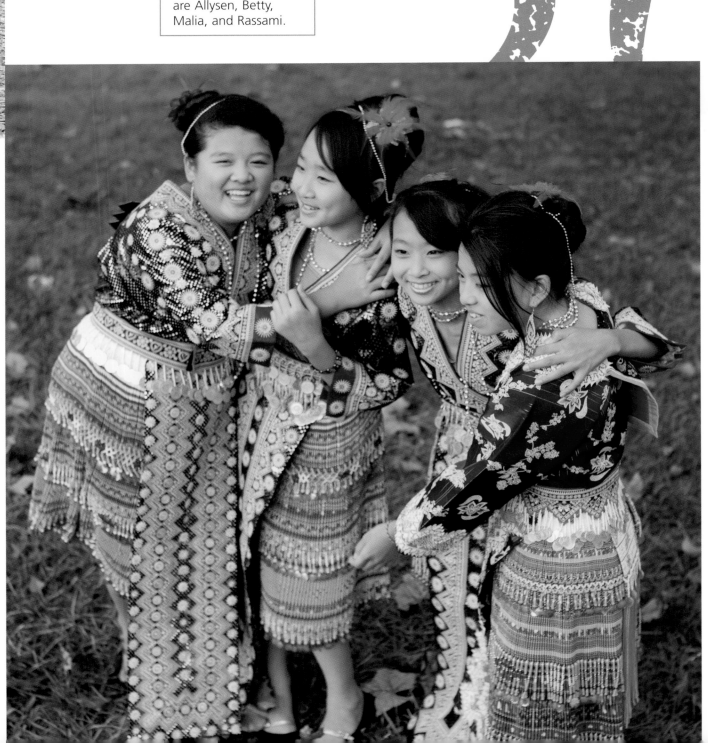

CTO
BER

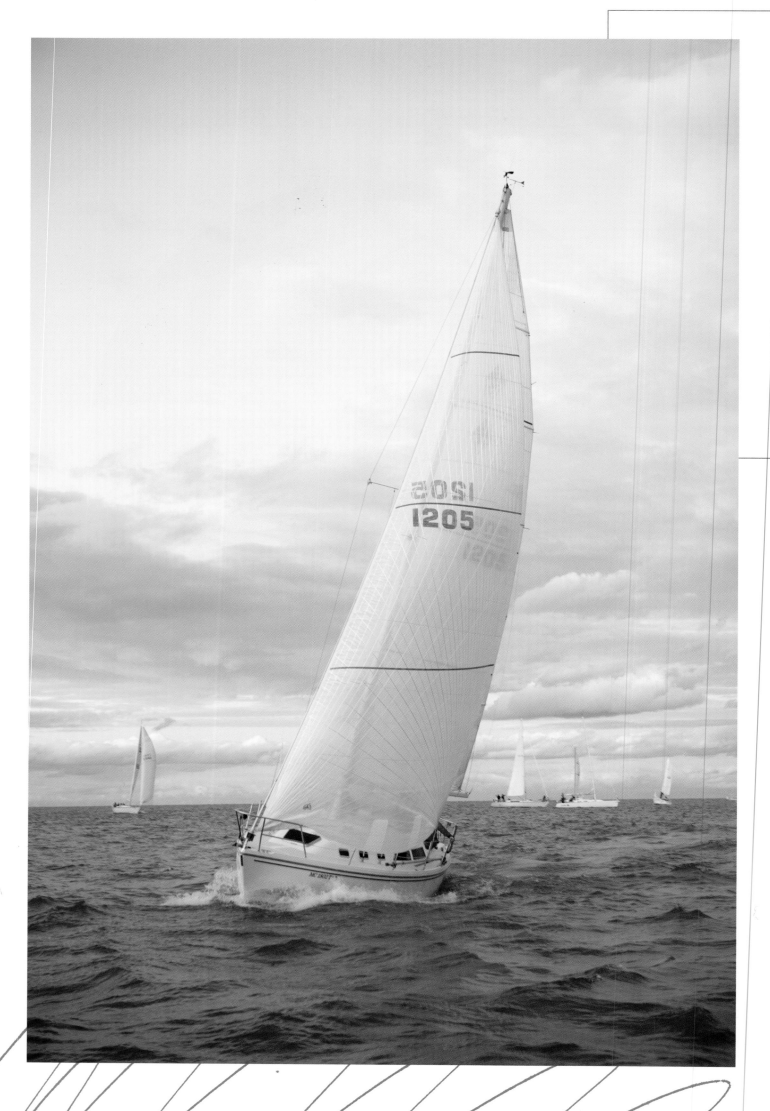

1

Sailing on Lake St. Clair during
the Canadian Club Race.

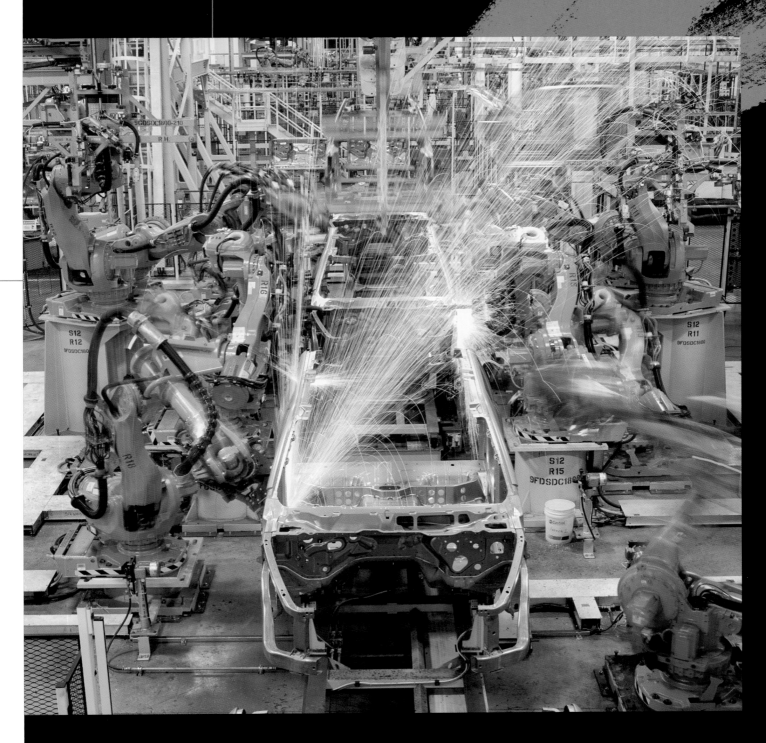

2

Robots on the assembly line in
the body shop at the Warren
Truck Assembly Plant.

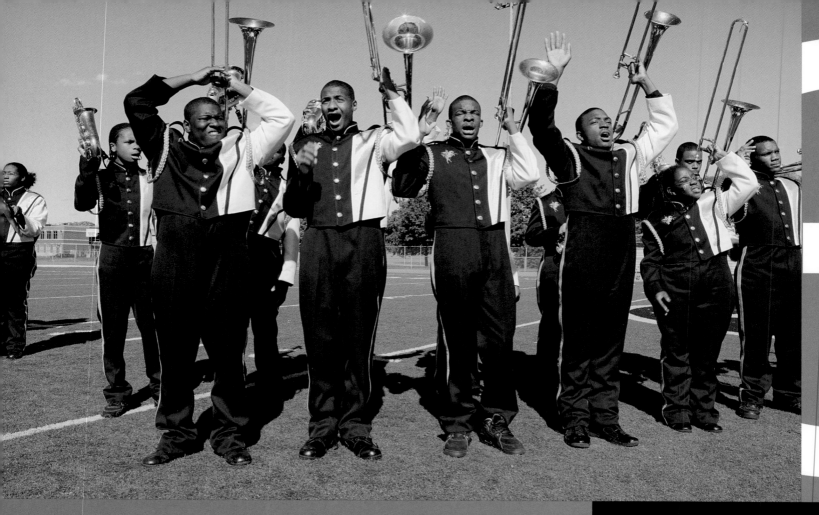

The Martin Luther King Jr. High School marching band performing at the homecoming football game.

4

Allen Toussaint at the Motor City Blues & Boogie Woogie Festival at Music Hall Center for the Performing Arts.

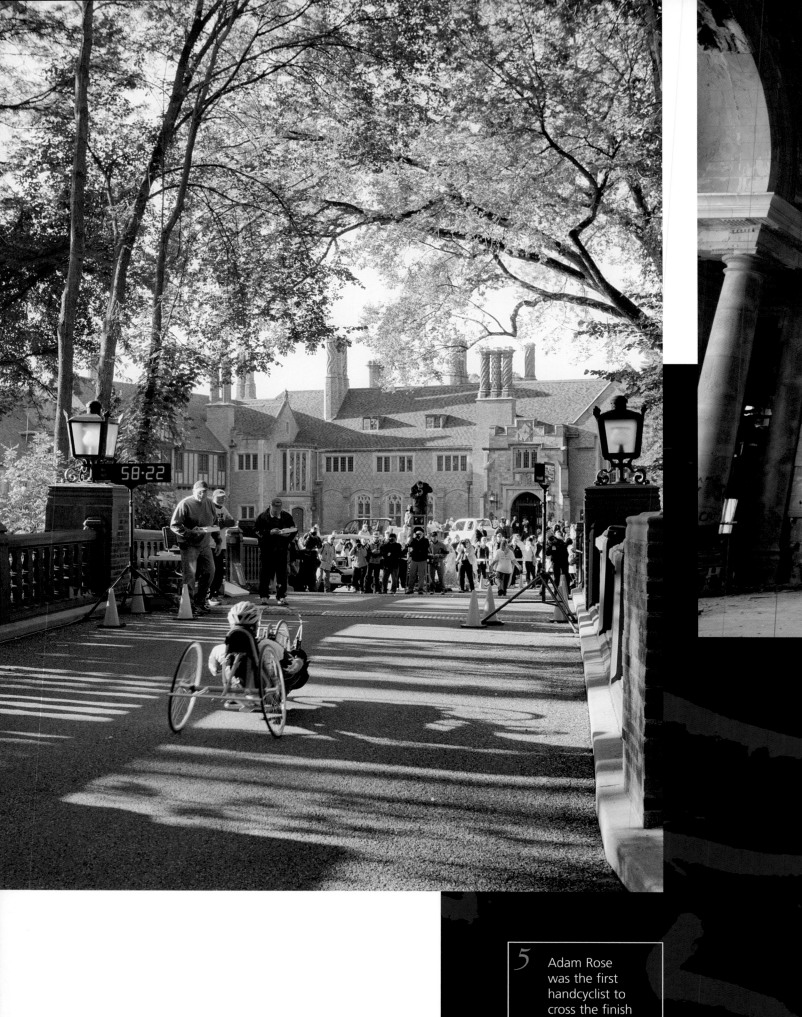

5 Adam Rose
was the first
handcyclist to
cross the finish
line in the
inaugural
Brooksie Way
Half Marathon.

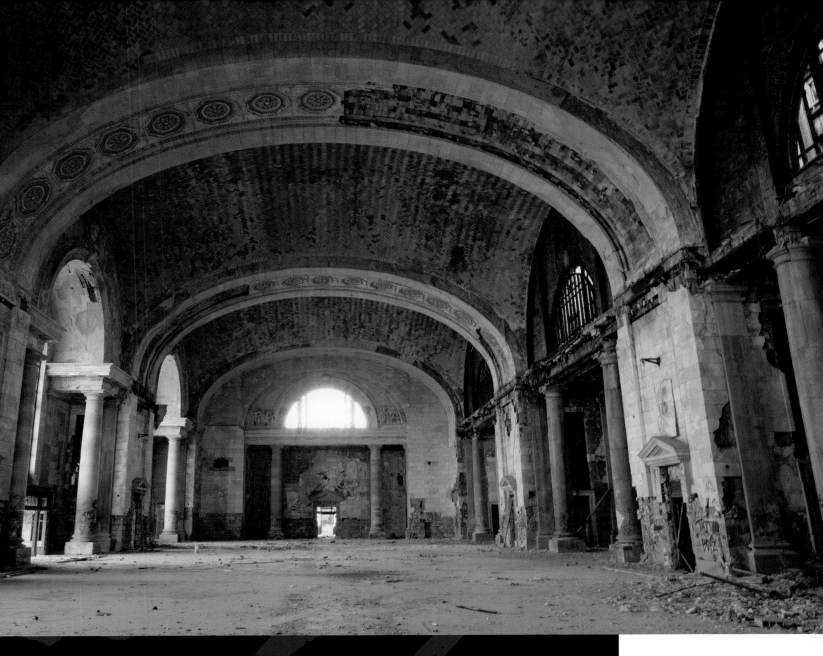

6 Inside the Michigan Central
Depot in Corktown.

7 A landfill in
Auburn Hills.

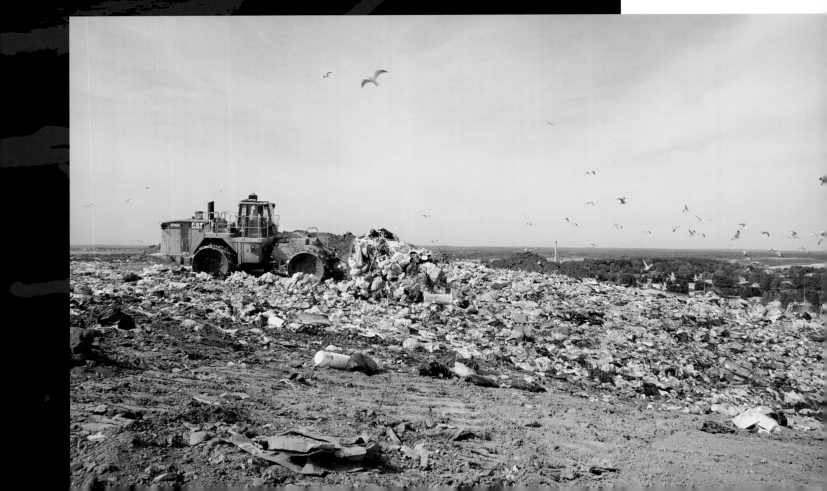

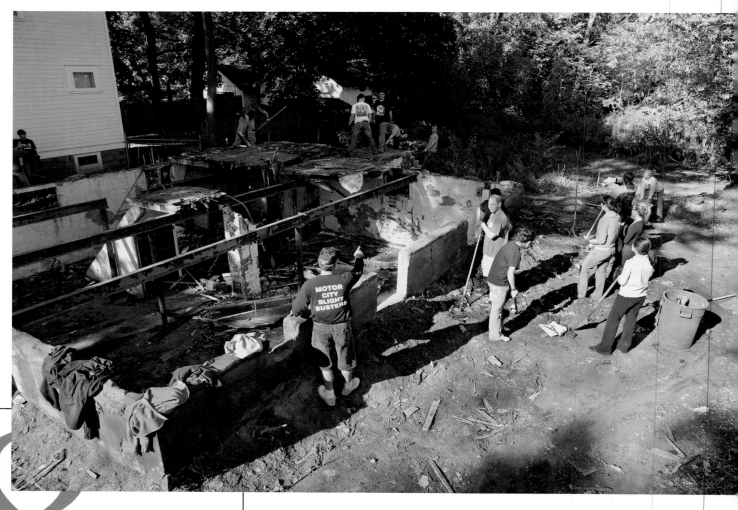

Motor City Blight Busters demolishing a vacant home.

8

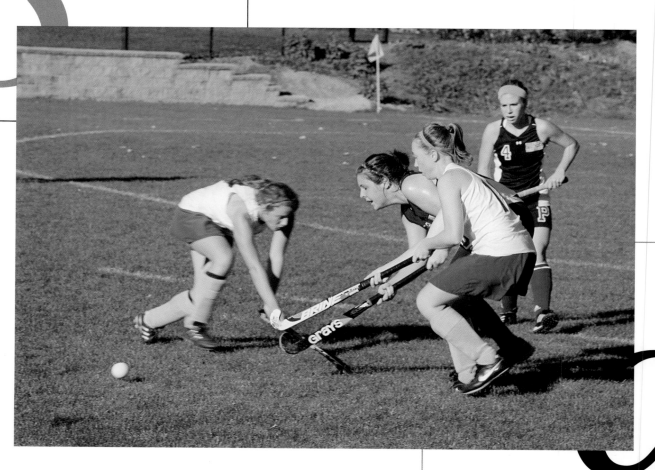

Crosstown rivals Marion High
School and Ann Arbor Pioneer
compete in field hockey.

9

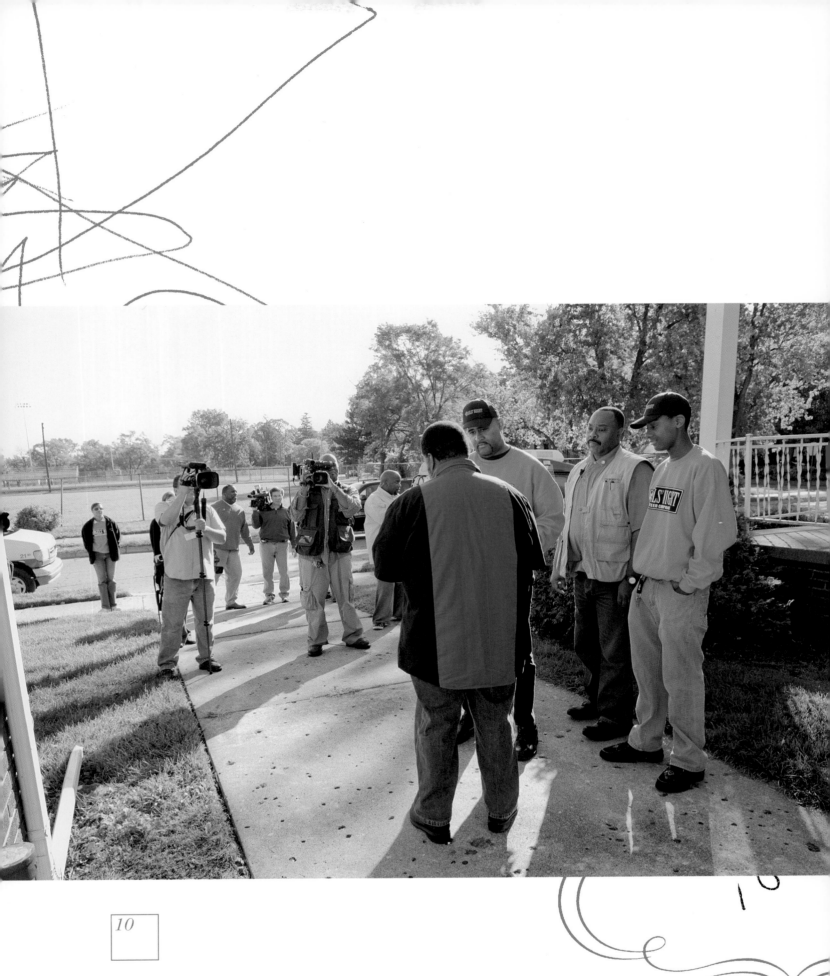

10

Mayor Ken Cockrel Jr.
knocks on doors to
recruit volunteers for
Angels Night.

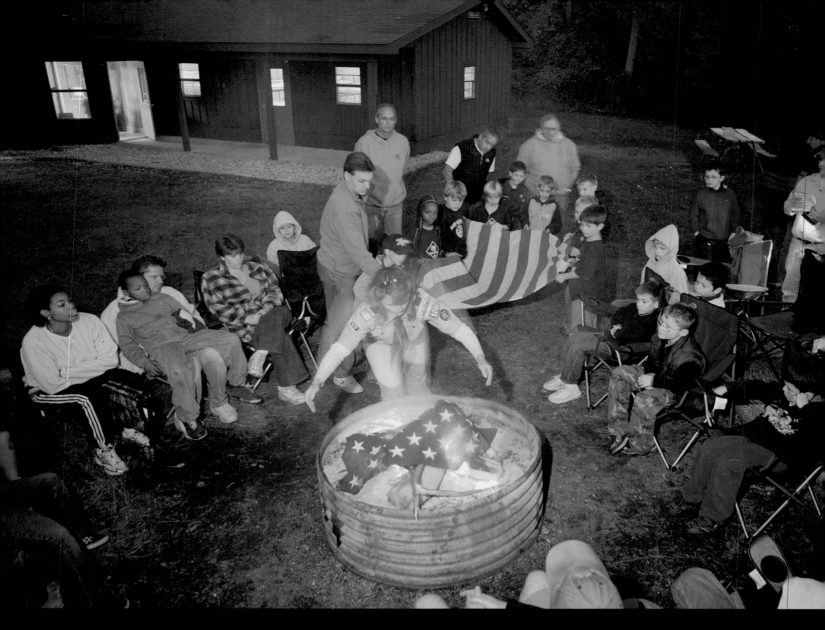

11

Members and parents of Cub Scout Pack 1049 ceremoniously retire an American flag at D-Bar-A Scout Ranch.

The cast of *Brundibar* rehearses at the Motor City Youth Theatre.

13

Rachel and Tracey from Rebels
Hair Studio in Roseville backstage
at the Hair Ball at the Royal Oak
Music Theater.

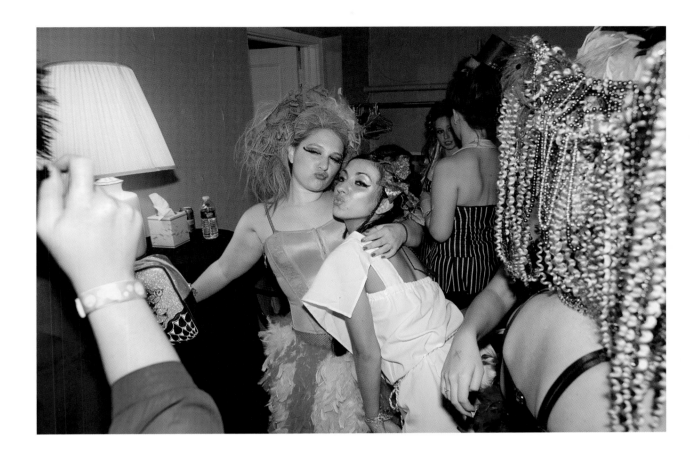

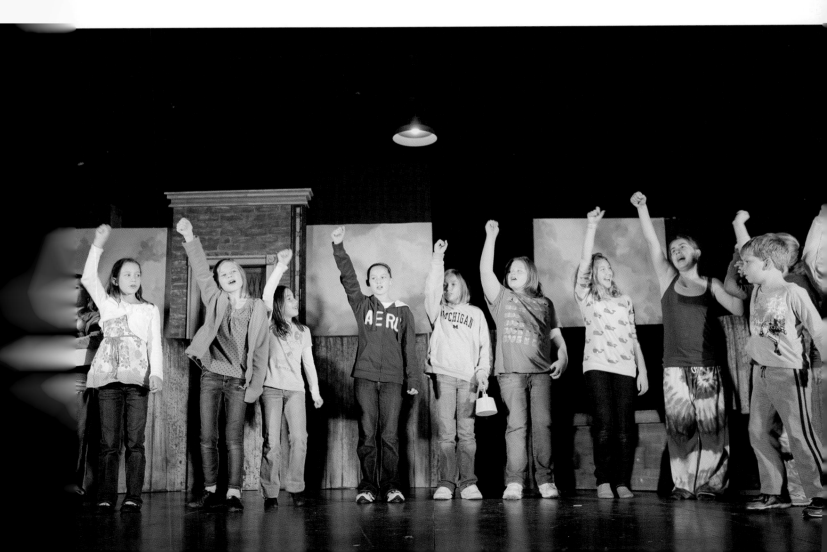

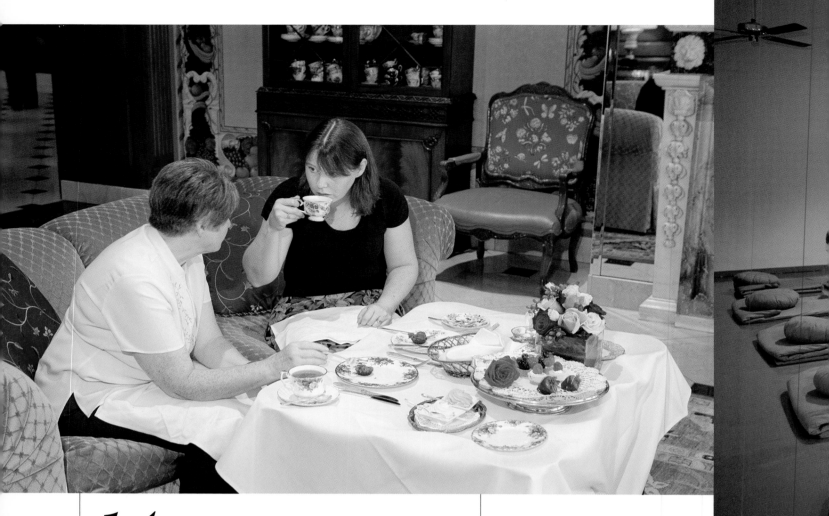

14

Jacqueline and
Margaret, both from
Scotland, enjoy high
tea at the Townsend
Hotel in Birmingham.

15

Faygo being
bottled at
the plant
on Gratiot.

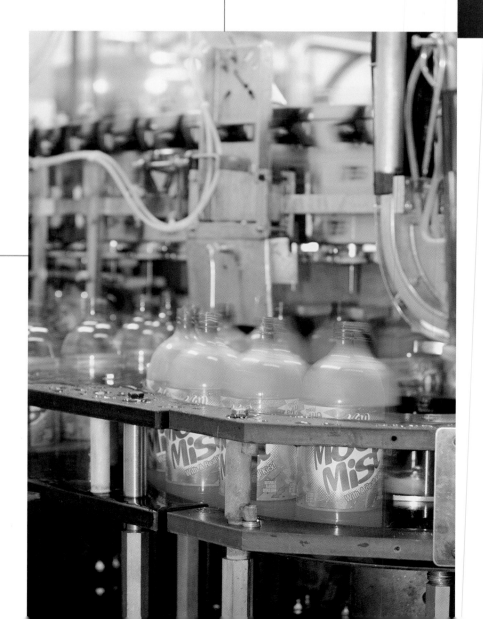

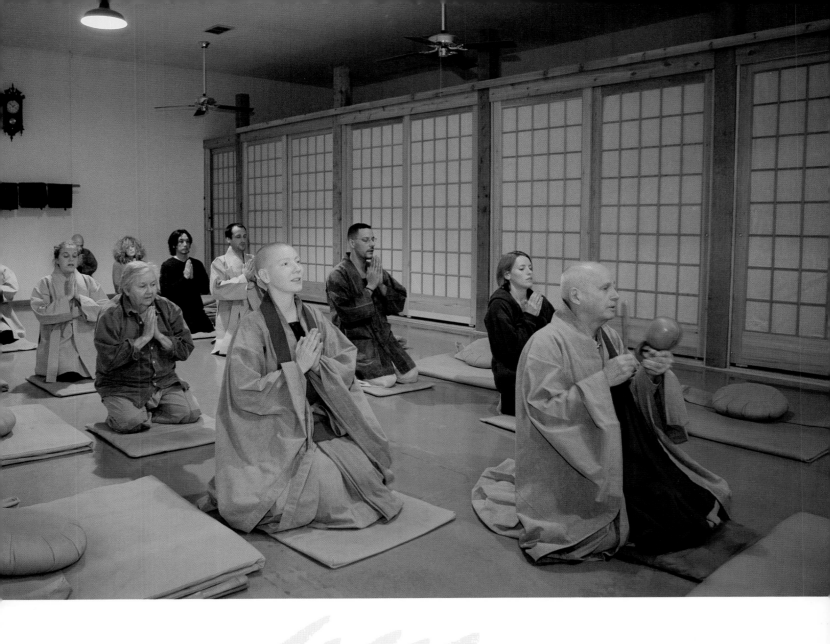

Hwalson Sunim, the abbot for the Detroit Zen Center, leads a meditation session.

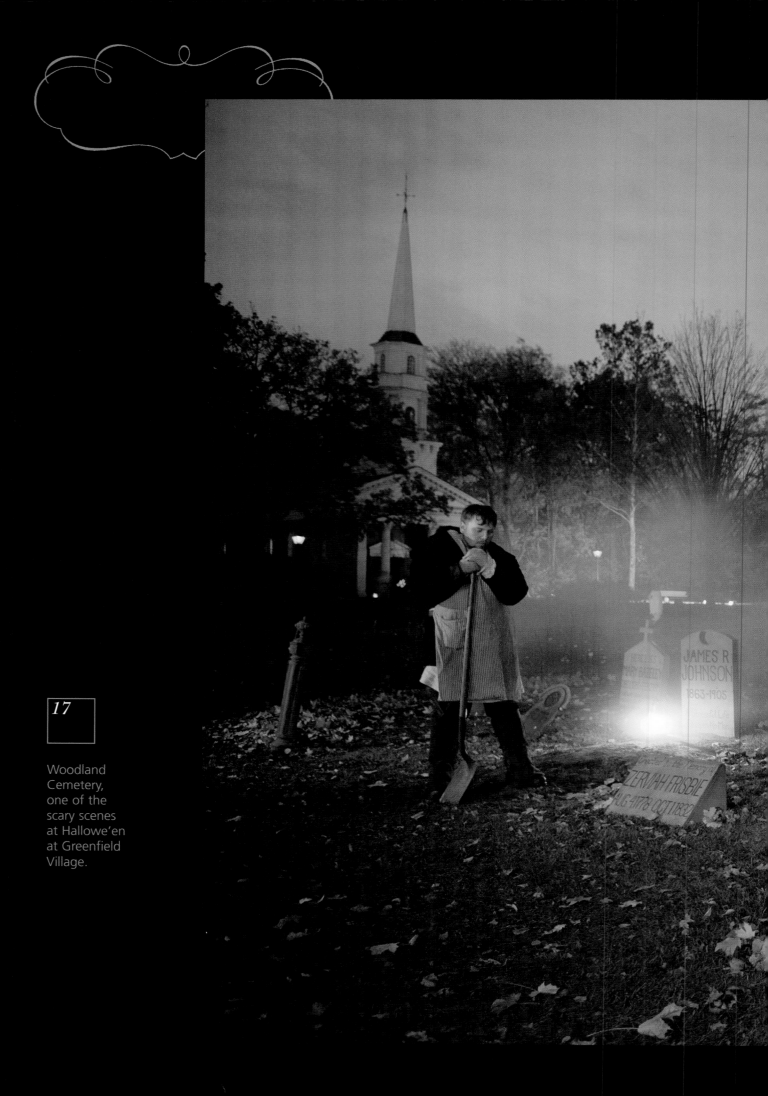

17

Woodland Cemetery, one of the scary scenes at Hallowe'en at Greenfield Village.

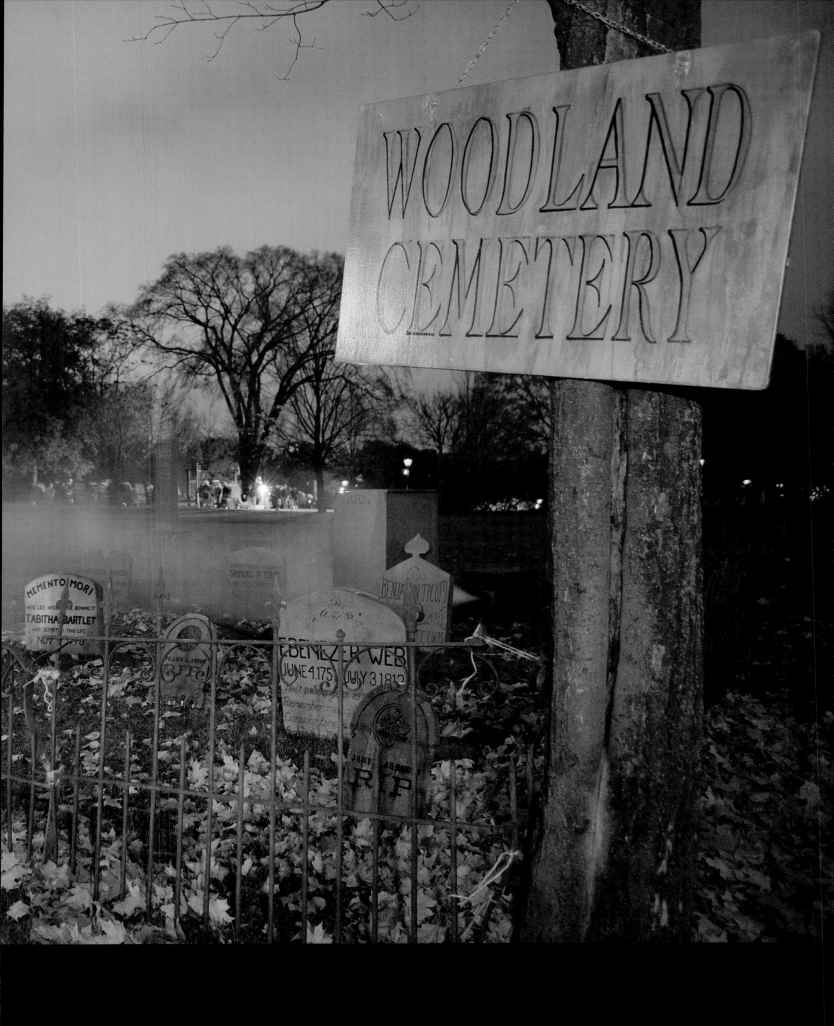

18

Michigan Sires Showcase at Pinnacle Race Course in New Boston.

Runners from the
Detroit Free Press
International
Marathon on the
RiverWalk.

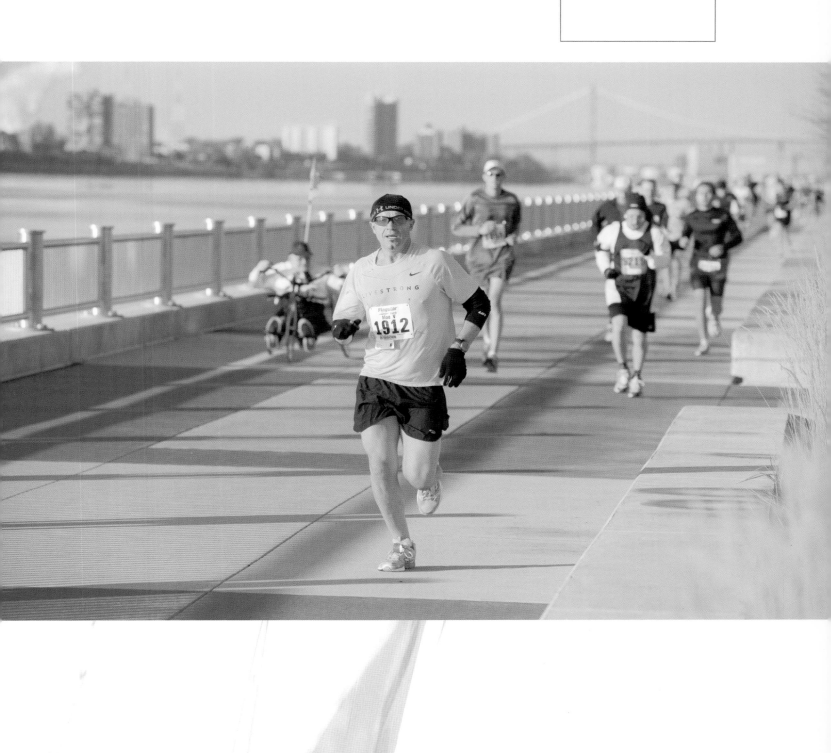

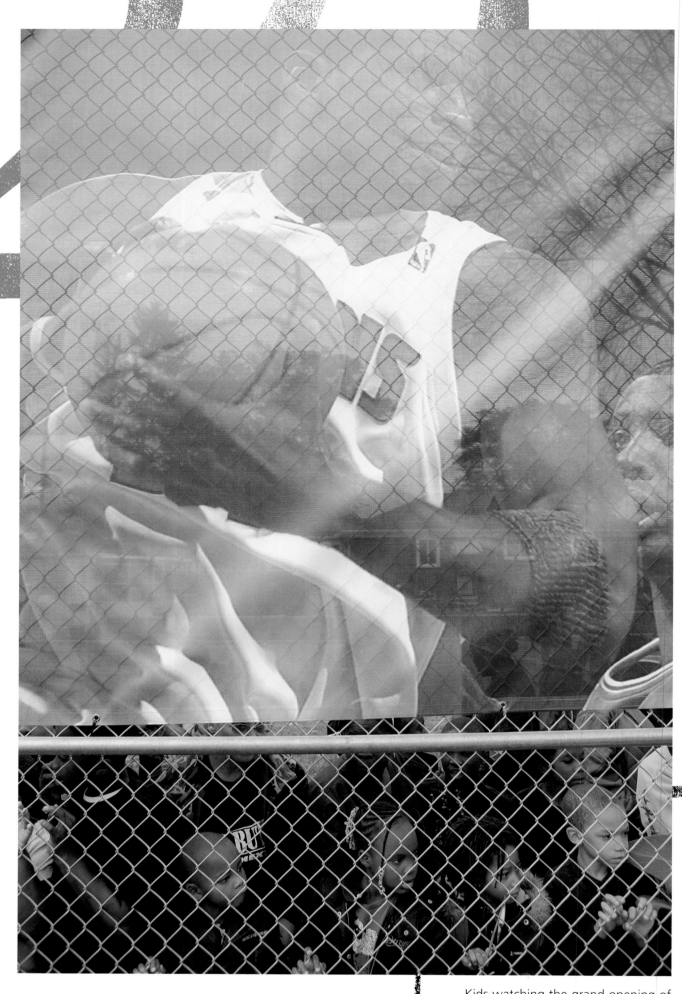

Kids watching the grand opening of Willie Johnson's Hoop-De-Do Court in Detroit.

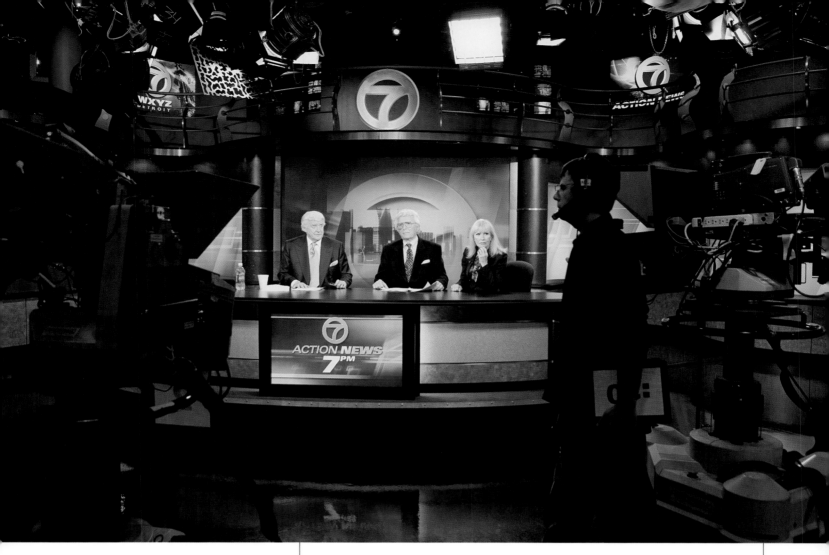

Bill Bonds, John Kelly, and Marilyn Turner help WXYZ celebrate their 60th anniversary in broadcasting.

21/22

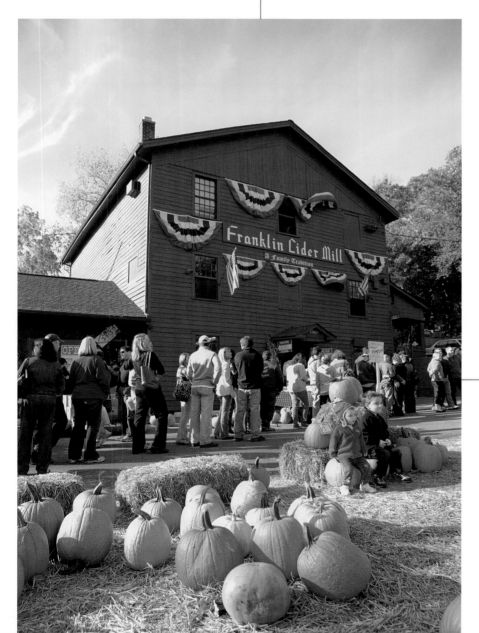

Ava and Brendan from Farmington Hills pose on pumpkins at the Franklin Cider Mill.

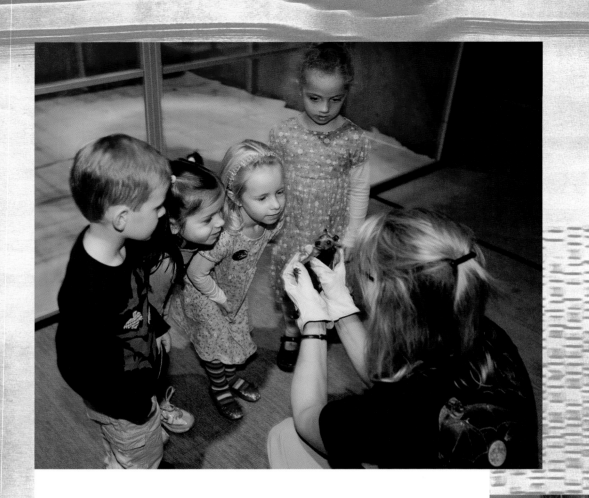

23

Sue Lochbiler of the Organization for Bat Conservation holds a straw-colored fruit bat from the exhibit Bats: Myths and Mysteries at the Cranbrook Institute of Science.

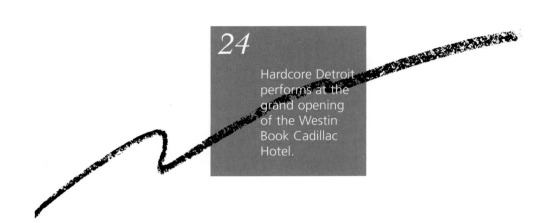

24

Hardcore Detroit performs at the grand opening of the Westin Book Cadillac Hotel.

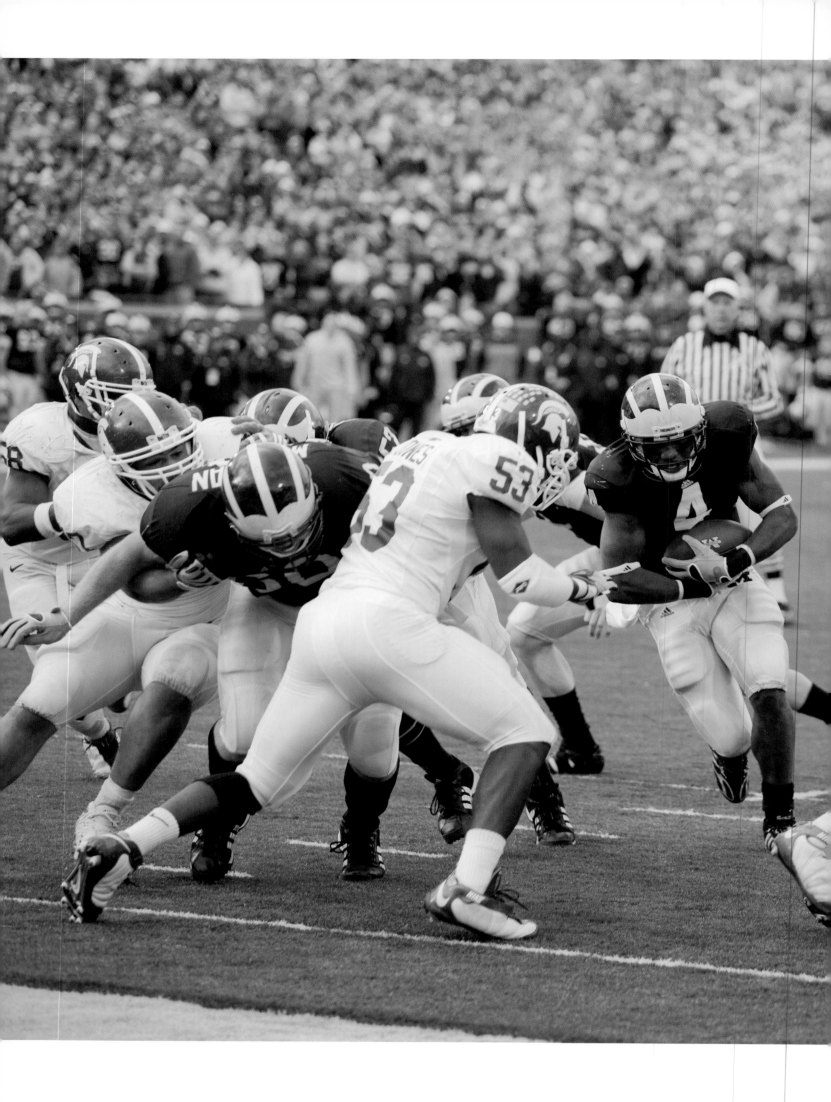

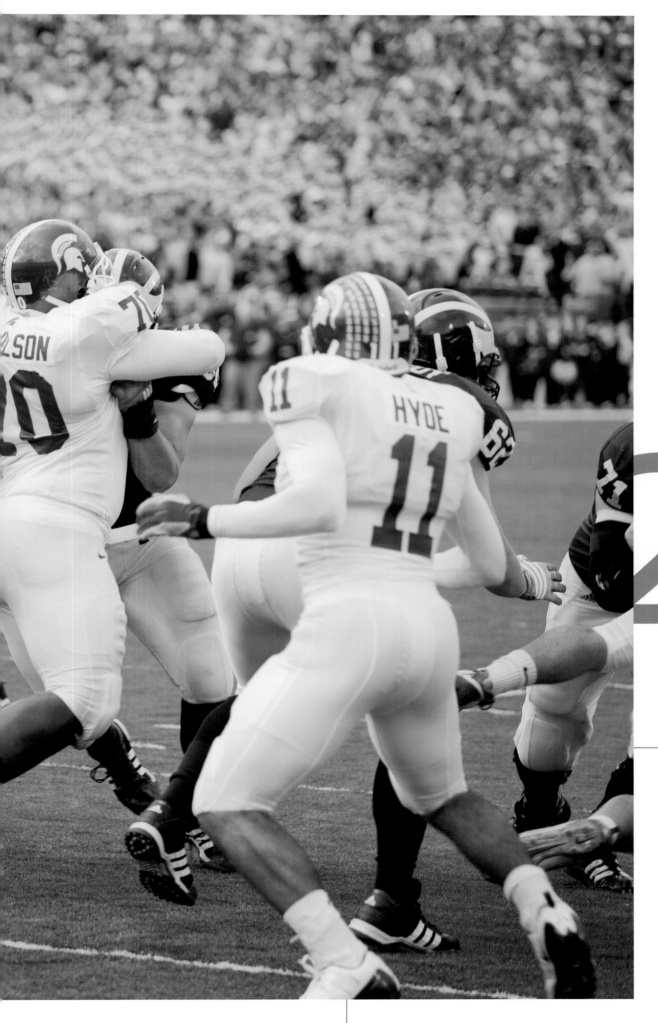

25

The University of Michigan–Michigan State University game in Ann Arbor.

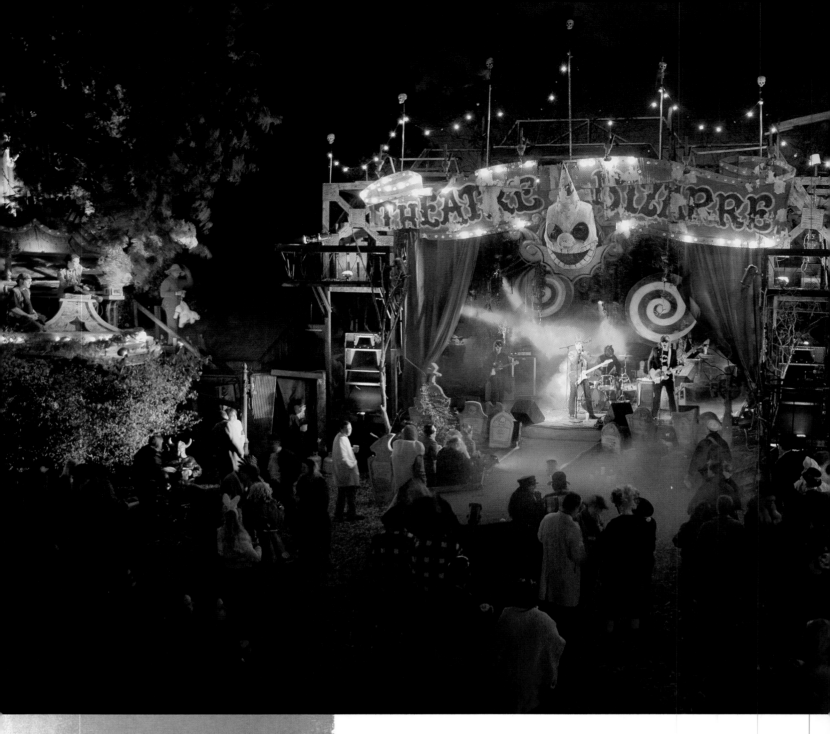

26

The band Fake Blood
performs at Theatre Bizarre
in Detroit.

Students from the
SURA Arts Academy
photograph the art
at the Arab American
National Museum
in Dearborn.

28

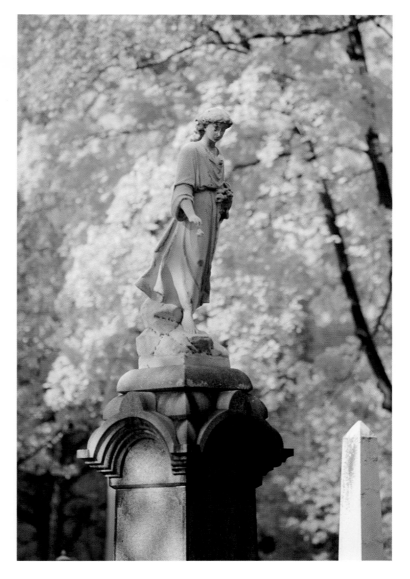

27 A monument at Elmwood Cemetery in Detroit.

Shenetta Coleman and
Shawny DeBerry patrol
during Angels Night.

29

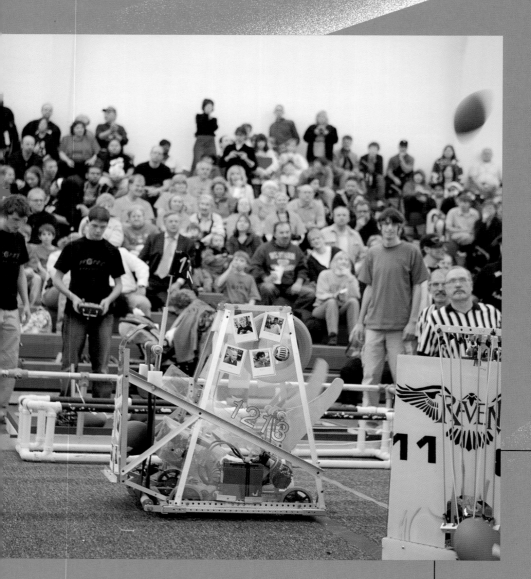

Groves High School
robot competes in
the OCCRA Robotics
Competition.

30

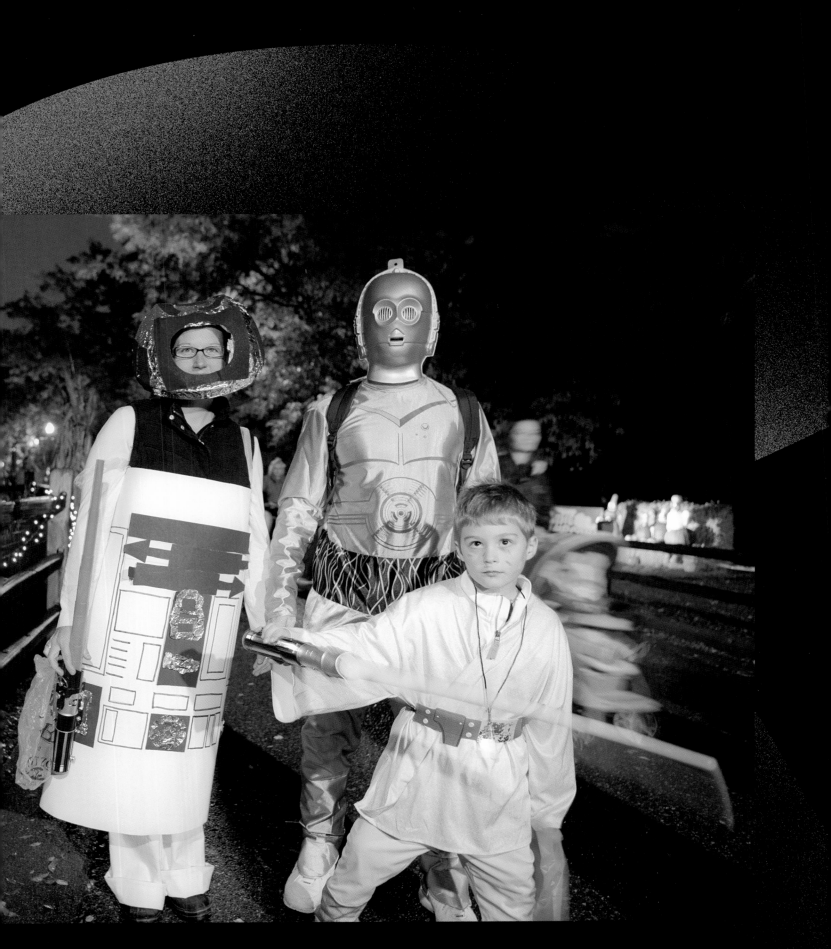

31 R2D2 (Heather), C3PO (Patrick), and their son, Luke Skywalker (Cooper), at the Zoo Boo at the Detroit Zoo.

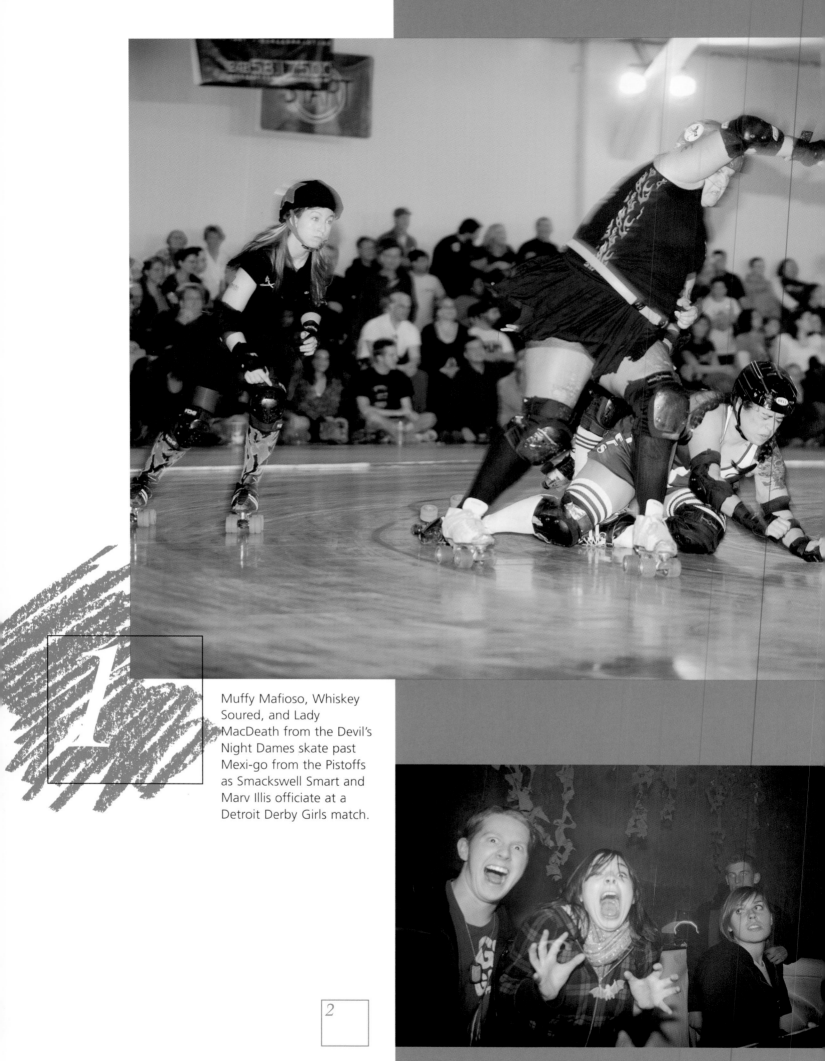

1

Muffy Mafioso, Whiskey Soured, and Lady MacDeath from the Devil's Night Dames skate past Mexi-go from the Pistoffs as Smackswell Smart and Marv Illis officiate at a Detroit Derby Girls match.

2

Having fun at Erebus in Pontiac, the largest haunted house in the country.

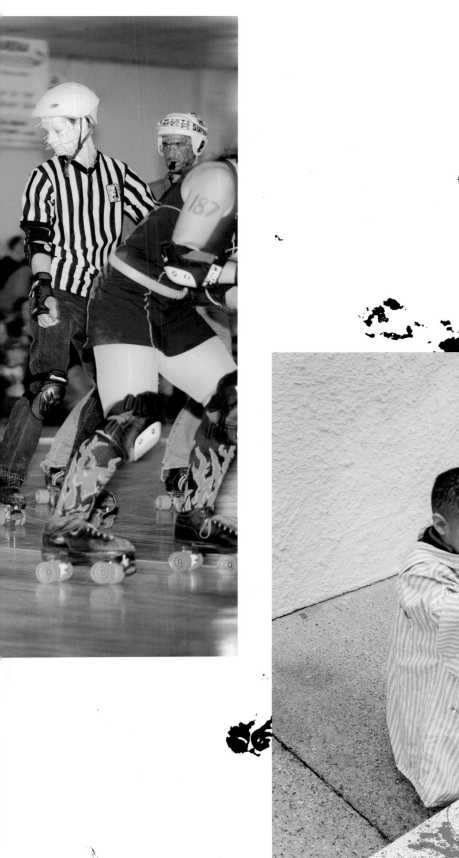

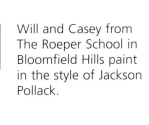

3 | Will and Casey from The Roeper School in Bloomfield Hills paint in the style of Jackson Pollack.

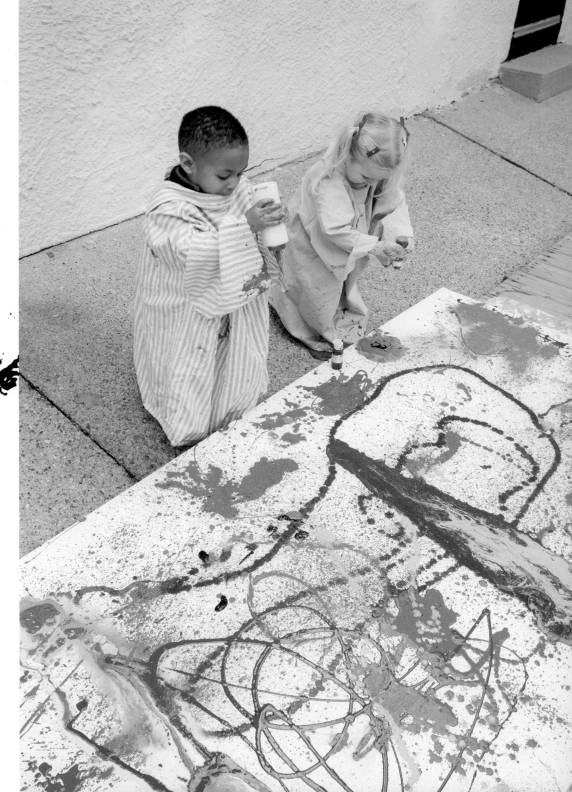

Voting at the Healing
Spring Missionary Baptist
Church in Detroit.

4

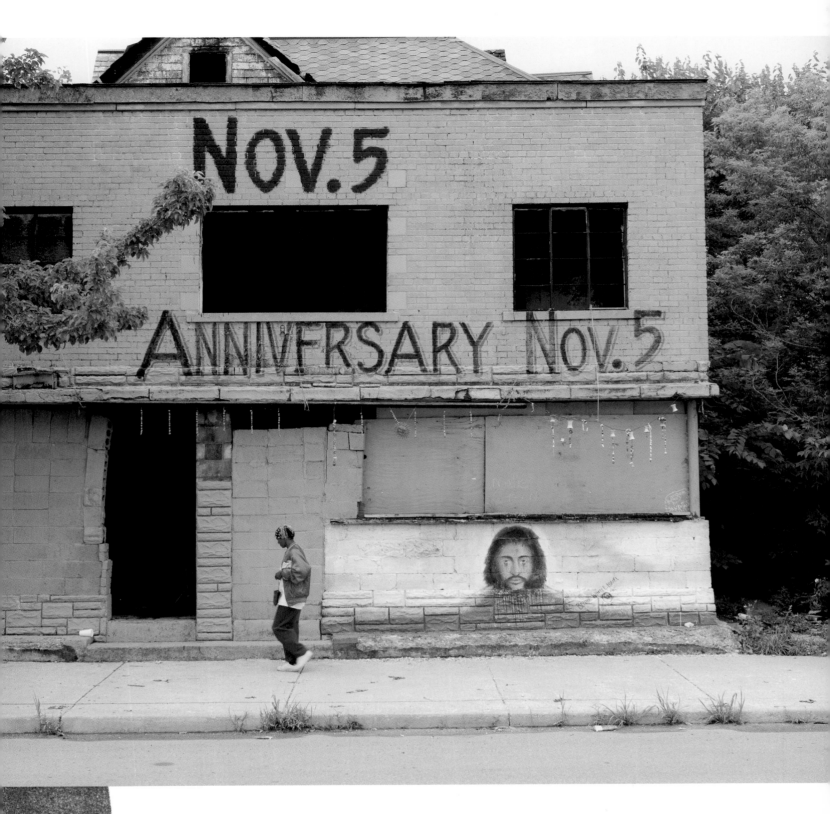

5 Malice Green memorial in Detroit.

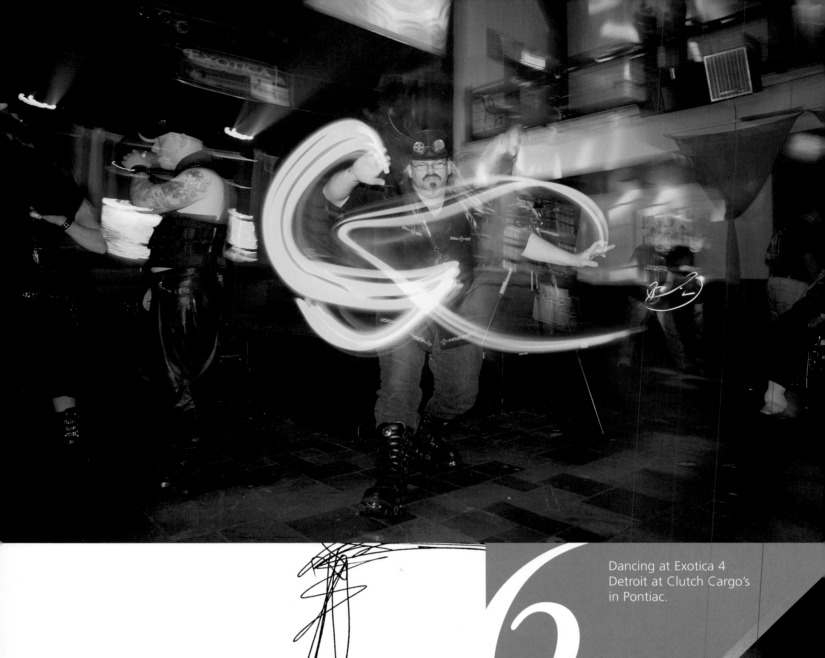

6

Dancing at Exotica 4
Detroit at Clutch Cargo's
in Pontiac.

7

Scott Lorenz from
Westwind Balloon Company
prepares his hot-air balloon
for flight.

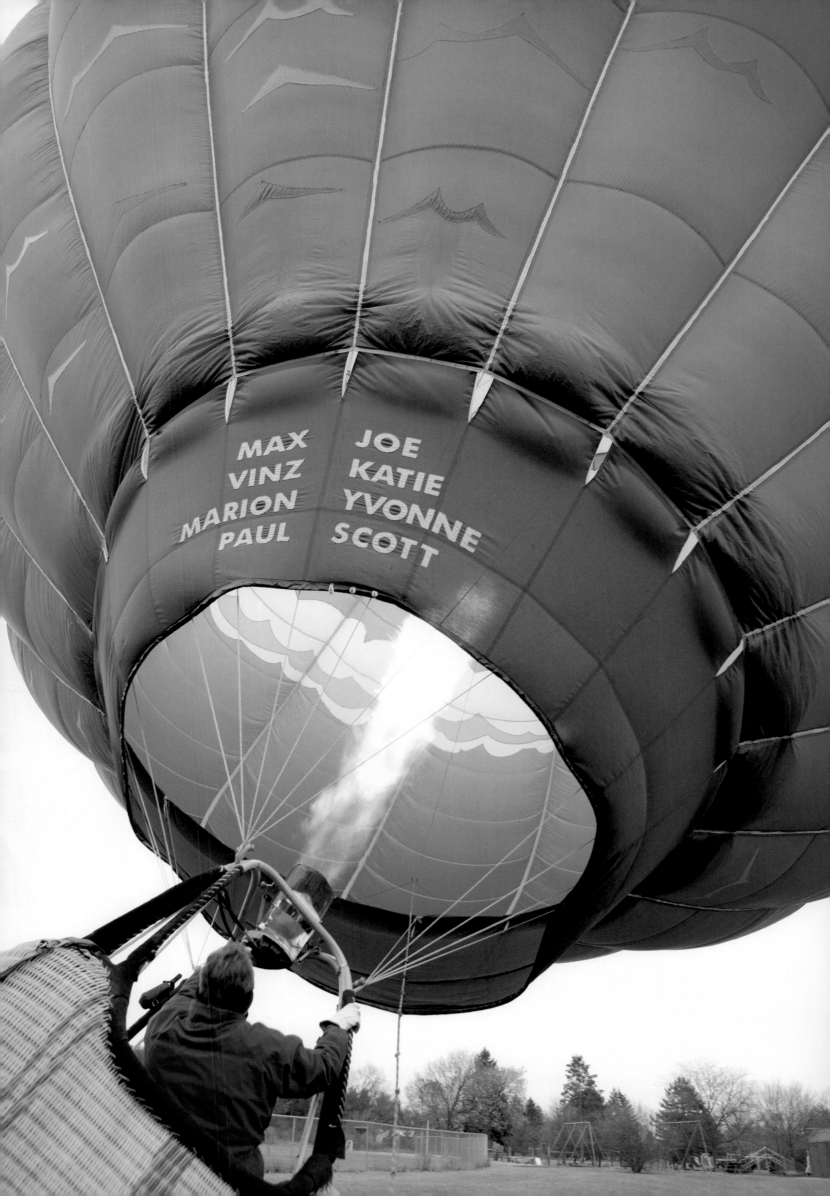

8

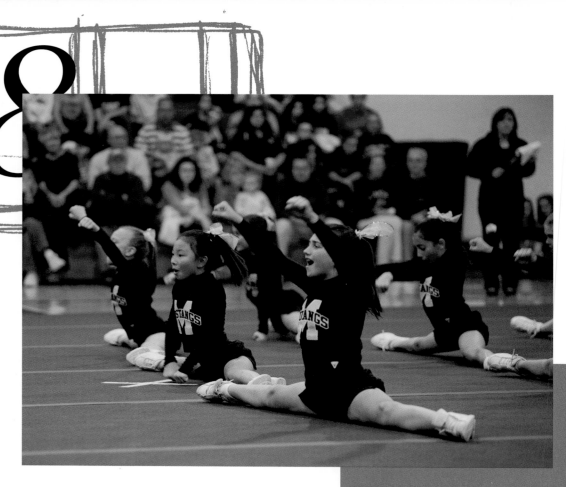

The Mustangs from
St. Lawrence School
in Utica compete
in the CYO Fall
Cheerleading
Competition.

Ten-year-old Calvin dances at the
16th annual Native American Festival
and Mini Pow Wow in Southfield.

9

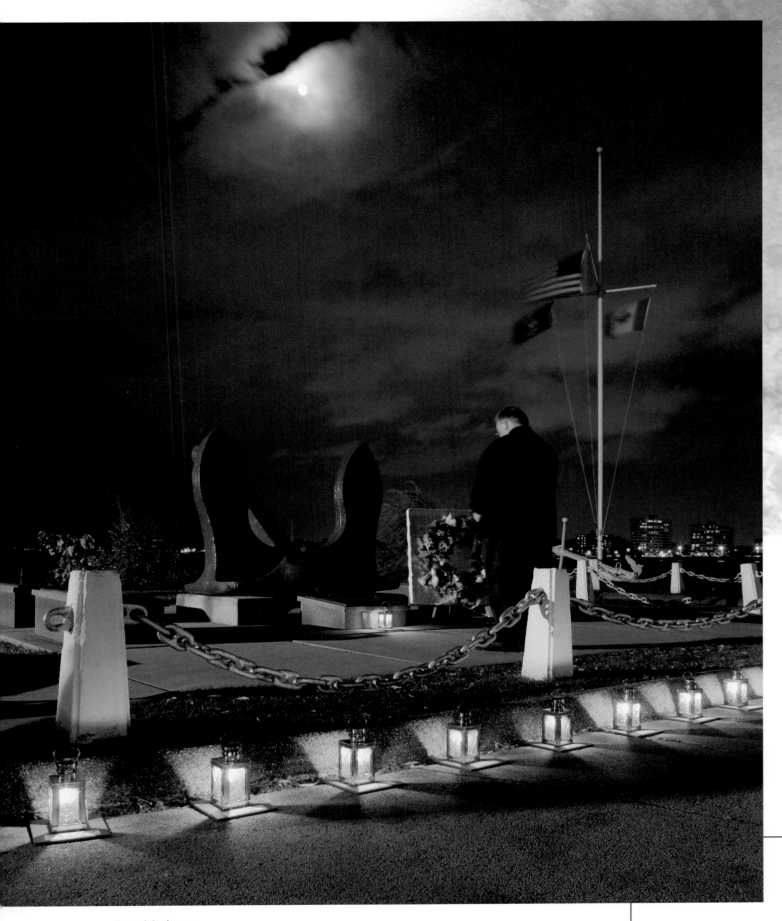

Lost Mariners
Remembrance at the
Dossin Great Lakes
Museum on Belle Isle.

10

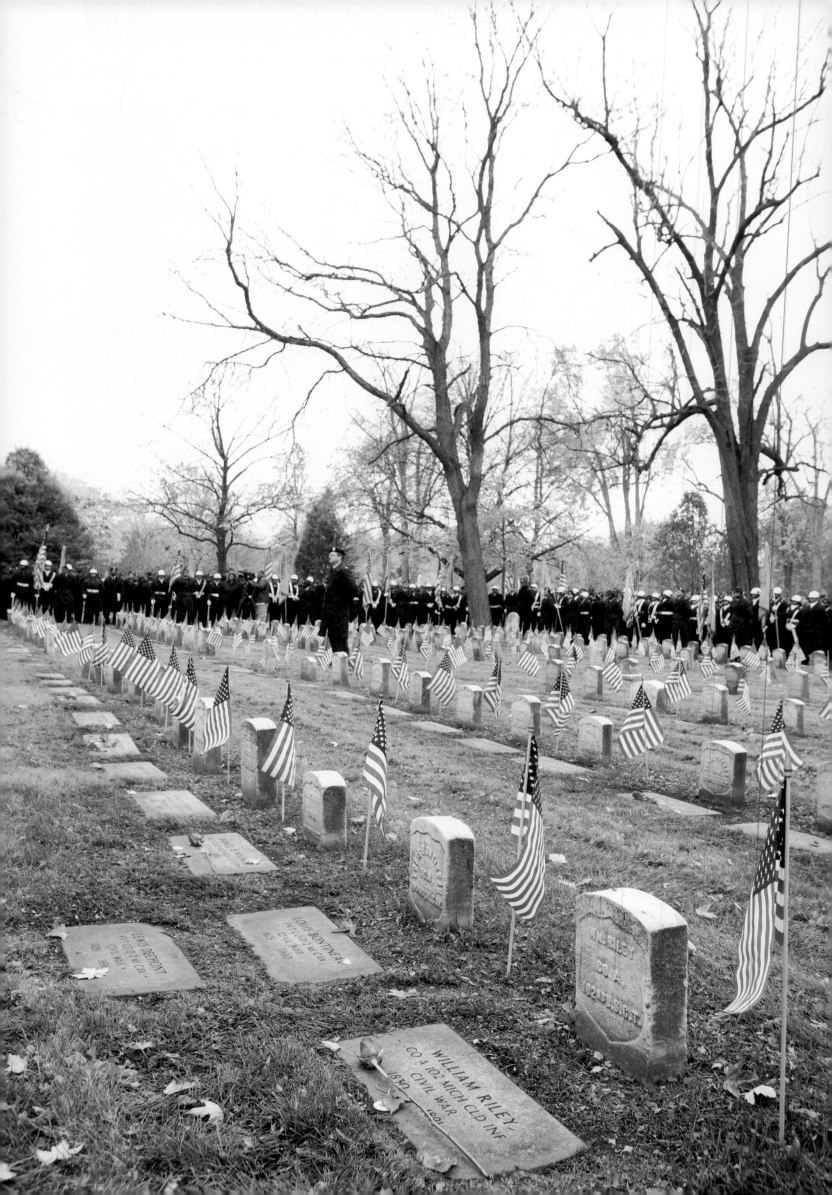

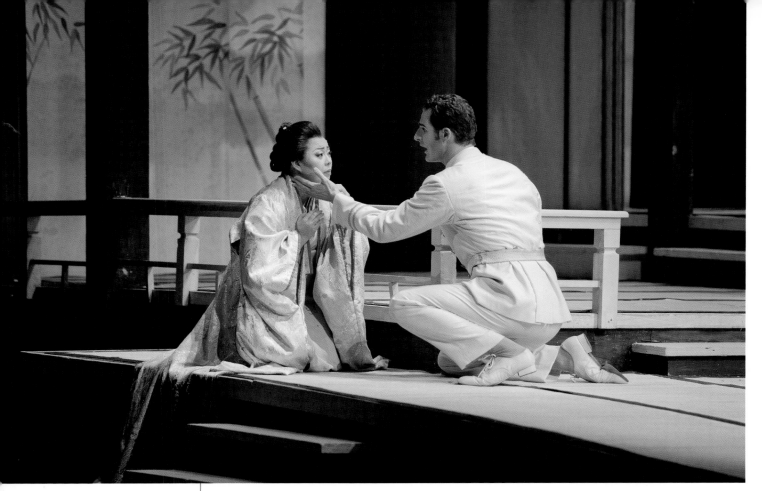

11

The 102nd U.S. Colored Infantry being honored at the Veterans Day ceremony at Elmwood Cemetery.

Mihoko Kinoshita as Cio-Cio-San and James Valenti as Pinkerton in the Michigan Opera Theatre's production of *Madame Butterfly* at the Detroit Opera House.

12

Mary at Pewabic Pottery removes items from the kiln.

13

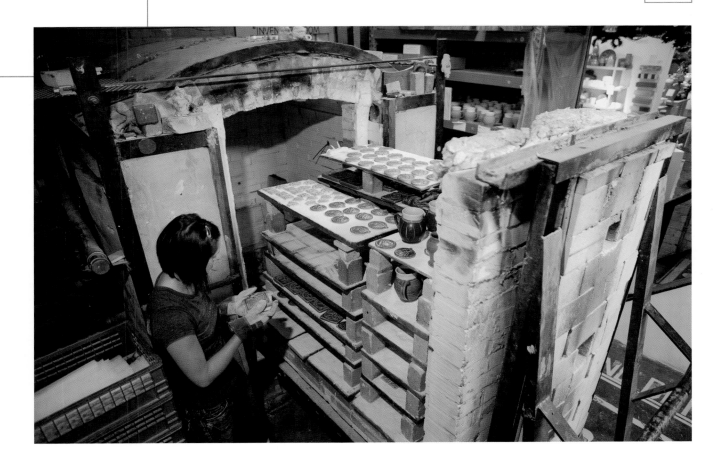

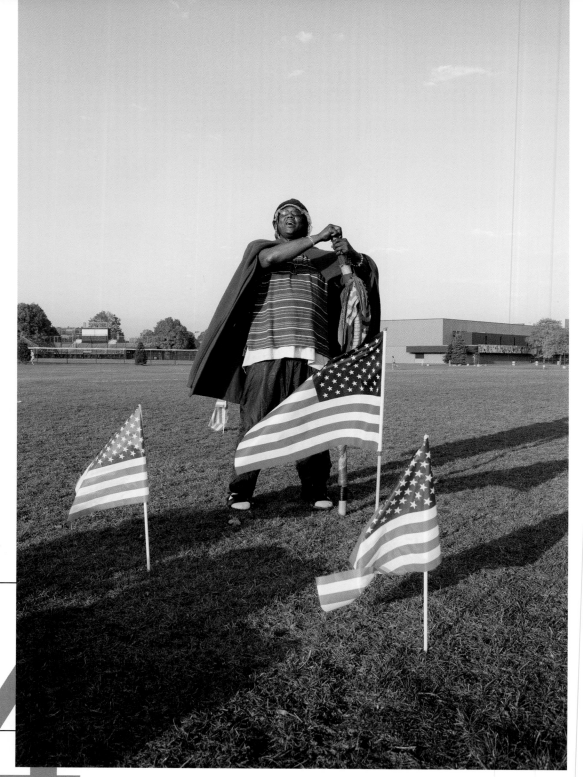

Dwayne Nolan holds court on Wayne State University's athletic field.

14

Jennifer Elliott, tattoo artist at American Pride Tattoo in Royal Oak, works on a flower for Elizabeth.

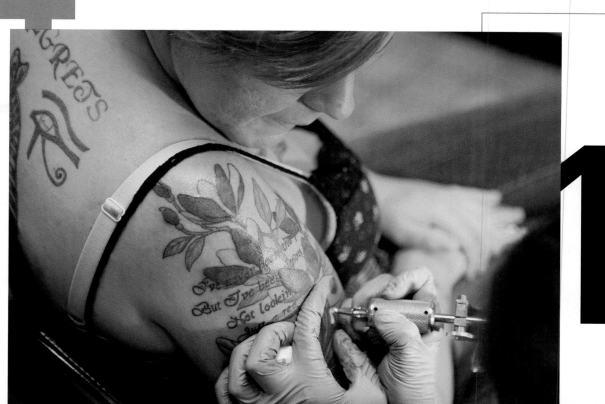

15

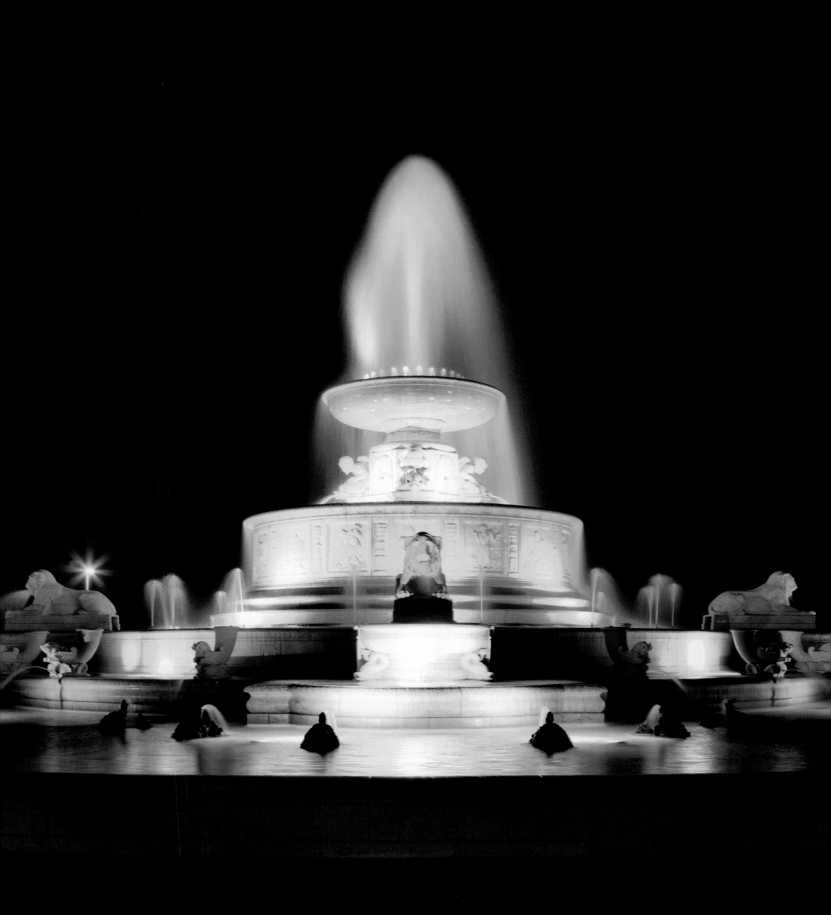

16 Scott Fountain
on Belle Isle.

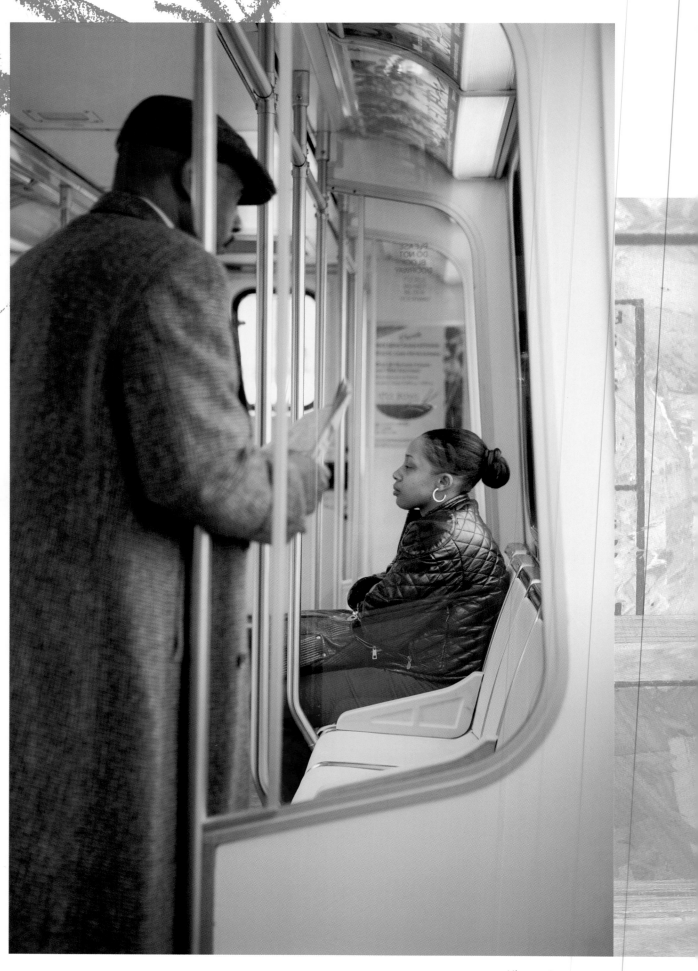

17

Kim rests on
the People Mover
while Claud reads
a newspaper.

18

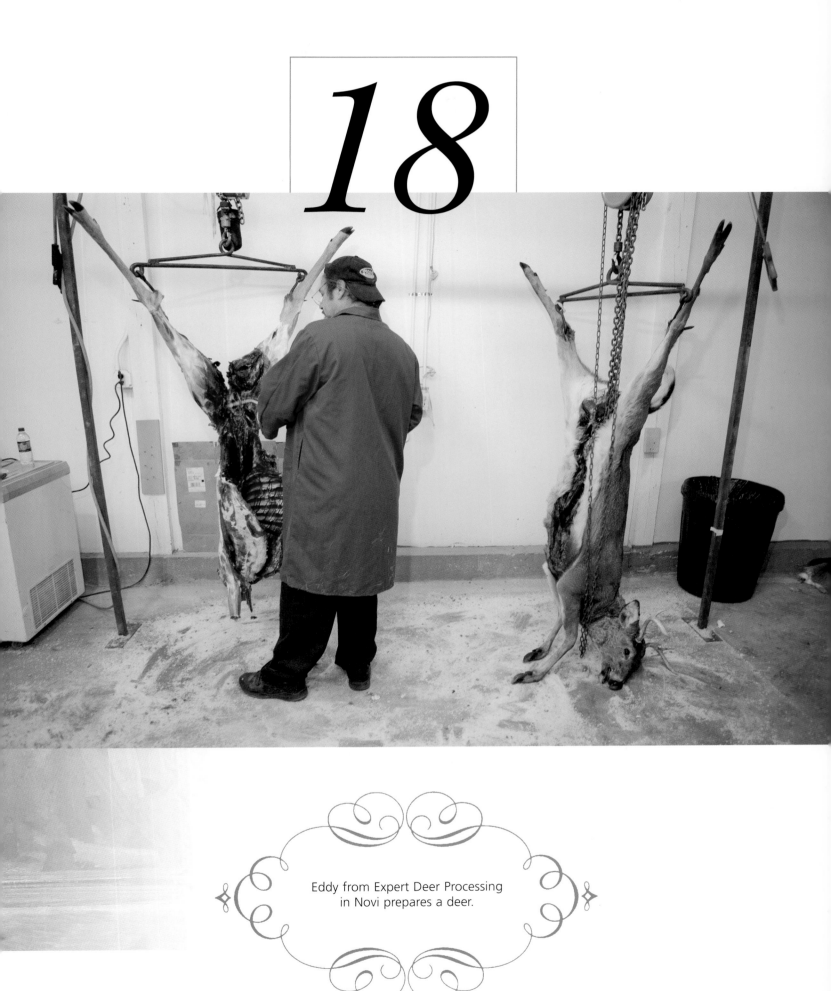

Eddy from Expert Deer Processing
in Novi prepares a deer.

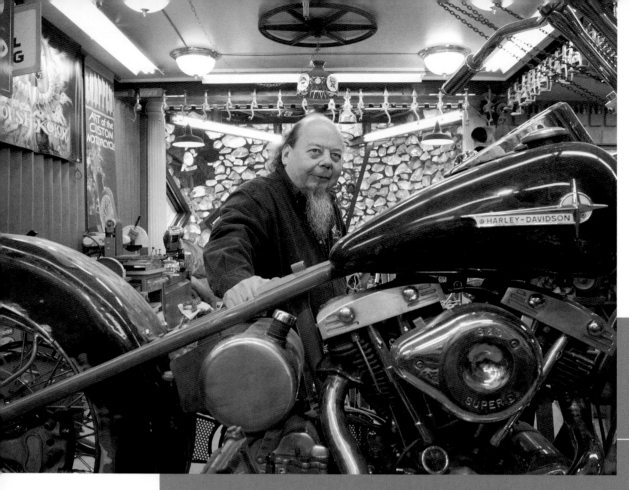

Ron Finch works on a rebuild in his shop in Pontiac.

19

20

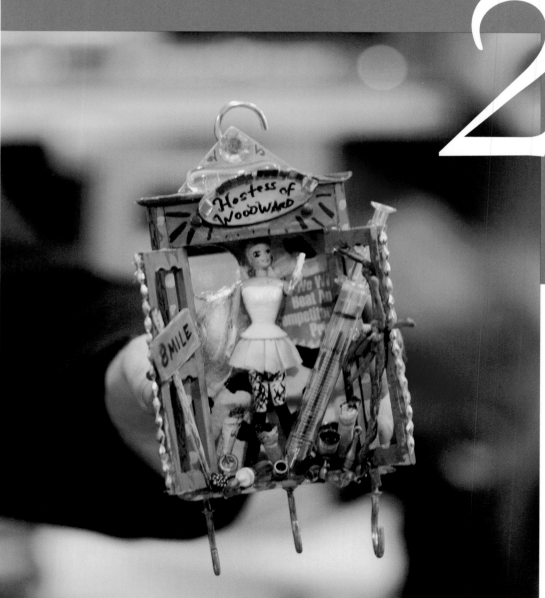

A sculpture created by Wyll Lewis, owner of American Pop in Ferndale.

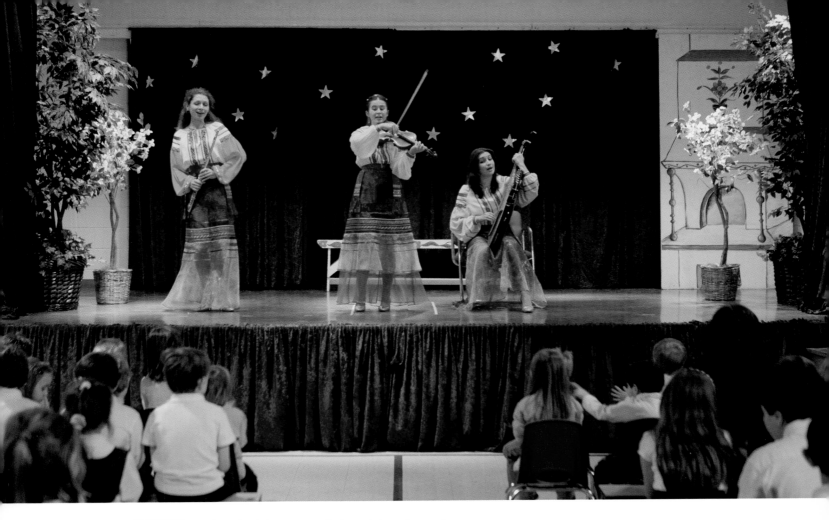

21 The Ukrainian group Polyanytsi performs for students at Immaculate Conception School in Warren.

Walter in Birmingham blows leaves from his yard.

22

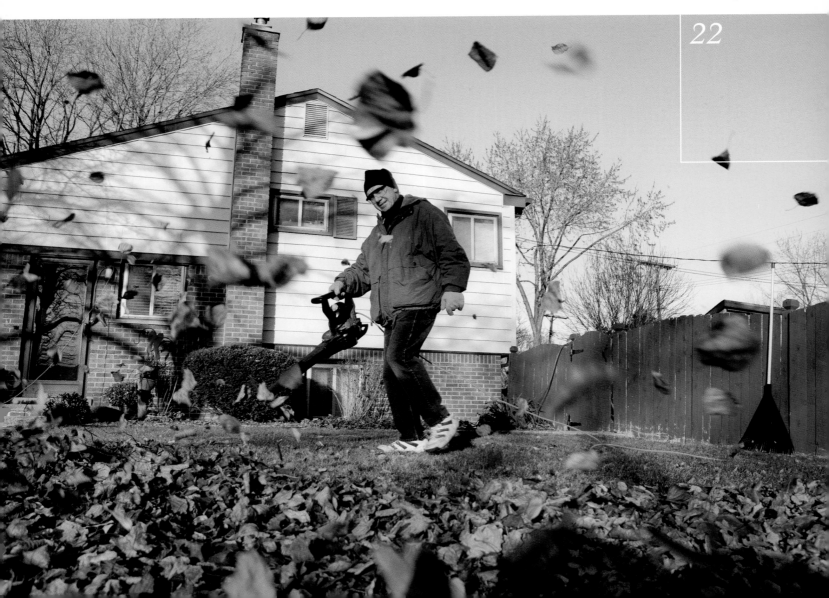

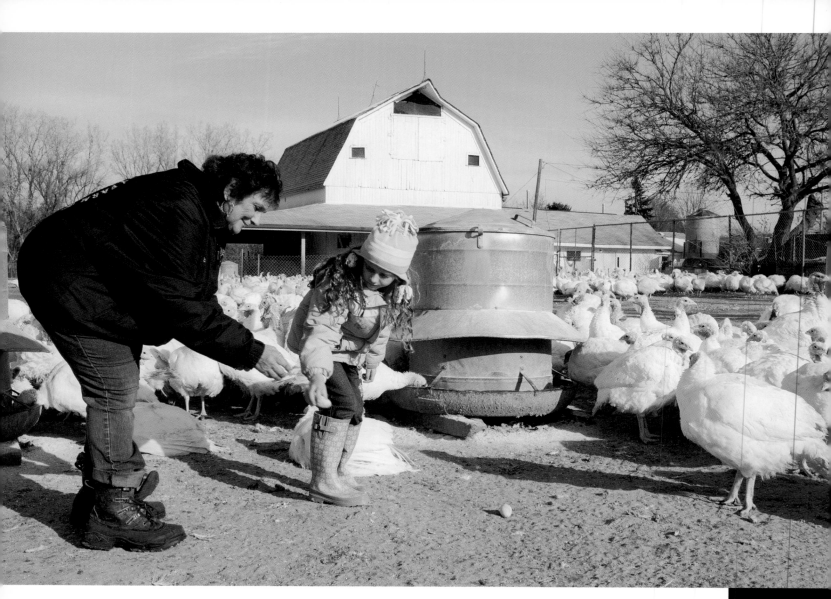

23 Christine Roperti, owner of Roperti's Turkey Farm in Livonia, collects eggs with her granddaughter Merida, seven.

Volunteers from Lighthouse of Oakland County hand out more than 4,800 Thanksgiving Day meals from the gym at All Saints Episcopal Church in Pontiac.

24

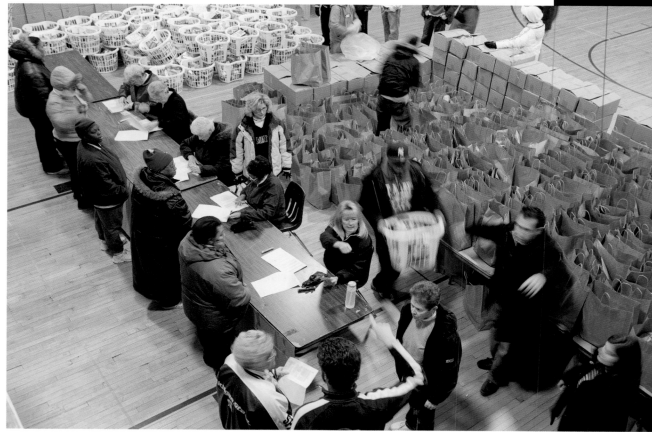

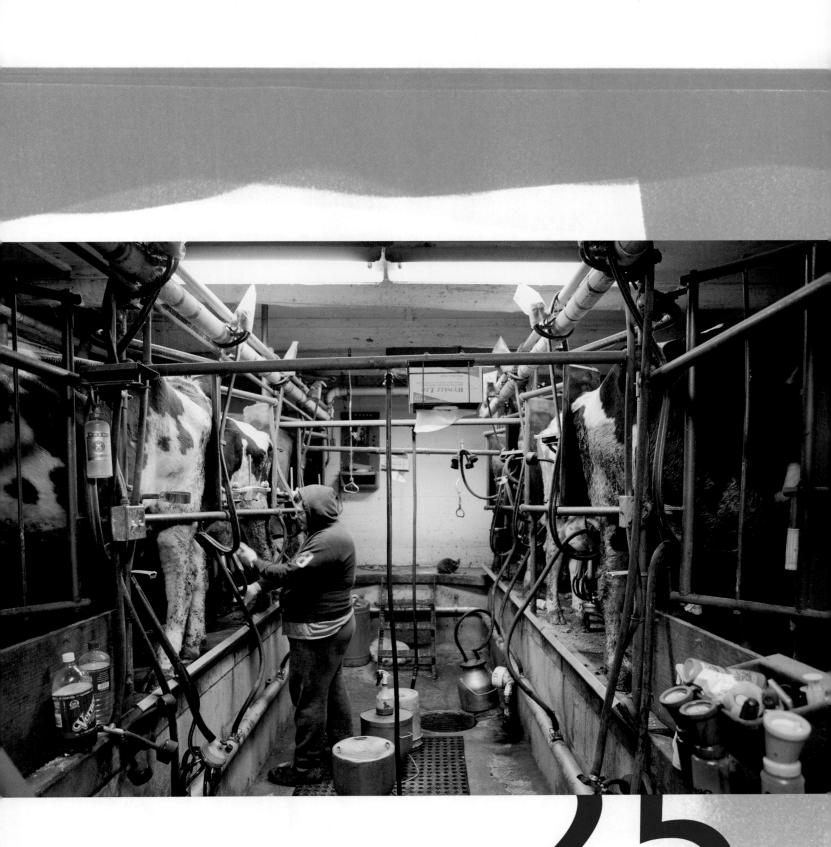

25

Howard DeForest milks cows at his family farm, Way-Lene Acres in Ann Arbor.

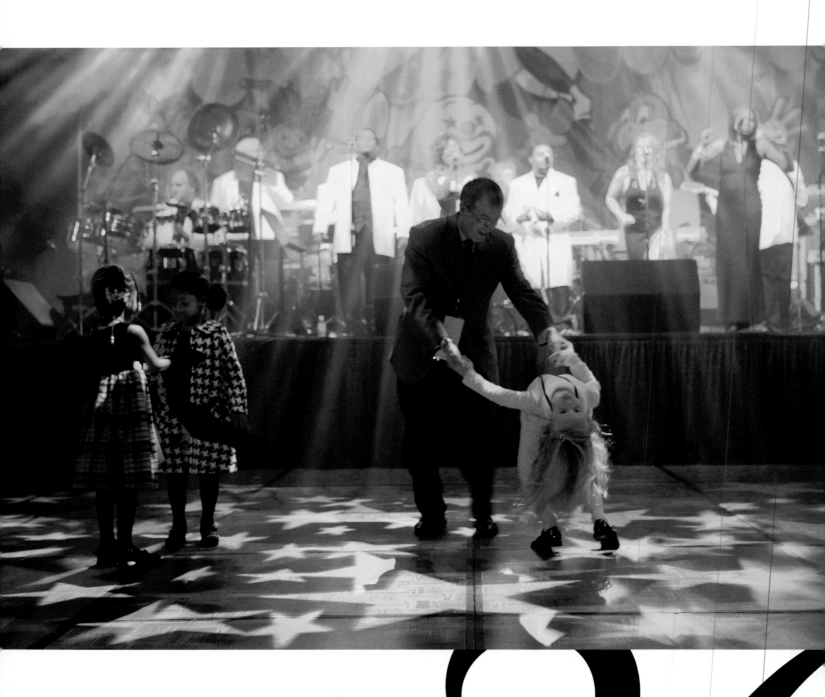

Anna, seven, dances with
her father, John, at the
Hob Nobble Gobble.

26

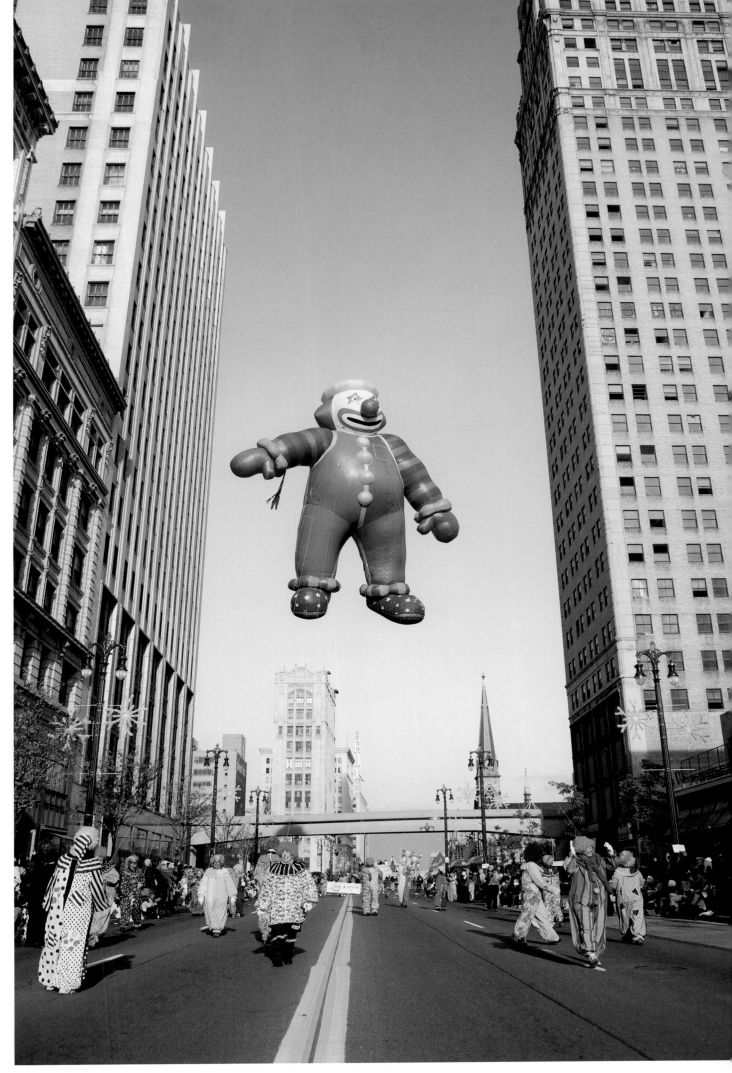

Detroit's Thanksgiving Day Parade.

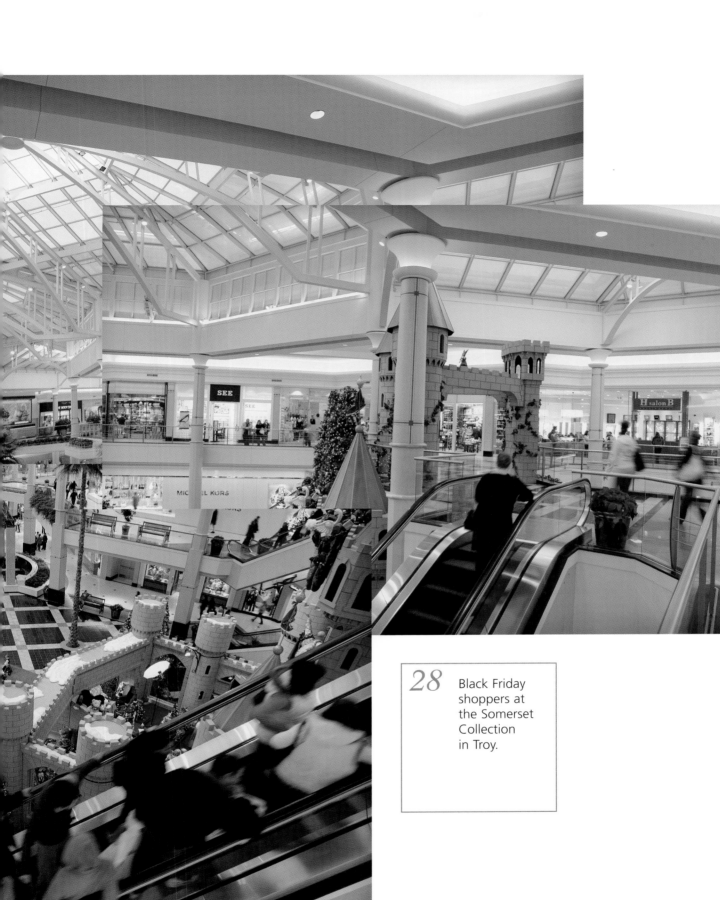

28 Black Friday shoppers at the Somerset Collection in Troy.

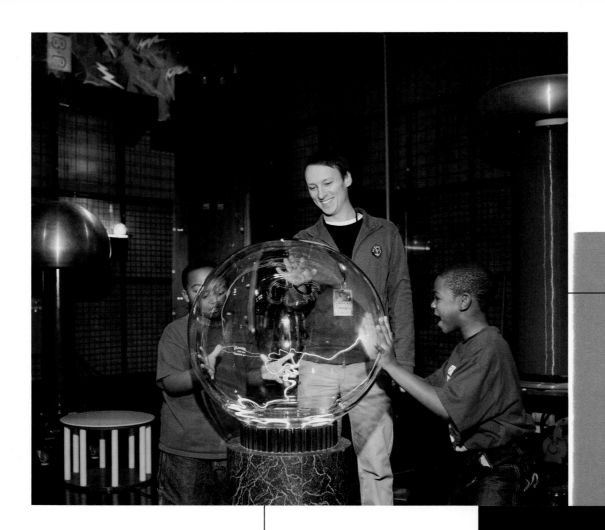

Andy Zulkiewski, stage presenter at the Detroit Science Center, shows students from Flagship Academy the plasma globe at the Sparks Theater.

Wayne County LightFest along Hines Drive, the Midwest's largest holiday light show.

30

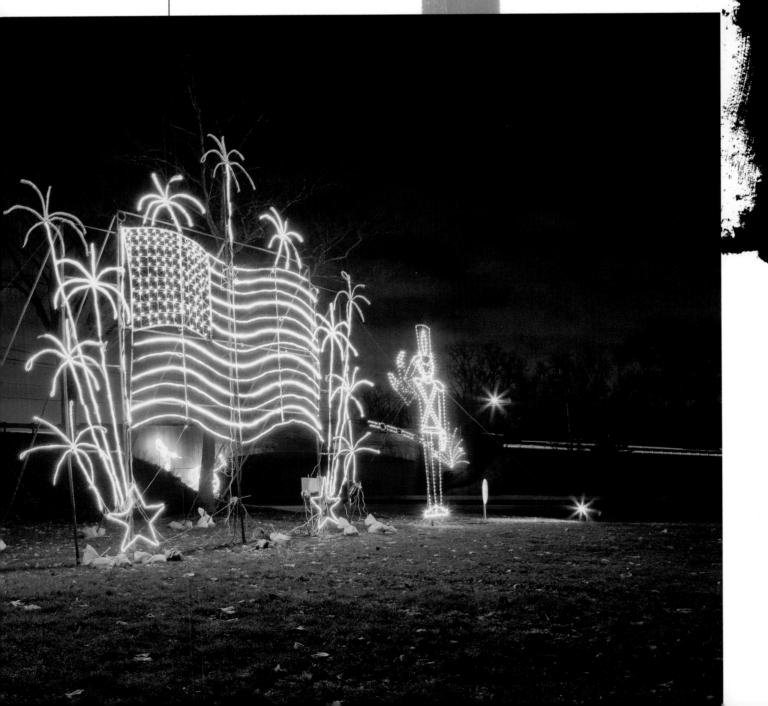

DECEM

1

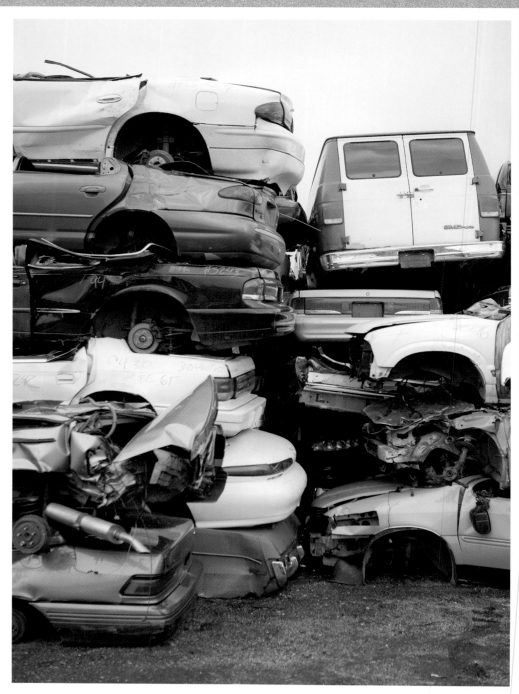

Cars stacked at
U.S. Auto Supply
in Detroit.

Operations
supervisor
Richard Braddock
monitors traffic
at Michigan
Intelligent
Transportation
Systems (MITS).

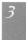

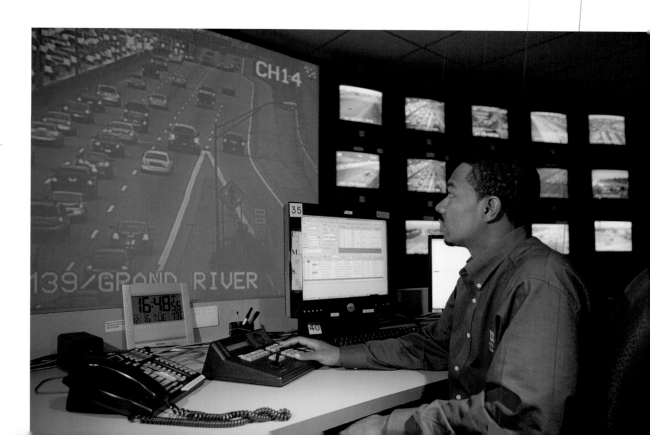

Mirrors hang from the ceiling
in the Great Hall at the
Detroit Institute of Arts.

4 Aldridge's Always Christmas at the Olde World Canterbury Village in Lake Orion.

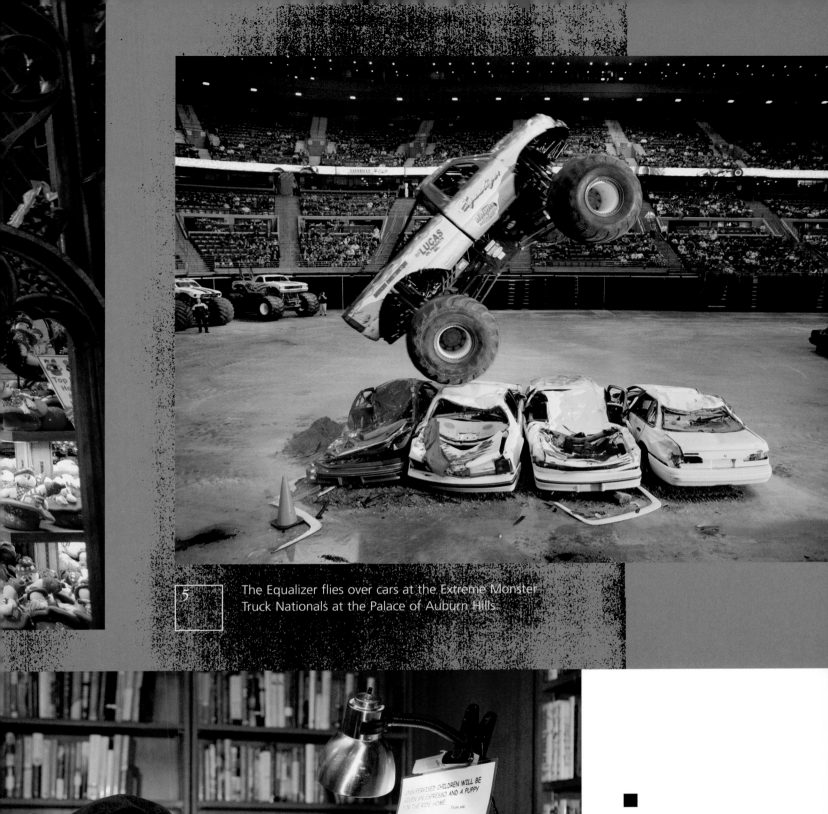

5 The Equalizer flies over cars at the Extreme Monster Truck Nationals at the Palace of Auburn Hills

Portrait artist Ariel draws Tochukwu at the Detroit Public Library on Noel Night.

Guests visit historical homes during the Palmer Woods Holiday Home Tour.

7

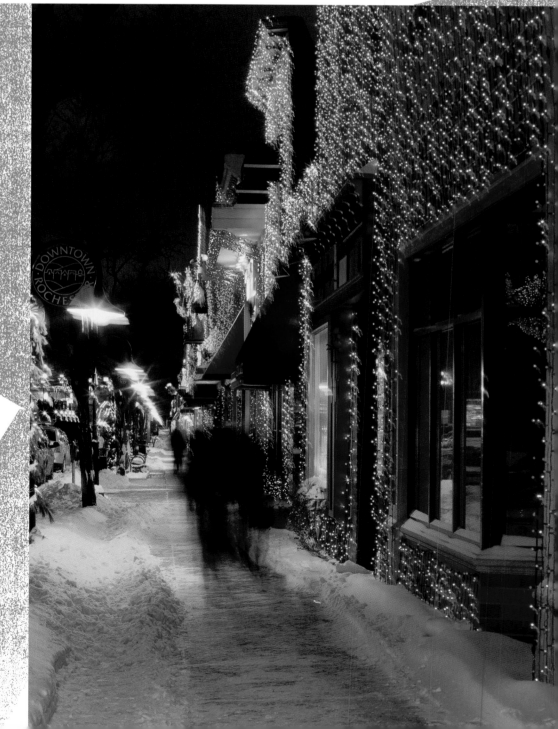

Shoppers enjoying the holiday lights in downtown Rochester.

8

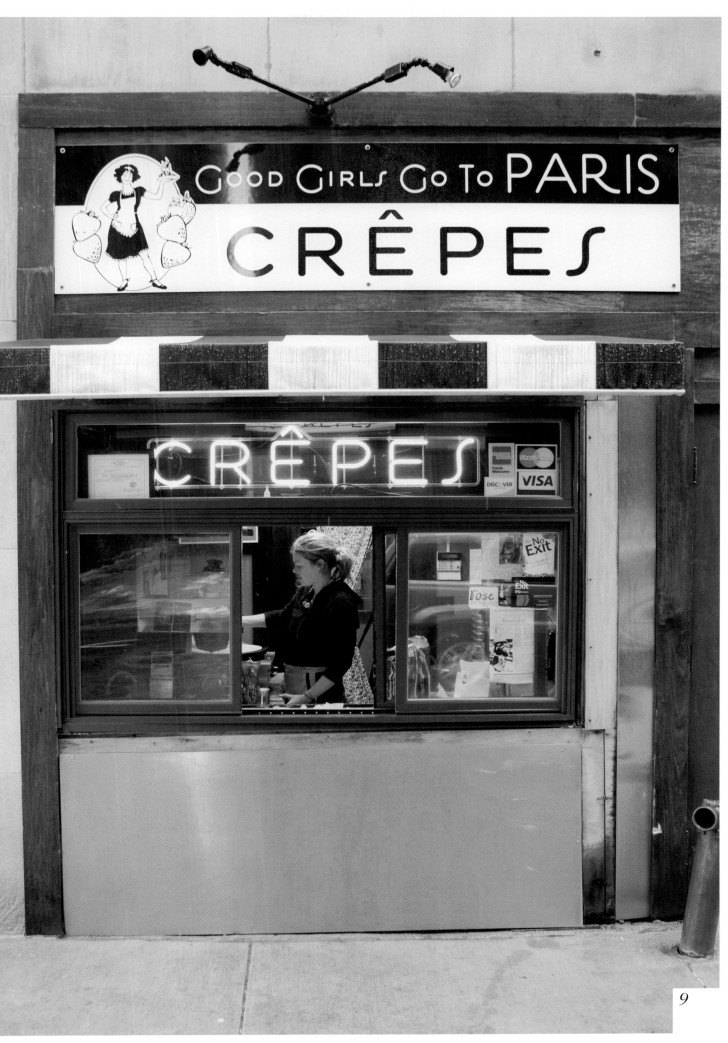

9

Mary at Good Girls Go to Paris Crêpes prepares a crêpe in Detroit.

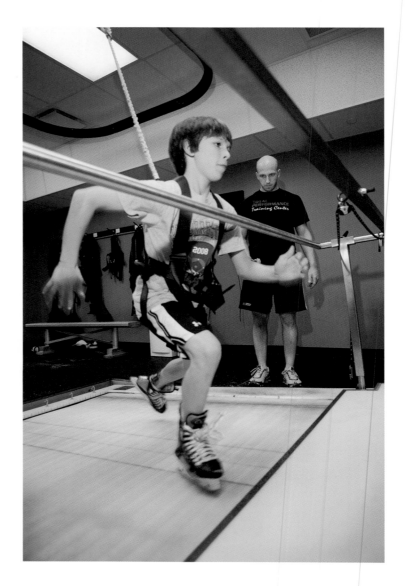

Adam practices skating at the Total
Performance Training Center in Wixom
while Gordie supervises.

At the David Pressley School of Cosmetology
in Royal Oak, Whitney practices styling on
a mannequin.

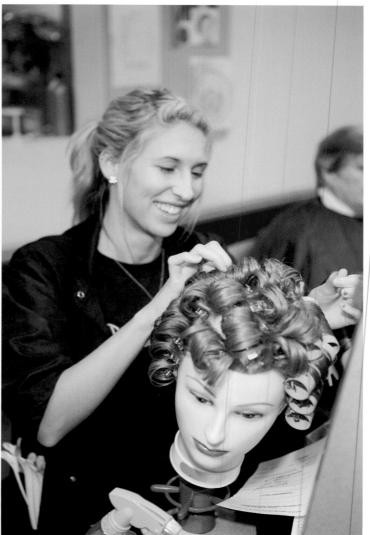

11

12

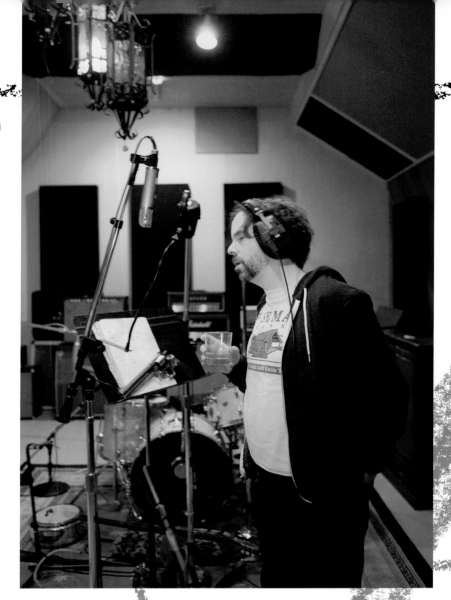

Ethan Daniel
Davidson records
at Rust Belt
Studios in
Royal Oak.

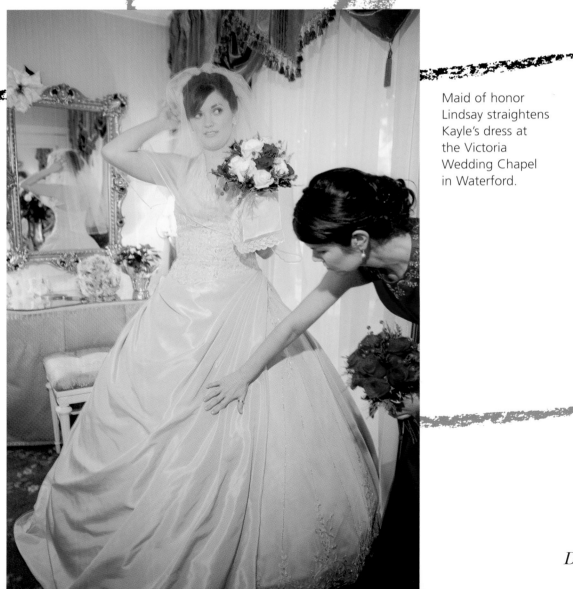

Maid of honor
Lindsay straightens
Kayle's dress at
the Victoria
Wedding Chapel
in Waterford.

13

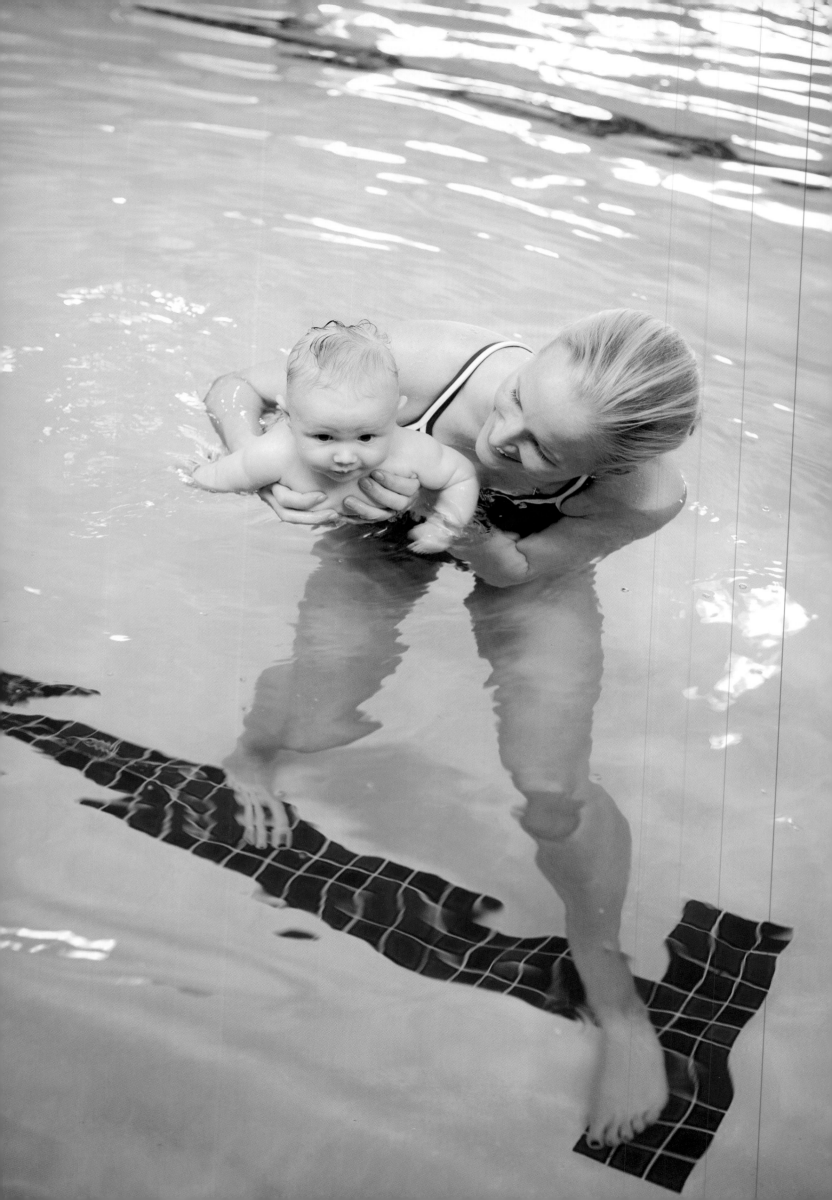

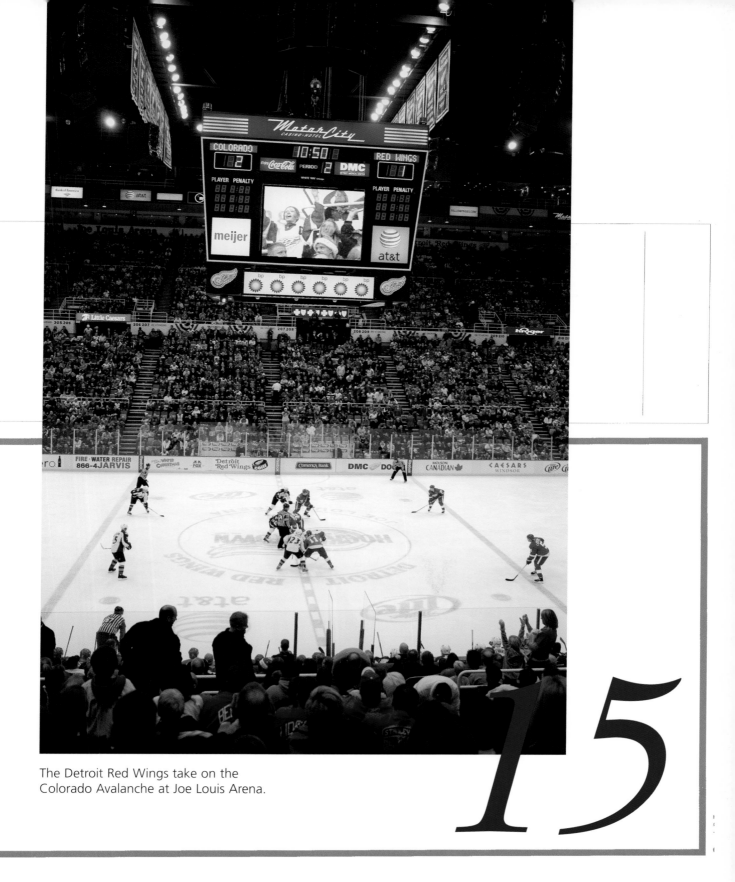

The Detroit Red Wings take on the
Colorado Avalanche at Joe Louis Arena.

15

Three-month-old Charlie
gets an introduction to
the water by Jenny
Vanker McCuiston, one
of the owners of the
Goldfish Swim School in
Birmingham.

14

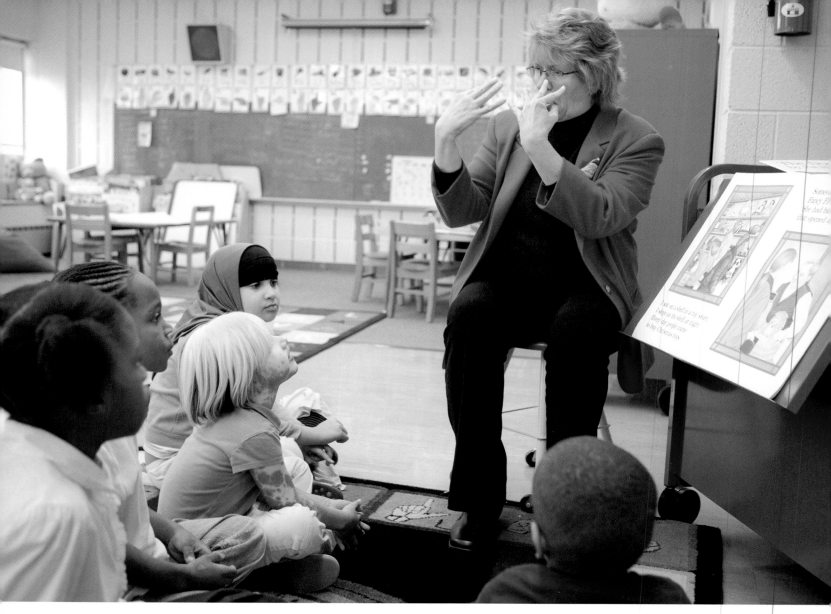

16 Barbara Sanderson, a teacher at the Detroit Day School for the Deaf, signs a book for students.

In an exhibition match at Ford Field, the U.S. Women's National Soccer team takes on the China Women's National team.

17

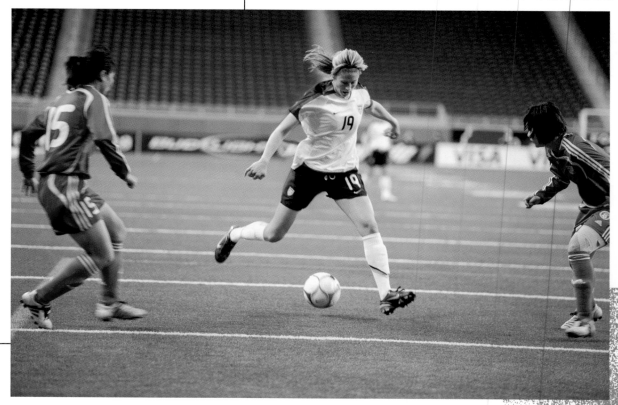

18 Beth and Gabby from the Academy of the Sacred Heart help at Art for a Cause in Birmingham.

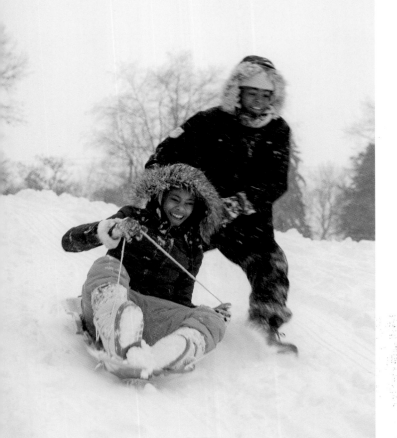

19 Cionne and Charles sled down a hill in Franklin.

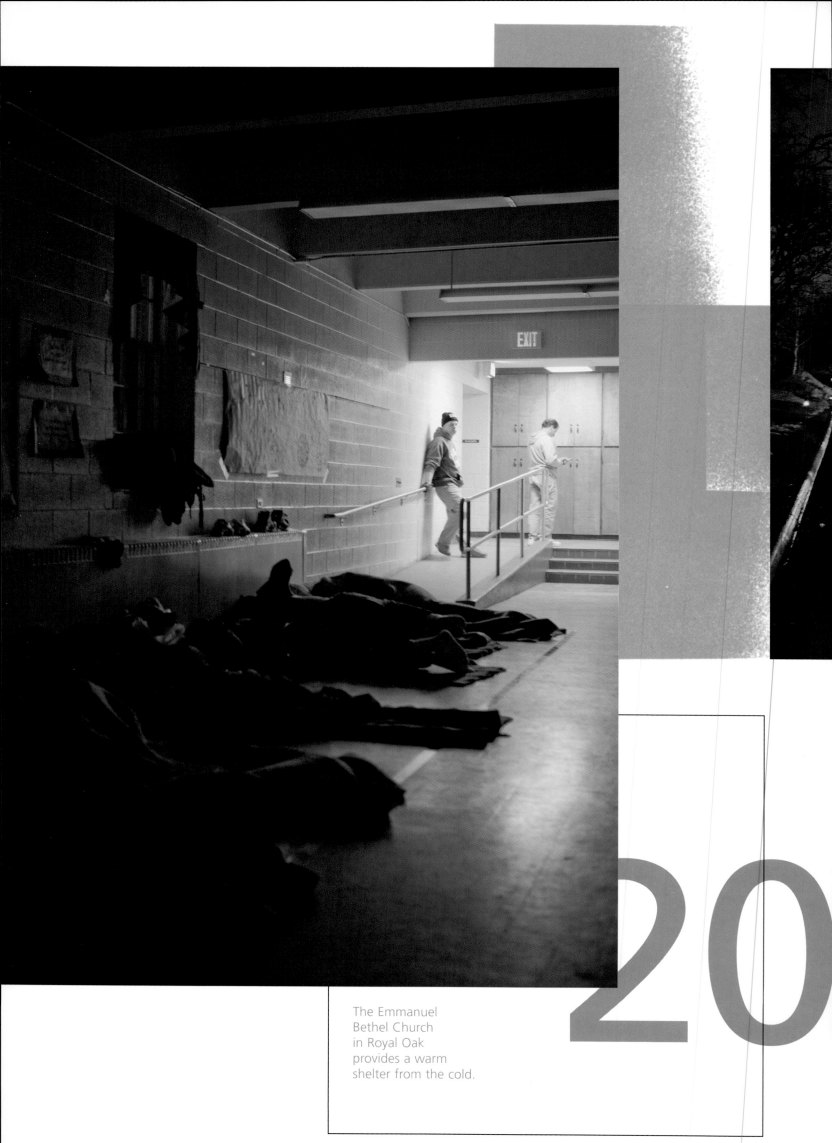

The Emmanuel
Bethel Church
in Royal Oak
provides a warm
shelter from the cold.

20

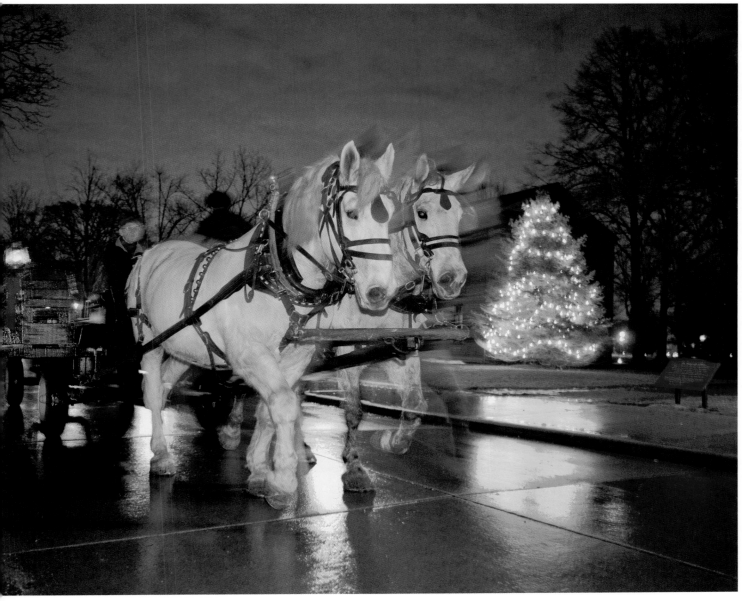

21 A horse-drawn wagon at Holiday Nights at Greenfield Village.

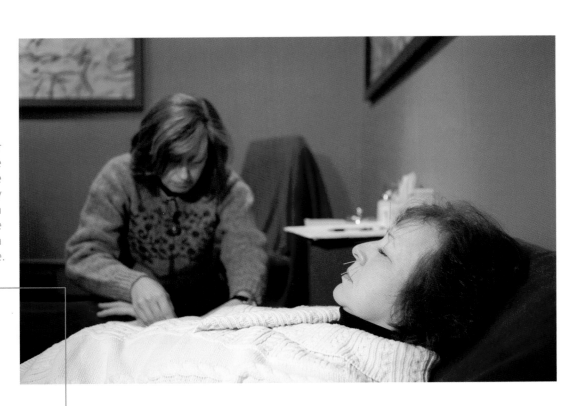

Darlene Berger treats Nadine at the Community Health Acupuncture Center in Ferndale.

22

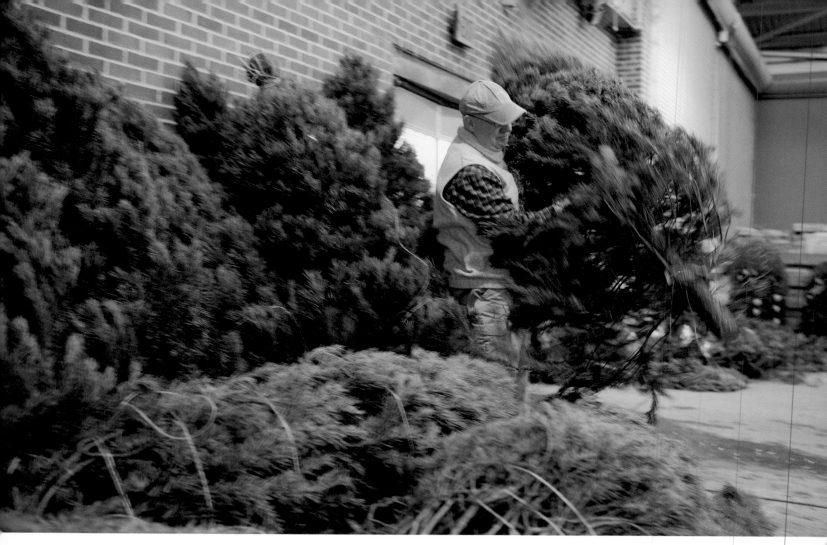

At Eastern Market, Dick from Lathrup Village hunts for a Christmas tree.

24

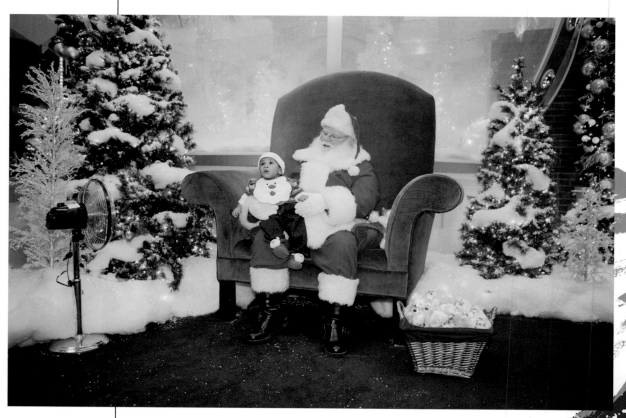

Seven-month-old David's first visit to Santa at Fairlane Mall.

25

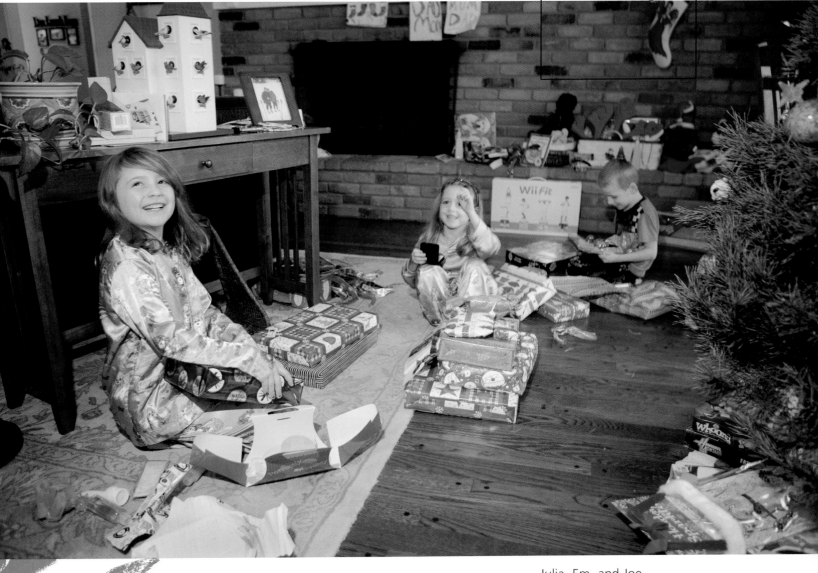

Julia, Em, and Joe
open presents on
Christmas morning in
Bloomfield Township.

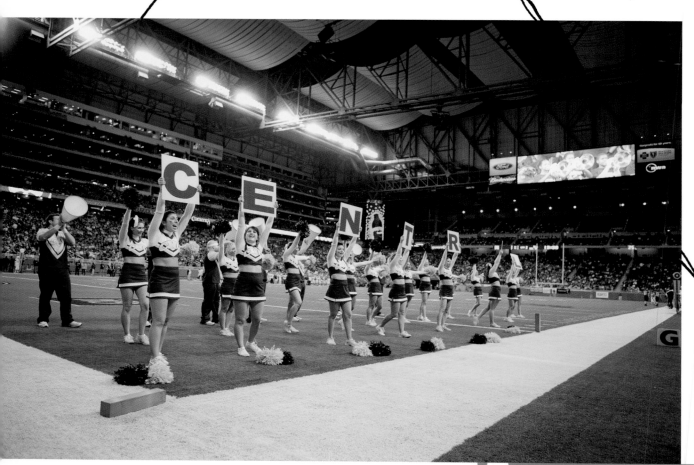

Central Michigan cheerleaders pump up the crowd at the Motor City Bowl.

For Hanukkah, Sophia wraps presents for the needy at the Woodward Avenue Shul.

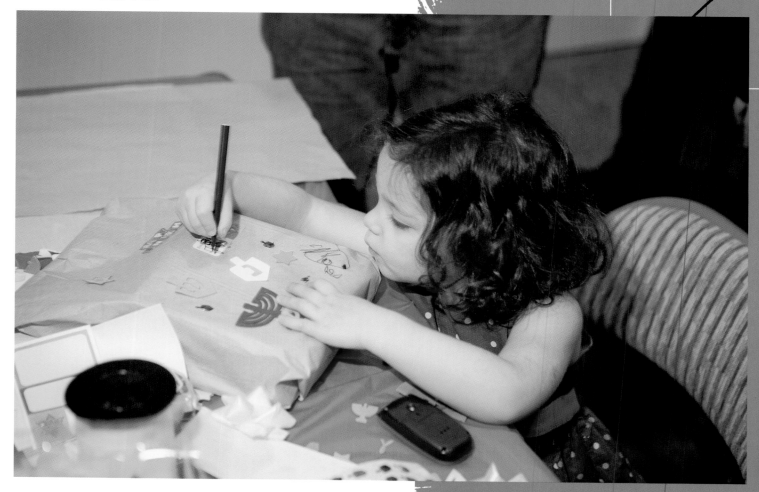

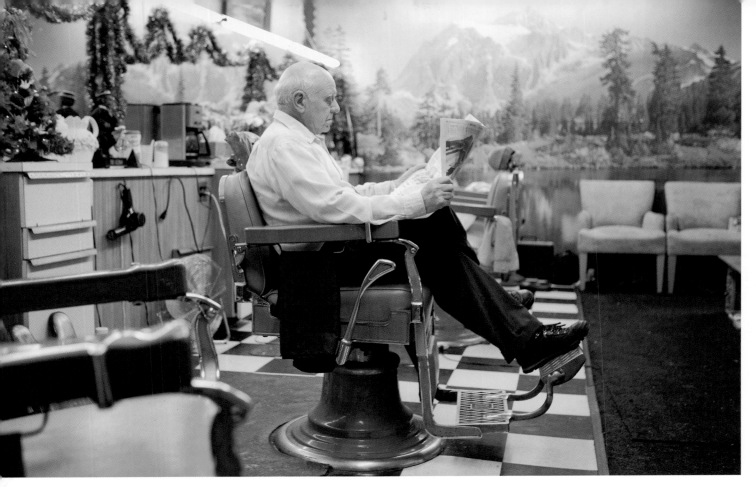

Paul reads the paper at his
Redford barbershop.

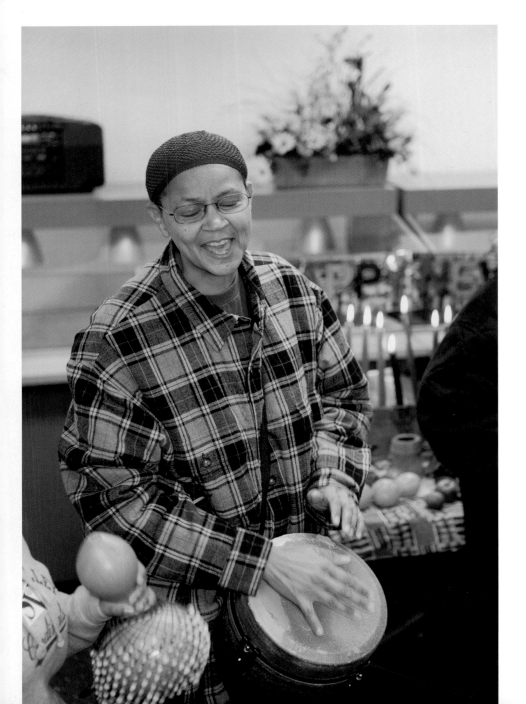

28/29

Dr. Amorie Robinson celebrates
Kwanzaa at the Kids Kwanzaa
Klub party at Full Truth
Fellowship of Christ Church
in Detroit.

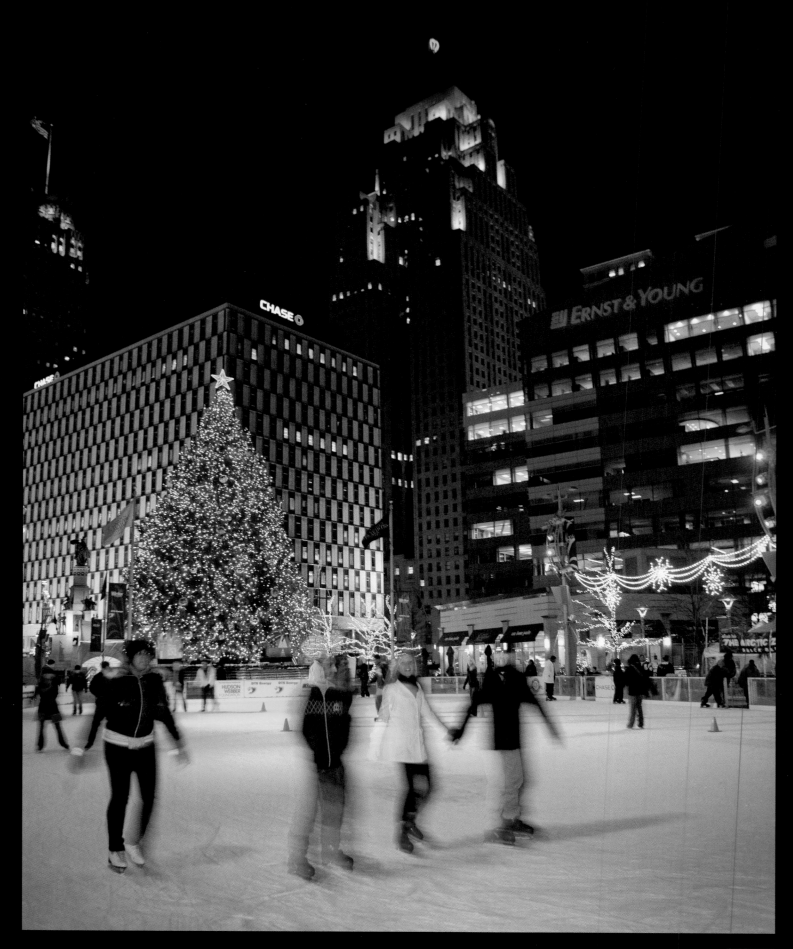

Skating at Campus Martius.

31

JANUARY

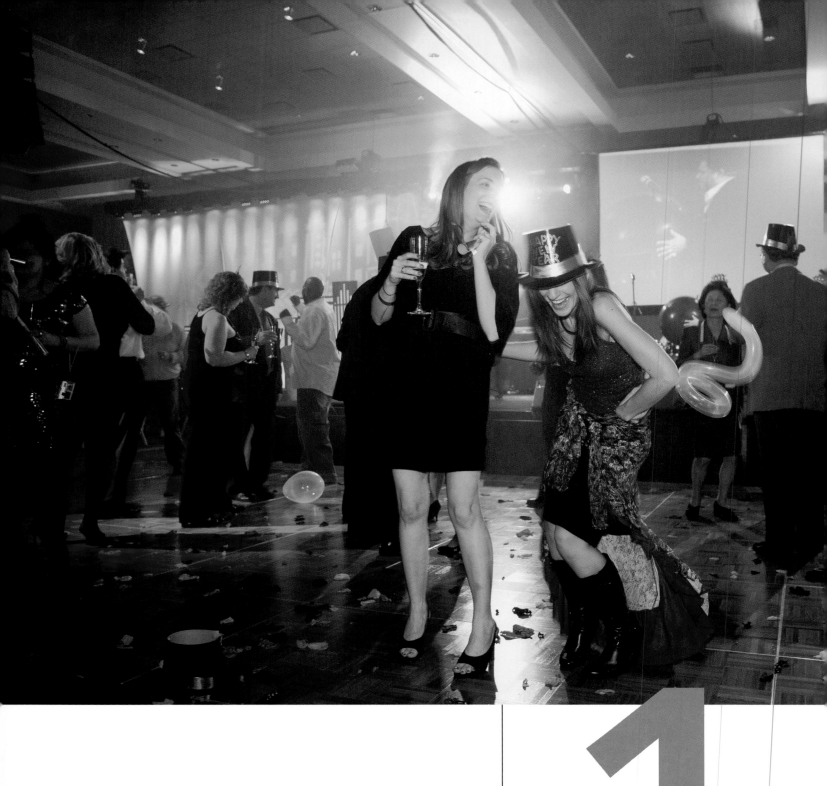

1

Celebrating
New Year's Eve
in the ballroom
of the MGM
Grand in
Detroit.

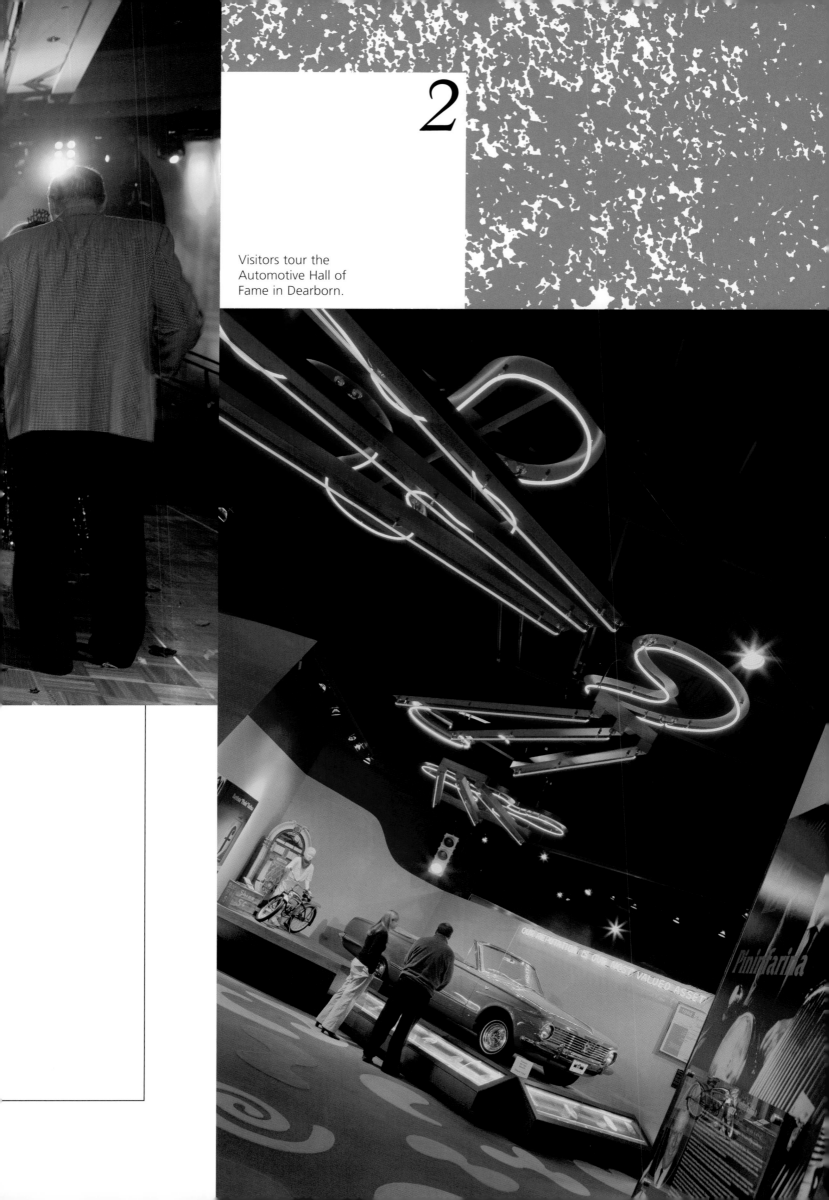

2

Visitors tour the
Automotive Hall of
Fame in Dearborn.

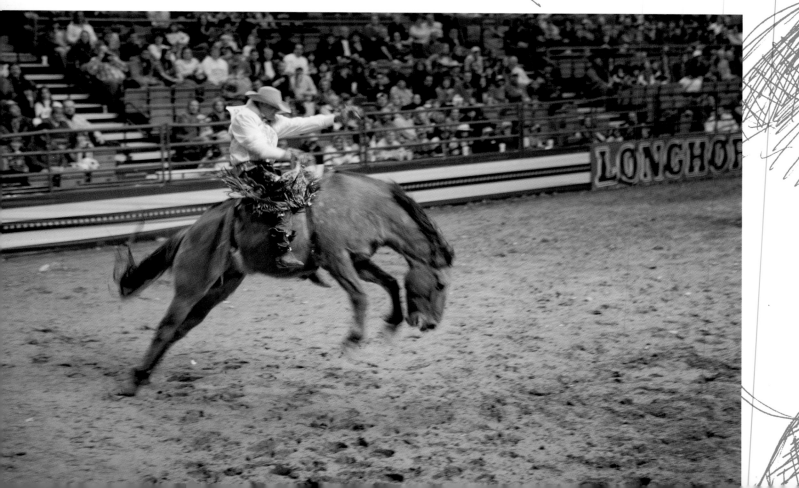

3 An "ART" display near Comerica Park.

4. The Longhorn World Championship Rodeo at the Palace of Auburn Hills.

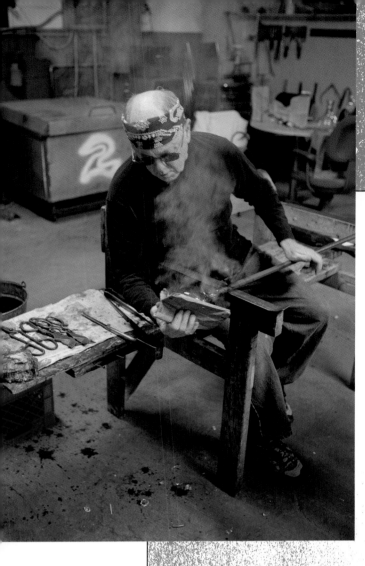

5 David Bakos,
student at
Michigan Hot Glass.

6

Photo exhibit from the book
*American City, Detroit
Architecture, 1845–2005*
at the Detroit Public Library.

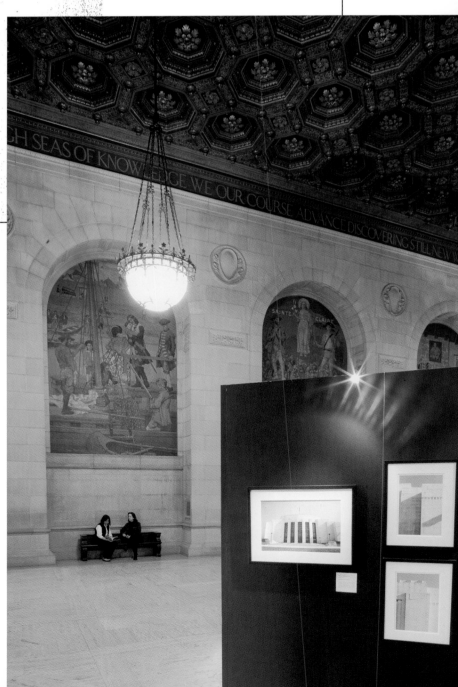

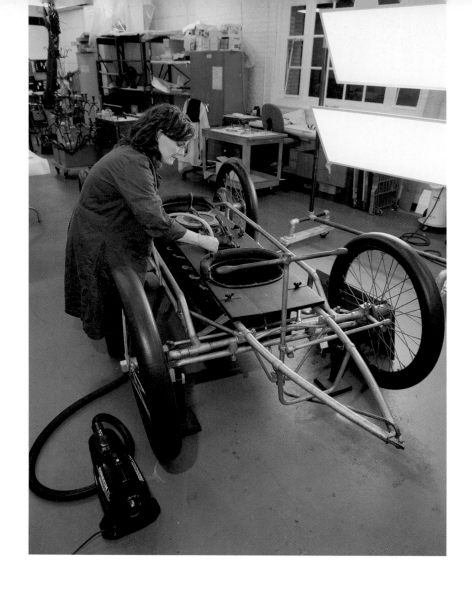

7

Clara Deck, senior conservator for The Henry Ford, cleans a Riker Torpedo Racer.

8 Rob, Drew, Rob, and Jacques play platform tennis in Grosse Pointe Park.

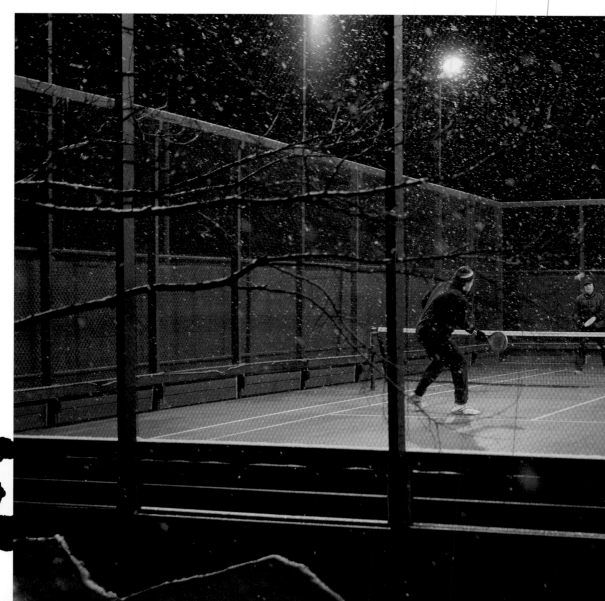

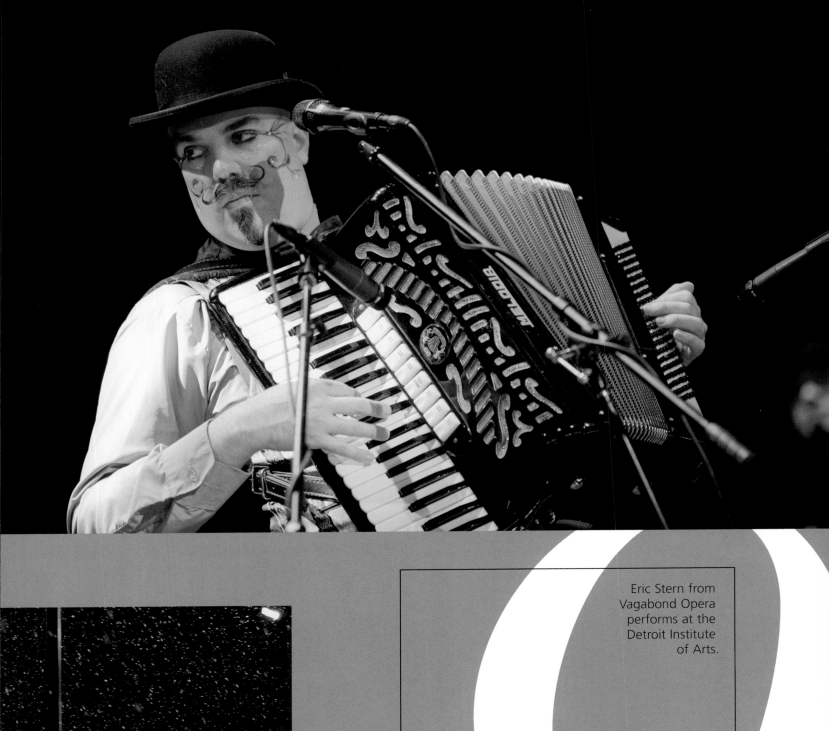

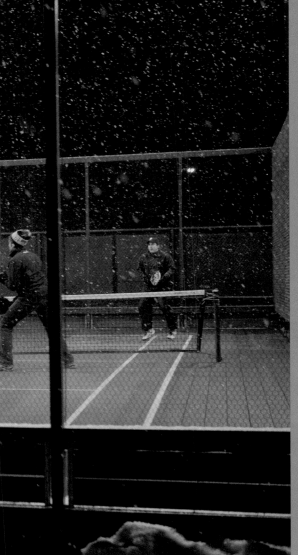

Eric Stern from
Vagabond Opera
performs at the
Detroit Institute
of Arts.

The Sagano Motel on
Woodward Avenue in Pontiac.

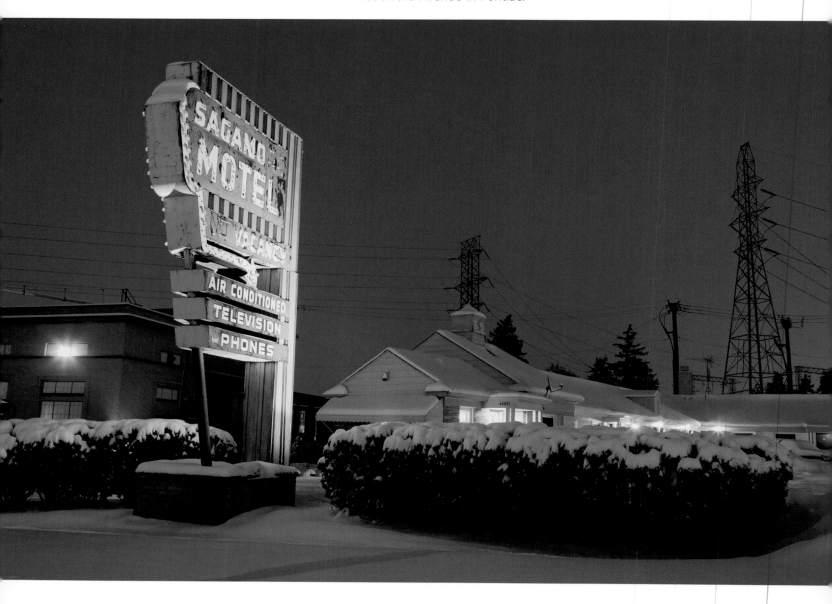

10

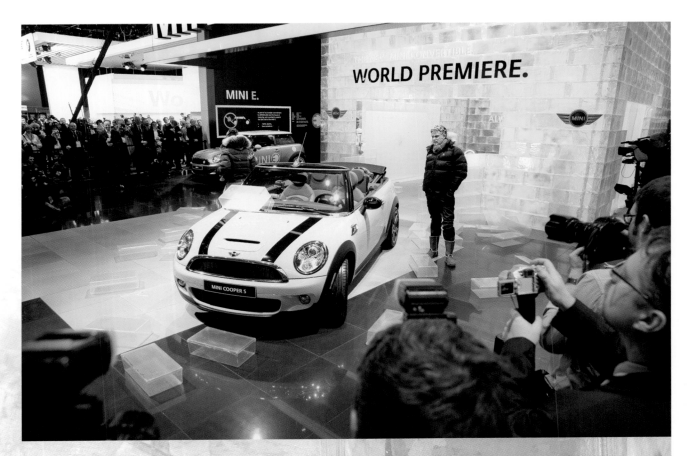

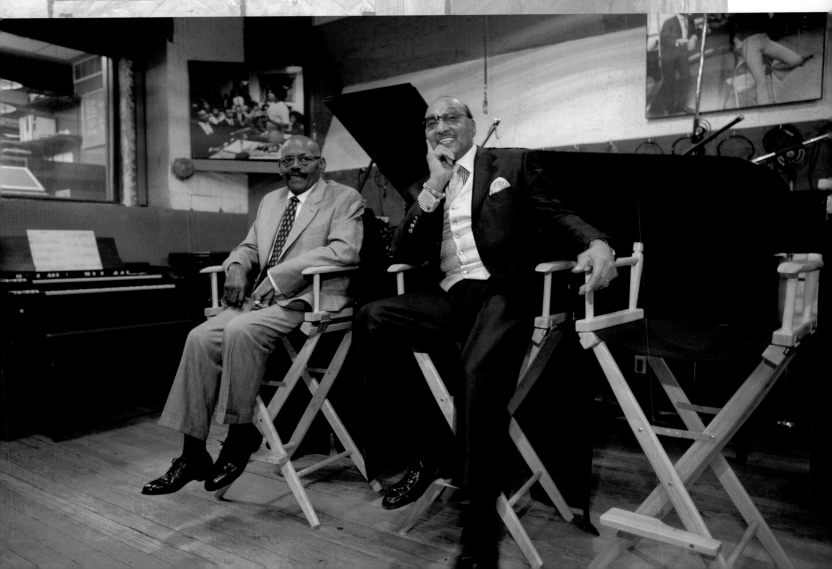

11 Unveiling the 2009 MINI Cabrio at the North American International Auto Show at the Cobo Center.

In Studio A of the Motown Historical Museum in Detroit, Uriel Jones of the Funk Brothers and Abdul "Duke" Fakir of the Four Tops return to celebrate Motown's 50th anniversary. 12

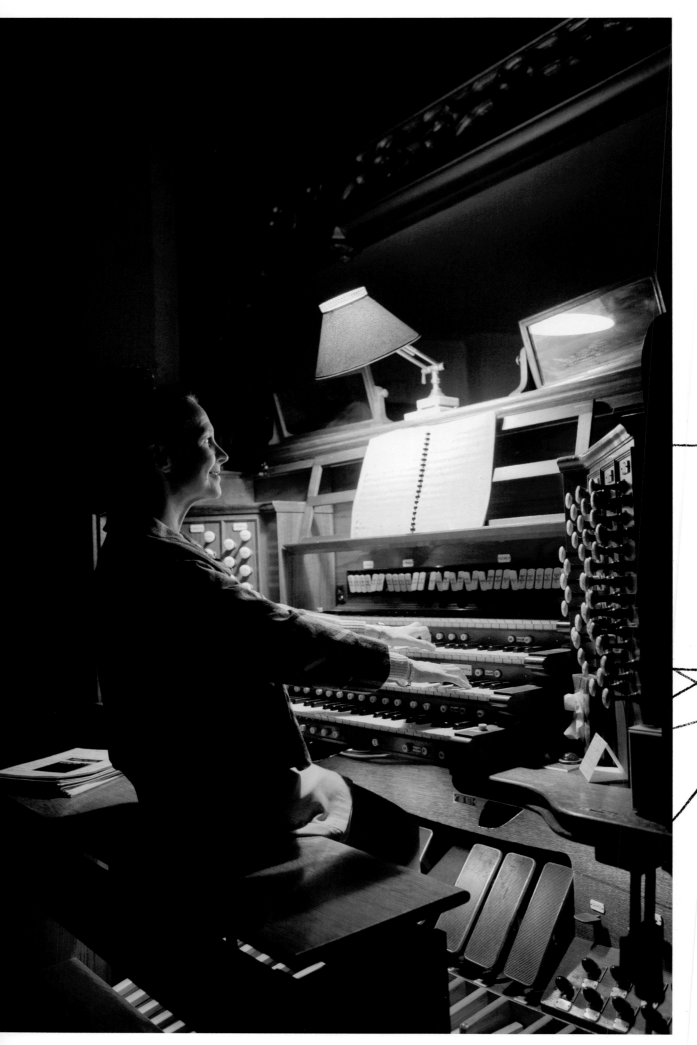

Organist Ava Janus practices at the Masonic Temple of Detroit.

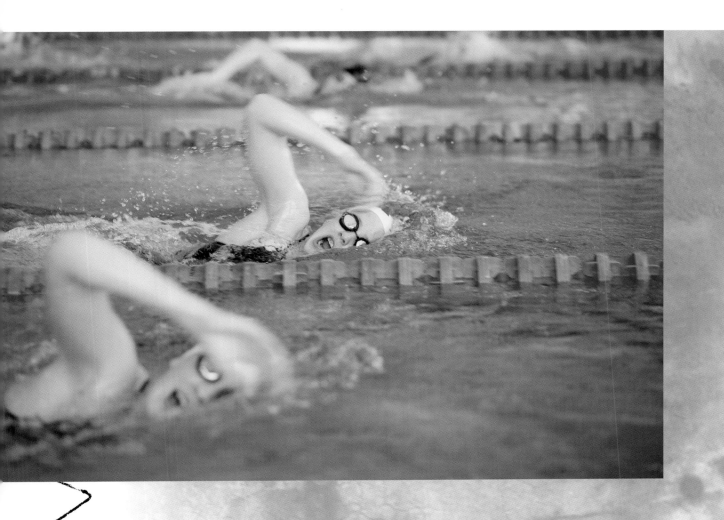

14

Caroline, Sami, and Madison from the Kingfish Aquatic Club train at Waterford Mott High School.

15

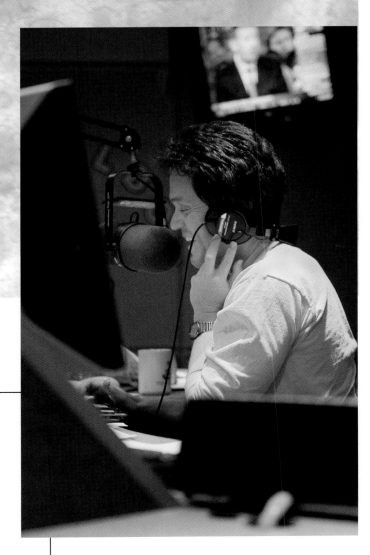

WJR radio personality Mitch Albom hosts *The Mitch Albom Show*.

16

Reva from Troy and
Mitchell from Roseville
dance at Skateland.

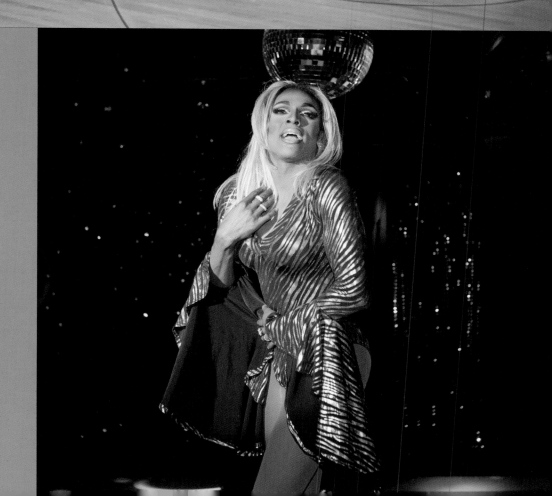

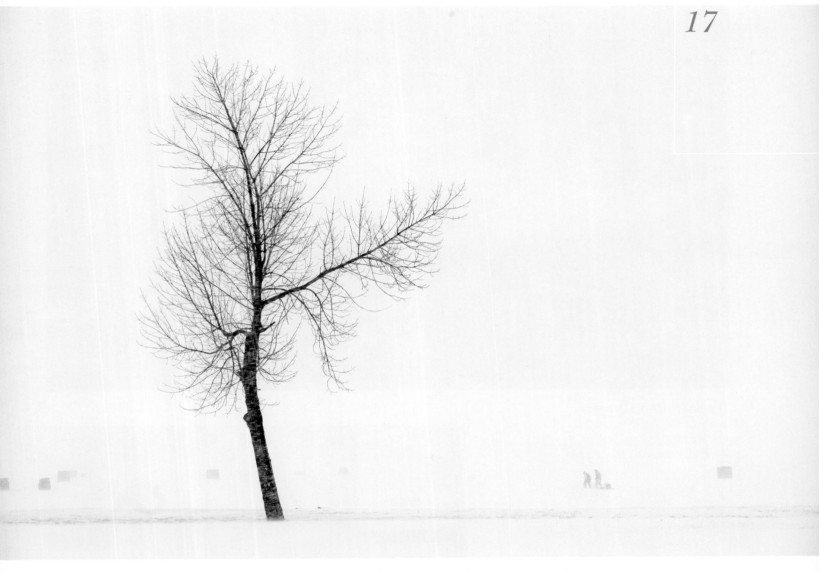

Ice fishing on Lake St. Clair near Selfridge Air Force Base.

18

Tianna Rambous
performs at the
Rainbow Room
in Detroit.

The Spain School Drama
Club performs for Martin
Luther King Jr. Day at the
African American Museum.

19

20

House on the Hills
by Rudy Fig, part of
the CPOPpor2nity,
an art exhibit at
C-Pop Gallery
in Detroit.

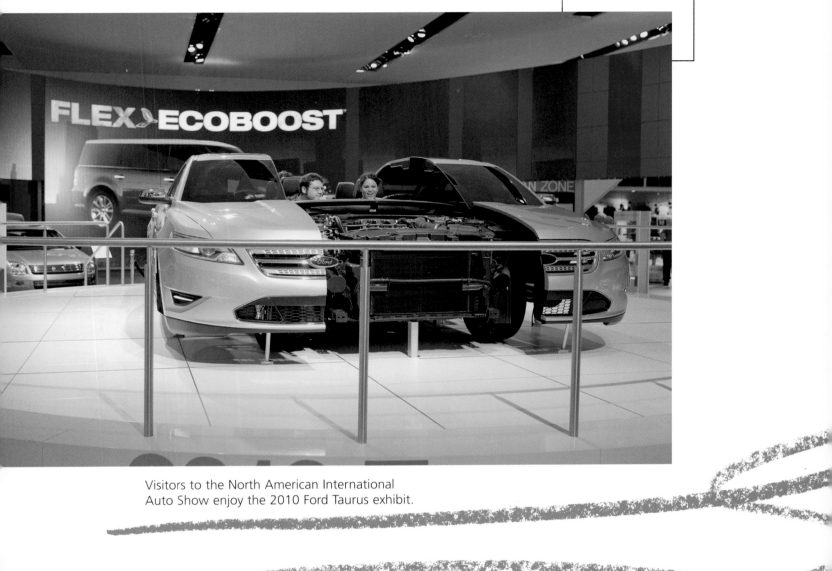

Visitors to the North American International
Auto Show enjoy the 2010 Ford Taurus exhibit.

The Streets of Old Detroit at the
Detroit Historical Museum.

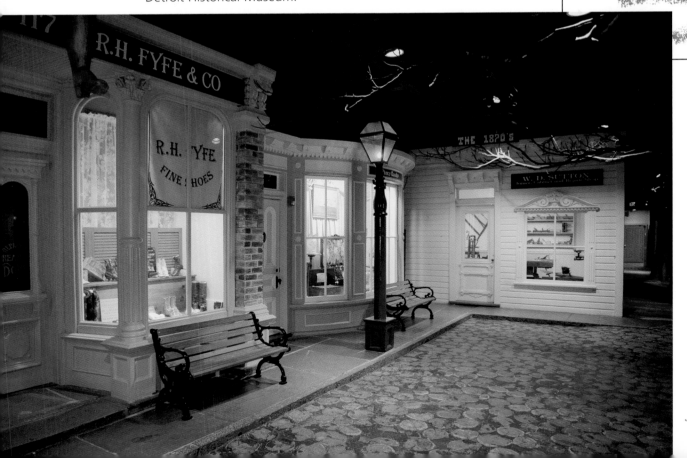

23 Erik Abbott-Main and Ashley McGill from the Detroit Dance Collective rehearse for Collage Concert at the Ford Community and Performing Arts Center in Dearborn.

At the Ann Arbor Chinese Center of Michigan, children perform for the Chinese Lunar New Year's Celebration. 24

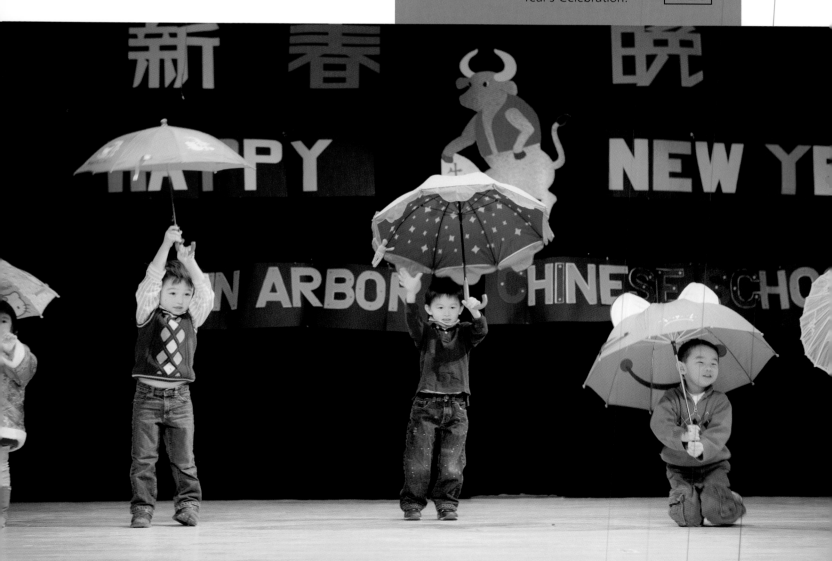

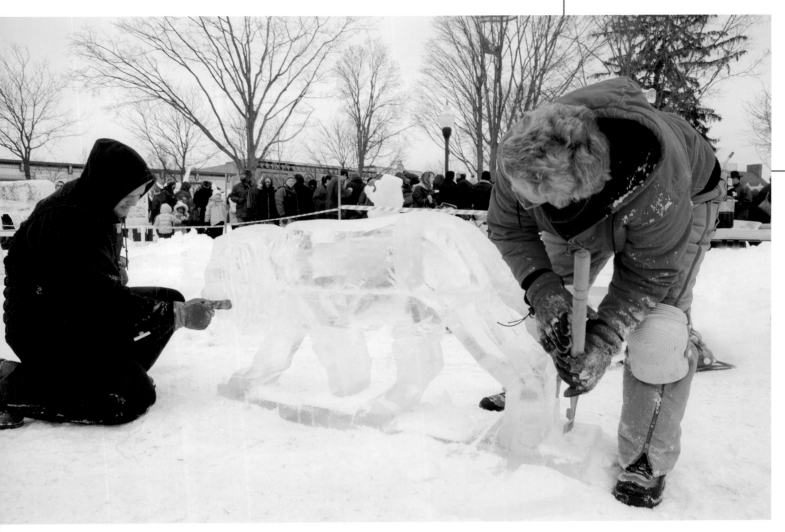

Lee Ulrich and Mary Daniels of the Schoolcraft Culinary Team carve a tiger at the Plymouth International Ice Sculpture Spectacular.

25

26

Students learning to fence at Grosse Pointe Fencing.

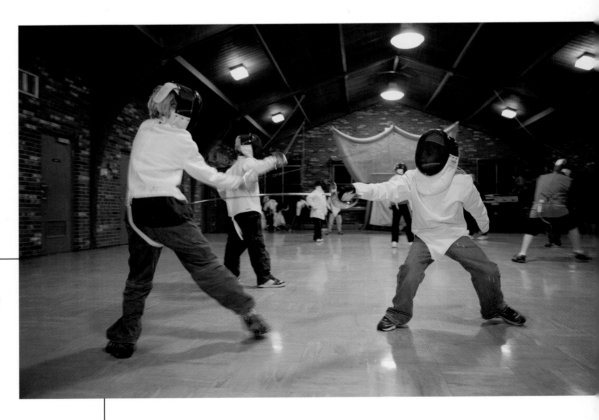

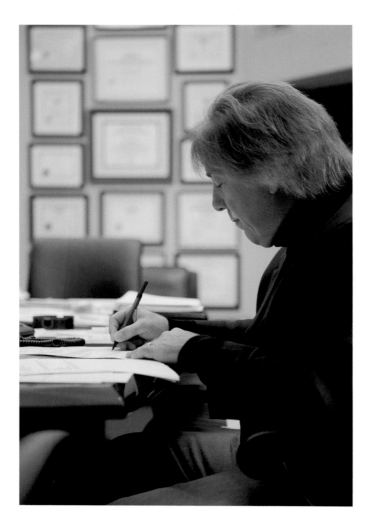

Geoffrey Fieger
prepares for a case
in his Southfield office.

28

Thom Gentle, a
conservationist from
Vermont, repairs
woodwork at the
Edsel and Eleanor
Ford House in Grosse
Pointe Shores.

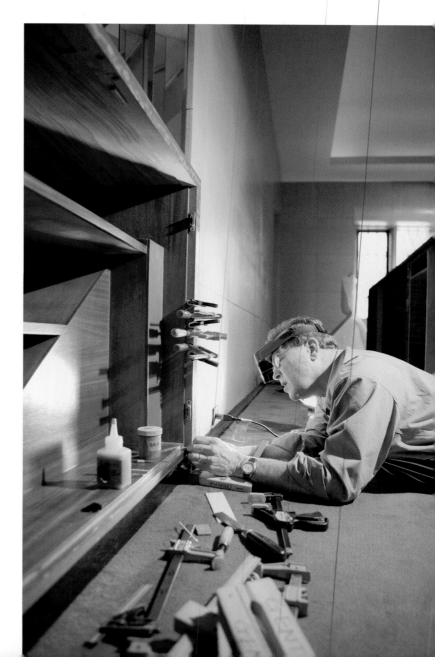

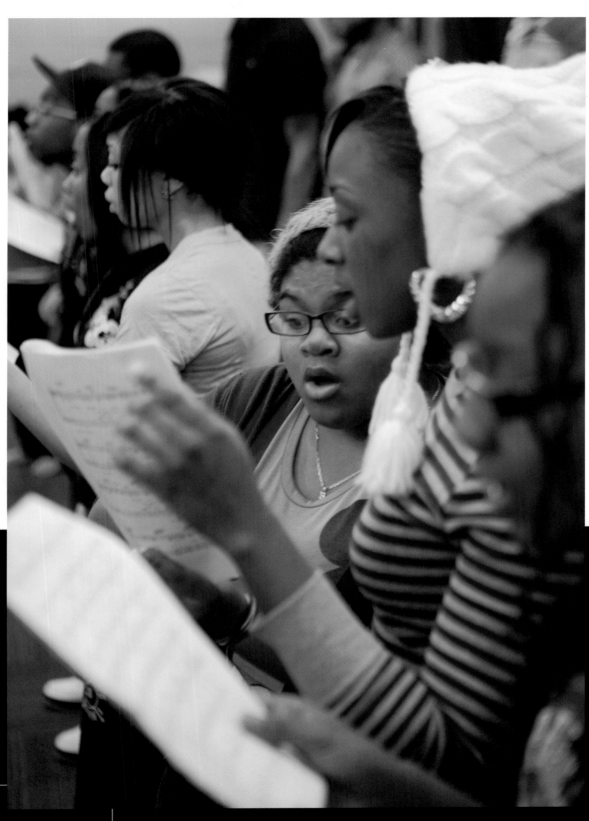

29

Brianna and Mashia rehearse at the Mosaic Youth Theater.

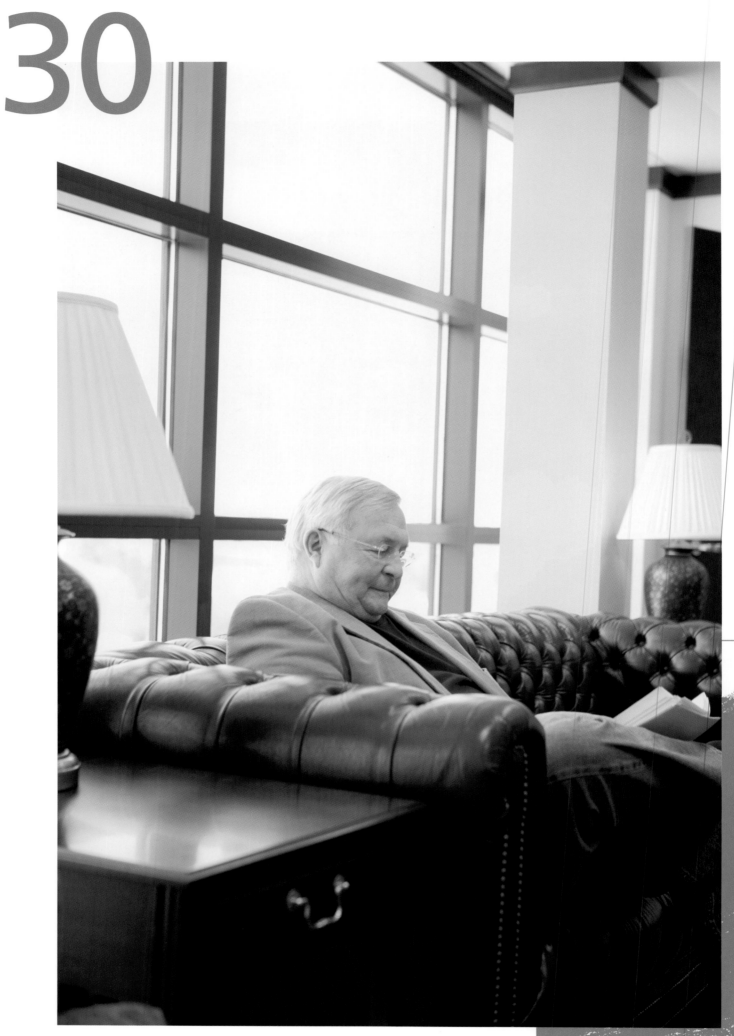

L. Brooks Patterson in his office in Waterford.

31

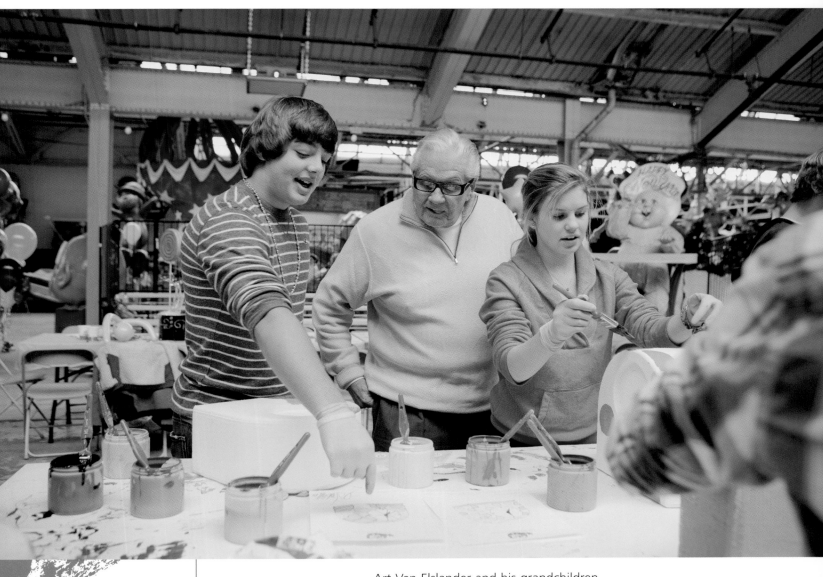

Art Van Elslander and his grandchildren decorate a float sponsored by Art Van.

FEBRUARY

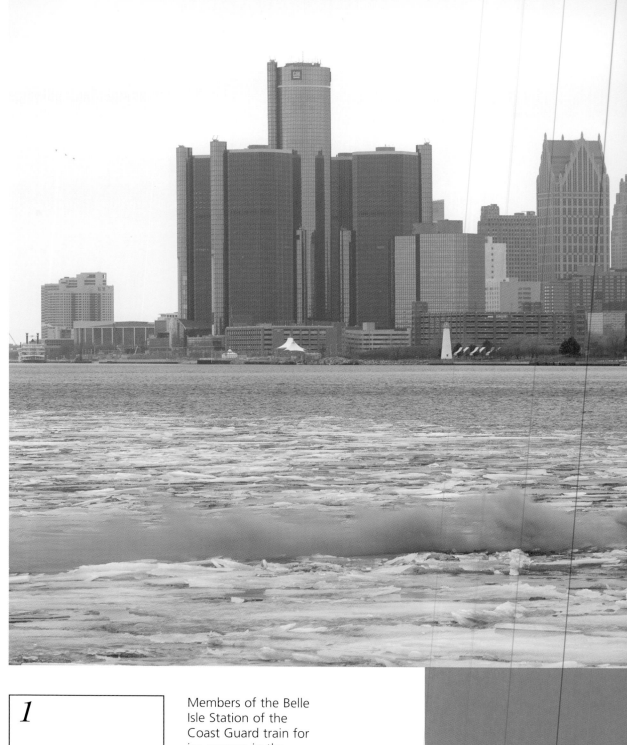

1

Members of the Belle Isle Station of the Coast Guard train for ice rescues in the Detroit River.

2

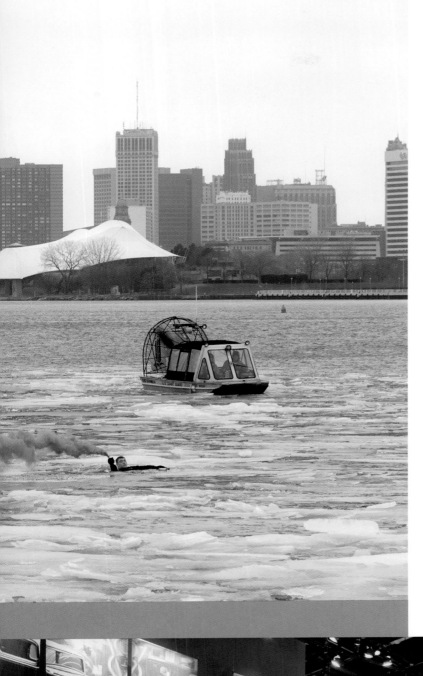

Visitors from China take the Ford Rouge Factory Tour.

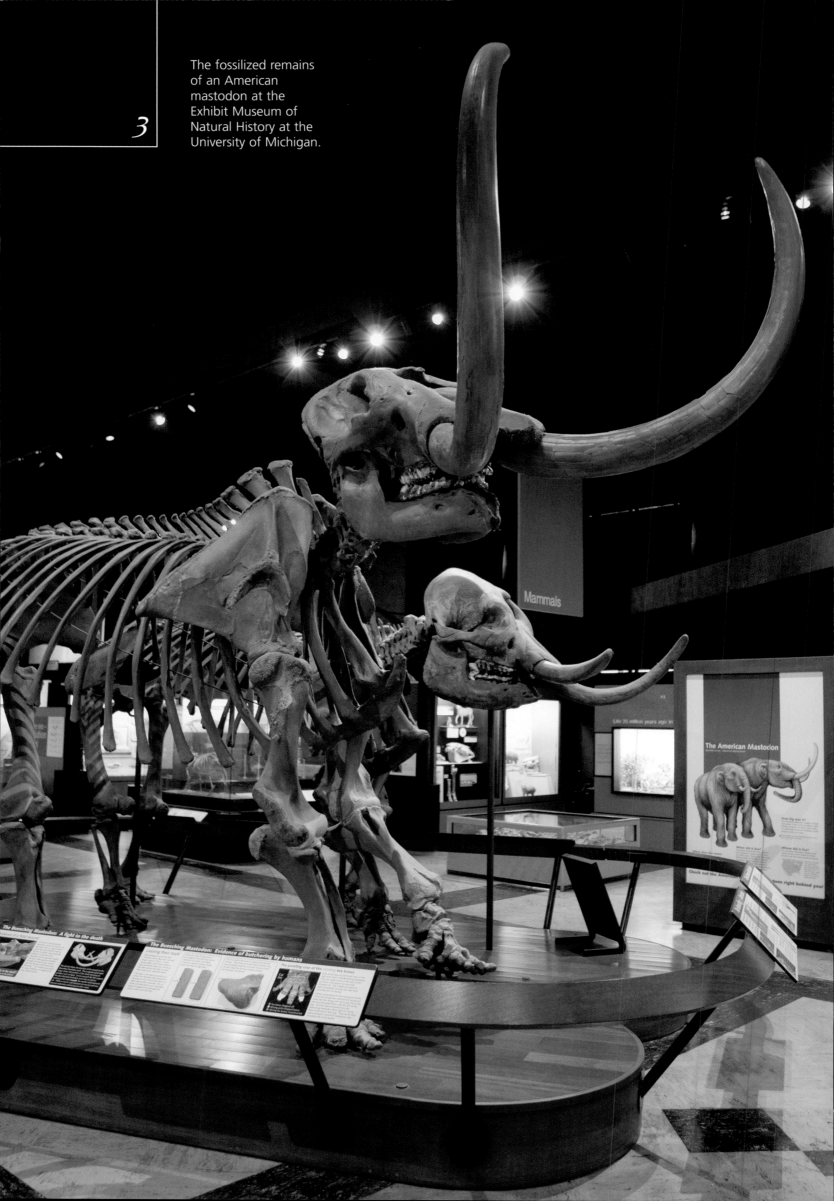

The fossilized remains of an American mastodon at the Exhibit Museum of Natural History at the University of Michigan.

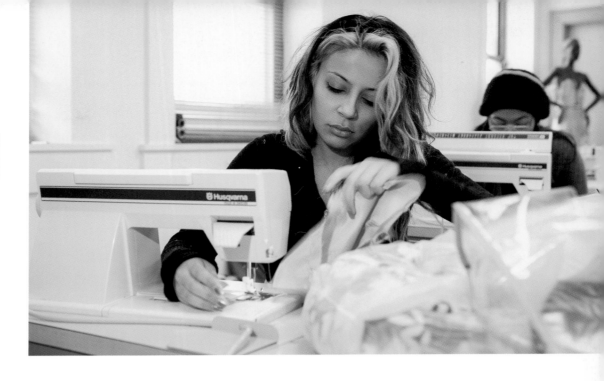

4

Rabia sews during a fashion design/merchandising class at Wayne State University.

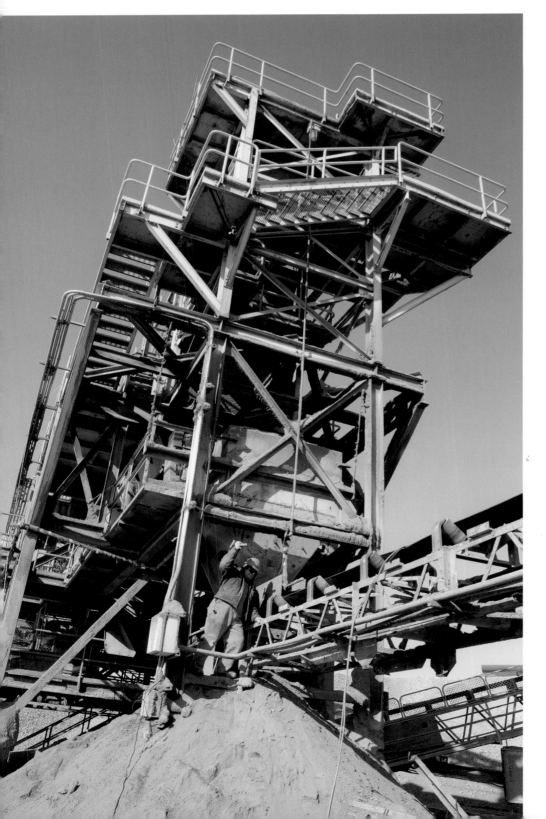

5

Workers for the Edward C. Levy Company.

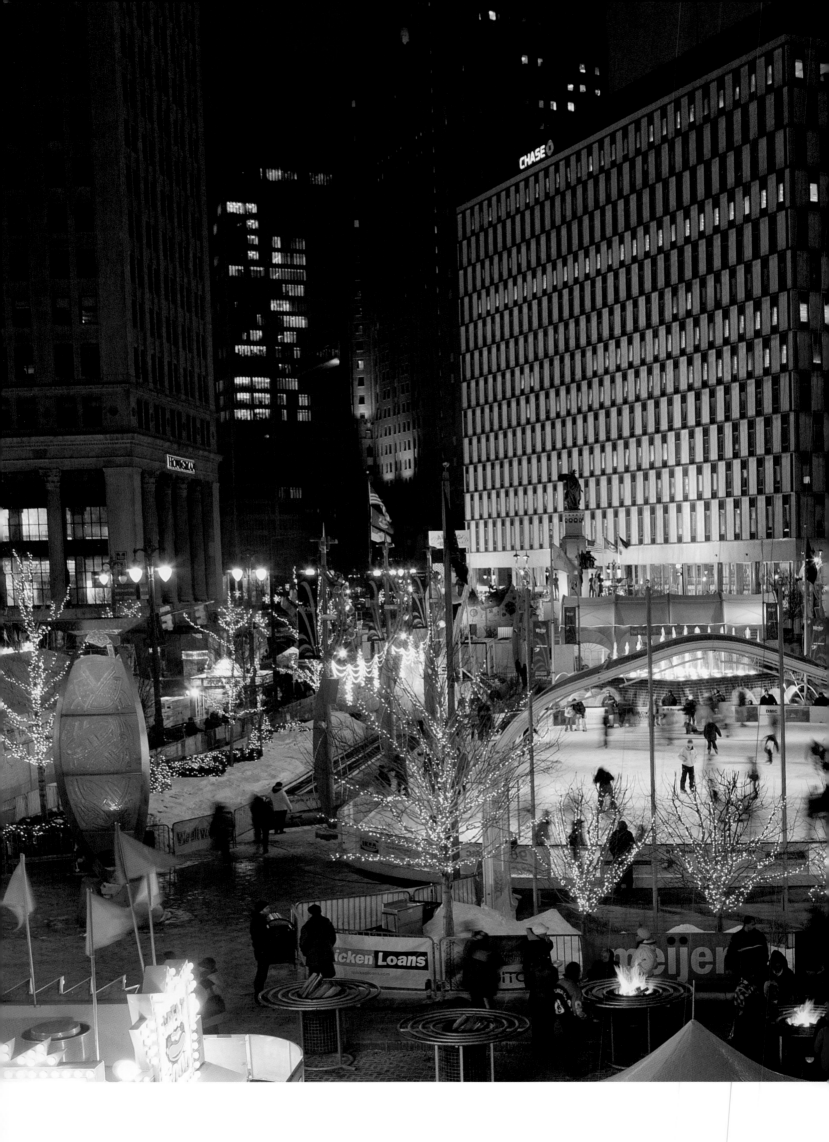

The Detroit
Winter Blast at
Campus Martius.

Pixie Le Punk
performs at the
Dirty Show in Detroit.

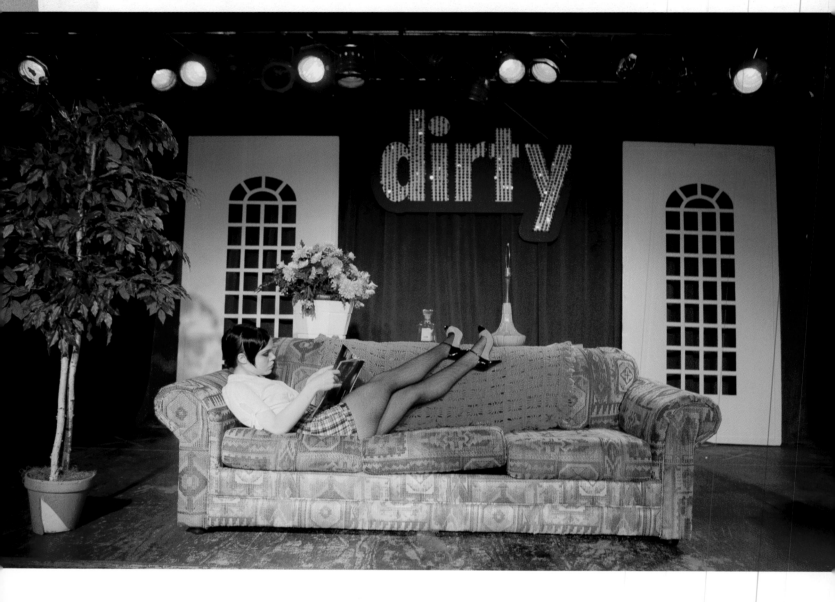

The Russell Industrial
Center sign.

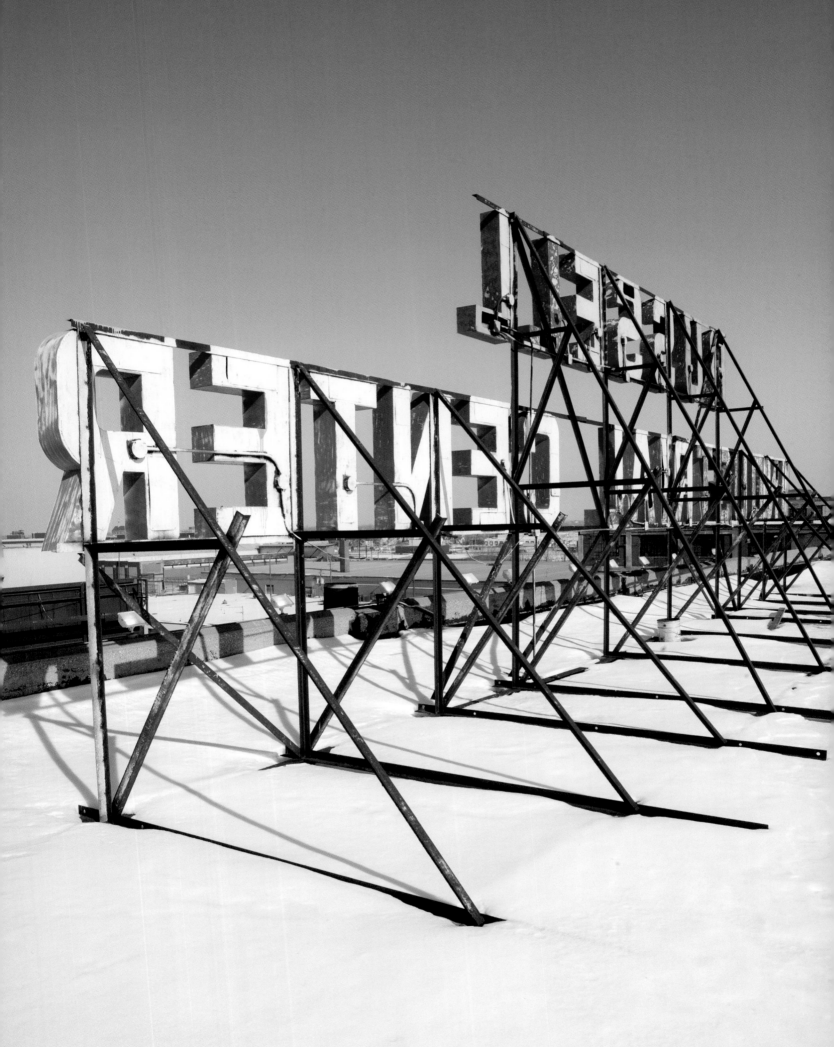

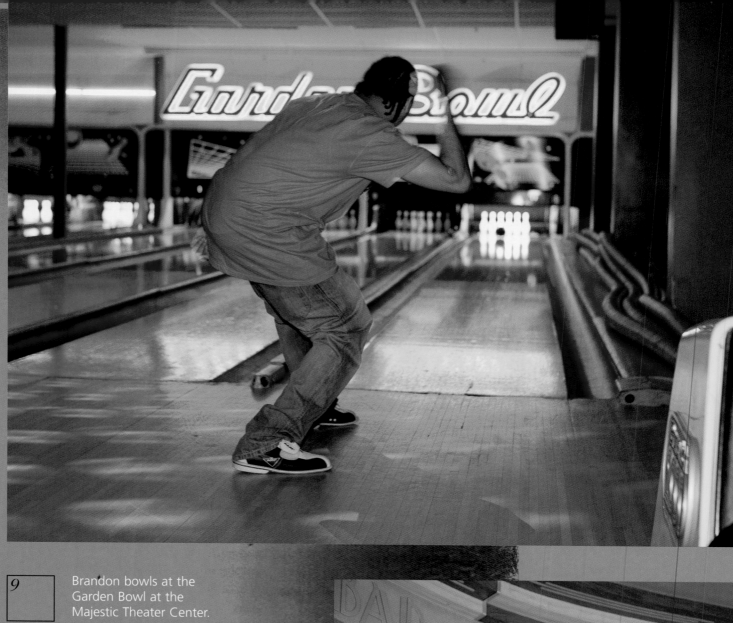

9 Brandon bowls at the Garden Bowl at the Majestic Theater Center.

10 The lunch crowd at the Elwood Grill in Detroit.

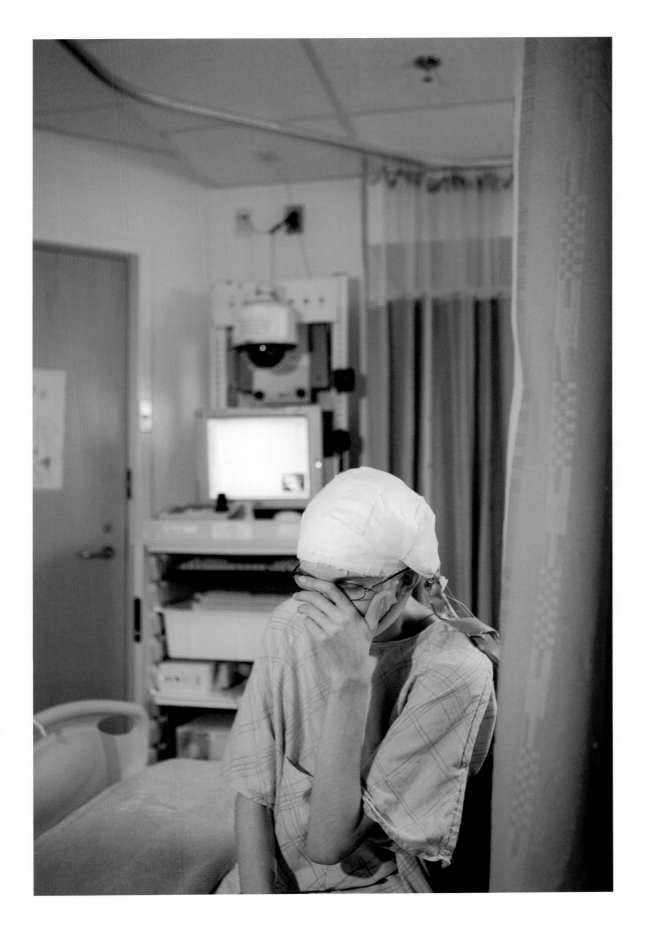

11

William,
recovering from
brain surgery at
Mott Children's
Hospital at
University of
Michigan in
Ann Arbor.

12

Wayne County executive
Robert Ficano practices his
State of the County address
in Canton.

13

Artist Sabrina Nelson and her date enjoy an evening at Café
D'Mongo's Speakeasy in Detroit.

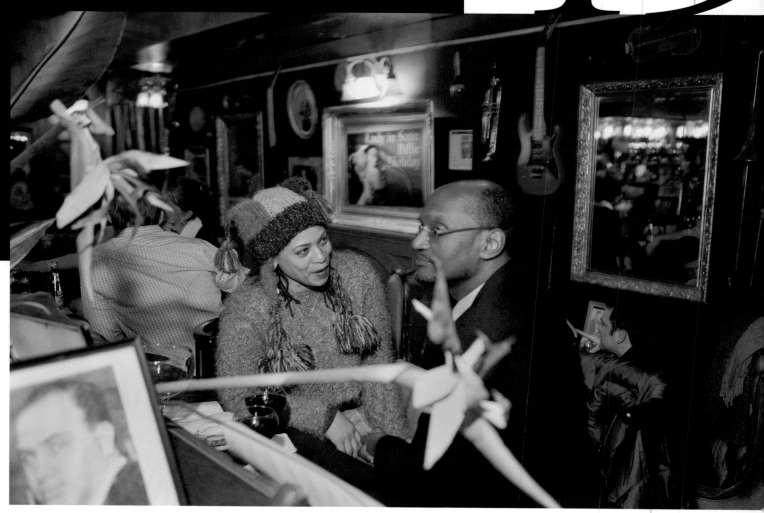

Guy and Allie enjoy
Valentine's Day at White
Castle in Canton.

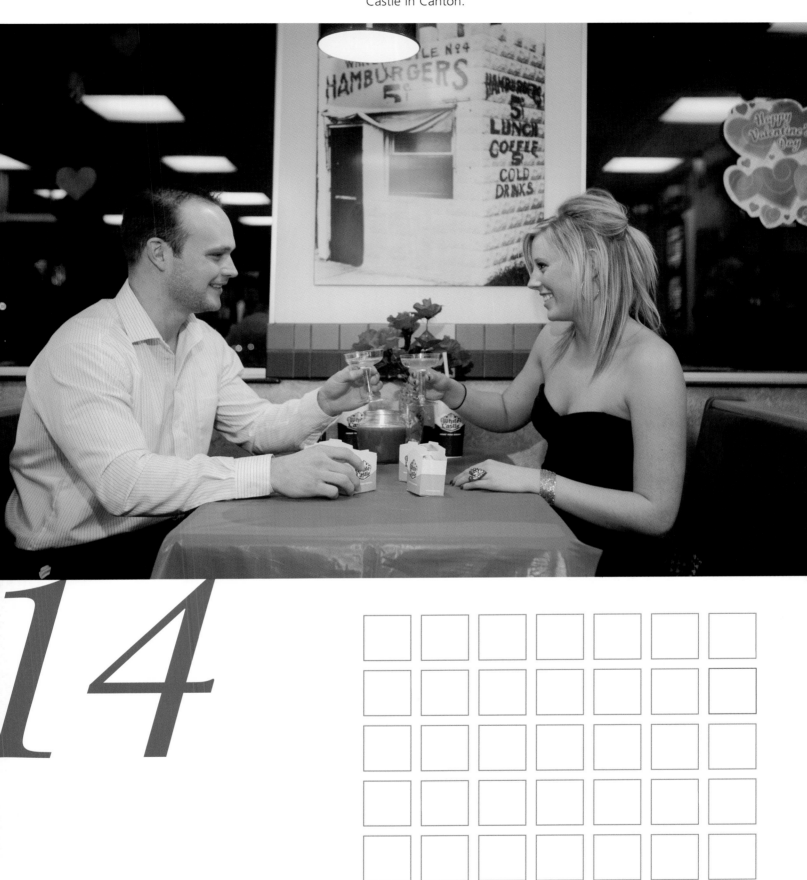

14

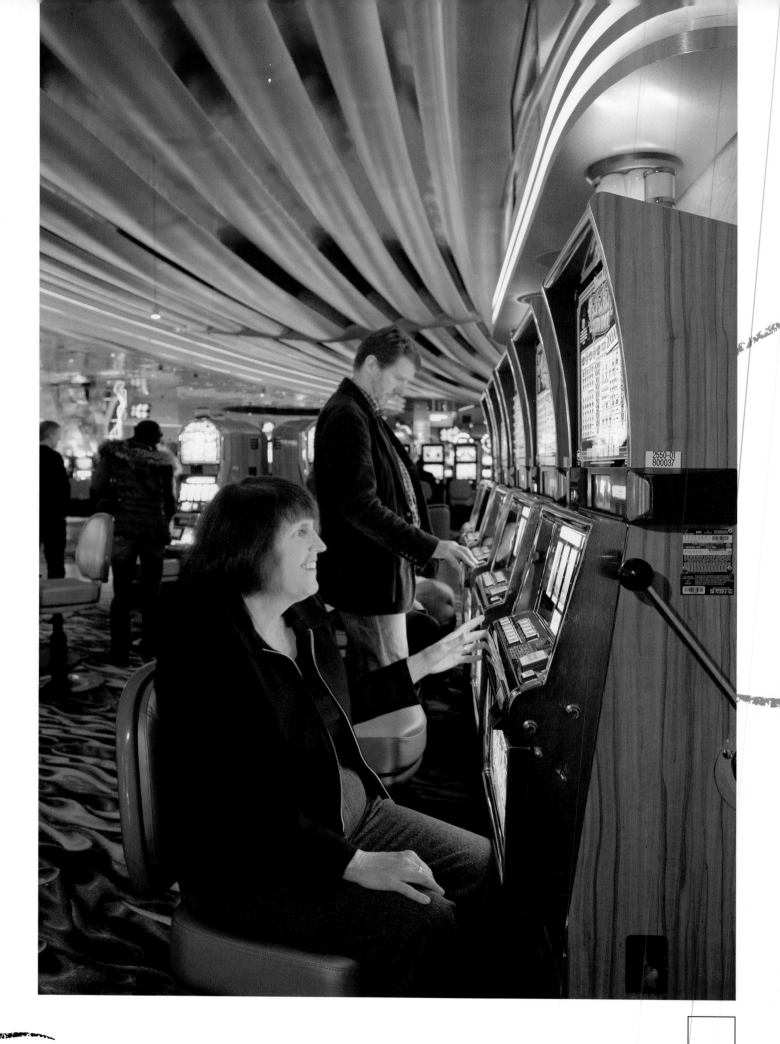

Gamblers at Motor City Casino.

15

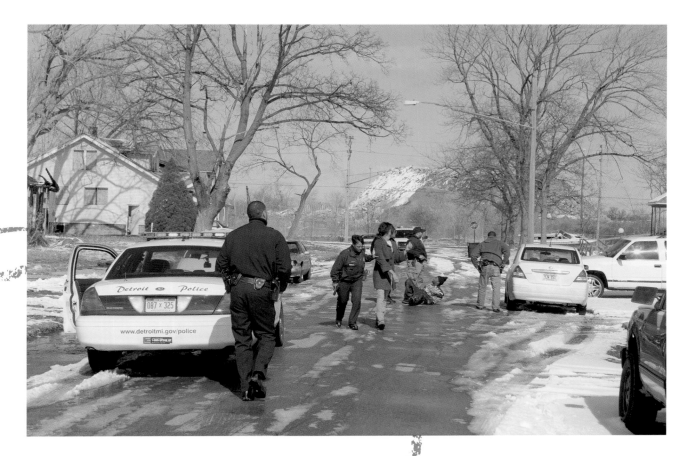

16 Detroit Police Officers Drake and Graham along with officers from the Southwest District apprehend a suspect.

17 Students play with the giant soap film at the Ann Arbor Hands-On Museum.

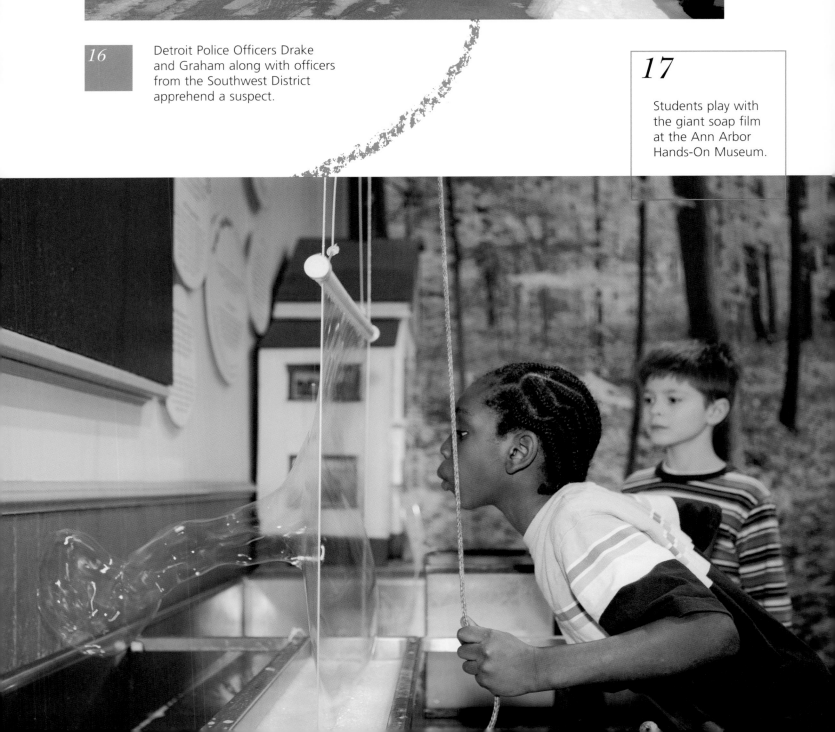

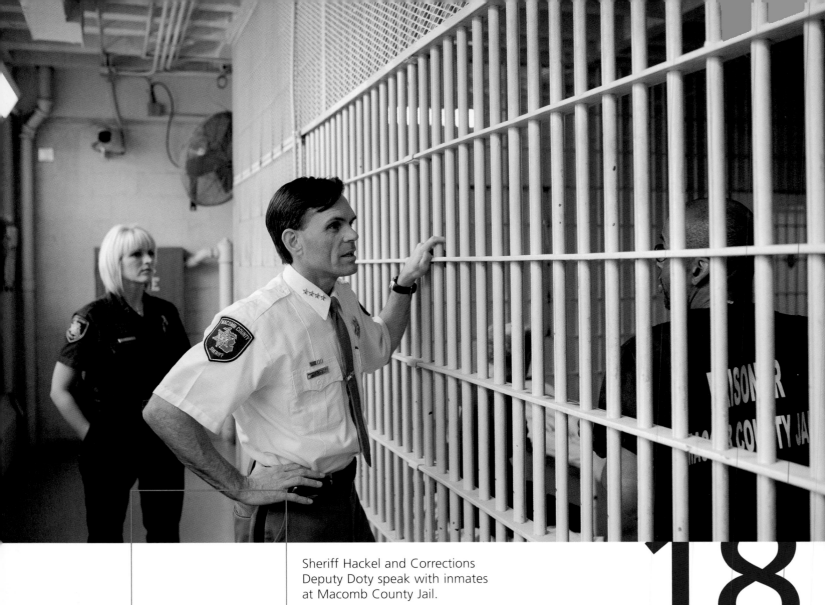

Sheriff Hackel and Corrections
Deputy Doty speak with inmates
at Macomb County Jail.

18

Catholic Central High School wrestler
Gerid Gee competes against Northville
High School wrestler Jon Nelson in a
districts match at Catholic Central.

19

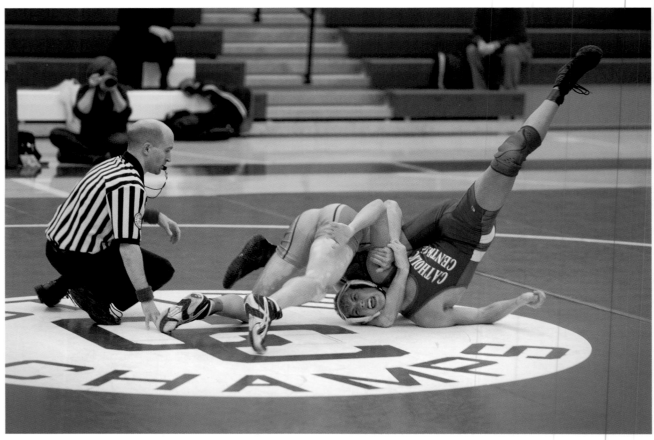

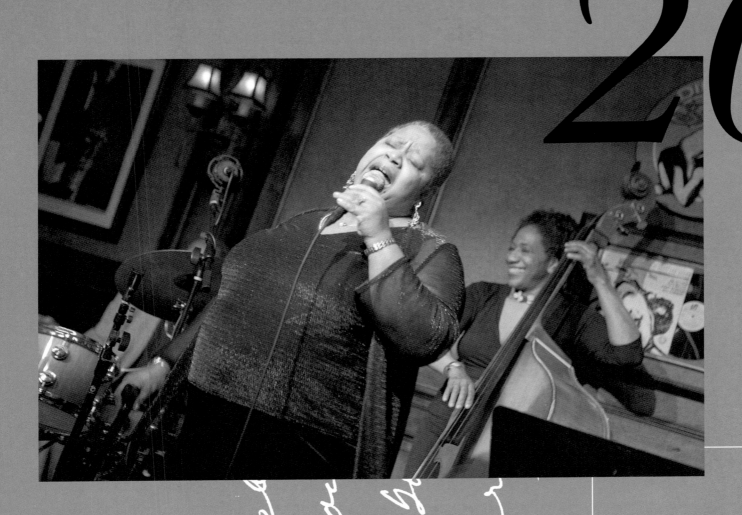

20

Shahida Nurullah sings at the Dirty Dog Jazz Café in Grosse Pointe Farms.

21

Karen, Jan, and Meg congratulate Buzz for his toss while featherbowling at the Cadieux Café.

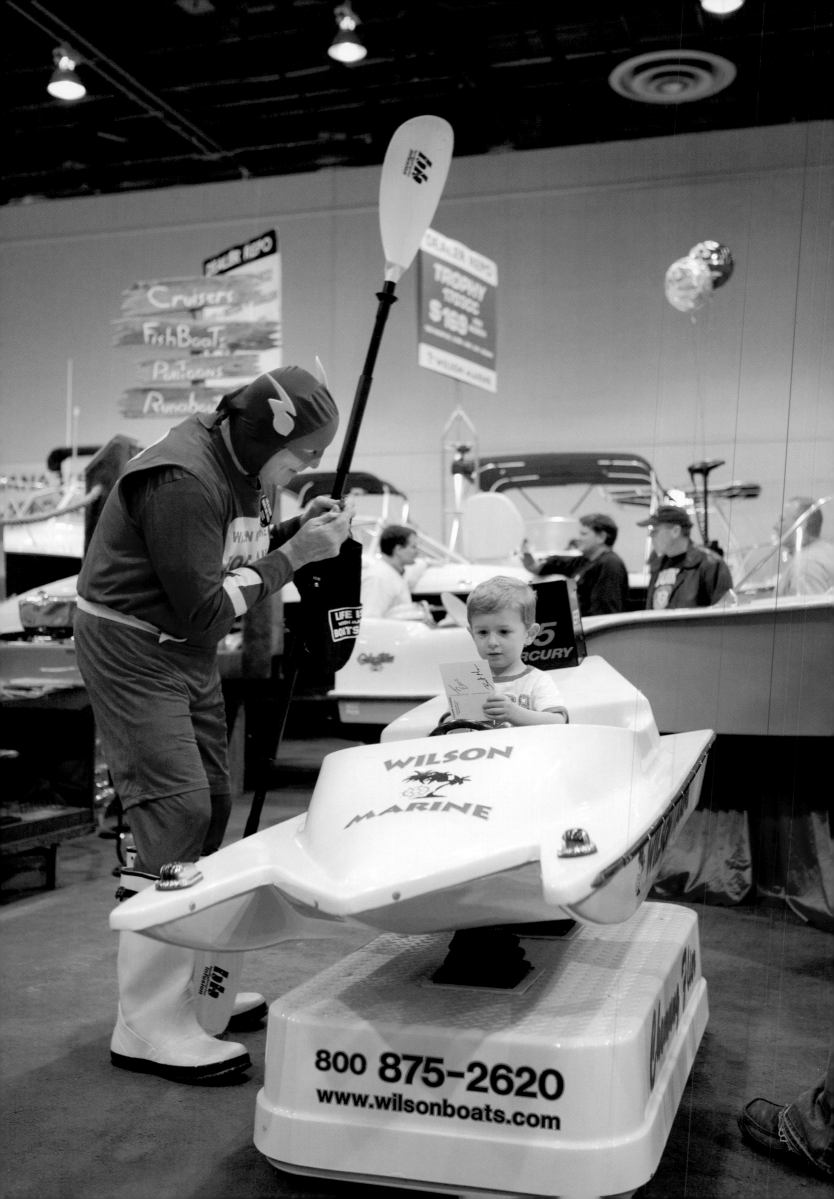

At the 51st annual Detroit Boat Show, Boatman signs an autograph for Eric, two, from St. Clair Shores.

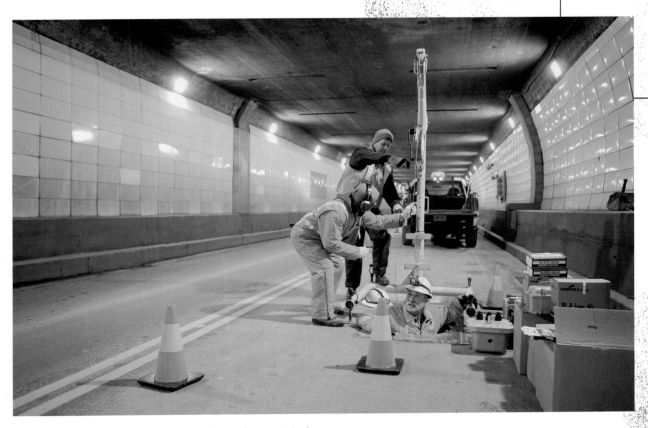

Detroit-Windsor Tunnel employees Mark Black and John Van Ham assist electrician Paul Adams as he enters the mid-river pump room.

Employees of the New Palace Bakery make paczkis for Fat Tuesday.

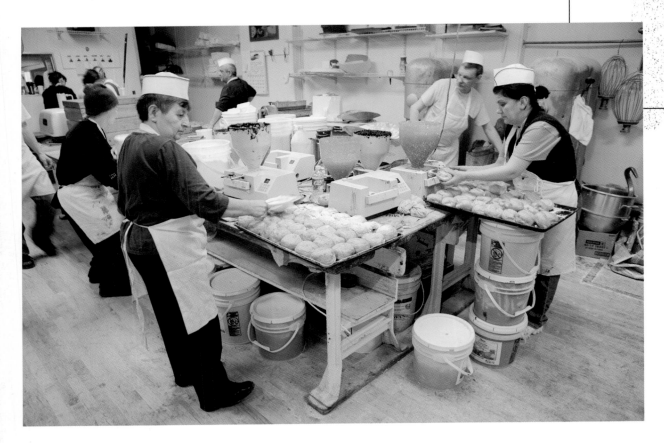

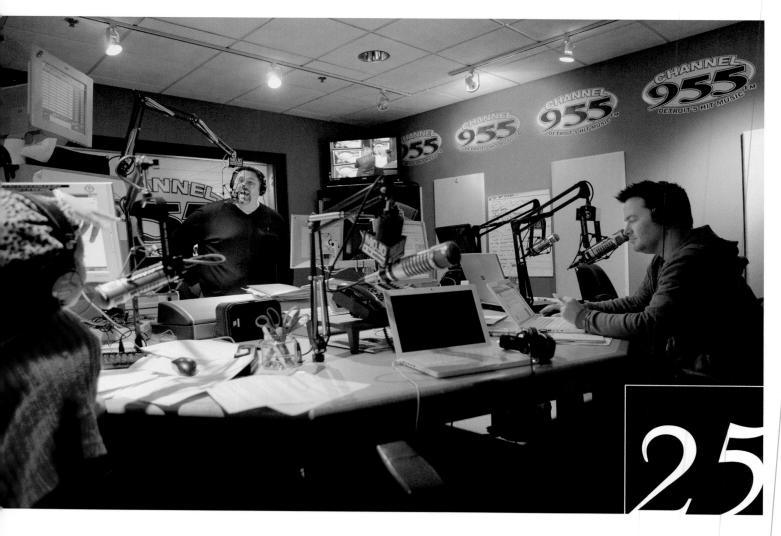

25

Channel 95.5
morning crew—
Mojo, Spike,
and Kyra.

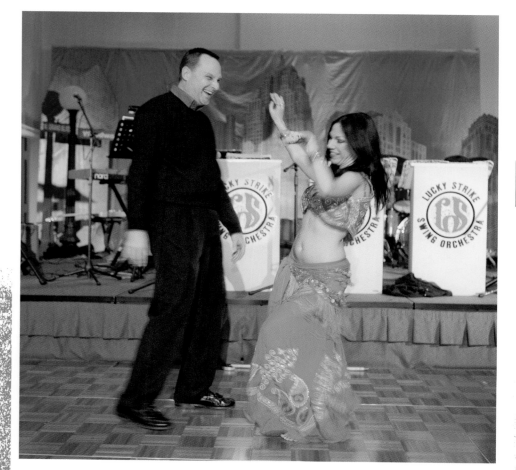

26

A belly dancer entertains
guests at the grand
opening of the
Doubletree Guest Suites
Fort Shelby in Detroit.

27

Cheryl from Round
Rock, Texas, and her
daughters, Kiersten
and Whitney, visit the
Star Trek exhibit at the
Detroit Science Center.

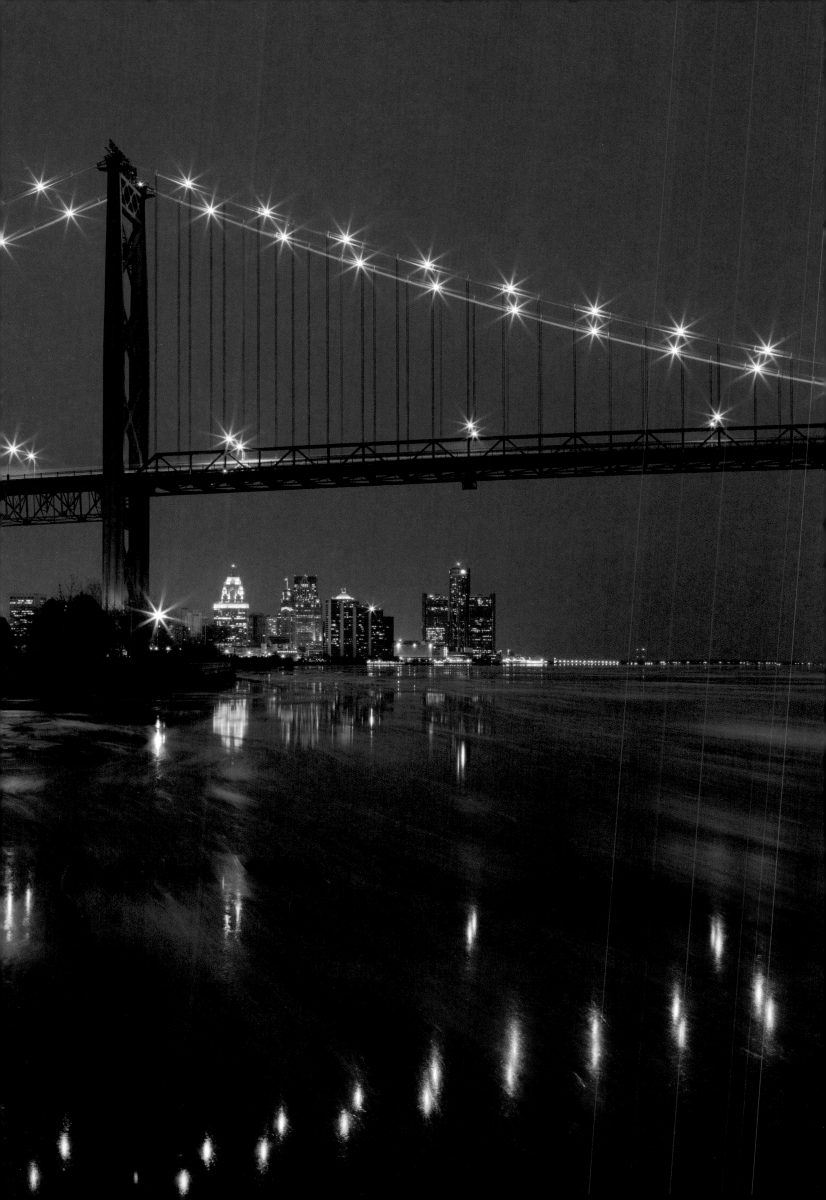

Nighttime falls on the city.

INDEX